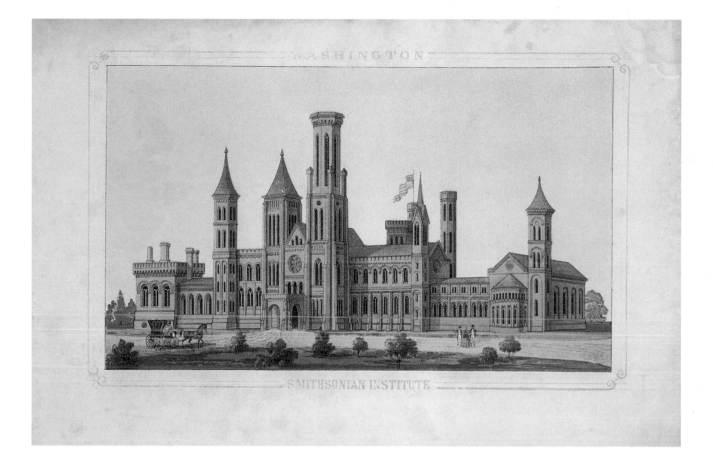

In Appreciation for your Support as a Contributing Member

LEGACIES

Collecting America's History at the Smithsonian

Steven Lubar and Kathleen M. Kendrick

PUBLISHED BY

Smithsonian Institution Press

WASHINGTON AND LONDON

IN ASSOCIATION WITH THE

National Museum of American History, Behring Center

Library of Congress Cataloging-in-Publication Data
Lubar, Steven D.
 Legacies : collecting America's history at the Smithsonian / Steven Lubar and Kathleen M. Kendrick.
 p. cm.
Includes bibliographical references (p.) and index.
ISBN 1-56098-886-X (alk. paper) — ISBN 1-56098-864-9 (pbk. : alk. paper)
 1. National Museum of American History (U.S.)—History. 2. Historical museums—United States. 3. United States—Civilization. 4. Material culture—United States—Collection and preservation. 5. Americana—Collectors and collecting. 6. National characteristics, American. I. Kendrick, Kathleen M. II. National Museum of American History (U.S.). III. Title.
E169.1.L846 2001
973'.074'753—dc21 2001020399

British Library Cataloguing-in-Publication Data available

Printed in Hong Kong, not at government expense

06 05 04 03 02 01 5 4 3 2 1

⊗ The paper used in this publication meets the minimum requirements of the American National Standard for Information Sciences—Permanence of Paper for Printed Library Materials ANSI Z39.48-1984.

Smithsonian Institution Press
Caroline Newman, Executive Editor,
 Museum Publications
Martha Sewall, Production Manager

Prepared for publication by Archetype Press, Inc.
Washington, D.C.
Diane Maddex, Project Director
Gretchen Smith Mui, Editor
Robert L. Wiser, Designer

Front cover: Table made by Peter Glass, about 1860 (see page 171).

Endleaves: Duke Ellington score, about 1940 (see page 30).

Page 1: Drawing of the Smithsonian Institution, 1855 (see page 12).

Page 2: Clothespin patent models, 1852–87. Invention has always been a key part of the National Museum of American History's story of progress. In 1908 and again in 1926 the Patent Office transferred thousands of patent models to the Smithsonian, including these clothespins.

Back cover: *A Handbook to the National Museum,* 1886 (see page 12).

Prop from *M*A*S*H*, 1972–83. Following the series finale of *M*A*S*H*, the Emmy-winning television show depicting a mobile army surgical hospital during the Korean War, the National Museum of American History collected props and two sets—the "Swamp" and the "O.R."—the most extensive documentation of a television program undertaken by the museum. Because many of the show's props were authentic to the period, they entered the collections not just as popular culture but also as military and medical artifacts of the Korean War. A special exhibition, *M*A*S*H: Binding Up the Wounds*, opened in July 1983 and drew record crowds.

Contents

Foreword

SPENCER R. CREW

DIRECTOR,
NATIONAL MUSEUM
OF AMERICAN HISTORY

The Smithsonian's National Museum of American History is a place to learn about and connect with the past. Its collections of historical artifacts preserve the memories and experiences of the American people, and each year its exhibitions bring those stories to life for millions of visitors. By choosing what objects to collect and what stories to tell, its curators have helped shape the ways we Americans understand and experience our nation's history.

Over the years the museum has collected different objects for different reasons. As views of history change, methods of historical investigation evolve and improve, and the public's understanding of the past matures, new ideas emerge about what is worth saving. Stories and artifacts once considered unimportant might be treasured by later generations, just as the value of once-precious things may fade with time.

The rich diversity of the National Museum of American History's collections speaks to these changing perspectives. While museum objects tell stories about the people who made, owned, and used them, they also symbolize the interests and values of the people who collected, preserved, and donated them.

The men and women who have collected America's history at the Smithsonian over the past 150 years have taken their jobs seriously. In their role as collectors, caretakers, and storytellers, they have reflected the hopes and dreams of their fellow Americans. As a result, the museum has become a place not just to discover the past but also to understand the present and ponder the future. As we contemplate the things that earlier generations have saved for us, we are inspired to think about what we are saving today and what might be worth saving in the years to come.

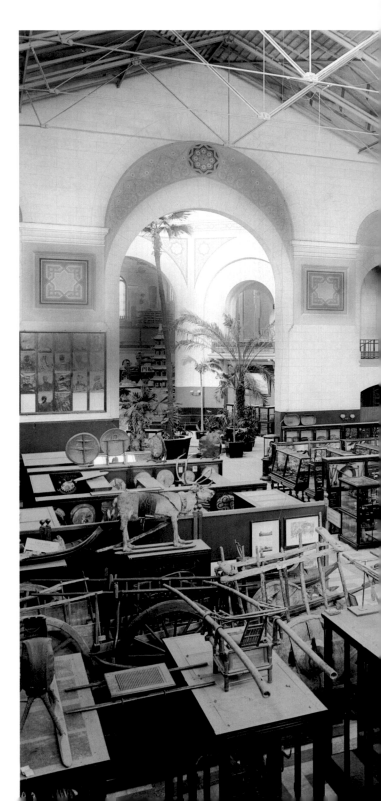

This book, which explores the history of the National Museum of American History's collections, comes at an opportune moment. A new century offers new promises and possibilities as well as new challenges, both for the institution and the nation. As we chart a path toward the future, knowledge about the past can provide a sense of continuity and purpose. Through the lessons of past struggles and achievements, history can inspire us to take on new challenges and set new standards. It can remind us of what binds us together as Americans, the common and varied threads of experience that have shaped our national identity.

This book encourages all of us—museum professionals, museumgoers, Americans—to think about the legacies we have inherited from the past and those we will pass on to future generations. It also asks us to consider the institutions that look after these legacies and the vital importance of their work. History museums are not only keepers of the past; by investing old stories and old objects with new meanings, they keep the past alive. As places where legacies are continually created, preserved, and passed on, they symbolize the value Americans invest in our nation's history.

Acknowledgments

STEVEN LUBAR AND
KATHLEEN M. KENDRICK

East Hall, National Museum (now the Arts and Industries Building), about 1890. Visitors to the Smithsonian in the late nineteenth century encountered halls of cultural and technological artifacts from around the world, classified and ordered according to ideas of human progress. As views of the past have changed, museum artifacts have been arranged in new ways to tell new kinds of stories.

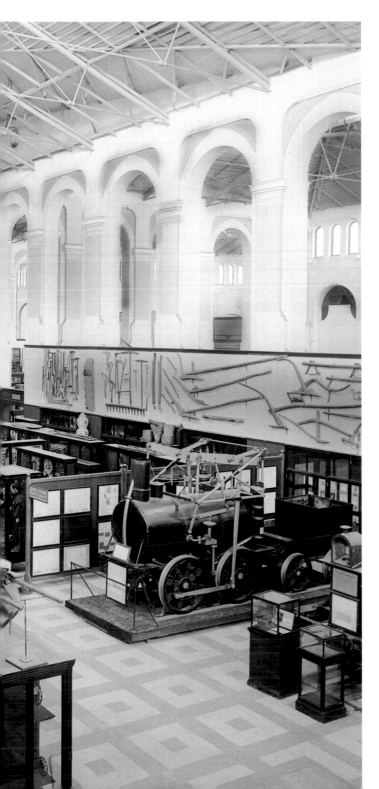

As with any publication, this book reflects the knowledge, interests, and biases of its authors. Out of the millions of stories at the National Museum of American History—more than 3.2 million artifacts at last count—we have selected just a few hundred, the ones we found most interesting and revealing. This is a personal rather than an official view of Smithsonian history, a glimpse into its inventory of treasures.

This book is based on research done for a forthcoming exhibition at the National Museum of American History. We are grateful for the early and generous support of Susan and Elihu Rose and for Dr. Rose's leadership as program committee chairman of the National Museum of American History Board.

In working on this book we have discussed Smithsonian history and collections with staff members, visiting scholars, and other museum professionals. Among many others who shared their experiences and expertise with us, we wish to thank Richard E. Ahlborn, David K. Allison, Joan Boudreau, Dwight Blocker Bowers, Lonnie G. Bunch III, Judy M. Chelnick, Spencer R. Crew, Michelle Delaney, Richard Doty, Bernard Finn, John Fleckner, Kate Fleming, Shelly Foote, Barbara Franco, Robert Friedel, James B. Gardner, Kathleen Golden, Patricia Gossel, Lisa Kathleen Graddy, Rayna Green, Briann Greenfield, Kate Henderson, Pamela M. Henson, Ellen Roney Hughes, James E. Hughes, Neal Johnson, Paula Johnson, Paul F. Johnston, Jennifer L. Jones, Peggy Kidwell, Ramunas Kondratas, Peter Liebhold, Bonnie Lilienfeld, Joanne Gernstein London, Keith Melder, David D. Miller III, Arthur Molella, Martha Morris, Douglas Mudd, Susan Myers, Shelley Nickles, Cecilia O'Leary, Craig Orr, Katherine Ott, Marc Pachter, Shannon Perich, Sarah J. Rittgers, Harry R. Rubenstein, Odette Diaz Schuler, Ann Seeger, Anne M. Serio, Terry Sharrer, David Shayt, Nikki Stanton, Carlene Stephens, Gary Sturm, Lisa Thoerle, Susan Tolbert, Steven C. Turner, Margaret Vining, Deborah J. Warner, Roger White, William Withuhn, William E. Worthington Jr., Helena E. Wright, and William H. Yeingst. Special thanks to the keepers of the accession files at the National Museum of American History, Nancy L. Card and Estelle Florence, for their help in mining that archive for the stories we tell here.

A richly illustrated book like this is as much the product of artists as writers, and it is a pleasure to acknowledge the talented photographers and staff of the Smithsonian Office of Imaging, Photography, and Printing Services, especially Lorie H. Aceto, Dave Burgevin, Harold Dorwin, Larry Gates, Joe Goulait, Eric Long, Terry G. McCrea, Richard Strauss, Hugh Talman, Jeff Tinsley, Jim Wallace, and Scott T. Williams. Thanks also to Archetype Press for skillfully transforming the raw materials into a beautiful book.

Our special thanks to our editor at the Smithsonian Institution Press, Caroline Newman, who believed in this book from the beginning, and also to the other members of the exhibition team: Nigel Briggs, Lynn Chase, and Jane Fortune.

What Is Worth Saving?

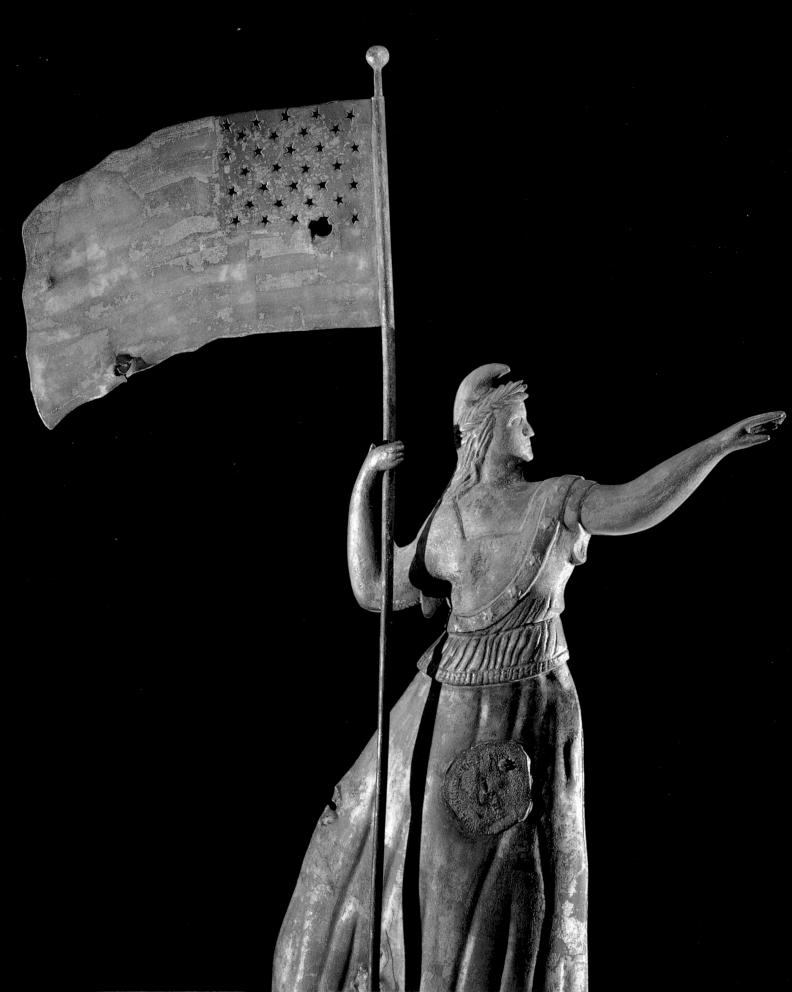

O N AUGUST 24, 1814, only hours before British forces occupied and burned the city of Washington, First Lady Dolley Madison was rushing to save what she could from the White House. As she packed up a wagon with "the most valuable portable articles," she could hear the cannons firing in nearby Bladensburg, Maryland. Time was running out; soon her own escape route would be blocked by retreating American soldiers. Urged to evacuate immediately, Mrs. Madison insisted on waiting until one more item was saved: a life-size portrait of George Washington by the artist Gilbert Stuart. But the large painting was screwed tightly to the wall and would not be easily removed. After several frustrating attempts, the servants finally broke the frame apart to free the canvas. With her "precious painting" placed in safe hands, Mrs. Madison fled the capital.[1]

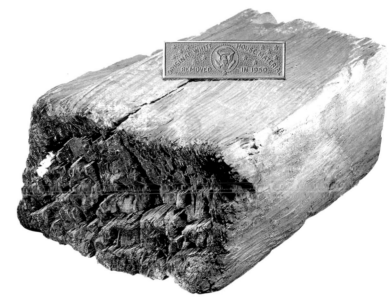

White House timber burned in the fire of 1814 (right). This charred timber, discovered during renovations in 1950, is believed to have survived the burning of the presidential mansion by the British during the War of 1812. It was acquired by a Washington, D.C., political memorabilia collector, Ralph E. Becker, who presented it to the Smithsonian in 1968.

The story of Dolley Madison's heroic rescue of the Washington portrait, told by the first lady herself in a letter she wrote to her sister that day, has become an American legend: A tale of patriotism and valor, it is also a story of the bond between people and material things. Even more, it is a story about the bond between Americans and the artifacts of history—the things they inherit from the past and the legacies they are entrusted to preserve as individuals, as members of families and communities, and as citizens. After all, Mrs. Madison saved a wagonload of articles from the executive mansion on that August afternoon in 1814, but she has been remembered and celebrated for saving just one. In rescuing the portrait of Washington from destruction, she was saving something not for herself but for the nation.

Faced with a similar dilemma, most people would likely find it difficult to choose one thing to save from their own homes. Although

Weather vane, about 1865 (opposite). From the Eleanor and Mabel Van Alstyne Collection of American Folk Art, donated in 1964, this weather vane depicts the Goddess of Liberty, a popular nineteenth-century symbol of America. As touchstones of history and identity, artifacts in the National Museum of American History reflect not just the lives of the people who made and used them but also the values of the people who chose to preserve them.

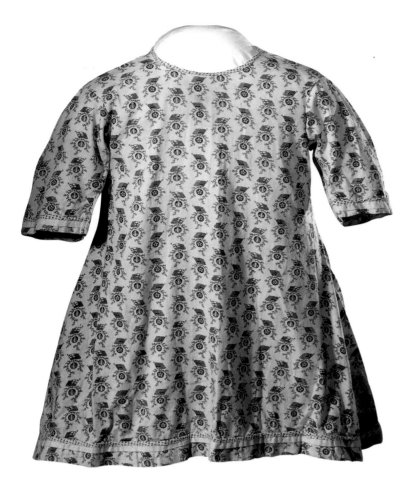

Child's dress, 1876. A traveling grain salesman from Iowa purchased the fabric, printed with flags and stars to commemorate the U.S. Centennial, for a dress for his baby daughter. A century later a family member who had inherited the dress donated it to the Smithsonian in honor of the 1976 U.S. Bicentennial.

they may curse their crowded closets and cluttered attics, many of the things they accumulate over the course of their lives are much more than just things. From bowling trophies to wedding china, patchwork quilts to diamond rings, faded photographs to finger-painted pictures, these objects mean something. They hold memories and represent values, tastes, and achievements. They remind their owners of family and friends, places they have visited, special moments they never want to forget.

As touchstones of history and identity, the things people preserve help them know who they are. Often, however, people intend things to do more than that. They also want them to help others remember who they were. To do that, they transform objects into legacies. In passing on a cherished keepsake to a loved one, people also try to pass on the stories and meanings they have invested in the object, in hopes that this small piece of themselves will endure long after they are gone.

The things people choose to save and pass on—the legacies they create—reflect their personal values and sense of identity. Through these legacies they construct an image of themselves, a memory for others to hold onto. But, of course, once an object leaves its owner's hands, it becomes part of someone else's life. It assumes new meanings, acquires different values. As the object's story is told and retold, it may change, losing certain elements and gaining new ones. It may eventually be lost altogether. Sentimental value may fade with passing time and new generations, leaving monetary and aesthetic value to determine the object's final destiny: the auction block, yard sale, trash heap—or history museum.

Nation's Attic or Nation's Legacy?

Storage room, National Museum (now the Arts and Industries Building), about 1890. In 150 years of collecting for the nation, the Smithsonian has constantly struggled with a singular problem: finding room to hold everything. By the time the new National Museum Building opened in 1881, officials were already seeking funds for a newer, larger structure to accommodate the rapidly growing collections.

The history museum—place of last resort for orphaned legacies, the unwanted things people cannot keep and cannot sell. At least that is the image conjured up by a popular name for the Smithsonian Institution's National Museum of American History: the nation's attic. No one knows for sure who coined the phrase, but it has haunted history curators for decades. Despite its familiar and affectionate overtones, the nickname implies mustiness and cobwebs, oddities and castoffs, forgotten and obsolete gadgets, useless junk.

And while that description may apply to a few of the millions of objects acquired over the years, the crucial fact is that the vast majority of artifacts in the National Museum of American History are not here by accident. They are here because someone at some time passionately believed they were worth saving. People have offered things to the museum because they deliberately wanted those objects, their stories, and their meanings to be remembered. They wanted to create a legacy, and they wanted that legacy to be preserved and passed on. Most important, people chose the Smithsonian as the repository for their cherished objects because they wanted to share them with the nation. They believed those objects had value not just as personal or even local or regional legacies but as part of a collective American legacy.

Over the years these objects have been cared for by different curators, transferred to different departments, and exhibited in different buildings as the Smithsonian itself expanded and changed. Originally housed in a single building on the National Mall in Washington, D.C., the Smithsonian Institution now encompasses more than a dozen museums, galleries, parks, and research facilities, extending from New York City to Panama.[2]

In the beginning, however, there was only the U.S. National Museum. Its roots lay in the collections of natural history, ethnological, industrial, and historical objects owned by the U.S. government and exhibited in the Patent Office building in Washington. After the Smithsonian Institution was established in 1846, Congress designated it the official caretaker of these collections. In 1858 the bulk of the collections was moved into the Smithsonian Castle, despite protests by Secretary Joseph Henry, who wanted the Institution to retain its independence and focus on scientific research. To relieve the Smithsonian of having to use funds from its endowment, Congress established an annual appropriation to support the National Museum.

Spencer Baird, assistant secretary of the Smithsonian (he succeeded Henry as secretary in 1878), presided over the National Museum. A naturalist who had devoted most of his life to collecting, Baird had arrived at the Smithsonian in 1850 with an extensive bird collection and a strong desire to develop a museum of natural history in Washington. As head of the National Museum, he set about creating a network of scientists, explorers, and traders who would supply

the museum with specimens of flora and fauna collected from all corners of the earth and especially from North America. Under Baird's leadership, the National Museum expanded from an assortment of curios to a comprehensive and systematically arranged collection, one that delighted scholars and the public alike.

Up until the late nineteenth century the National Museum remained focused on scientific collections as curators labored to document the natural history of the continent and the ethnology of American Indians. That focus began to expand, however, after the Smithsonian acquired a vast collection of cultural material from the Centennial Exhibition of 1876. The arrival of these artifacts, which filled several dozen railroad cars, prompted Smithsonian officials to ask Congress for more space to accommodate them. In 1881 a new National Museum Building (known today as the Arts and Industries Building) opened next door to the Castle. It became a showcase for new collections that included decorative arts, technology, and historical relics. In 1883 the museum acquired a collection of George Washington's relics and other historical memorabilia that had remained at the Patent Office during the 1858 transfer, back when only scientific material was deemed appropriate for the Smithsonian. With this acquisition the National Museum formally began collecting and exhibiting artifacts related to national history.

Over the next eight decades the museum expanded its national history collections by accumulating political and military relics, costumes, inventions, decorative arts, scientific instruments, and other cultural objects. These objects were exhibited in the National Museum Building and also in special areas in the Natural History Building, which opened across the National Mall in 1910, but they lacked a building to call their own.

Such an opportunity finally arose after World War II. With Cold War tensions running high, many officials keenly felt the need for a museum that would illustrate the "American way of life" and celebrate the nation's cultural, scientific, and technological achievements. In 1955 President Dwight D. Eisenhower signed a bill authorizing construction of a new Museum of History and Technology as part of the Smithsonian Institution. In 1957 the existing National Museum was officially split into two museums: the Museum of Natural History and the Museum of History and Technology. Curators identified existing collections that would form the basis for the new Museum of History and Technology—armed forces, science and technology, European and American culture, arts and industries, and civil history—and set about collecting more artifacts in these areas to develop exhibitions for the new museum.

The Museum of History and Technology opened on the National Mall in 1964. In 1980 it was renamed the National Museum of American History to underscore and reinforce its emphasis on collecting, preserving, and exhibiting the material culture of the American people.

Drawing of the Smithsonian Institution, 1855 (opposite top, left). Designed by the architect James Renwick Jr. and completed in 1855, the building now known as the Castle housed all Smithsonian operations, including the National Museum, until 1881. In addition to exhibit galleries and collections storage, the Castle also contained a library, lecture halls, laboratories, and offices, as well as living quarters for Secretary Joseph Henry and his family.

A Handbook to the National Museum, 1886 (opposite top, right). By the 1880s, under the leadership of the Smithsonian's second secretary, Spencer Baird, the National Museum had evolved from an assortment of curios into a comprehensive, systematically arranged collection of anthropological artifacts, natural history specimens, art works, and historical relics.

Conceptual drawing of the National Museum, 1878 (opposite center). Opened to the public in 1881, this building contained eighty thousand square feet of exhibitions dedicated to natural history, geology, anthropology, art, technology, and history. It served as the main National Museum building until 1910, when the Natural History Building opened across the National Mall.

National Museum of History and Technology (now the National Museum of American History), 1972 (opposite bottom). On its opening weekend in January 1964, the Smithsonian's new Museum of History and Technology drew fifty-four thousand visitors. Originally planned as a series of fifty exhibition halls dedicated to such topics as farm machinery, railroads, electricity, textiles, period costume, armed forces history, and domestic arts and furnishings, the museum has since undergone many changes in the way it organizes and presents American history to the public.

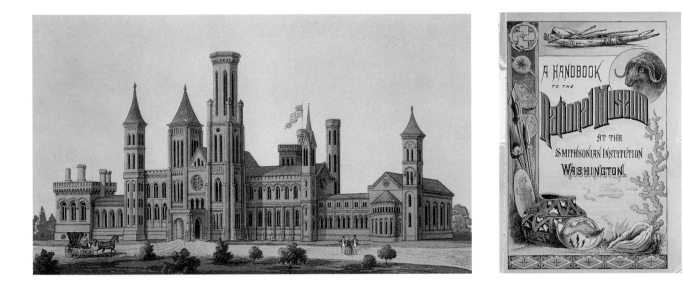

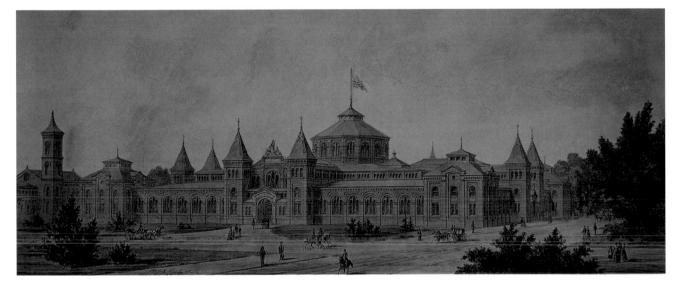

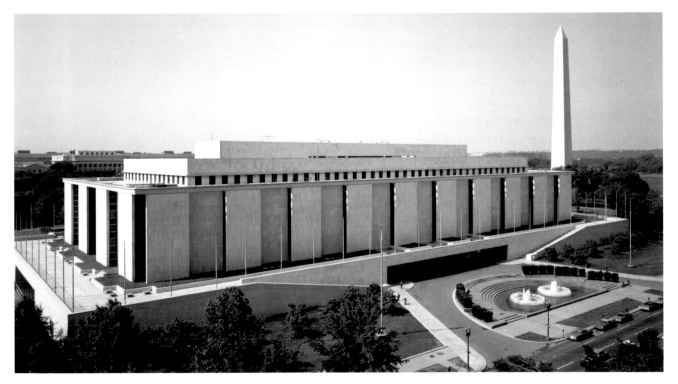

A Collaborative Legacy

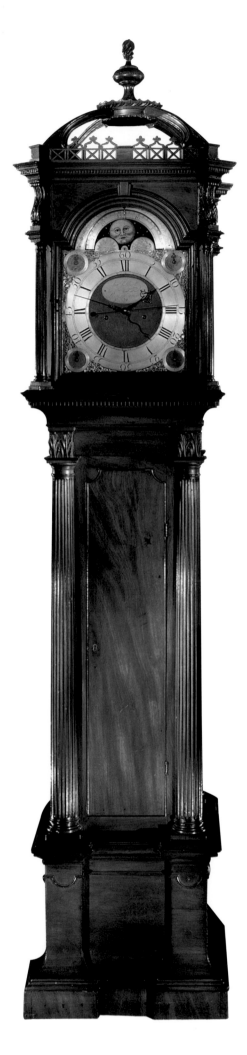

What does the National Museum of American History save? Like the personal legacies people create for themselves, the American legacy created at the Smithsonian has been shaped by ideas about history and identity, about who Americans are and who they have been—not as individuals but as a nation. In large part these ideas have come from museum curators, whose decisions about what to collect have been informed by historical scholarship and guided by research interests. Over the years changes in how historians interpret the American past have affected how curators collect it. Curators have actively sought out artifacts to fill in missing pieces in the museum's historical picture, tell important stories better, or tell for the first time stories that have previously been untold.

But only a portion of the museum's artifacts originated with curators' wish lists. Many more have been offered by individuals and organizations who believed their personal treasures were also valuable national legacies. In the course of accepting or rejecting these offers, curators have engaged in an ongoing dialogue with the American people about what is important and who is included in the nation's history.

At times this dialogue has ignited into debate, with curators, collectors, politicians, and community groups clashing over the value of a particular artifact and whether it belongs in a national museum. Some visitors will wonder, Why don't I see artifacts that represent my history? How dare they show us that object, that way? And just what is Archie Bunker's chair doing in the Smithsonian, anyway?

Visitors and politicians are not the only ones asking these questions. Debates about what is worth saving are always going on inside the museum as well. Although a museum may seem to be a single, simple entity, it is not. The National Museum of American History today employs about four hundred people, almost one hundred of whom have some collecting responsibilities. Decisions about artifacts are made by many people at many levels, and rarely is there unanimous agreement about what should be collected or exhibited.

Neither are donors a single, simple entity. Each year hundreds of people give artifacts to the museum for a variety of reasons: personal, promotional, and political. Individuals donate family heirlooms, corporations present their latest products, and collectors bequeath their treasures. Some give objects in memory of relatives or friends, others to publicize their own achievements. Many objects are offered because they fit conventional ideas of what belongs in a history museum; their owners claim that they are the first, the oldest, or associated with a famous person or event. Many others are offered because they represent new and different ways of defining the past. They speak to experiences that have not traditionally been included in the National Museum. By donating objects that

National Museum staff, about 1890. Over the years the National Museum's collections have been shaped by many different individuals, both inside and outside the museum. Museum artifacts reflect changing ideas about what is worth saving from the past.

Ellicott clock, 1769 (opposite). A masterpiece of eighteenth-century American clock making, this tall case clock was built by Joseph Ellicott, a Quaker millwright and mechanic. The Ellicott family donated this horological treasure, long sought by curators, to the National Museum of American History in 1999.

represent their own cultures, communities, and values, diverse Americans have claimed their place as part of the nation's story.

The National Museum of American History's collections thus document not just the history of America but also a history of ideas about America, its people and its past. The museum is itself a collaborative legacy, one constructed by a variety of individuals and groups with different interests and agendas. Just as the nation encompasses many people, the national collections encompass many artifacts contributed by many people, all with their own stories. Each, on its own, may seem idiosyncratic. But looked at together, these separate stories reveal larger themes and patterns of change in how Americans have viewed the nation's past.

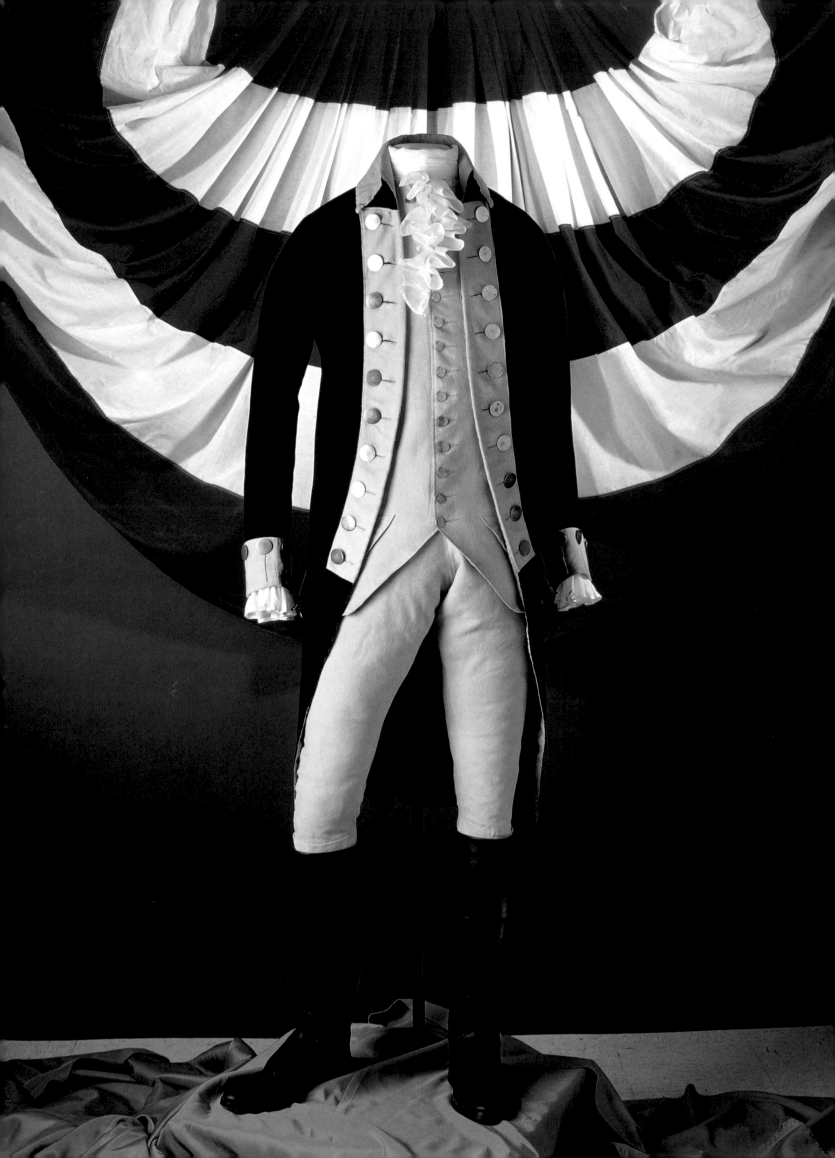

Imagining the National Museum

George Washington's uniform, 1770s–80s (opposite). The uniform coat, waistcoat, and pair of knee breeches came to the Smithsonian in 1883 from the Patent Office. (The ruffled shirt and boots are reproductions.) Although these items were all worn by Washington, they were not all worn together. The general wore the waistcoat and breeches during the Revolutionary War but did not wear the uniform coat until about 1789, after he had resigned from the Continental Army to become the nation's commander-in-chief.

Howdy Doody puppet, 1950s. This freckle-faced puppet in cowboy boots remains a favorite baby boomer childhood memory and popular culture icon. Hosted by "Buffalo Bob" Smith and his marionette sidekick, *The Howdy Doody Show*, which was broadcast live on NBC five days a week from 1947 to 1960, was the first nationally televised children's program. In 1980 Rufus Rose, the puppeteer who brought Howdy Doody to life, bequeathed one of the puppets used on the show to the Smithsonian.

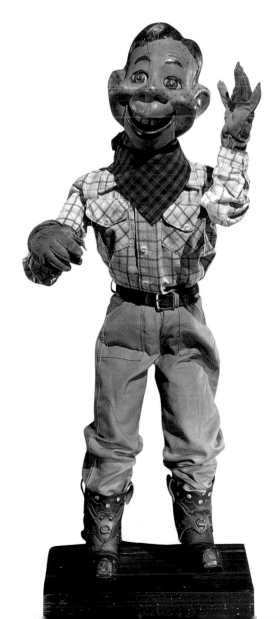

This leads to a central point of this book: history has a history. People's understanding of the past—and the stories and objects they value from it—are influenced by the needs, values, and interests of the present and therefore change over time. Artifacts in the National Museum of American History reflect not just the lives of the people who made and used them but also the values of the people who chose to preserve them. They record efforts to define a national identity based on a shared heritage. They represent different answers to the question, What is worth saving?

As of 2000 the collections of the National Museum of American History contained 3,207,342 artifacts. This book investigates the history behind more than 250 of these artifacts to find out when they were collected and why. What values and meanings were invested in these objects by the people who donated them and the curators who collected them? How do they fit into the museum's larger picture of America? What experiences and beliefs have they contributed to the national legacy?

Each of these objects also reflects different ideas about what kind of place a national museum of American history should be. What do people think of when they think of a history museum? What role should a history museum play in the nation's cultural life? How should it present the story of America's past? Artifacts suggest a variety of answers to these questions; indeed, over the years both curators and the public have imagined the National Museum and interpreted its mission in various ways.

The first four chapters take as their starting points four ways to imagine a history museum: as a treasure house, a shrine to the famous, a palace of progress, and a mirror of America. Each represents different ideas Americans have expressed about the kind of objects the Smithsonian should collect to represent the nation. They reflect different categories of value, different definitions of what is worth saving. These notions of value have also changed over time in response to changing ideas about American history and identity.

The first chapter, A Treasure House, asks these questions: What makes something a treasure? How has the meaning of *treasure* changed over time? What kinds of treasures has the Smithsonian collected and why? People invest different kinds of value in artifacts— monetary, aesthetic, historical, personal, spiritual. Value is, after all, in the eye of the beholder, and the treasures we Americans have placed in the National Museum reveal a great deal about who we are, as individuals and as a nation.

A Shrine to the Famous, the second chapter, examines a particular type of treasure: relics of famous people. Whereas cathedrals traditionally display the relics of saints, museums display artifacts of secular heroes. One can learn much about America by considering who has been enshrined in the National Museum. The collections contain

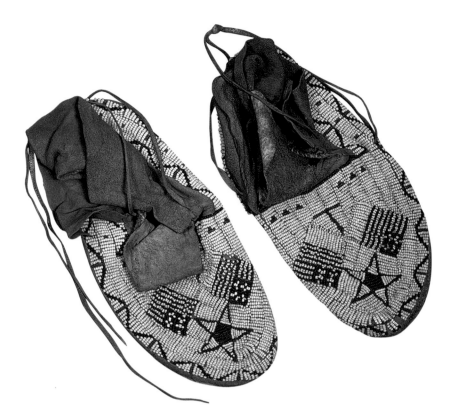

Moccasins, 1870s. A delegation of Plains Indians presented President Ulysses S. Grant with these beaded moccasins during a peace conference in Washington, D.C. Since the nineteenth century, Native Americans have adapted and used the American flag in various ways to symbolize their own relationship to the nation. For the tribal leaders who brought these moccasins to Washington, the flag design may have symbolized allegiance to the United States, a desire for government aid and protection, or an entreaty for peace and land rights for their people. In 1973 Grant's grandson, Chapman Grant, donated the moccasins to the Smithsonian.

a few literal relics—the hair of presidents, for example. More typically, it has collected personal belongings and symbolic items, from George Washington's sword to Muhammad Ali's boxing gloves. Heroes reflect the experiences and needs of the generation that creates them, and those needs have changed as America has changed. Who has been included in the Smithsonian's historical hall of fame, and how have these people reflected certain American values and ideals?

Americans have long embraced the idea of progress as a key element of national identity. The third chapter, A Palace of Progress, explores the ways the Smithsonian Institution has served as a place to measure how far humankind has progressed and predict what advances the future will bring. In the late nineteenth century curators helped shape the way Americans thought about progress by building technological collections and exhibitions along an evolutionary continuum from "primitive" to "civilized." For much of the twentieth century, exhibitions celebrated modern inventions as the pinnacle of human achievement. In recent years, however, the National Museum of American History has followed the American public in asking questions about progress: Progress for whom? What are the costs of progress? Does progress in science or technology always mean social progress?

A Mirror of America, the fourth chapter, looks at objects the National Museum has collected to represent the American cultural heritage and way of life. What kind of image has it reflected, and how has this image changed over time? While early historical collections focused on well-to-do colonial families and their descendants, after World War II the museum gradually broadened its scope to include a more diverse array of cultures and communities. New kinds of objects

$20 gold coin, 1907. This high-relief coin was one of several experimental pieces struck in December 1907 to test the new design of the $20 gold coin. The work of the sculptor Augustus Saint-Gaudens, who had been commissioned by President Theodore Roosevelt, it features a figure of Liberty on the obverse and an eagle on the reverse. At the insistence of U.S. Mint officials, the $20 coins that ultimately went into circulation between 1907 and 1933 were produced with a much lower relief so they could be struck more easily. A gift from Saint-Gaudens to President Roosevelt, this coin was donated to the Smithsonian in 1967 by Cornelius Van Schaack Roosevelt, the president's grandson.

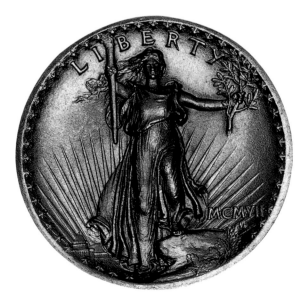

Erector set heart pump, 1950. Using a toy Erector set, William Sewell Jr. and William W. L. Glenn, Yale University medical students, built this section of a heart pump, which Sewell successfully used in experimental bypass surgery on dogs. Acquired in 1959 from Sewell's mother, this heart pump is one of many invention prototypes in the Smithsonian collections.

brought new kinds of stories, and these stories often challenged and complicated traditional interpretations of the past. Since the 1970s the National Museum of American History has committed itself to a history that represents all Americans, one that includes stories of conflict and inequality as well as triumph and achievement, one that inspires a richer understanding of American identity and the experiences and beliefs that have shaped American history.

These four chapters focus on why specific artifacts have been collected at specific times. The final chapter, From Artifacts to America, suggests why all of the objects in the National Museum of American History are worth saving: they help us understand what it means to be American. After objects enter the museum, they take on new meanings and serve new purposes. Just as the objects people give away to friends and loved ones become part of someone else's life, the objects people give to the museum become part of a bigger story, the nation's story. They reveal not just evidence about one person's life but also larger truths about American history and identity.

The National Museum of American History helps preserve the nation's legacy by holding onto precious things from the past—the objects Americans have wanted to save and the objects they have wanted to be remembered by. But the legacy is far more than just the objects themselves. It is the combined experiences, beliefs, and values that these objects evoke. It is what these objects, as touchstones for a shared history and identity, have meant to the American people. This is the National Museum of American History's true legacy, and it will continue to grow, change, and take on new meanings as long as Americans continue to use it as a place to save something for the nation.

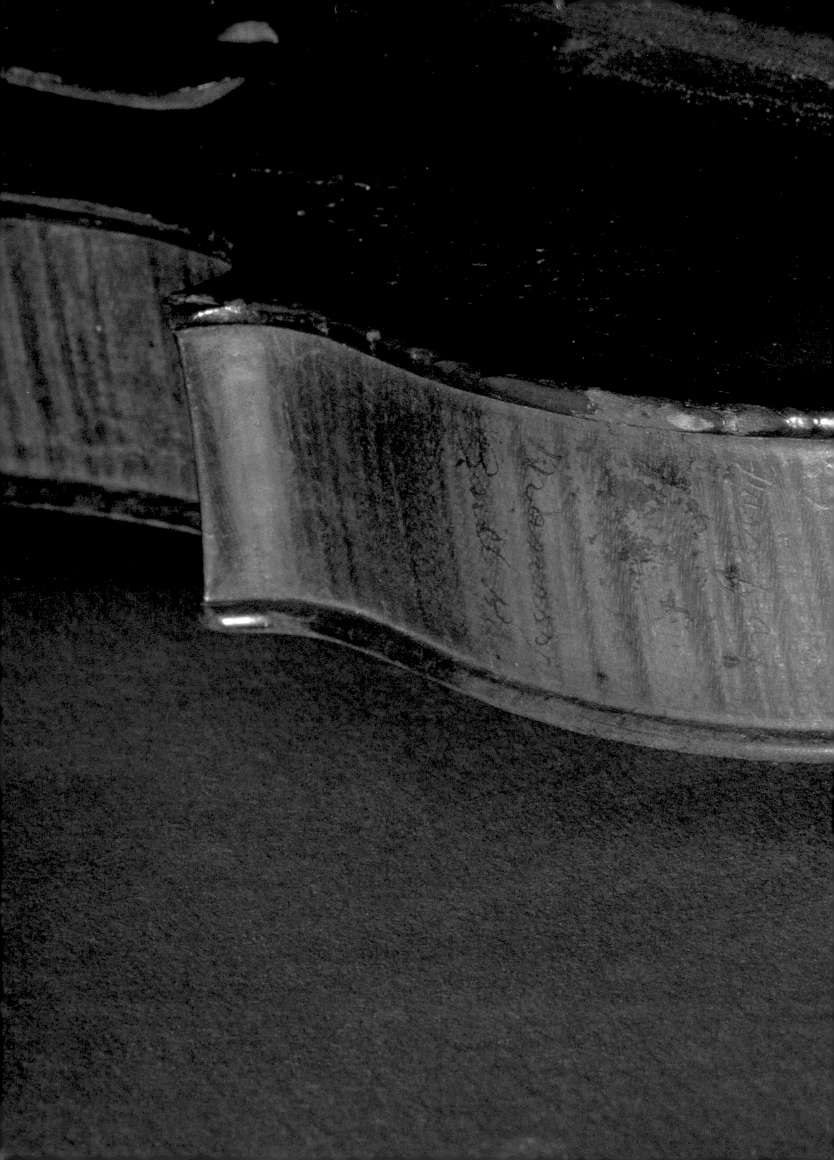

A Treasure House

Although yesterday's treasures may be forgotten, they are not gone. Like geological strata, the artifacts in the Smithsonian's vaults record the ways that generations of Americans have imagined, valued, and preserved the past. Each object represents an effort to capture something valuable about America—a story, an idea, a way of life.

Ruby slippers worn by Judy Garland in *The Wizard of Oz*, 1939. The rubies are not real, and the shoes are worn about the edges. But Dorothy's ruby slippers (one of several surviving pairs) have been one of the most popular artifacts at the National Museum of American History since they were collected in 1979. What makes them a treasure?

Solomon Conn's fiddle, 1863 (pages 20–21). Among the National Museum of American History's many personal souvenirs of war and military service is Solomon Conn's fiddle. On the back and sides of the instrument, Conn inscribed the names of the places he traveled as an infantryman in the Eighty-seventh Indiana Volunteers, under General William Tecumseh Sherman. Conn's grandsons donated the violin to the Smithsonian in 1988.

IN CELEBRATION of its 150th anniversary in 1996, the Smithsonian Institution launched a traveling exhibition—*America's Smithsonian*—to bring its scientific, cultural, and historical wonders to cities nationwide. Curators of the National Museum of American History were charged with culling fifty treasures from its more than 3 million artifacts to be included in the show.

History museum curators often hesitate to single out particular artifacts as treasures. In part this is because there is no easy way to measure historical value; history is too complicated to make such sweeping judgments. In part curators shy away from such judgments because *treasure* suggests a high price, and they do not wish to emphasize an artifact's monetary value; once it is in the museum, after all, it generally cannot be sold. And, especially in recent years, history museums have been more interested in typical things than in one-of-a-kind rarities. Curators have tried to collect ordinary objects to tell stories of everyday life, rather than precious objects that tell extraordinary stories.

But, in fact, treasures are an integral part of a museum's identity and the visitor's experience. They set a museum apart from the rest, helping it secure a claim to fame and a spot on the tourist's itinerary. For many visitors the trip to see certain museum treasures—the original Star-Spangled Banner, for example—resembles a religious pilgrimage or a rite of passage. For others it is a chance to revisit a favorite object remembered from a trip long ago.

And so, after discussion and debate, curators at the National Museum of American History finally selected a sample of treasures for the exhibition. These included a pair of red sequined shoes, twinkling under the lights but showing their wear; a fuzzy green puppet with ping-pong balls for eyes; a somewhat shabby stovepipe hat; a pair of mismatched chairs; a sheet of music paper with notes scribbled in pencil; a pink rhinestone-studded gown, not very fashionable; a compass in a wooden case; and a lightbulb with a broken filament.

At first glance these "treasures" might hardly seem worth picking up at a garage sale, let alone preserving in the nation's museum as precious legacies or displaying in high-security cases as priceless articles. But take another look. The ruby slippers were worn by Judy Garland in her role of Dorothy in the classic 1939 film *The Wizard of Oz*. The puppet is Kermit the Frog, the Muppet star of the television show *Sesame Street*. The stovepipe hat was worn by President Abraham Lincoln to Ford's Theater on the night of his assassination. The chairs are those used by Generals Ulysses S. Grant and Robert E. Lee as they signed the terms of surrender at the end of the Civil War. The sheet of music paper is an original handwritten composition by the jazz master Duke Ellington. The pink

gown was worn by Mamie Doud Eisenhower to her husband's inaugural ball in 1953. The compass was used by Lewis and Clark on their journey through the newly purchased territory west of the Mississippi. And the lightbulb is one of the first incandescent lightbulbs developed by Thomas Edison.[1]

As this second look reveals, what makes something a treasure—the source of its value—is not just the object itself but the story and meaning attached to it. The literary scholar Stephen Greenblatt proposes two models for artifacts and exhibitions in museums. Some, he says, are centered on *wonder*, others on *resonance*. Wondrous objects stop people in their tracks and call attention to themselves; their value is self-evident. Many of the objects in art museums fall into this category. Objects with resonance, on the other hand, reach beyond themselves to evoke a larger world. They suggest the complexity of the social and cultural forces from which they emerge. They tell stories or allow people to tell stories about them. They are authentic and as such are messengers from the past. Some might be relics—that is, artifacts that capture in themselves the memory of a

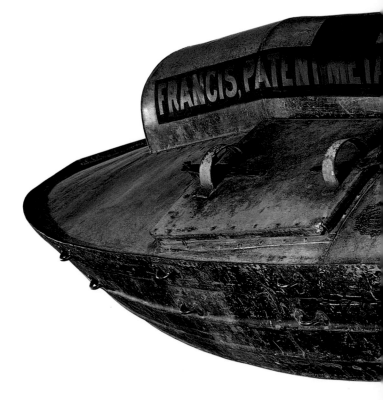

Furniture from Appomattox Court House, Virginia, 1865 (opposite). The chairs used by Generals Robert E. Lee and Ulysses S. Grant as well as the table on which Grant signed the terms of surrender to end the Civil War were quickly taken as souvenirs by Union officers. In the early twentieth century these relics were reunited in the Smithsonian. Grant's chair (right) was bequeathed in 1906, the table arrived in 1912, and Lee's chair (left) was donated in 1915.

Life car invented by Joseph Francis, 1847 (below). Founder of the U.S. Life-Saving Service and inventor of this life car for transporting shipwreck victims to shore, Joseph Francis was one of the nineteenth century's greatest heroes. In 1890 the National Museum acquired the Francis life car used to rescue 199 passengers from the wreck of the *Ayrshire* in 1850. Francis asked that "the relic may be preserved as sacred which has performed an unparalleled feat in saving so many lives." It was one of the most popular exhibits on display at the turn of the twentieth century and included on every list of Smithsonian treasures. But as maritime disasters became less common, Francis's fame diminished, and the life car was moved into a smaller exhibit on disasters at sea.

famous person or significant event. But all of these artifacts are resonant, not wondrous. History museums, for the most part, concern themselves with resonance. A history museum's treasures—whether a chair, a lightbulb, or a pair of shoes—have no intrinsic appeal. Their story must be known or told.[2]

Even more important, their stories must resonate with the audience. In 1897, a century before Dorothy and Kermit hit the highway, the Smithsonian Institution published a fiftieth anniversary account of its history and holdings. Curators contributed chapters describing the treasures of their various collections. Among the "memorials of events and places of historic importance," technological firsts, and "personal relics of representative men," there are a few familiar faces: Washington, Grant, Lincoln, Morse. In fact, several objects, including a bronze life mask of Lincoln and Morse's telegraph, made the Smithsonian's list of treasures in both 1897 and 1996.

But by and large the Smithsonian Institution of 1897 would seem a strange and alien place to the average visitor—and even the average curator—of today. Consider these other "objects of great historic value" featured in the fiftieth anniversary book: a cylinder from the first steam engine used in America, imported from England in 1753; the saddle of Johann de Kalb, American general in the Revolutionary War; a silver urn presented to Commodore John Rodgers, defender of Baltimore during the War of 1812; the 1860 garrison flag of Fort Moultrie, South Carolina; the grand prize trophy presented to the United States at the Berlin International Fishery Exhibition in 1880; and the gold medal presented by Congress to Joseph Francis, inventor of life-saving equipment, in 1888.[3]

Even with identifying labels these treasures still seem unfamiliar and obscure today, their evocative power lost in the shifting sands of time. Francis's life-saving apparatus is no longer front-page news. Most Americans remember World War II and Vietnam, not the battle of Baltimore. The technological marvel of the steam engine has come and gone. Surely curators could restore a meaningful context to these objects by placing them in an exhibit; they are all still historians' treasures, with interesting stories to tell about the past. But sitting alone in a case, would they generate the same excitement as the ruby slippers or an Edison lightbulb, objects whose stories are known? Would visitors come to the museum expressly to see them? Would curators select them to represent the museum, to represent American history? Not likely. Their "great historic value" has faded considerably. They are no longer treasures in the grandest sense of the word. Why is that?

A Vocabulary for Value

The answer lies in the complexities and vagaries of value. Just as yesterday's trash, to coin a phrase, can be today's treasure, today's treasure may indeed become tomorrow's trash. An artifact might be worth saving—worth treasuring—because it was rare or because it was representative. It might be a treasure because it is interesting, valuable, or important. It might be treasured as a souvenir of the past or for its interest to the present or the future. It might be a relic, valuable for its connection to some famous person or significant event. It might be a treasure to an individual, a community, or the nation. It might be an aesthetic treasure or a treasure despite its artlessness.

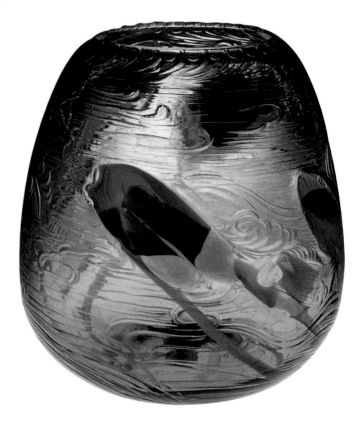

Aesthetic treasures—the things collected by art museums—are in many ways easier to evaluate. Art historians have reached a general agreement on the value of art and an aesthetic canon. But that canon is fairly recent, and the history of the Smithsonian's art collections in the nineteenth century shows the slipperiness of aesthetic judgments. Among the goals defined for the Smithsonian in its early days was the creation of a public art collection. But the fledgling Institution could not afford original paintings, so it turned instead to copies of great paintings and sculptures and acquired prints, including a collection of 1,335 European engravings owned by George Perkins Marsh, U.S. congressman from Vermont. (The Marsh Collection was the first collection purchased by the Smithsonian.) The rationale given by Charles Coffin Jewett, assistant secretary of the Smithsonian—"Engravings furnish us with translations . . . of the best creations of genius in painting and sculpture, the originals of which are utterly beyond our reach"[4]—suggests what he saw as the value of artistic treasures: their link to genius and creativity. Similarly, many museums purchased plaster casts of classical sculptures.

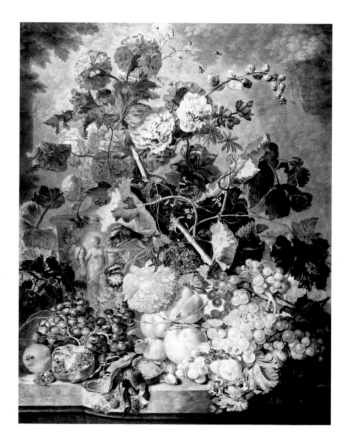

By the end of the nineteenth century, however, art museums were valuing the authentic over the copy, inspiration over education, and plaster casts and engravings vanished into storage vaults. They were no longer treasures but embarrassingly poor substitutes for the real thing. The concern for the authentic, for masterpieces, was part of a fierce debate among American art museums at this time. Should they, like the Metropolitan Museum of Art in New York City, be galleries of "masterpieces by artists of different countries hung to secure the greatest aesthetic satisfaction, as was done in the Louvre"? Or should they, like the Boston Museum of Fine Arts and the Pennsylvania Museum in Philadelphia, model themselves on the South Kensington Museum in London and focus on industrial art, design, and education?[5]

The Smithsonian, like many American museums, chose the latter. Its curators considered it their mission "to educate the public taste, and . . . to forward the growth of the arts of design."[6] Whereas earlier collecting aimed to demonstrate how American arts and crafts measured up to European standards, by the 1890s the Smithsonian was celebrating

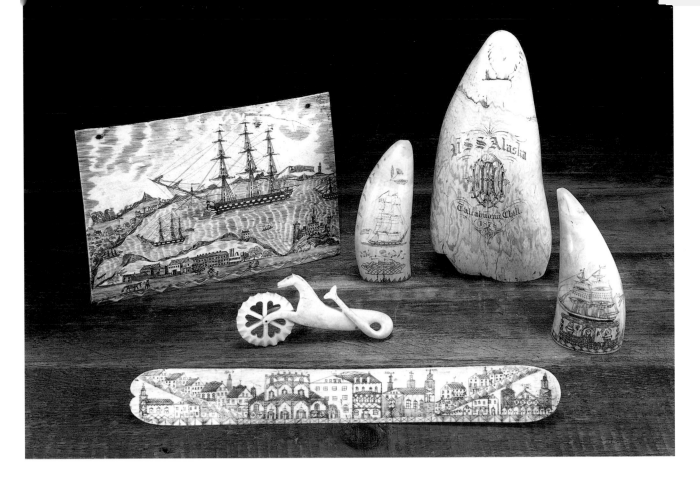

Scrimshaw, 1800s (above). Sailors on whaling voyages in the 1800s often passed the time by carving intricate patterns and pictures on bone or ivory. In 1964 the Smithsonian acquired Eleanor and Mabel Van Alstyne's collection of nineteenth-century American folk art. These examples of everyday "people's art"—including weather vanes, carousel animals, shop signs, portraits, and scrimshaw—were described by curators as "the most truthful expression of [America's] creative talents."

Favrile glass vase by Tiffany Glass and Decorating Company, New York City, 1893–96 (opposite top). Louis Comfort Tiffany, a leading figure of the Art Nouveau movement, was especially admired for his stained-glass windows and iridescent Favrile blown glass bowls and other vessels. This vase is part of a group selected by Tiffany for the Smithsonian in 1896, when curators were collecting contemporary American crafts to illustrate the links between art and industry.

A Fruit Piece, **mezzotint by Richard Earlom after Jan van Huysum, 1781** (opposite bottom). In 1849 the Smithsonian acquired some 1,335 engravings, including works by Albrecht Dürer, Rembrandt, and others, collected by George Perkins Marsh, U.S. representative from Vermont and a Smithsonian Institution regent.

and helping cultivate a uniquely American style. From Tiffany vases to folk art, it valued artistic objects not simply for aesthetics but as historical and contemporary expressions of American industry and identity and as models for industrial design.

By the early twentieth century most American art museums had adopted the aesthetic goals of the Metropolitan Museum of Art. The Smithsonian joined this movement with the creation of a National Gallery of Art in 1907, but this gallery—its name was changed to the National Collection of Fine Arts in 1937, when the present National Gallery was created—was small in comparison with the Smithsonian's collection of industrial and practical arts. The new National Gallery became Washington's gallery of masterpieces, and the Smithsonian collections focused instead on anthropology, industry, and history. Aesthetic value was, in general, given less importance than scientific or historical value. In Greenblatt's terms, resonance rather than wonder—stories rather than aesthetics—would guide collecting.

What, then, makes something of *historical* value? The answers are many, and they tell much about people's feelings toward things and toward the past. Age, rarity, and connection with historic events or people all help produce historical value. But there is more to historical value than that. Artifacts have historical value when people today care about the history they represent.[7]

The first and most obvious source of value is simply age. Old objects are more likely to be of historical interest than new objects. But not all old things are equally valued. A rock by the side of the road is a few billion years old, but it holds little historical interest except to a geologist. Old buildings are razed every day to make room for new buildings, but only a select few inspire people to throw themselves in front of the bulldozers. Landfills overflow with old clothes, cars, and

other castoffs from a consumer society, where *old* usually connotes something out of fashion, out of date, and ready to be replaced.

Some objects valued and preserved because of their age are distinguished not just as old but as the oldest. Museum guidebooks are filled with such phrases as *only known, oldest surviving, first successful,* and other superlatives. Knowledge of an object's rarity—that it is the first, last, or only one of its kind—can dramatically increase appreciation of its value.

The 1831 *John Bull* locomotive, a Smithsonian treasure, was not the first locomotive in the world or the first locomotive in America. It was, however, one of the first locomotives to be used successfully in America and was significant to railroad builders of the day. But its value today comes not from its history so much as from its survival. Locomotives from the 1830s are rare; thus, its rarity makes it a treasure. Today it is the world's oldest operable locomotive—or, more grandly, the world's oldest operable self-propelled vehicle.

In addition to antiquity and rarity, objects gain historical value from their associations with a person, place, or event. An object with a documented history of manufacture, ownership, and use carries

***John Bull* locomotive, 1831.** The *John Bull* was built by Robert Stephenson and Company in England and purchased by the Camden and Amboy Railroad and Transportation Company in 1831. Previously American railroads had tried to build their own locomotives, but the Camden and Amboy decided to buy a locomotive type that had already proven itself. The *John Bull* was used by the railroad for many years. In 1876 its historical value was recognized when it was displayed at the Centennial Exhibition in Philadelphia in an exhibit organized by J. Elfreth Watkins. When Watkins became curator of transportation at the Smithsonian in 1884, he acquired the locomotive for the museum. It has been on display almost continuously since then (see pages 136–37). In 1981, for its 150th anniversary, it was operated for one last time, gaining the title "oldest operable locomotive." In 1985 it was flown to Dallas for an exhibition, adding another "oldest" to its name: the oldest locomotive to fly in an airplane.

more weight than an anonymous antique. And, of course, the more illustrious and exciting the provenance, the better. But evaluating the significance of these associations raises historical questions. In the case of locomotives, which was most important—the first locomotive that moved under its own power, the first that did useful work, the first that made money for its operator, or the first of the type that came to dominate the field? One of the great controversies in Smithsonian history began in 1914 over the wording of a label for an airplane. Curators insisted that the Langley aerodrome, the invention of Samuel Langley, former Smithsonian secretary, was the first airplane "capable of flight" even though it never flew successfully. The Wright brothers refused to donate the first airplane that actually flew, the Wright *Flyer,* until the 1940s, when the Smithsonian backed off this claim.[8]

Historical questions help define historical treasures. The value of artifacts, even the way that value is determined, changes over time as different aspects of history become more important or relevant. Historical treasures are found where they are sought, in the history that seems worth examining. Historical value reflects the history that people find important.

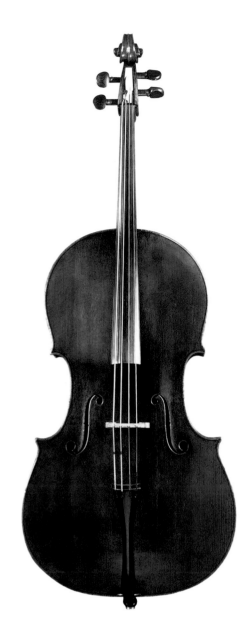

Stradivari violoncello, 1701 (left). The Smithsonian today has one of the finest collections of Stradivari instruments in the world. Its first Stradivari was this 1701 violoncello, donated in 1981 by Charlotte Bergen, who wished to support American performances of European music—a purpose not too different from the Smithsonian's reasons for collecting European art more than a hundred years earlier.

Duke Ellington manuscript score for "Light," part of ***Black, Brown and Beige,*** **about 1940** (below). In 1988 the Smithsonian acquired more than three hundred cubic feet of archival materials relating to the career of the great jazz musician Duke Ellington: sound recordings and original manuscripts as well as photographs, scrapbooks, and business records. The collection documents Ellington's contributions as a composer, performer, orchestra leader, and an ambassador of American music and culture abroad. The Ellington Collection is both an aesthetic treasure and a historical one, used by musicians for performances and by scholars to better understand the man and his music.

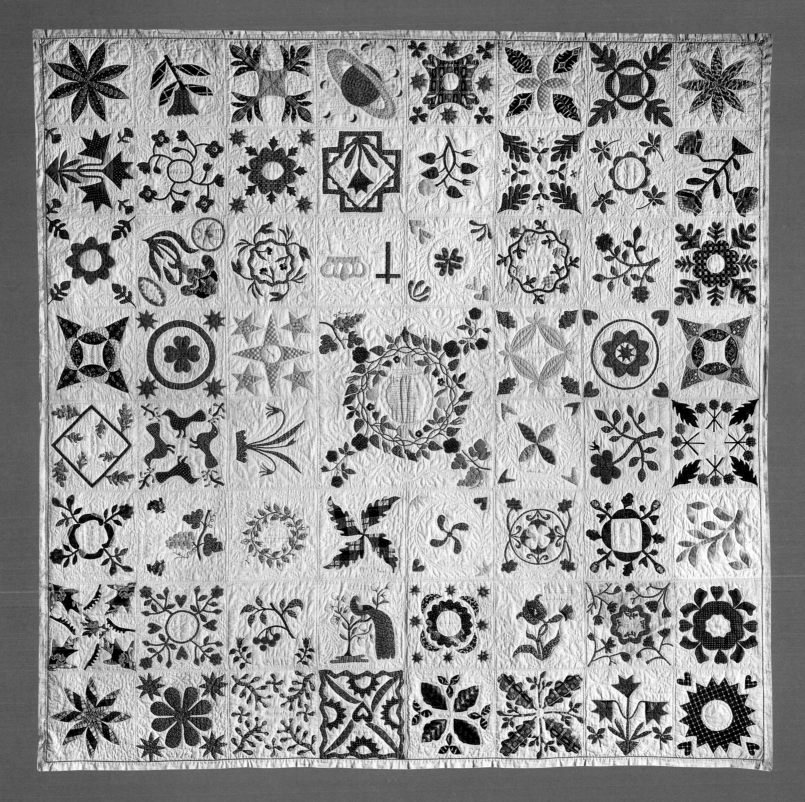

Quilt made by members of the Presbyterian Church, Maltaville, New York, 1847. This album quilt was presented to Mary Benton Barnard Hill, wife of the pastor of the Presbyterian Church, as a "token of esteem." Each square was made by a different seamstress, and many are signed. The Smithsonian acquired the quilt in 1931.

What Is a Treasure Worth?

Can one put a price on a treasure? Absolutely, as fans of the popular PBS series *Antiques Roadshow* would say. The show makes clear that a very important aspect of an object's value is its provenance, the story that can be told around it, and the meaning it holds for an individual, a family, or a community. But it is the value of an object for a particular community—the collecting community—that the show emphasizes. The object may tell a great story, but the appraiser has the last word.

Still, one will look in vain for a price tag on a museum treasure, except in the insurance files. Museums and antique dealers privilege different kinds of value. Value, according to the economist Adam Smith, "has two different meanings. . . . [It] sometimes expresses the utility of some particular object and sometimes the power of purchasing other goods which the possession of that object conveys." Although both kinds of value overlap and influence the other, exchange value is the dealers' bottom line, while museums are more interested in intrinsic and utilitarian value. What are objects worth, not in exchange for other objects but as themselves?[9]

Economists explain value in terms of scarcity, a mismatch of supply and demand. When there is more demand for an object than there is supply, the price goes up. The object becomes more valuable. A higher price reduces demand and increases supply. At some price suppliers want to sell, demanders want to buy, and, as the economists say, the market clears. The deal is made, and one knows what the thing is worth.

While this is true, it is also—like so much of what economists say—not the whole picture. What is interesting, most of the time, are not the details of setting a price but rather the reasons why people want things. What creates demand? George Simmel, whose *Philosophy of Money* (1907) still stands as the most insightful analysis of value, suggested that value is never inherent but a judgment that people make. Objects are difficult to acquire not because they have intrinsic value; rather, "we call those objects valuable that resist our desire to possess them."[10] Demand is cultural, political, and social. Value is too.

Because money has a readily identifiable face value, it might seem easy to determine its price. In some ways this is true. As the economists like to say, money is fungible: any one dollar is the same as any other dollar, interchangeable for it. But even the value of money is political, defined by its

$100,000 gold certificate, 1934. The largest denomination of U.S. paper money ever produced, the $100,000 gold certificate was part of a series of gold certificates issued by the U.S. Treasury to Federal Reserve banks in exchange for the gold the banks turned over to the treasury. The printing on the bill includes the phrase, "This is to certify that there is on deposit in the Treasury of the United States of America One Hundred Thousand Dollars in Gold payable to bearer on demand as authorized by law." This note, always a popular attraction, came to the Smithsonian in 1978 from the U.S. Treasury.

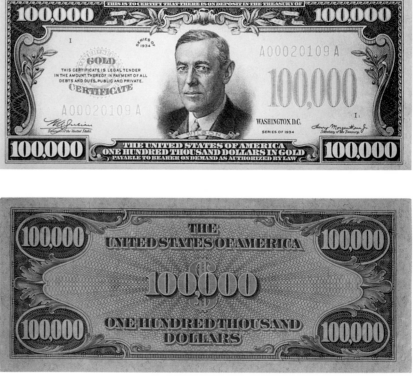

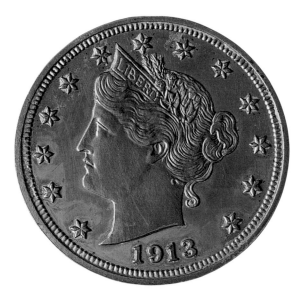

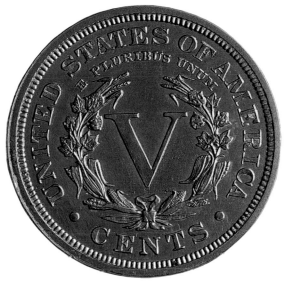

Liberty head nickel, 1913. Officially, the U.S. Mint stopped making Liberty head nickels in 1912. But by accident or design someone at the Philadelphia mint struck at least five nickels dated 1913—and created an instant collector's item. The former owners of this particular 1913 Liberty head nickel, given to the Smithsonian in 1977, include King Farouk of Egypt, an avid coin collector. The coin's history, including the distinguished numismatists who owned it, add to its value.

history and culture and its meaning to an individual, a community, or a nation. And when considered not simply a medium of exchange but an artifact in itself, money raises even more questions about value. Money—with its historical, aesthetic, collector's, intrinsic, and declared value—is a good place to start thinking about the meaning and value of artifacts.

Consider these monetary artifacts, all in the Smithsonian collections, and try ranking them in order of value: a 1934 $100,000 gold certificate; an 1838 British gold sovereign, part of James Smithson's bequest to the United States that led to the founding of the Smithsonian Institution; a clamshell, carefully painted with the name of a store (Leiter's Pharmacy), the value (fifty cents), and the date (1933), used as money in Pismo Beach, California, during the Depression; and a 1913 Liberty head nickel.

One might begin with intrinsic value. Take away the words on the surface and consider just what the object is worth. The gold sovereign has some value: gold is a useful and attractive metal, while nickel is worth a lot less. As for the clamshell or piece of paper, they are basically worth nothing at all, unless one is in desperate need of a sharp object to scrape with or something to write on.

Face value is more interesting than intrinsic value. Each of these artifacts has a value written on it, and while it might take a while to figure out the exchange rates between, for example, the 1838 British pound and the 1934 U.S. dollar, one might end up with a ranking of value, at the time they were produced, not too far different from the list as given here.

But why take face value at, well, face value? Why should a piece of paper with a dollar sign and the number 100,000 on it be worth more than a piece of real gold? The face value of the $100,000 note, like any paper money and most coinage, depends on a legal fiction, politics, some shared social and cultural beliefs and at bottom an unlikely reliance on the government's good word. (That was especially the case after 1933, when the U.S. government no longer kept gold to back up its paper currency.) The Pismo Beach clamshell depended on similar legal fictions but had a smaller community to enforce its value. It all comes back to the story told about the objects—and, in the case of money, who believes the story.

For the National Museum of American History, face value is no longer important at all, except from a purely informational standpoint, as a means of identifying the object. Tempting though it might be in times of budget cuts, the museum cannot spend the National Numismatic Collection. Instead, curators must think in terms of collector's value, sentimental value, or historical value. Collectors are concerned with rarity and desirability; in addition, museums are concerned with usefulness in understanding or teaching about the past.

Coin collectors superimpose a new value system on top of the one that the government has established for money. Look up the 1913 Liberty head nickel in an official catalogue of U.S. money, and one will discover that there is no such thing. The U.S. government stopped issuing Liberty head nickels in 1912. But, whether by accident or design, someone at the U.S. Mint in Philadelphia struck at least five of these nickels in 1913—and created an instant collector's item.

The coin was rare, and so it was worth collecting. Indeed, the dealer who offered one of the coins for sale in 1976 called it "the most famous of all American coins" and set its price at $300,000. But rarity alone did not determine the price. The catalogue noted that its "past owners read like a 'Who's Who of Numismatics,' and it is certain that similar fame will accrue to its next owner." So in addition to rarity, its history and an appeal to the emotions helped increase its monetary value.[11]

Rarity and sentimental value combine even more clearly in the case of the 1838 gold sovereign. While it has a collector's value, that value is insignificant compared to its sentimental value or to the story it helps the historian tell. For this is not just an ordinary gold sovereign (if there is indeed such a thing) but rather one of the two surviving sovereigns from the bequest that established the Smithsonian Institution.

In his will James Smithson, an English scientist who died in 1829, specified that, should his nephew die without children, his fortune should be used "to found at Washington, under the name of the Smithsonian Institution, an Establishment for the increase and diffusion of knowledge among men." When the will was probated, in 1835, the Smithson fortune, some 105 bags of gold sovereigns, was worth about $500,000 (the equivalent of about $7 million today). When the bags of gold coins arrived in the United States, they were melted down, restruck into U.S. currency, and used to fund the Smithsonian Institution. But two pieces were preserved by the U.S. Mint in Philadelphia, and in 1923 they were deposited in the Smithsonian along with the rest of the mint's historical collection.

So while a sovereign is a coin, this particular sovereign is much more than that. It is a symbol, a material representation of the creation myth of the Smithsonian Institution, a part of a community's story. While another British sovereign of the same period might look identical, it does not have the same history and would not tell the same story. An 1838 gold sovereign is worth a few hundred dollars. But the Smithson gold sovereign is, in the way that the term is usually used, priceless.

The Pismo Beach clamshell also tells a historical story. During the Great Depression, currency shortages caused by bank closings led many communities to create temporary money, or scrip. Unable to make change during the bank holiday of March 1933, a resident of Pismo Beach, taking a figure of speech and making it literal, hit on the idea of converting clams into cash. Businesses issued clamshells as change, in several denominations. The shells were signed as they changed hands.[12]

British sovereign, 1838. In his will James Smithson, an English scientist, provided for the establishment of the Smithsonian Institution. In 1838 his bequest—105 bags of British gold sovereigns—was shipped from England, and all but two sovereigns were melted down to produce new American coins. These two sovereigns, transferred from the U.S. Mint in 1923, have since come to symbolize the origins of the Institution.

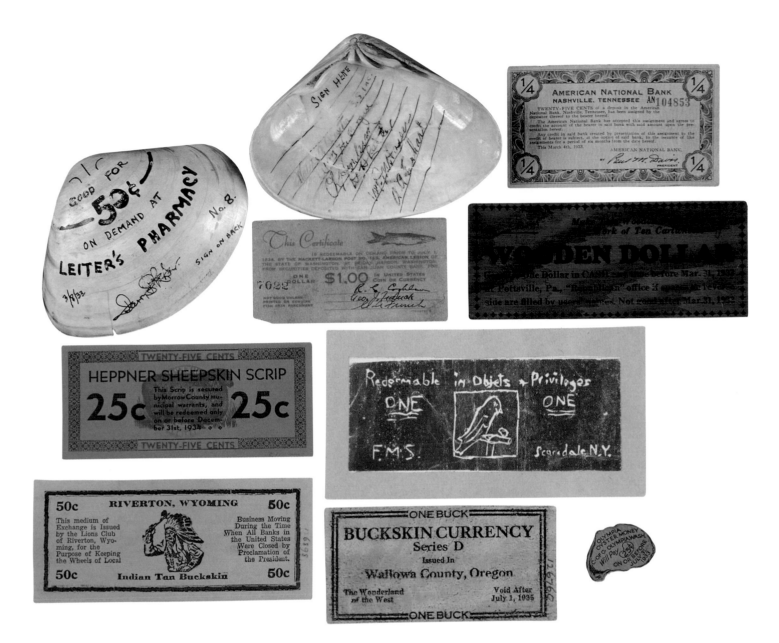

Emergency money, 1933. When the nation's banks closed in 1933, many people hoarded their money. To keep the economy going, store owners, communities, and even schools issued their own; Leiter's Pharmacy in Pismo Beach, California, "issued" clamshells (upper left). Some of this emergency money was later collected by the Chase Manhattan Bank, which exhibited historical money at its main headquarters in New York. In 1979 the bank donated most of its collection to the Smithsonian.

The Pismo Beach clamshells express many kinds of value. They had monetary value; although not as universally exchangeable as the gold sovereign or government-issued currency, they were, in their time and place, more useful. They capture a moment in a community's history as well as the nation's history. And, after arriving at the Smithsonian, they gained a new dimension, a family history, when they were visited by the children of one of the people who had signed them decades earlier.

So any object, even a humble clamshell, can have value if people agree that it does. Artifacts become treasures when people—individuals, families, collectors, communities, a nation—agree to regard them as such. Shared acceptance of an object's value can be based on rarity, like the 1913 Liberty nickel; symbolic importance, like the Smithson sovereign; or community acceptance, like the $100,000 bill and the Pismo Beach clamshells. The practice of investing artifacts with symbolic value beyond themselves leads to the most complicated kind of historical value—connection to history—and the most vexing of museum artifacts—the relic. An understanding of relics can lead to a fuller appreciate of many of the artifacts—and stories—in museum collections.

From Relics to National Treasures

All artifacts that gain value through resonance tell stories. But some artifacts—relics—are of interest only for their story; they need their history to survive, to have any value at all. A relic is an object linked by a story to a specific person, place, or event. Without the object the story told by the relic may be forgotten or discounted, and without the story a relic quickly loses its identity and its value.

A relic is a story one can touch. If one believes the story, a relic provides an immediate, tangible, and intimate connection to the past. (In the Middle Ages, religious relics had to prove themselves by performing miracles, but presumably a good story encouraged believers to see miracles.) Relics are the most difficult artifacts to understand and value, but an appreciation of them can lead to a better understanding of many less loaded artifacts in a history museum. Historical artifacts—resonant artifacts, relics—gain their value in part from their stories.

To a believer a relic is an object of real value. Religious relics reinforce religion; national relics become part of civil religion and pillars of national identity. Even Charles Mackay, the cynical author of *Extraordinary Popular Delusions and the Madness of Crowds* (1841), had a weakness for relics. "The love for relics," he wrote,

is one which will never be eradicated as long as feeling and affection are denizens of the heart. It is a love which is most easily excited in the best and kindliest natures, and which few are callous enough to scoff at. Who would not treasure the lock of hair that once adorned the brow of the faithful wife now cold in death, or that hung down the neck of a beloved infant now sleeping under the sward? They are home-relics, whose sacred worth is intelligible to all: spoils rescued from the devouring grave, which to the affectionate are beyond all price.[13]

A relic is of value only as long as its story seems worth telling, as long as people want to connect to the history it represents. While its meaning still resonates with the public, a relic may be exhibited in a museum, and curators may do their part to keep it alive by telling and retelling its story. But eventually a relic's magic fades, as the people and events it describes recede from public memory and interest. At this point, if the relic is taken off exhibit, it is not missed. Its story, recorded on a catalogue card, may arouse curiosity or amusement, but the relic itself lacks the emotional power and relevance that originally compelled its preservation. It is essentially dead.

Modern museums are skeptical of relics. In part this is because of the influence of art museums: relics, often fragments, are rarely beautiful, museum-quality artifacts. More reasonably, some curators judge the

First gold found at Sutter's Mill, California, 1848. On January 24, 1848, James Marshall found this tiny piece of gold in a stream near John Sutter's sawmill in northern California. News of the discovery inspired the great Gold Rush of 1849. Marshall and Sutter gave the gold nugget to a U.S. Army officer in San Francisco, who sent it to Washington, D.C., to the National Institute, a predecessor of the Smithsonian Institution. When the institute's charter expired in 1862, its collections were transferred to the Smithsonian.

Fragment of Confederate flag cut down by Colonel Elmer Ephraim Ellsworth, 1861. The day after Virginia voted to secede from the Union, eight regiments of infantry were sent across the Potomac River to seize Arlington Heights and Alexandria. Colonel Ellsworth, the leader of the Eleventh New York Volunteer Regiment, saw a Confederate flag flying over the Marshall House hotel. Ellsworth charged up the stairs and cut down the flag, only to be shot by James Jackson, the hotel proprietor, who was then killed by Francis Brownell, one of Ellsworth's soldiers. The incident electrified Washington, D.C. Ellsworth lay in state at the White House, Brownell received the Medal of Honor, and everyone wanted relics of the Marshall House incident. Over the years the Smithsonian acquired Jackson's shotgun and Brownell's rifle and Medal of Honor as well as this piece of the flag in 1961.

value of a relic by what it contributes to the knowledge of history, and for much of the twentieth century many curators, like many historians, have had a narrow view of history. Carl Guthe, author of the guide *The Management of Small History Museums* (1964), leaves out emotion and belief and indeed much of culture in his dismissal of relics. Consider his appraisal of "an old letter attached to a handkerchief with an embroidered design [which] in one corner states that it was given to the great-grandmother of a local citizen by a famous political figure when he visited the community in the 1850s." This is, he sneers, "a romantic souvenir of an insignificant historic incident. It has historical value only as an example of the type of embroidery done in the 1850s."[14]

G. Ellis Burcaw, another museum expert, puts the warning in stronger terms: "Relics, curiosities, personal memorabilia, glorification of specific individuals or specific families . . . do not belong in a public museum. . . . No two-headed calves. No bricks from the old school house or mementos of prominent families."[15]

There is a third, more important reason to be wary of relics. Relics, considered in their traditional way, call for an unquestioning acceptance, not historical analysis. The very name suggests religious belief, not scholarly understanding. Relics taken at face value—which is really what Guthe and Burcaw are warning about—are only occasionally of much historical value. The story that makes them valuable is often a bit confused. Consider Huckleberry Finn's description of a family treasure:

Uncle Silas he had a noble brass warming-pan which he thought considerable of, because it belonged to one of his ancestors with a long wooden handle that come over from England with William the Conqueror in the Mayflower or one of them early ships and was hid away up garret with a lot of other old pots and things that was valuable, not on account of being of any account, because they warn't, but on account of them being relicts, you know.[16]

But read between the lines of the story, considering not the relic itself but rather what it meant to those who thought it worth saving, and the relic becomes more interesting. Relics may not be the most reliable historical evidence, as Mark Twain reminds us, but they are nonetheless of value. Uncle Silas thought his warming pan valuable because he liked the story it told—and this reverence indicates something important about Uncle Silas. Relics may do a poor job of capturing their own history, but they do a good job of suggesting what history their keepers think is worth saving.

Brooke Hindle, in an article entitled "How Much Is a Piece of the True Cross Worth?" (1978), directly raises the question of a relic's

value and gives a thoughtful answer: relics "provide direct, three-dimensional evidence of individuals who otherwise would exist only as abstractions."[17] The historian David Lowenthal argues in *The Past Is a Foreign Country* (1985) that relics "remain essential bridges between now and then."[18] They can be teaching tools, abstractions made concrete. But even more they can capture emotions and experiences. Rachel Maines and James Glynn, the most eloquent contemporary advocates for relics, write:

[Relics] tell stories: the stories they tell are the stuff of social and intellectual history—the interaction of emotions, ideas, and beliefs with material culture.... The emotional force of association objects is their validation of memory and physical connection to the past. They concretize abstract memories, especially those of intense experience not easily captured in words: danger, suffering, birth, marriage, and the thrill of achievement. Places and artifacts associated with personal and communal marker events provide a means of understanding and coming to terms with an emotionally charged past.[19]

Relics are worth saving because someone thought they were worth saving. They indicate in a direct way what someone thought was important.

Relics preserved in a national museum can tell even more. They show what a nation thought was important. They preserve national myths, and national myths are a key to understanding what makes people a nation. Simone Weil, in *The Need for Roots* (1949), writes that "a collectivity has its roots in the past.... We possess no other life, no other living sap, than the treasures stored up from the past and digested, assimilated, and created afresh by us."[20] The telling and retelling of national myths, along with the display of national icons, shape national identity. Indeed, when they are used for political purposes, they can sometimes shape national history. And so the National Museum of American History has treasured relics connected to the nation's founding fathers and others who have defined or redefined the United States.

Cup that held President McKinley's last drink, 1901 (left). While attending the Pan-American Exposition in Buffalo, New York, on September 6, 1901, President William McKinley paused to have a cup of coffee. Moments later he was shot by the anarchist Leon Czolgosz. McKinley died several days later, and Theodore Roosevelt became president. This cup, which supposedly held McKinley's last drink, was donated to the Smithsonian in 1967. According to the donor, her mother-in-law, who served as a hostess at the Pan-American Exposition, received the cup from one of her assistants after the assassination.

Thomas Jefferson's desk, 1776 (below). This desk, one of numerous inventions Jefferson devised for his own convenience, was designed in May 1776 and built by Benjamin Randolph, a Philadelphia cabinetmaker and prominent patriot. It features a lap desk with an adjustable book rest and a lockable drawer, and Jefferson planned to use it while traveling between Monticello and Philadelphia. Jefferson gave the desk to his granddaughter Ellen Randolph Coolidge and her husband in 1825, and their children gave it to the nation in 1880. Urging its acceptance, Senator John Warfield Johnston of Virginia declaimed: "On that desk was done a work greater than any battle, loftier than any poem, more enduring than any monument...." It was displayed at the U.S. State Department for more than forty years and then transferred with other relics to the Smithsonian in 1921.

The Declaration of Independence is the founding document of the nation, and so the desk on which Thomas Jefferson wrote that document is tied to America's creation story as closely as any artifact.[21] An article in the Smithsonian's 1953 annual report declared the desk "perhaps the most important" relic in the museum, and many Smithsonian curators have since seconded that opinion.[22]

But the reverence for the desk and even for the document drafted on it is, in fact, a political creation that came into being long after the declaration itself. The story of the Jefferson desk and the Declaration of Independence demonstrates well the elusive nature of relics. As surprising as it may seem, at the time of its writing and for decades afterward the declaration was not treated like a precious document. Copied onto a low-quality piece of parchment, it was poorly cared for, "one of the most abused documents in the history of preservation ... battered and bandaged since its birth." It was not put on public display until 1841, when it was pinned to a wall in the Patent Office. For its centennial anniversary in 1876, the declaration traveled to Independence Hall in Philadelphia, and later it was displayed in the U.S. State Department library. But not until the twentieth century did the document finally assume the status of a precious relic. It received its own shrine at the Library of Congress in 1924, and in 1952, at the start of the Cold War, it joined the other "Charters of Freedom" in a resplendent shrine at the National Archives.[23]

Jefferson certainly would have been pleased to see what he came to think of as his work displayed in such splendor, just as he would be delighted to see the desk on which he drafted the document treated as a treasure by his country's national museum. But as the historian Pauline Maier has noted, Jefferson's memories of the declaration and the history he claimed for it do not always match the real story. The physicality of the document and the desk have helped perpetuate a Jeffersonian cult that masks a more complicated and interesting story. Such is the nature of relics: they can hold only simple stories; they tell only a part of the truth.

The Declaration of Independence, written by a committee of the Continental Congress in June 1776, drew on many similar documents that had been drafted by groups throughout the American colonies as well as other documents declaring the rights of Englishmen. Although a central figure in the story, Jefferson was, as Maier writes, "no Moses receiving the Ten Commandments from the hand of God, but a man who had to prepare a written text with little time to waste, and who ... drew on earlier documents of his own and other people's creation. [It] was the work not of one man, but of many."[24]

The Declaration of Independence attracted relatively little attention after it was issued. Each state set about writing its own declaration of independence, only some of which referred to the national one. Only rarely did July Fourth celebrations include a reading of the document that presumably had made independence possible. "During the

first fifteen years following its adoption," according to Maier, "the Declaration of Independence seems to have been all but forgotten."[25]

The declaration's modern reputation originates not from a grateful nation of 1776 but from the politics of the early republic. In the 1790s the Jeffersonian Republican party "rediscovered" the declaration, which it deemed not just a political document declaring the country independent but a fundamental philosophical statement of human rights. Federalists, in contrast, disparaged the declaration and Jefferson's role in it. But the War of 1812, which revived the British threat, as well as the decline of the Federalist Party brought the declaration back into favor.[26]

By the 1820s, fifty years after the Revolutionary War, a new generation was looking back on that era with nostalgic reverence. The country was booming, and with the boom came a longing for the old values of the Revolution. Now an aging man concerned about his personal legacy as well as the future of the nation, Jefferson encouraged this revival of interest in the events of 1776, penning many letters about his role during the "Heroic Age" of the Revolution. More than ever, he looked back to what he now saw as his crowning achievement: the Declaration of Independence.

It was during this era of nostalgia that the relics of the Revolution became important. The Marquis de Lafayette's visits to the United States in 1824 and 1825 piqued interest in the past, and the crowds that gathered to see him also rushed to collect Revolution-era relics. Lafayette's secretary noted that "monuments of the revolution" from "fragments of arms or projectiles" to "military buttons" were saved, "every thing which recalls this glorious epoch, is to them a precious relic, which they regard almost with a religious reverence."[27]

This nostalgia fed on the romantic concept of associational psychology popular in the 1820s, the notion that the sight of an object could evoke the events and people with which it was associated. "A glove, a gorget, a lock of hair, a battle map connected by memory with great men or great deeds," wrote a historian of this period, "could trigger in the imagination of those so instructed a chain of associated images, arousing thereby the appropriate emotion of awe and bringing the mind to a condition of moral sensitivity and reflection." And objects of national interest—whether American places, American history, or American things—would stir Americans most deeply.[28]

This 1820s enthusiasm for the Revolution-era past, not the actual events of 1776, is the proper context for understanding that precious relic, the Jefferson desk. In 1776 Jefferson valued the desk for its convenience and utility. Similarly, the declaration itself was not considered a document of exceptional value, simply a means to an end. But from the vantage point of fifty years, it was important enough for Jefferson to claim a larger role in its writing than he actually played and argue that even the desk on which it was written had become sacred. In 1825 Jefferson presented the desk to his granddaughter Ellen Wayles Randolph Coolidge and her husband. He attached a note to the bottom, which reads in part:

Thomas Jefferson's desk, 1776. When the desk was displayed in 1876, politicians lauded the relic with language both political and religious. Robert C. Winthrop, president of the Massachusetts Historical Society, called it "as precious and priceless a piece of wood as the secular cabinets of the world have ever possessed," "among the choicest and most famous treasures of the Nation." Similar praises accompanied the desk's presentation to the nation in 1880. William W. Crapo, U.S. congressman from Massachusetts, called the desk "a precious memorial of Jefferson" and tied its story to the politics of the day. Crapo, a liberal and progressive Republican, saw the desk as a symbol of Jefferson's commitment to popular government, liberty, and union.

Politics, as well as Religion has its superstitions. These, gaining strength with time, may, one day, give imaginary value to this relic, for its association with the birth of the Great Charter of our Independence.[29]

Writing to the Coolidges about the desk, Jefferson predicted that by 1876 his descendants might see it "carried in the procession of our nation's birthday, as the relics of the saints are in those of the Church."[30]

Jefferson, perhaps the least conventionally religious of the founders, ultimately turned to religion to describe the declaration and the desk: "Small things may, perhaps, like the relics of saints, help to nourish our devotion to this holy bond of the Union, and keep it longer alive and warm in our affections." His use of religious language and his belief in the importance of "devotion to this holy bond of the Union" reflected the Revolutionary War generation's search for a national religious identity. Martin Marty, a scholar of American religion, describes the founders' concern to "find the cement for social bonding, the lubrication for cultural process, the common terms for public discourse" at a time when America was already a diverse country. "It was unthinkable that they could do so without something like a common religion," Marty writes, "but this common faith did not dare to be opposed to the differing views about ultimate reality" Americans held.[31]

Their solution was to transform America's revolution into a new "civil religion." The Declaration of Independence and the Constitution became the new sacraments, an affirmation of a new secular order, marked by the country's founding. By the nineteenth century the signing of the declaration was considered a religious event as much as a political one. Consider the way John Quincy Adams used religious language in his Fourth of July oration in 1837:

Is it not that the Declaration of Independence first organized the social compact on the foundation of the Redeemer's mission upon earth? That it laid the cornerstone of human governance upon the first precepts of Christianity, and gave to the world the first irrevocable pledge of the fulfillment of the prophecies, announced directly from Heaven at the birth of the Saviour and predicted by the greatest of the Hebrew prophets six hundred years before.[32]

And so the desk on which the declaration was signed became a relic of the new civil religion. Jefferson's granddaughter and her husband did indeed see the desk celebrated, not in a procession but in the late-nineteenth-century equivalent—the 1876 Centennial Exhibition, held in Philadelphia.

The Jefferson desk, then, reveals more about the history and politics of the nineteenth century than of the 1770s. The same is true of most relics: they tell more about their own history as relics than that of the moment or individual they are a relic of. They are reminders of the earlier moment; they connect people to it but always through the lens of their own history. The historical value of relics is their story, and their changing story tells not about the relic but about the period when the story was deemed worth telling.

There are some artifacts that by their very nature have symbolic meaning. A flag is first and foremost an icon. Even new, it stands for something: the nation or patriotic ideals. But a particular flag can be at the same time both an icon and a relic, a universally recognized image and a reminder of a specific moment.

The Star-Spangled Banner, the flag that flew over Fort McHenry during the War of 1812 and inspired Francis Scott Key to write the poem that became America's national anthem, is one of the Smithsonian's most precious relics. Major George Armistead, commander of Fort McHenry during its bombardment by the British on September 13 and 14, 1814, took the flag with him after the battle. Long treasured by the Armistead family and citizens of Baltimore, the Star-Spangled Banner became a relic of national significance after the Civil War.

Since it came to the Smithsonian in 1907, the Star-Spangled Banner has undergone a transformation from relic to icon and back again. For more than fifty years it was displayed in a case in the Arts and Industries Building, where visitors could see the flag in its true condition: badly tattered and missing eight feet of its original length, which had been clipped away for souvenirs. Exhibited as a relic, the flag showed through wear and tear the eventful history of which it was a part.

In 1964 a new version of the Star-Spangled Banner was unveiled at the Museum of History and Technology. As the centerpiece of a museum dedicated to American culture and achievement, the historic relic became a patriotic icon. The ragged edges were tucked and tugged to form a neat square; the missing portion was replaced with a colored backdrop. Instead of seeing the flag up close, as they had in the Arts and Industries Building, visitors now looked up to the flag, hanging high in the museum's entrance hall. Seen from a distance, the flag looked whole again. It looked clean and new, the ideal of a flag rather than an actual artifact. Recast as an icon, the flag took on a larger meaning, one that resonated with Cold War values. No longer just relic with its own specific history, the Star-Spangled Banner was now *the* American flag; its story was America's story.

In the spring of 1999 the Star-Spangled Banner was taken down for much-needed conservation work. Experts have determined that the flag is too fragile to continue hanging as it had since 1964. Soon the museum will once again have to decide how to display this famous flag, how to balance its value as an icon, a relic, and an artifact that helps illuminate American history. For the Star-Spangled Banner tells many stories—not just stories of a battle and a song, of a family and a museum, but larger stories about what the American flag means to the American people. The value of the flag, as a relic and an icon, resides in both what it is and what it stands for.

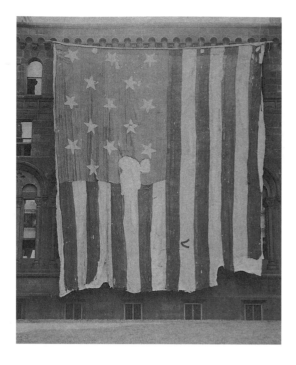

Star-Spangled Banner, 1814, Smithsonian Institution (the Castle), in 1907. The Star-Spangled Banner is the flag that flew over Fort McHenry during the British attack on Baltimore in the War of 1812. Major Armistead, the commander of the fort, took the flag home with him after the battle, and for the next century he and his family were the flag's caretakers. They displayed it at patriotic events, cut small pieces from the flag to give as presents, and even sewed an *A* (presumably for *Armistead*) onto it. In 1907 Eben Appleton, Major Armistead's grandson, loaned the flag to the Smithsonian Institution and donated it five years later.

Star-Spangled Banner, 1814, Museum of History and Technology (now the National Museum of American History), 1964–99 (opposite). When the Star-Spangled Banner was exhibited at the new Museum of History and Technology in 1964, it was made into a central icon of the building. It was displayed as a flag, not as a relic of a flag.

As every schoolchild knows, Plymouth Rock is where the Pilgrims landed in 1620. In fact, no one knows where the Pilgrims actually landed, and there is certainly no reason to think that they might have landed on a rock. Yet since the American Revolution, the Pilgrims and Plymouth Rock have been potent weapons in almost every ideological battle in American history.

The story begins when the citizens of Plymouth, Massachusetts, a hotbed of revolutionary fervor, set up a liberty pole next to the courthouse. Several Sons of Liberty decided to bring what they called Forefathers' Rock into town and place it next to the pole. By chance they broke the rock in two while moving it. Even better symbolism, they thought, interpreting the splitting of the rock as foretelling the division of the British empire. Good symbolism—but why in 1774 or 1775, a century and a half after the Pilgrims arrived in the New World, does a rock suddenly appear as part of the Pilgrim myth? A 1776 sermon gives a clue. The Reverend Sylvanus Conant of Plymouth, drawing on the commonly accepted parallel between the Puritans and the ancient Jews wandering toward their Promised Land, preached that "GOD . . . took them on the wings of his providence and wafted them over here. He set their feet upon a rock, and established them so firmly that none of the powers or machinations formed against them have been able to pluck them up." The biblical symbolism appealed to patriots who believed that, in the war against an unjust king, God was on their side. Plymouth Rock, relic of a chosen people, thus became an apt symbol of American identity during the Revolution.[33]

The rock, being just a rock, proved a flexible and useful symbol. Its meaning shifted in response to new events and new interpretations of the Pilgrims' role in American history. In 1802 John Quincy Adams described the Mayflower Compact, signed by the Pilgrims before they landed, as the birth of indigenous American government. Charles Wentworth Upham, a Massachusetts legislator who had formerly been a minister, wrote in 1846 that Plymouth Rock should be recognized as "the point from which the ever-advancing and ever-expanding wave of Anglo-Saxon liberty and light began to flow over America."[34]

But by the 1920s, debunked as the landing site of the Pilgrims and of little interest to historians and politicians, Plymouth Rock became just another tourist attraction. The Plymouth Antiquarian Society, keeper of the rock, discovered a piece that had broken off and was being used as a doorstep. The Smithsonian was offered a piece of that piece in 1983, and at the insistence of Secretary S. Dillon Ripley, who traced his own ancestry to the *Mayflower*, it was accepted.

A rock is just a rock. Without all of its stories—without the original story of the Pilgrims' landing, the various interpretations of that story, and then the story claiming that this is a piece of that particular rock—it means nothing. It would indeed be most useful as a doorstep.

Piece of Plymouth Rock, 1620. Plymouth Rock has been an important symbol—but one with varying meanings—since its "invention" in 1774 as part of an attempt to promote the Revolution's cause by associating it with the Pilgrims. In the 1820s Plymouth Rock became a symbol for New Englanders of that region's importance to the nation's history. In the 1850s abolitionists used the rock as a symbol of New England's opposition to slavery. In the late nineteenth century it was promoted as a symbol of the English roots of the American elite and their opposition to immigration. The rock, moved to a display in downtown Plymouth in 1774, was reinstalled on the shore under a protective canopy in 1880. In 1920 the Plymouth Antiquarian Society discovered a missing four-hundred-pound piece of the rock—being used as a doorstep. In 1983 the society offered a piece of its rock to the Smithsonian, and in 1984 officials traveled to Plymouth to accept the gift.

Relics of the Recent Past

Bugle from the U.S.S. *Maine*, 1898. This bugle was recovered from the wreck of the U.S.S. *Maine*, which blew up in Havana Harbor, Cuba, on February 15, 1898, killing more than 250 American sailors. Although most likely an accidental explosion, it was reported as an enemy attack by the sensational "yellow" press to incite enthusiasm for war. Two months later, rallied by the cry "Remember the *Maine!*" the U.S. Congress declared war on Spain. After the conclusion of the Spanish-American War, the U.S. Navy salvaged relics from the *Maine*, many of which, including this bugle, were transferred to the Smithsonian in 1920.

The kind of history making that established Plymouth Rock as a relic of the settlement of the United States or the Jefferson desk as a relic of the Revolution goes on today, as it always has. In addition to collecting ready-made relics, curators have also created new relics to help tell important stories about the country and its past. During the Spanish-American War, the Smithsonian sent agents to Puerto Rico, Cuba, and the Philippines to "secure for the Museum such relics and mementos of the campaign as would be of interest to the people."[35] In the 1960s and 1970s curators ventured outside the museum's front door and into the streets, collecting artifacts from civil rights marches and antiwar protests to remind future generations of those struggles. In doing so the Smithsonian has created new relics, new national treasures.

The collecting of recent history, especially politically important artifacts, is fraught with difficulty. William Yeingst and Lonnie G. Bunch, curators at the National Museum of American History, faced these problems when in 1993 they decided to acquire a Woolworth's lunch counter from Greensboro, North Carolina. On February 1, 1960, four black college students sat down at this "whites only" lunch counter and refused to leave until they were served. It was not the first sit-in, but it was perhaps the most important, and its eventual success, after almost six months, was a major victory for the civil rights movement.

Without a doubt this lunch counter represented an important American story, a story worth telling. After extensive negotiations with Greensboro and Woolworth's officials, a small part of the lunch counter was crated and shipped to the Smithsonian. Here the curators faced the next question: how to display it. It might be placed in an exhibit that provided an appropriate context, such as American politics or the civil rights movement. Or it might stand on its own, as an object treasured for its "iconic or patriotic value"—that is, as a relic. Treating it this way, the curators argued, "allowed the museum to place this racially specific episode squarely within the mainstream of American history."[36] In its new setting, a prominent position near the Star-Spangled Banner and the Horatio Greenough statue of George Washington, the Greensboro lunch counter makes an argument that the civil rights movement is as important as the nation's founder or the events that inspired the national anthem. Like the Jefferson desk, the Greensboro lunch counter speaks to the moment it was made a relic as much as to the historical moment it represents.

By the time the Smithsonian acquired the Greensboro lunch counter, it was no longer politically controversial. The civil rights movement had been accepted as an important part of American history. Another contemporary relic illustrates the power—and peril—of collecting the immediate past.

Woolworth's lunch counter, Greensboro, North Carolina, site of a 1960 civil rights sit-in. One of the most significant protests of the civil rights movement took place at this lunch counter. On February 1, 1960, four African American students from North Carolina Agricultural and Technical College sat at this "whites only" lunch counter, asked to be served, and, when they were not, refused to leave. The sit-in and boycott of the store lasted six months and was the focus of national publicity. On July 25 the lunch counter was desegregated, a victory for the civil rights movement. The closing of the Greensboro Woolworth's in 1993 presented curators with the opportunity to acquire this historic artifact. After extensive negotiations with Woolworth's executives and representatives of the local community, a small piece of the lunch counter was donated to the Smithsonian.

In 1978 the National Museum of American History acquired the chairs that Archie and Edith Bunker made famous in the hit television show *All in the Family* (1971–79). Curators listed their reasons for collecting these artifacts: "they were central props in a television show that was significant on a number of levels: as a leading example of situation comedy . . . ; as a pivotal show that caused change in the genre; as revealing of common beliefs, values, and behaviors in American life during the 1970s; and as a widely shared American cultural experience."[37]

The Bunker chairs quickly became more than just another artifact. As familiar popular culture icons, they provoked strong and often conflicting responses from visitors. Some enjoyed being reminded of a favorite television show. But others saw the chairs as a profane intrusion on the museum's sacred space. One visitor's comments reflected this sentiment:

In 1969 when I visited the Smithsonian I was amazed of being in front of those millions of relics for which I called myself that Institute a National Shrine, but, when I learnt ARCHIE BUNKER'S chair is going to be there in exhibition I got the impression such a sanctuary will be converted, gradually, to another 'pawn shop' or second hand store.

Even the Smithsonian's new secretary reacted with concern. In 1985, after reading an article in the *Chicago Tribune*, "Smithsonian Treasures TV Trivia," Robert McCormick Adams wrote:

Most people, I believe, come to the Smithsonian and to the museums as places to view treasured achievements that are tangible as well as enduring. But if the relics of TV are accepted as additions to the permanent collections of museums, with accompanying fanfare, is there not some danger that we will contribute to the ongoing erosion of vital standards of judgment and performance in the society at large?[38]

Collecting relics of the recent past challenges the museum, for the story that defines them is still contested. Neither the Greensboro lunch counter nor the Bunkers' chairs were collected or displayed without controversy. Why these objects, these stories, to represent the American past? They raise the same questions that Jefferson's desk raised in the 1820s and that Plymouth Rock raised in the 1840s. Relics are objects that tell stories, and when relics are enshrined, the importance of those stories is proclaimed. But the museum is not only a place to proclaim stories; it is also a place to discuss them. It is a forum as well as a shrine.

Archie and Edith Bunker in their chairs on the set of *All in the Family*, 1970s. These chairs, the visual centerpiece of the television show *All in the Family*, were purchased from a used-furniture store in California. Norman Lear, producer of the show, was clear about the meaning of Archie's chair: "Its symbolism cuts across all generations, cultures, races, times. Everybody's father had a chair, or something akin to it—someplace that was sacrosanct to him and him alone. In my father's case, for example, it was a red leather chair. We'd never think of sitting in it—it was *his* place." A curator from the National Museum of American History attended the taping of the final episode in March 1978 and acquired the chairs at the suggestion of John Brademas, U.S. representative from Indiana, who urged that they be preserved in the Smithsonian "as part of the cultural legacy of our country."

Personal Treasures

Just as the National Museum of American History saves objects to tell the nation's stories, individuals save objects to tell their own personal stories. Souvenirs, heirlooms, mementos—these objects have many names, each suggesting a different kind of memory. By tying one to the past—one's own past, that of one's family or community—they help remind people of who they are. One of the most touching scenes in John Steinbeck's *The Grapes of Wrath* depicts the Joads deciding what to take with them when circumstances force them to abandon their home and possessions and leave Oklahoma for California. Every one of the "doomed things" seems precious: some they received as gifts; some belonged to family members; some they used. All are reminders of their lives. "How will we know it's us without our past?" they lament.[39]

Why objects relating to important events in the nation's history belong in a national museum is clear, but why the Smithsonian should collect individuals' personal treasures is less clear. Remember the warning of Ellis Burcaw, the museum expert: no personal memorabilia.[40] But by collecting this kind of relic, the museum can preserve and present the stories of individual Americans. National relics, properly analyzed, lead to political history. Personal relics lead to the nation's social and cultural history. Understanding what objects have been important to people and why can provide insight into not just how people lived but how they thought about their lives, what they thought was worth saving.

In 1977 and 1978 the psychologists Mihaly Csikszentmihalyi and Eugene Rochberg-Halton undertook an extensive survey of people's attitudes toward the objects in their home and discovered just how important things are to people. "Men and women make order in their selves (i.e., 'retrieve their identity') by first creating and then interacting with the material world," they wrote. "The nature of that transaction will determine to a great extent the kind of person that emerges. Thus the things that surround us are inseparable from who we are."[41]

And people surround themselves with a vast range of things. Csikszentmihalyi and Rochberg-Halton devised a complex nomenclature for artifacts that connect people to the past, a nomenclature that suggests the range of uses of personal treasures. Mementos are general reminders of the past. Souvenirs represent the memory of a place. Recollections are memories of a specific occasion. Heirlooms are something handed down in the family. Another category—"had it for a long time"—suggests that the object has gained its importance simply by possession. Objects with familiar, ethnic, or religious associations constitute another category, as do collections and gifts.

All of these terms suggest that personal treasures, like relics, are artifacts that have stories—memories—tied to them. When separated from their owners and stripped of their story, they are mute and meaningless things. But with the stories intact they are reminders of one's lives and loved ones. "The souvenir and the collection," writes Susan Stewart, a philosopher of artifacts, "are objects generated by means of narrative."[42] As with relics, the story is an essential element. The Smithsonian has long preserved the stories of objects owned by famous individuals, but in the case of "everyday" things that belonged to "ordinary" people, it took curators many years to realize the value of preserving the narrative along with the object.

Gold nugget watch and fob, 1886. A. W. Callen of Junction City, Kansas, had this watch and fob encrusted with nuggets from his Colorado gold mine. In 1886 he presented them to his children as birthday gifts. His daughter received the watch, set with four rubies and a diamond; his son received the fob, inscribed "with Love from his Father 'Old Grizzly.'" The pieces were handed down in the family to Robert Callen King, who bequeathed them to the Smithsonian in 1963.

Girl's blue jeans, 1970 (opposite). In 1973 Brigid McMenamin wrote the Smithsonian: "This may be an unusual request. . . . My favorite jeans will be three years old this spring . . . they're so thin, my mother wants to throw them away . . . is it possible that you may be able to use them in a display?" She had worn the jeans everywhere and had even fought with school authorities for the right to wear them to school. "These jeans aren't art, but they're a sample of costume in America . . . best of all, they're authentic."

Almost anything can preserve a memory—a seashell, a pressed flower, a piece of wedding cake, a lock of hair, a child's artwork. In capturing certain periods in people's lives, rites of passage, and key moments, mementos remind people of who they used to be. They are also reminders of others dear to them. A young girl wrote in the 1840s: "How many passages of my life seem to be epitomized in this patchwork quilt . . . that bright copperplate cushion which graced my mother's easy chair . . . old brocade-looking calico, presented by a venerable friend . . . a fragment of the first dress which baby brother wore when he left off long clothes."[43]

Mementos, which are by their nature intensely personal, take on new meanings in the museum as clues to understanding American culture. They document various expressions of identity and ways of remembering the past. In the museum objects once used to preserve personal memories—a biker's denim vest, a teenager's patched jeans, a soldier's scrapbook—become touchstones for national memory. They serve as reminders of a bygone era, of the people Americans used to be.

Hell's Angels jacket, 1960s. This denim jacket was worn by a member of the notorious Hell's Angels motorcycle gang, which mingled and occasionally clashed with the hippie counterculture of San Francisco during the 1960s. In 1989 this jacket arrived at the Smithsonian with a letter: "The enclosed . . . is an authentic jacket owned by Hairy Henry or Hank as he was more commonly called. Each patch bearing a man's name was worn in memoriam for his lost brothers. Hank has since passed away and I felt you were the appropriate entity to receive this jacket. . . . I hope you share my belief and give this a place."

SOUVENIRS

Some mementos are easier to understand than others. The souvenir calls to mind a specific place or event, a memory of times past. It is a badge of honor, a proof of a journey. Souvenirs are the material culture of nostalgia, authentic experience preserved in an artifact. They bring the past and present together, magically combining the two. The function of a souvenir, Stewart writes, is to "envelop the present within the past." This is what gives the souvenir its magic. But it is, of necessity, a "failed magic," for the souvenir cannot bring back the past; it can only generate a desire for it.[44]

To bring back a souvenir to remember a trip by, to try to pack an authentic piece of the place into one's suitcases, is a natural human impulse. A whole genre of objects has evolved to satisfy tourists' craving for souvenirs. "Tourist art" or "airport art," as these artifacts are called, has long been derided as inauthentic. Recently, however, tourist art has aroused interest among anthropologists, for it raises profound

Souvenir pennants, 1940s–60s. Popular items from the 1940s through the 1960s, pennants have since given way to T-shirts and other mass-produced collectibles at souvenir stands. For some tourists, adding such a souvenir to their collection can be more pleasurable than the trip itself. These pennants were collected by an American family during their travels and donated to the Smithsonian in 1977.

questions about the nature of authenticity. What was once intended as a precious commodity for an elite in one culture becomes a symbol of a different sort of elitism—the ability to travel—in another culture. The identity of the producer becomes part of the status of the consumer.[45]

Souvenirs of travel are well represented in museum collections, where earlier they often served to represent foreign places, not always accurately. Sometimes these objects say more about the tourists themselves than about the places visited. Indeed, many old Smithsonian collections of the "exotic" are, in fact, collections of tourist art.

In the years 1910–19, for example, the Smithsonian became a storeroom of sorts for the textiles, manuscripts, stained glass, and ceramics purchased by Alice Pike Barney, a Washington, D.C., artist and socialite, on her trips abroad. (She lent them to the Smithsonian and then asked for them back when she wanted to redecorate her house.) These artifacts—"a collection of miscellaneous antique art objects

"JOHN" "TEST RUN" "MAC" "HERB" AND "SHORTY" "YOUNG" "YUK" "GIFF" "MAC" "SHORTY"

"JENNETTE" "BOB" "JENNY" "MAC" AND "SNUFFY" "HERB" AND "JAKE" "HOLSHER" "JACKSON" "ACKER" "DE CARO" "MAC DONALD"

and antiquarian furnishings," as the curator tactfully described them—were initially considered authentic art. But further analysis revealed that many were fake or at least much less ancient than Barney supposed. With the passage of time, however, these objects have become interesting again, as examples of what rich Americans thought appropriate to collect.[46]

Mass-produced souvenirs of travel, which date back to the beginning of tourism, serve not so much as a way to collect culture as a way to remember the experience of the trip. In the United States the souvenir industry developed rapidly during the nineteenth century, as visitors flocking to sites such as Niagara Falls, Yosemite, and Mammoth Cave sought ways to take the spectacular views home with them. By the 1890s souvenir stands teemed with china plates, silver spoons, beaded whimsies, stereographs, postcards, and other *aides memoire*. The variety of souvenirs continued to expand during the twentieth century. In the 1950s, for example, no self-respecting tourist would neglect to buy a souvenir pennant to show off his or her travels.

The remarkable thing is that even the humblest souvenir—a mass-produced pennant, a stone picked up from the shore, a ticket stub—can hold potent memories. Susan M. Pearce describes the mnemonic power of souvenirs in bittersweet terms, as "samples of events which can be remembered, but not relived . . . they are lost youth, lost friends, lost past happiness; they are the tears of things."[47]

Perhaps for this reason the National Museum of American History contains many souvenirs of war and military service. Men and women who served their country as youths hold onto reminders of their career. The military history collections include Bibles, scrapbooks, carved bullets and shells, and clothing, memorializing every aspect of wartime experience.

World War II GI's photograph album, 1944 (above). In 1979 the Smithsonian acquired this album, an American soldier's souvenir of his time in Europe during World War II. Since the Civil War, Americans' experience of war has been captured, brought home, and remembered through photographs. The Smithsonian has many war photographs in its collections, mostly the work of professional media or government photographers. Yet the museum has also collected amateur photographs taken by the soldiers themselves. These personal snapshots, pasted into scrapbooks or packed away with other battle souvenirs, reveal aspects of war not seen in official images.

Sword surrendered by Japanese officer, 1945 (opposite top and bottom). On August 22, 1945, on Aka Island, near Okinawa, Japan, Colonel Julian G. Hearne Jr., commanding officer of the Twenty-fourth Infantry Regiment, accepted the surrender of Japanese troops under the command of Major Yoshihiko Noda, the first formal surrender of a Japanese army garrison in Japanese-held territory at the end of World War II. Major Noda turned his sword over to Colonel Hearne (below), and the other Japanese officers turned their swords over to other members of the U.S. regiment. In 1981 Colonel Hearne gave the sword to the Smithsonian, writing that "the sword really belongs to the American people."

THIS MAY BE OPENED FOR POSTAL INSPECTION
THIS CONTAINS: 1 JAP. SABRE
PERMIT INCLOSED

Collections are another kind of personal treasure, not necessarily a reminder of an individual or family past but a form of self-expression. There are many theories about why people collect, from the psychoanalytic—"All collectors are anal-erotics, and the objects collected are nearly always typical copro-symbols," offered by E. Jones in 1912—to the capitalistic—"A man's Self is the sum-total of all that he can call his," offered by William James in 1892.[48] These may or may not be good explanations, but they certainly are not complete explanations. The act of collecting represents much more than a stage of psychological development or the measurement of self-worth.

Marjorie Akin, in an article appropriately titled "Passionate Possession" (1996), outlines a variety of reasons that drive people to collect.[49] For some it is a sense of personal aesthetics; they enjoy looking at the things they save, arranging them in a pleasing fashion, and contemplating them. For others it is a sense of control, order, or completion. This is often the case with children's collections. As William Ackerman, executive director of the Children's Museum of Manhattan explains, "Developmentally, kids generally start collecting at around age five or six. They do it, for one reason, because a collection is a world that they can control. . . . A collection is theirs, they created it. They decide if it is good. It is an expression of who they are."[50]

Other collectors are driven by a desire for a connection with the past. Sometimes this is a personal or family past; sometimes it is an ancestral past, real or imagined; sometimes it is just the past of history books. Roy Rosenzweig and David Thelen, whose *Presence of the Past* (1998) analyzes a survey of the ways that Americans connect with history, found that a collection was a common way to forge links to the past; thirty-nine percent of Americans had hobbies or collections related to the past.[51]

Some collectors have a straightforward motive for collecting: making money. Related in a complex way to this impulse is another kind of profit: increases in symbolic capital or status. This is the kind of collecting that Thorstein Veblen described so well in his 1899 book *The Theory of the Leisure Class*, particularly the chapter on conspicuous consumption: "Conspicuous consumption of valuable goods," he remarks, "is a means of reputability to the gentleman of leisure."[52]

And finally there is collecting for the thrill of the chase. Collecting is fun, and finding the right object that fills the hole in the collection provides a sense of accomplishment.

Button collection, about 1935. The inscription above this collection—"Who's got the [button?] Betty Jane has the [buttons!]"—reflects a young collector's pride. But for Betty Jane Meggers, collecting was more than just a hobby; it was a part of family life. Between 1914 and 1970 William and Edith Meggers collected numerous toys, gadgets, souvenirs, utensils, and other artifacts, all of which they preserved in their Washington, D.C., home. (According to Betty Jane, her father "never threw anything away.") In 1974 the "Meggers Museum," including Betty Jane's buttons, was bequeathed to the Smithsonian.

Radiator emblems, 1910–40. By scavenging junkyards and trading with other collectors, Hubert G. Larson collected 278 radiator emblems from classic automobiles. When he donated his collection to the Smithsonian in 1964, Larson wrote: "I have shown about 100 of these at various hobby shows and have found that people seem very interested in recalling cars of earlier days."

Personal aesthetics, profit, fun—all are good reasons for individuals to collect. But not for museums. Although curators are often delighted to acquire private collections, museums and individual collectors collect for very different reasons. History museums collect to preserve, understand, and interpret the past.

Sometimes, because different ends can yield the same results, museum collections look identical to personal collections. Curators of the history of technology, for example, often attempt to create a systematic collection, to have one of every kind of object in a series. For individual collectors, systematic collecting usually serves to satisfy personal desires and interests. But for the museum, such systematic collections help illustrate the evolution of a particular kind of technology.

Sometimes museum collections look completely different from personal collections. The boxes of shards or bits of twisted metal that make up archaeology collections, the archival collections packed with manuscript pages and clippings that only a graduate student could love—only a few dedicated collectors would find these articles worth their space. The stories these collections tell are less popular and in some ways more difficult to tease out. But they are important stories nonetheless, and these collections can be treasures too—research treasures.

HEIRLOOMS

Some mementos and souvenirs become heirlooms. Heirlooms suggest a different kind of nostalgia, not for a personal past but for a family history. Objects inherited from ancestors bring with them a patina that suggests not only the artifact's age but also the family's distinguished lineage and ancestry.[53] John Cheever's short story "The Lowboy" describes an inherited antique lowboy "as a kind of family crest, something that would vouch for the richness of his past and authenticate his descent from the most aristocratic of the seventeenth-century settlers."[54]

But personal treasures are, by definition, personal. The meaning does not always move with it. And without a meaningful story they are only things. For them to make sense in the museum, curators must collect not only the artifact but also the story.

Seed pearl jewelry, 1836. On her eighteenth birthday, in 1836, Mary Lucile Stevens received this set of seed pearl jewelry from her mother. The pearls were passed down through the generations, ceremoniously presented to daughters of the family on their eighteenth birthdays. In 1984 the sons of the last woman to inherit the pearls donated them to the Smithsonian.

A History of Value

The National Museum of American History is indeed full of treasures. But, as indicated, value is more than simply the sum of an object's age, rarity, and associations. The ultimate value comes from outside the object, from the people who deem its story worth remembering and repeating. For an object to be more than a personal treasure, it must evoke events and individuals within the realm of public memory and reinforce current beliefs about the nation, its history, and its place in the world. Many of the treasures of a century ago fail to resonate with contemporary Americans' sense of the past and national identity. Since these objects were collected and celebrated, Americans have moved on, changed, grown up, become new people. These objects do not seem to be theirs anymore.

But although yesterday's treasures may be forgotten, they are not gone. Like geological strata, the artifacts in the Smithsonian's vaults record the ways that generations of Americans have imagined, valued, and preserved the past. Each object represents an effort to capture something valuable about America—a story, an idea, a way of life. Over time ideas about what is valuable—and ideas about what is American—have changed, bringing new treasures into the spotlight and sending old ones back into storage. New voices have emerged to tell new stories. Such changes reveal that history, indeed, has a history. By looking at objects that have been considered treasures over the past 150 years and retelling their stories, changing views of the American past can be identified and better understood.

Trade card, about 1900. Isadore Warshaw, a New York bookseller, devoted nearly fifty years to collecting trade cards, letterheads, advertisements, and other materials documenting the history of American business. Images from his collection were used for advertisements, historical displays, and product research. In 1967 Warshaw sold his collection of more than a million items to the Smithsonian. It has proved to be a treasure trove for researchers interested in everything from tractor repair manuals to images of race and ethnicity in American advertising.

A Shrine to the Famous

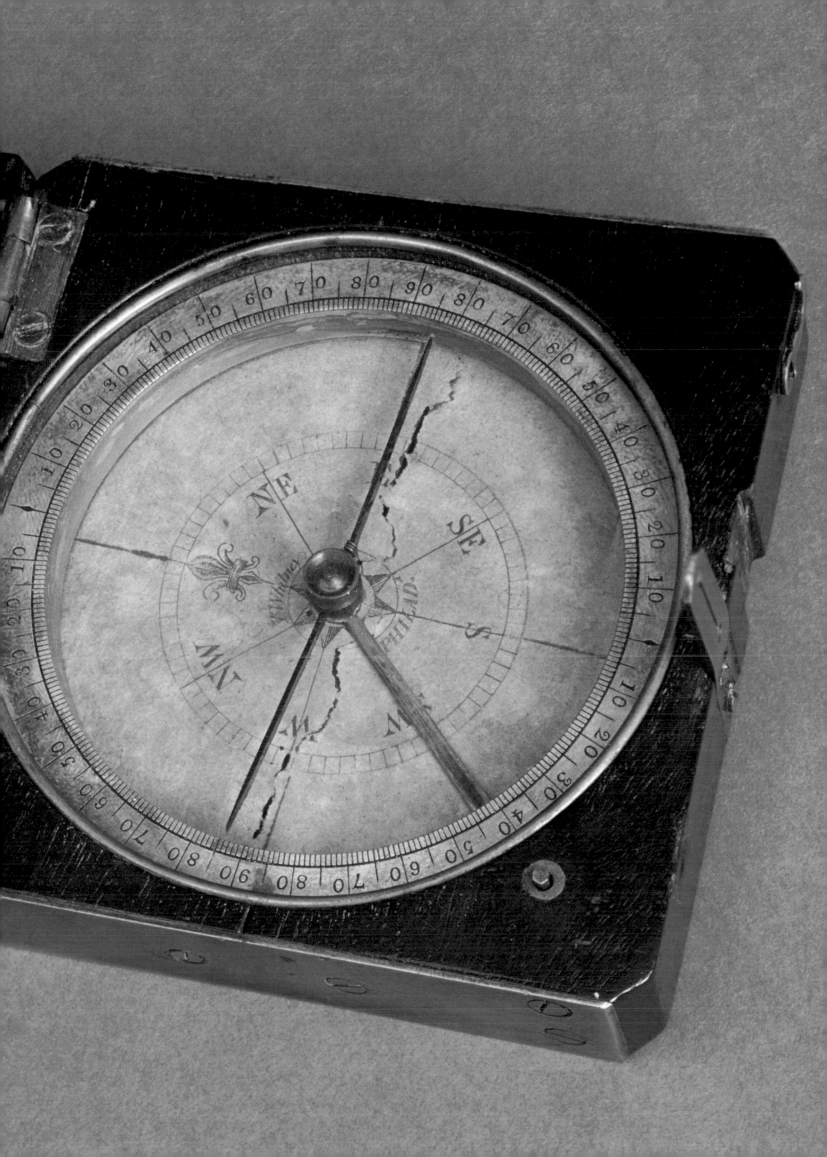

Mementos of the famous
do not simply materialize on
pedestals. Like all artifacts,
they must be brought to the
Smithsonian by someone who
believes they belong here.
Embedded in every personal
relic—from Washington's sword
to first ladies' gowns, from
Muhammad Ali's gloves to
Ed Roberts's wheelchair—
is a declaration about who is
worth remembering and why.

Framed display of U.S. presidents' hair, 1850s. In the nineteenth century it was common to honor famous Americans by preserving locks of their hair. One of the historical relics transferred from the Patent Office museum in 1883 was this display featuring the hair of the first fourteen presidents of the United States, from George Washington to Franklin Pierce. As times change, *how* people remember is often as revealing as *who* they remember.

Compass used on the Lewis and Clark expedition, 1804–6 (pages 60–61). President Thomas Jefferson dispatched Meriwether Lewis and William Clark, both experienced soldiers, to explore the uncharted northwest territory acquired from France through the Louisiana Purchase of 1803. Their mission was to assess the land's resources, find a land route to the Pacific Ocean, and make contact with Native Americans. Early in their journey they were joined by Sacajawea, a Shoshone woman who helped guide the party westward across the Rocky Mountains to the Pacific Ocean. The compass Clark used to navigate the route was given to Captain Robert A. McCabe, a U.S. Army officer who later served as an Indian agent in Minnesota and Michigan. After his death in 1839, the compass was passed down through his brother's family for nearly a century. In 1933 McCabe's grandniece presented the compass and case to the Smithsonian.

CCORDING TO WITNESSES on that February day in 1843, there was not a dry eye in the House. The occasion was Samuel T. Washington's offering of a gift to the nation: the battle sword of his great-uncle, George Washington, and a walking stick bequeathed to him by Benjamin Franklin. G. W. Summers, U.S. representative from Virginia, rose to address the crowd. He gestured to Franklin's cane, topped with a gold liberty cap, a prominent symbol of the Revolution. "Upon that staff once leaned the sage of whom it has been said, 'He snatched the lightning from heaven, and the sceptre from tyrants.'" Summers then turned to Washington's sword. "A mighty arm once wielded this sword in a righteous cause even unto the dismemberment of empire. . . . It was never drawn except in defense of public liberty." He concluded with a ringing proclamation: "Let the sword of the hero and the staff of the philosopher go together. Let them have place among the proudest trophies and most honored memorials of our national achievements."[1]

The House of Representatives erupted with cheers and applause. The sergeant-at-arms took custody of the precious relics, and the gentleman from Massachusetts, former president John Quincy Adams, rose to submit a resolution of acceptance. His voice charged with emotion, Adams contemplated the objects at hand and the men associated with them:

The sword of Washington! The staff of Franklin! Oh, sir, what associations are linked in adamant with those names. . . . Washington and Franklin! What other two men, whose lives belong to the eighteenth century of Christendom, have left deeper impression of themselves upon the age in which they lived, and upon all aftertimes?

In accepting on behalf of the American people "these venerable relics of the wise, the valiant, and the good founders of our great confederated Republic, these sacred symbols of our golden age," Adams expressed a final hope:

May they be deposited among the archives of our Government; and may every American who shall hereafter behold them, ejaculate a mingled offering of praise to that Supreme Ruler of the universe, by whose tender mercies our Union has been hitherto preserved through all the vicissitudes and revolutions of this turbulent world, and of prayer for the continuance of these blessings, by the dispensations of his providence to our beloved country from age to age, until time shall be no more.[2]

Following this benediction the assembly once again burst into thunderous applause. Congressmen dabbed their eyes and gathered around for a closer look at the sacred relics, many asking to hold and caress them, like Christian pilgrims in the presence of saints' bones or pieces of the true cross.[3]

George Washington's battle sword and scabbard, 1770s (above). Washington carried this sword as commander-in-chief of the Continental Army during the Revolutionary War. He willed the sword to his nephew, Samuel Washington, a U.S. Army captain, with orders to use it "only in self-defense or in the defense of country and its rights." In 1843 Washington's grandnephew donated the sword to the U.S. government, and in 1922 it was transferred from the State Department to the Smithsonian.

Benjamin Franklin's walking stick, about 1780 (left). Franklin received this cane while serving as ambassador to France during the 1780s. In his will he bequeathed this reminder of the Revolution and its ideals to George Washington: "My fine crab-tree walking stick, with a gold head curiously wrought in the form of the cap of liberty, I give to my friend, and the friend of mankind, *General Washington*. If it were a Sceptre, he has merited it, and would become it." Washington's grandnephew donated the cane to the U.S. government in 1843; it was transferred to the Smithsonian from the State Department in 1922.

No Proper Repository

Yet despite the grandeur of their reception, these relics did not really have a proper shrine to call their own. Instead, they were exhibited alongside other miscellaneous historical and scientific artifacts in the new Patent Office building. The grand halls of the Patent Office, designed to display patent models submitted by inventors, also served as a museum for the U.S. government's collection, known as the National Cabinet of Curiosities. (The National Institute, established in 1840 as the National Institution for the Promotion of Science, was the official caretaker of the government's collections at the Patent Office before they were transferred to the Smithsonian.) An 1855 catalogue of the museum listed relics of George Washington, Benjamin Franklin, Thomas Jefferson, and other statesmen; industrial artifacts; military relics; assorted portraits and statuary; and natural history and ethnological specimens gathered from around the world by military exploring expeditions. This collection of curiosities definitely lived up to its name; just one of the sixty-three cases described in the 1855 catalogue contained the following: a fossilized turtle from Ohio; a Turkish newspaper; "the famous edible bird nests from China"; specimens of India rubber sent by Goodyear and Company to the 1853 Mechanics' Fair in Philadelphia; a mitten made from buffalo wool; a sash stained with the blood of Captain James Cook; a piece of Connecticut's famous Charter Oak; a hairbrush made by a student at the Illinois Institution for the Education of the Blind; a piece of the cornerstone of the Washington Monument, laid in 1848, and a "Silk hat worn by a traveling monkey."[5]

Given this bizarre and colorful hodgepodge, perhaps it is understandable that, when confronted with the prospect of acquiring the National Cabinet of Curiosities, the first secretary of the Smithsonian Institution was less than enthusiastic. Joseph Henry had been appointed to lead the Smithsonian in 1846, the year the U.S. Congress used James Smithson's bequest to establish an institution dedicated to "the increase and diffusion of knowledge among men." One of the most renowned American scientists, Henry envisioned the Smithsonian as a center for scholarly research, not a popular museum. He strongly opposed the government's plans to use the Institution as a showcase for its eclectic collections, fearing that the result would be reminiscent of a P. T. Barnum sideshow and that the budget would go to taking care of artifacts, not advancing science.[6] But in 1858, over Henry's objections, Congress transferred a large number of objects from the Patent Office to the Smithsonian's new National Museum (originally located in the Castle), along with funds for their care and exhibition. The Smithsonian thus became the official curator of the nation's collections.

Significantly, however, this initial transfer did not include the contents of the case that, among the Patent Office's many wonders, visitors reportedly admired most of all: the case featuring Washington's sword

Benjamin Franklin portrait medallion, about 1776.
In 1774 the English potter Josiah Wedgwood introduced a series of small portrait medallions depicting famous figures of the day. One of the best-selling likenesses was that of Benjamin Franklin, whose energetic pursuits as a journalist, inventor, entrepreneur, statesman, and diplomat defined him, in the eyes of many people of that generation, as the quintessential American. This Franklin medallion came to the Smithsonian in 1981 as part of the Henry Rau Collection of Wedgwood pottery.

and Franklin's cane as well as other Washington relics such as furniture and housewares from Mount Vernon, his uniform, camp chest, and writing case used during the Revolutionary War, and his commission as general of the Continental Army.[7] Why were these treasures not added to the National Museum? In its early days the Smithsonian was conceived mainly as a scientific institution; its collections were assembled and curated by men of science. It showcased the products of scientific research and the exploring expeditions that travelled to new territories and foreign lands. It was a place not for looking back at the past but for studying the present and envisioning the future.

The fact that the National Museum initially focused on natural history, not national history, may have also reflected ambiguous attitudes toward American history and the government's role in preserving it. In the first half of the nineteenth century, history posed a dilemma for the young nation. The Revolution had liberated Americans not only from British rule but also, in creating a new society that aspired to democratic ideals, from the burden of Old World traditions and values. In that sense the past seemed largely irrelevant to the business of government, which was focused on the present and future, on shaping a more perfect union. Moreover, public history often took the form of hero worship, a practice that struck some as antithetical to democracy. As one American wrote to the *Philadelphia Public Ledger* in 1837 on the question of whether state money should help fund the proposed Washington Monument: "We are opposed to the least expenditure of public money for the mere purpose of honoring individuals, however distinguished. . . . We venerate as highly the character, and feel as grateful for the services of Washington, as any republican, or as is consistent with that self respect, without which no one can be a republican."[8]

On the other hand, as the nation struggled to forge an identity in its early decades, few could deny the power of heroes and history to unite and inspire a fragmented populace. As early as the 1770s the British artisan Josiah Wedgwood started capitalizing on the American appetite for heroes by issuing ceramic portrait medallions of Washington, Franklin, and other Revolutionary War leaders; by 1779 such medallions were outselling Wedgwood's tea services.[9] Charles Willson Peale did his part to enshrine national heroes in his museum in Philadelphia, displaying portraits of famous Americans along with natural wonders.[10]

Despite his own statements to the contrary—"Democracy has no monuments. It strikes no medals. It bears the head of no man on a coin"—John Quincy Adams clearly understood that the glorification of

Chair from George Washington's bedroom at Mount Vernon, 1760s–90s. According to tradition, Washington sat in this armchair shortly before he died in 1799. Much of the furniture and other items from Washington's estate were inherited by Martha Washington's granddaughter, Eleanor Parke Custis Lewis, after Mrs. Washington's death in 1802. In 1878 Congress appropriated funds to purchase the Lewis family's collection of Washington relics. The objects were first displayed at the Patent Office and then transferred to the Smithsonian in 1883.

Musket presented to Thomas Jefferson in 1805.
President Jefferson received this musket, inlaid with coral and silver, from the Bey of Tunis's ambassador at the end of the Tripolitan War. It was exhibited at the Patent Office along with other presidential artifacts until 1883, when the U.S. government's historical collections were transferred to the Smithsonian.

Ivory cane given to John Quincy Adams in 1844.
After serving as the sixth U.S. president, from 1825 to 1829, Adams won a seat in the U.S. House of Representatives, where he challenged a rule forbidding antislavery groups from presenting petitions to Congress. In gratitude, abolitionists presented Adams with this cane, the top of which is inscribed "Right of Petition Triumphant." The cane was exhibited at the Patent Office until 1883, when it came to the Smithsonian.

Washington, Franklin, and other heroes could promote patriotism and national unity.[11] In fact, Adams claimed a place for himself in the pantheon in 1844, when he donated to the national collections an ivory cane that had been awarded to him by abolitionist supporters. Adams often visited the Patent Office to admire his gift, and, seeing his cane displayed alongside the artifacts he had exalted as "venerable relics of the wise, the valiant, and the good," he felt a pride that sometimes vexed his republican conscience. He confessed to his diary: "I crave pardon for the vanity of this memorial."[12]

The creation and perpetuation of national heroes through visual media, monuments, and museum relics helped shape and strengthen American culture in the early nineteenth century.[13] As the Wedgwood example implies, much of this early history making was conducted on commercial and popular levels rather than imposed from above. Indeed, the status of the National Cabinet of Curiosities reflected the government's relatively minor role in preserving and promoting a collective national memory. In contrast to the expeditions it dispatched to document the continent's natural resources and indigenous peoples, the government acquired historical relics by random acts of generosity rather than a conscious collecting plan. At the Smithsonian's new National Museum, scientists labored to classify natural and ethnological specimens and create systematic, coherent displays. Meanwhile, although the old Patent Office relics did represent fragments of a historical narrative, little effort was expended to strengthen it. Politicians, it seemed, made poor curators. For the Smithsonian, American history remained a curiosity, beyond the pale of its scientific mission.

Things began to change, slowly but surely, after the Civil War. Confronting a nation that had torn itself apart, many political and cultural leaders appealed to history as a means to reunite it. In 1864, as the war still raged, Congress created the National Statuary Hall in the U.S. Capitol. Modeled on the Roman Pantheon, the hall housed statues of famous Americans, "illustrious in their historic renown, or distinguished for their civic or military service, such as each state shall determine are worthy of national remembrance."[14] Through these marble and bronze representatives, Congress symbolically brought America's heroes together under one roof, as part of a shared national past. Fittingly, Statuary Hall occupied the former Hall of Representatives, where in 1843 John Quincy Adams had welcomed the relics of Washington and Franklin and offered a prayer of thanks that the Union these men helped create had been preserved "through all the vicissitudes and revolutions of this turbulent world." Adams was long since gone—a plaque on the floor marked the spot where he collapsed from a stroke in 1848—but his prayer still echoed amid the figures along the colonnade, watched over by the sculpture *History* above the Rotunda door.

A "New Hunger for History"

By 1870 there was, as described by the historian Michael Kammen, a "new hunger for history" among Americans.[15] Popular interest in the past intensified as the country moved away from the war and toward a major milestone, the centennial of its independence. At the Centennial Exhibition of 1876 in Philadelphia, the celebration of present-day achievements was mixed with a dose of retrospection. Exhibit cases glittered with modern machinery and consumer products and bulged with samples of the land's bounty—fish, livestock, timber, agriculture, minerals. But fairgoers could also inspect a colonial-style New England cottage, furnished with antiques and costumed interpreters. Nearby, an array of George Washington relics also provided a tangible connection to the Revolutionary War past.

With the public clamoring for more history, the U.S. government stepped in to meet the demand, taking a series of unprecedented steps to define, preserve, and promote a national collective memory. In 1878 Congress appropriated money to complete the Washington Monument, which had languished as a pitiful stump since the original funds ran out in 1855. In 1880 the U.S. State Department removed Washington's sword and Franklin's cane from their dusty, crowded case at the Patent Office and enshrined them in its library, along with the original Declaration of Independence and the desk on which Jefferson drafted it. Meanwhile, next to the Smithsonian Castle, construction of the new National Museum Building (known today as the Arts and Industries Building) was nearly finished. Designed to house the carloads of specimens the Smithsonian had inherited from the 1876 Centennial Exhibition, the spacious new building also paved the way for another acquisition that would change the Institution forever. In 1883 Congress authorized the transfer of the final batch of "curiosities" from the Patent Office to the Smithsonian: the relics of George Washington and his fellow founding fathers.

With this transfer the scope of the National Museum officially expanded beyond natural history and anthropology to encompass the political and cultural history of the United States. The Patent Office memorabilia formed the nucleus of a new curatorial unit, Historical Relics, featuring "personal relics of representative men" and "memorials of events or places of historic importance."[16] Although these were not the first historical artifacts to enter the Smithsonian collections—miscellaneous relics had trickled in since the Institution's founding—beginning in the 1880s these kinds of objects were accorded new prominence and actively sought by curators. This new interest in history at the museum was accompanied and informed by the rise of history as an academic profession in the late nineteenth century. During this era the first doctoral degrees in his-

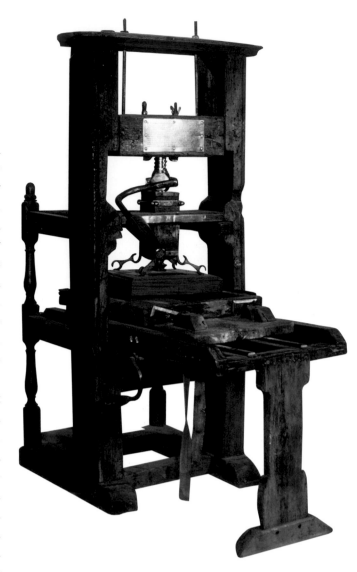

Franklin press, about 1725. The brass label affixed to this printing press in 1833 tells an intriguing story. In 1768 Benjamin Franklin, then the American envoy to England, visited a London printing shop, saw this press, and identified it as the one on which he had worked as an English printer's apprentice in 1725–26. Although these claims have been difficult to prove, they convinced John B. Murray, an American working in London, to purchase the "Franklin" press in 1842 and ship it to the United States, where for forty years it was exhibited at the Patent Office. In 1847 Murray, looking for a buyer, offered the press to the Smithsonian for $5,000 but was turned down; in 1848 he attempted to raffle it off but could not sell enough lottery tickets. In 1883 the Franklin press, still on loan from Murray, was transferred to the Smithsonian with the Patent Office collection. In 1892, after Murray's death, his widow offered to sell the press to the Smithsonian for $750. After nearly ten years of bureaucratic wrangling, the Franklin press was officially added to the Smithsonian collections in 1901.

Samuel S. Cox memorial vase, 1891. Cox, a congressman from New York, headed legislative efforts to create, organize, and expand the U.S. Life-Saving Service. A predecessor of the Coast Guard, it was established in 1871 to rescue victims of shipwrecks by maintaining patrol stations along American shores. In 1891, in honor of Cox's support, members of the Life-Saving Service presented his widow with this elaborate silver vase, decorated with mermaids, seashells, a life buoy, a portrait of Cox, and a scene of lifesavers rescuing people from the sea. Mrs. Cox presented the vase to the Smithsonian the following year.

tory were awarded by American universities, beginning with Johns Hopkins and Yale in 1882. New professional organizations, such as the American Historical Association and the Organization of American Historians (founded in 1907 as the Mississippi Valley Historical Association), were created to promote historical scholarship and set standards for research. The American Historical Association, founded in 1884 and incorporated by Congress in 1889, held its annual meetings at the Smithsonian and deposited its records and publications in the collections.

Enshrined in the National Museum, the Washington relics were soon joined by those of other presidents and statesmen as well as soldiers, scientists, inventors, and explorers. In 1922 the State Department gave custody of its most sacred treasures—Washington's sword, Franklin's cane, and Jefferson's desk—to the Smithsonian. By that time the National Museum had become the repository for, in Representative Summers's words, "the proudest trophies and most honored memorials of our national achievements."

Curators have continued to cultivate this role up through the present day by collecting and exhibiting the relics of famous Americans. These artifacts tell stories not just about the individuals themselves but also about fame in America. They reflect changing ideas about who is worth remembering and why. Many figures honored by the Smithsonian have remained familiar over the years; their tales have been told and retold, and their possessions retain a magical allure. Others, however, have faded from public memory. Their articles have passed from spotlighted cases into storage drawers, and their stories are all but forgotten, gone with the era that celebrated them.[17]

Fame may be fleeting, but it can also be recaptured. Once-forgotten individuals may be rediscovered and resurrected by a new generation looking for historical role models whose lives resonate with contemporary concerns and values. Even those who never left the public stage, who have remained permanent fixtures of the national narrative, find themselves reinvented by different groups and new generations. Indeed, such reinvention is key to their survival in popular memory. As Charles Horton Cooley observed in his 1918 essay, "Fame," a famous figure must appeal "not one time only, but again and again, and to many persons, until it has become a tradition."[18] The image of a famous person must therefore be both constant and flexible; it must be rooted in the past and remain relatively intact over time, but it must also adjust to match the social conditions and tastes of the present.[19] The Smithsonian collections thus document not just the fact of fame but also the processes of memory making and remaking, the modification of an individual's image and story to suit the needs and tastes of the times.

Washington: The First American Hero

Perhaps no historical figure has been subjected to more revision than George Washington, the first national hero. Building on the collections transferred from the Patent Office in 1883, Smithsonian curators have collected countless objects associated with Washington. Ranging from locks of hair to a marble statue, from his battle sword to an egg poacher used at Mount Vernon, these objects reflect the various ways Americans have imagined and remembered Washington as both man and myth.[20]

After the Revolution and especially after his death in 1799, Washington was glorified by the American people. Mason Locke "Parson" Weems's enormously popular *Life and Memorable Actions of George Washington* (1800) was hagiography rather than biography, crammed full of fabulous tales of his valiant deeds and saintly character. Yet not everyone shared this view of the "Father of His Country," particularly those who worried that their own contributions were being eclipsed by the Washington mythos. In his letters to Dr. Benjamin Rush, written between 1805 and 1813, John Adams railed bitterly against the deification of Washington, a man whose intelligence and education, Adams believed, did not measure up to the standards for great men set by the Age of Enlightenment. Rather than a man who achieved fame by his own merits, wrote Adams, Washington the hero was the creation of "puffers," an illusion rendered by "masks and veils and cloaks" and "aristocratic tricks"[21]:

The great character [Washington] was *a Character of Convention*. . . . There was a time when northern, middle, and southern statesmen and northern, middle, and southern officers of the army expressly agreed to blow the trumpet of panegyric in concert, to cover and dissemble all faults and errors, to represent every defeat as a victory and every retreat as an advancement, to make that Character popular and fashionable with all parties in all places and with all persons, as a center of union, as the central stone in the geometrical arch.[22]

Whether such a calculated collusion actually occurred or was simply the fantasy of a neglected and frustrated founding father, Washington did indeed become the icon of the early republic. "It is noteworthy that every American considers it his sacred duty to have a likeness of Washington in his home, just as we have images of God's saints," observed Pavel Svinin, a Russian diplomat who visited the United States in 1811–13.[23] Washington's idealized image—paraded on the streets, painted on household wares, and hung above mantels— helped connect Americans to the new nation and to one another.

By the mid-nineteenth century the country had begun to outgrow the image of Washington as a classical superhero. The movement to restore Mount Vernon, which began in the 1850s, signified the quest

Fire bucket, about 1830 (opposite). The first national hero, George Washington became a powerful and popular icon of American identity. The Latin slogan on this fire bucket—*Veni, vidi, vici* (I came, I saw, I conquered)—evokes the Roman leader Julius Caesar, with whom Washington was often compared. Lacking a lengthy history of their own, early Americans often used classical symbols to represent the new nation and its political ideals. The Smithsonian added this fire bucket to its American folk art collection in 1955.

Relics of George Washington, National Museum (now the Arts and Industries Building), 1891. Prominently displayed in the North Hall, the personal effects of Washington and other founding fathers were among the first things visitors saw when they entered the National Museum. The historical relic collection remained on exhibit at the Arts and Industries Building until 1964, when the Museum of History and Technology opened across the National Mall.

for a new, domesticated image of Washington that responded to new social needs and tastes. At a time when the nation was struggling with territorial expansion, rapid industrial growth, and sectional tensions, many Americans looked to home and family life for comfort. In the process they sought a more intimate and sentimental relationship with their national father figure.[24] Instead of tall tales and grandiose oratory that elevated Washington to mythic proportions, the public became fascinated with details about the human side of the hero. These personal details, embodied in artifacts such as kitchen utensils, china platters, bedroom furniture, shoe buckles, and false teeth, drew crowds of pilgrims to Mount Vernon, to the museum at the Patent Office in Washington, D.C., to the Centennial Exhibition of 1876 in Philadelphia, and, with the transfer of the Patent Office's Washington relics in 1883, to the Smithsonian Institution.

The search for a more complete view of Washington continued into the twentieth century. Biographers attempted to separate the image from the man, peeking behind the public facade to expose the private self. For historians like Paul Ford, author of *The True George Washington* (1896), the purpose of humanizing Washington was to make him more sympathetic and accessible. In transforming Washington from lofty icon to ordinary citizen, Ford and others hoped to inspire patriotism by creating a more practical role model.[25] But some biographers had a different motive for uncovering the true Washington: debunking. The disillusionment, cynicism, and distrust of leaders engendered by World War I played out in such books as William E. Woodward's *George Washington: The Image and the Man* (1926), which criticized Washington as materialistic, undemocratic, and, worst of all, ordinary: "He was the American common denominator, the average man deified and raised to the nth power. His preoccupations were with material success, with practical details, with money, land, authority . . . and these are the preoccupations of the average American. He was great in all ordinary qualities."[26]

Since Woodward invented the verb in 1923, debunking has become an increasingly popular pastime.[27] Today, as America's national conscience contends with the civil rights movement and its aftershocks, Washington's name is coming down from public schools in protest of his ownership of slaves. In a way this is nothing new: back in the 1840s and 1850s abolitionists also objected to having a southern slaveholder as a national icon. Yet Washington has not gone away; he has not been forgotten or discarded. His image is entwined with and absorbed into the fabric of the nation. The story of George Washington—the story Americans have invented, passed down, debunked, defended, and reinvented—is the story of America. Through him the nation has celebrated its ideals and confronted its shortcomings.

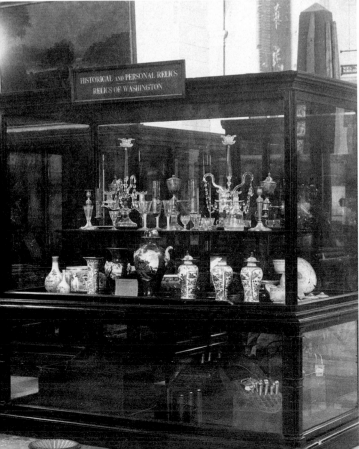

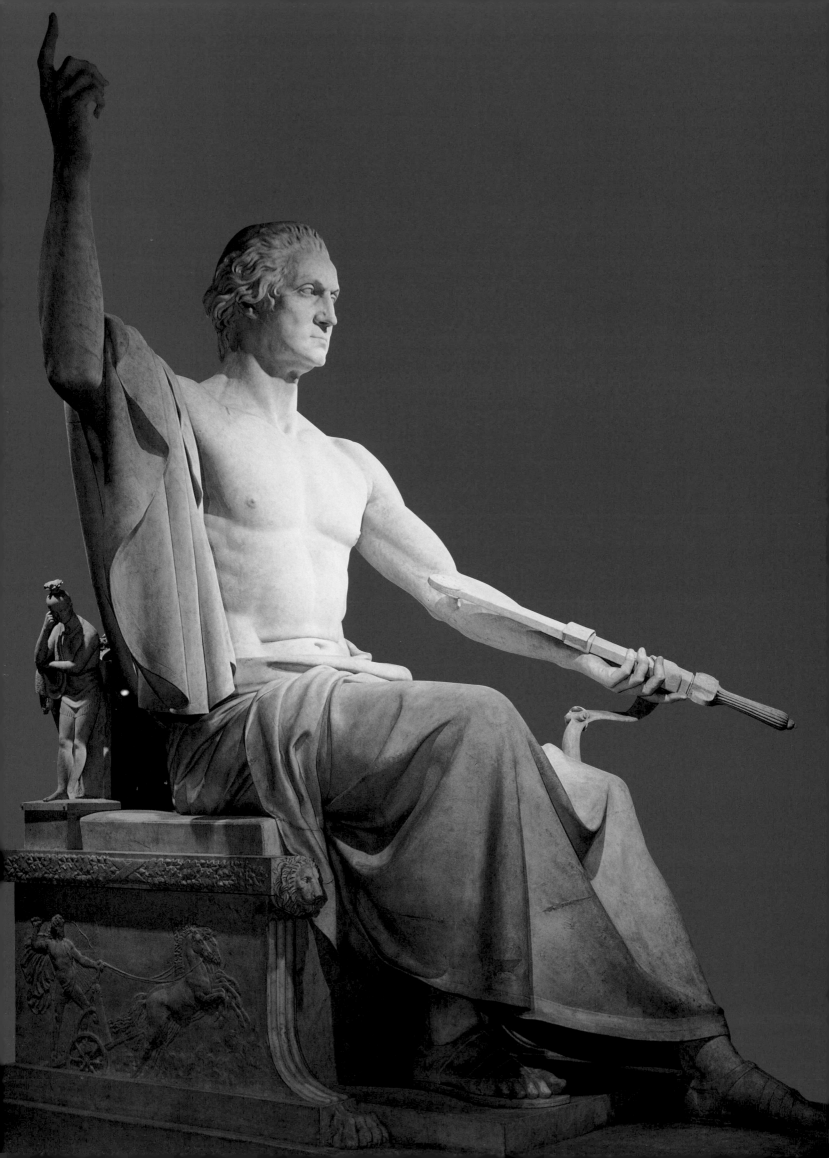

Presidents: The Nation Personified

Warren G. Harding's pajamas, about 1921–23 (below). President Harding wore these monogrammed silk pajamas, made by Chavert and Fils of New York and Paris, during his short term in the White House. After Harding's death in 1923, Mrs. Harding gave many of his personal effects to Colonel O. M. Baldinger, a family friend and senior presidential aide. In 1954 Baldinger presented several Harding items, including the pajamas, to the Smithsonian.

Ever since George Washington first assumed the presidency in 1789, Americans have interpreted their presidents, for better or for worse, as personifications of the nation. In the narrative of American history, presidents have traditionally occupied center stage, and their personal possessions have followed suit at the Smithsonian. The collection of presidential memorabilia, inaugurated in 1883 with the Washington relics, has captured and cultivated the public's fascination with the men who both literally and figuratively represent the country. Through these artifacts the Smithsonian has encouraged a patriotic respect and affection for America's leaders while also, especially in more recent years, exploring the history of the presidency and the emblems of power, politics, and personality that have shaped the presidential image.

In the nineteenth century presidential relics preserved in museums were sometimes pieces of the president himself. A popular curiosity from the Patent Office collections, a framed display of "locks of hair from distinguished heads," featured the hair of fourteen presidents, from George Washington to Franklin Pierce. Nineteenth-century Americans often collected hair from both famous figures and loved ones and incorporated it into memorial jewelry, photographs, and other keepsakes. Other kinds of memorials, like life and death masks, preserved a symbolic if not actual piece of the beloved's body.

George Washington, **sculpture by Horatio Greenough, 1840** (opposite). To commemorate the centennial of Washington's birth in 1832, Congress commissioned Greenough to create a statue to be displayed in the Capitol Rotunda. As soon as the marble statue arrived in the capital city in 1841, however, it attracted controversy and criticism. Greenough had modeled his figure of Washington on a classical Greek statue of Zeus, but many Americans found the sight of a half-naked Washington offensive, even comical. After the statue was relocated to the east lawn of the Capitol in 1843, some joked that Washington was desperately reaching for his clothes, on exhibit at the Patent Office several blocks to the north. In 1908 Greenough's statue finally came in from the cold: Congress transferred it to the Smithsonian. It remained at the Castle until 1964, when it was moved to the new Museum of History and Technology (now the National Museum of American History). The marble Washington has held court on the second floor ever since.

In 1888 a group of prominent artists and intellectuals donated to the Smithsonian a set of plaster and bronze casts of Abraham Lincoln's face and hands. The group, led by Richard Watson Gilder of *Century Magazine,* had raised funds to purchase the original plaster casts made by Leonard Volk in 1860 on Lincoln's nomination as the Republican presidential candidate. From those casts the group commissioned the sculptor Augustus Saint-Gaudens to produce bronze replicas. In 1886 Gilder wrote to Spencer Baird, secretary of the Smithsonian, describing the project and offering the results to the National Museum. Emphasizing that these "most valuable objects" should not be "treated as mere curiosities" but rather "preserved in some special nook, alcove, or apartment where they would not be stolen or injured," Gilder added this tantalizing detail: "The original Lincoln mask, by the way, still contains some of the hairs pulled out in the operation."[28]

In the case of famous people, especially venerated leaders such as Washington and Lincoln, hair and other intimately associative items became not just sentimental souvenirs but sacred relics. But to modern eyes the Victorian fascination with bodily mementos and the trappings of death may appear morbid, even profane. Even when such memorials were commonplace, Smithsonian officials occasionally resisted the public demand for sensational relics, aiming instead to project a more dignified, authoritative image.

Such an occasion arose following the assassination of President Lincoln on April 15, 1865. The murder of Lincoln—who himself owned a ring containing a piece of Washington's coffin—touched off a frenzy of relic hunting in the nation's capital. In a letter to his family written four days after the assassination, William Clark, a War Department stenographer who rented the room in the boardinghouse across from Ford's Theater where Lincoln was brought to die, described the scene: "The people are awfully indignant, hundreds calling daily at the house.... Everybody has a great desire to obtain some memento from my room, so that whoever comes in has to be closely watched for fear they will steal something." But the passion for death relics did not disgust Clark; on the contrary, he proudly informed his family, "I have a lock of [Lincoln's] hair which I have had neatly framed, also a piece of linen with a portion of his brain.... The same mattress is on my bed, and the same coverlid covers me nightly that covered him while dying."[29]

Meanwhile, across the street, souvenir hunters descended on the scene of the crime. A week after the assassination, War Department officials, in response to complaints that the chair in which Lincoln sat "has been much clipped and mutilated by persons desirous of carrying away pieces of it as relics," removed it from the theater. A top hat allegedly worn by Lincoln to Ford's Theater that fateful night also ended up in the custody of the War Department. By 1867 the hat was on display in the Patent Office, next to Washington's uniform and other presidential memorabilia.[30]

Top hat allegedly worn by Abraham Lincoln to Ford's Theater on April 15, 1865. In 1867 this hat and other relics from Lincoln's assassination were removed from exhibition at the Patent Office and transferred to the Smithsonian. For many years the hat was kept in storage because museum officials believed it was in poor taste to show objects connected with the assassination of a president.

But by the end of that year the Lincoln hat and chair were no longer on view. Instead, they were packed up in a pine box and locked away in the basement of the Smithsonian Castle, by orders of Secretary Joseph Henry. According to Solomon G. Brown, an employee present when the assassination relics were brought over from the Patent Office, "No one was allowed to see them. No record was made of them, as Professor Henry did not want it known that such articles were in the place."[31] At the time the Smithsonian was not officially collecting presidential mementos; it was a scientific institution, and Henry did not wish to compromise its scholarly reputation by catering to the public appetite for sensational relics.

In 1892 Captain Osborne H. Oldroyd, head of the newly organized Memorial Association of the District of Columbia, set about establishing a museum in the house on Tenth Street where Lincoln had died. He persuaded the Smithsonian to loan him the Ford's Theater chair and hat for exhibition. They remained in Oldroyd's museum until 1896, when a judge seized the hat as evidence in a lawsuit regarding its rightful owner. The plaintiffs, descendants of the Reverend Phineas D. Gurley, identified the hat as the one worn by Lincoln at his second inauguration and given to Gurley by Mrs. Lincoln as a souvenir. Gurley's widow claimed to have deposited the hat in the Patent Office after her husband's death in 1865. But the Smithsonian maintained that the hat had been picked up at Ford's Theater by the authorities and turned over to the War Department. After an initial ruling in favor of Gurley's family, the Smithsonian finally won the "Lincoln Hat Case" on appeal, and the hat and chair were quietly returned to storage in 1897.

Some thirty years later Blanche Chapman Ford, widow of the former manager of Ford's Theater, wrote to curators asking if it was true that the walnut rocking chair her husband had carried up to Lincoln's box to provide a more comfortable seat for the president was at the Smithsonian. If so, why was it not on exhibit? "*This is historical*," she insisted. Theodore Belote, curator of historical collections, gave an impassioned response: "It is not our policy to show objects of any type directly connected with such a deplorable and horrible event as the assassination of a President of the United States. . . . [S]hould [the War Department] indicate a willingness to return it to Mrs. Ford such action would meet with my entire approbation." In the spring of 1929, the chair was returned to Mrs. Ford, who later auctioned it off to the highest bidder: the Henry Ford Museum in Dearborn, Michigan.[32]

As for Lincoln's hat, it has finally come out of the basement. In 1996 a debate arose over whether the hat should travel the country as part of the Smithsonian's 150th anniversary exhibition. Secretary I. Michael Heyman, in striking opposition to his predecessor Joseph Henry, insisted on including the hat, citing its value as both a historical relic and a popular attraction. In 2000, when a new exhibition on the American presidency opened at the National Museum of American History, Lincoln's hat was one of the featured artifacts.

Bronze life mask of Abraham Lincoln, by Augustus Saint-Gaudens, 1886. In 1860, at the time of Lincoln's nomination as the Republican presidential candidate, plaster castings were made of his hands and face. In 1886 a group of artists and intellectuals who wished to see Lincoln's memory preserved commissioned Augustus Saint-Gaudens, a prominent American sculptor, to produce bronze replicas based on the earlier plaster castings. In offering a set to the Smithsonian, the group asked that they be treated not "as mere curiosities" but rather as "most valuable objects."

Like the Lincoln hat, many presidential objects in the collection are three-dimensional character sketches; they capture personalities and deeds that shaped a president's public image. Thomas Jefferson's lap desk, as discussed earlier, suggests a complex and fascinating story about how Jefferson secured his place in posterity. A radio microphone used by Franklin D. Roosevelt to deliver his "fireside chats" during the Great Depression is an early example of how presidents have used the mass media to develop a familiar rapport with the American people. A contemporary object that tells a similar story—a saxophone owned by William Jefferson Clinton—was loaned to the Smithsonian in 1993, a year after Clinton made his famous musical appearance on the *Arsenio Hall Show* during the 1992 presidential campaign. In turn, the mass media can reshape the president's image to fit popular taste, as evidenced by a 1903 Teddy bear, inspired by a newspaper cartoon about Theodore Roosevelt.

Media manipulation of the president's image, a phenomenon the Smithsonian became increasingly interested in documenting during the latter half of the twentieth century, is perhaps best preserved in the ephemera of political campaigns. These artifacts suggest how candidates have been packaged and sold to the public. Museum curators became more interested in the history of campaigning just as candidates were starting to tap into the greatest advertising engine of all: television. Around 1960, jump-started by the donations of Ralph E. Becker, a memorabilia collector, the Smithsonian began to document the history of presidential and other campaigns. Becker, a Washington, D.C., attorney and a founding member of the Young Republicans, began donating material to the Institution in the late 1950s and over the next twenty years continued to add to his gift, including new items from contemporary political campaigns. When Becker formally presented his collection to the Smithsonian in 1961, he expressed his hopes that "by study and observance of my collection, many Americans will be brought to a fuller appreciation of our political heritage and a greater understanding of man's noble experiments in government—American democracy."[33] Curators have since collected buttons and ribbons, dolls and umbrellas, banners and bumper stickers,

Radio microphone used by Franklin D. Roosevelt in 1933 (above). The first president to regularly address the nation over the airwaves, President Roosevelt held his first "fireside chat" in March 1933 to explain why the banks were closing. Through his radio talks, Roosevelt developed an intimate, reassuring rapport with the American people that helped build confidence in his leadership during the Great Depression. In 1964 the Smithsonian acquired this microphone from CBS Radio as part of its efforts to document political uses of the mass media.

Jimmy Carter teeth mask, 1976 (left). Since the Smithsonian began collecting political memorabilia in the 1960s, curators have often attended rallies and conventions to acquire material from candidates and their supporters. This paper mask, representing Carter's famous grin, was purchased from a street vendor outside the 1976 Democratic National Convention in New York.

Miniature log cabin, 1840 (right). In the 1840 U.S. presidential race, the Whig party identified its candidate, William Henry Harrison, with the log cabin, a symbol of the common man. This log cabin, carried in campaign parades, came to the Smithsonian in 1961 as part of the Ralph E. Becker Collection of Political Americana.

Teddy bear, about 1903 (below). A conservationist who also loved to hunt big game, President Theodore Roosevelt made news by refusing to shoot a bear cub on a hunting trip in 1902. Inspired by a political cartoon in the *Washington Star* depicting Roosevelt with the cub, the Ideal Toy Company created the "Teddy bear." A cuddly alter ego for the macho Roosevelt, the toy became a popular culture icon. In 1963 the son of the toy company's founder presented one of the original stuffed bears to Roosevelt's son Kermit, who donated it to the Smithsonian along with other mementos of his father.

and countless other campaign souvenirs emblazoned with the faces, names, and slogans of candidates. Rather than offering insight into the candidates' real lives, these artifacts reflect the images that campaign managers hoped Americans would carry in their minds when they went into the voting booth.

While the mass media has provided exaggerated, larger-than-life images of America's elected leaders, it has also whetted American appetites for details of presidents' private lives, for the opportunity to catch a candid, behind the scenes glimpse of the commander-in-chief. In 1968 the Smithsonian mounted an exhibition entitled *Pastimes of the Presidents*, with objects such as Grover Cleveland's trout flies, Warren G. Harding's bridge whist set, and a pin from Harry S. Truman's White House bowling alley illustrating the hobbies and leisure activities of the nation's chief executives. In collecting and displaying these mementos, the Smithsonian has engaged in the all-American pastime of alternately putting presidents on pedestals and pulling them back down to earth. Yet some personal objects, such as the luxurious silk pajamas worn by President Harding, may tell more about America's leaders than citizens might want to know.

As dissimilar as they may seem, the Lincoln assassination relics and Harding's silk pajamas both raise issues that curators must wrestle with in preserving the memorabilia not only of presidents but of all kinds of famous—and infamous—Americans. When is a personal artifact too personal to exhibit? Is the Smithsonian's job to uphold the official images of famous individuals or to deconstruct them by offering glimpses into their private lives, revealing evidence of their flaws and foibles, documenting their downfalls as well as their triumphs?

Generally speaking, the Smithsonian has portrayed famous people in a positive light. When given a choice, curators have tended to select artifacts that support the image, rather than undermine it. And, of course, these have been the kinds of objects most frequently offered to the Institution by those who wished to see a person's memory preserved—friends, family, fans, or the individual himself or herself.

In at least one case, however, the objects collected to memorialize a president's triumphs also preserve the story of his downfall. Following the death of Ulysses S. Grant in 1885, the Smithsonian received a vast collection of relics belonging to the late warrior-president. From military trophies and medals to exotic gifts from foreign governments, the Grant relics painted a heroic portrait of their former owner. But this image had been seriously tarnished by the scandals that racked Grant's administration and by the political and financial troubles that continued to plague him after leaving office in 1876. Eight years later Grant was bankrupt, having lost his money in a shady Wall Street investment scheme. He borrowed $250,000 from William H. Vanderbilt, and when he could not raise the cash to pay it back, he handed over his golden medals and trophies instead.

As the twentieth anniversary of the end of the Civil War drew near, Americans wanted to remember Grant as a valiant leader, not a corrupt and flawed politician. When he succumbed to throat cancer in 1885, Grant was lauded as a national savior. The following year the glorious prizes that Grant had sacrificed to save himself from financial ruin were posthumously restored, when Vanderbilt presented the Grant relics to the U.S. government as a joint gift from himself and Mrs. Grant. The public flocked to the Smithsonian to see their hero's treasures; they also left flowers at Grant's tomb and visited the cottage where he died, which was purchased and transformed into a shrine by the Grand Army of the Republic, a veterans organization. Grant's memoirs were published just after his death, granting the late president the last word on how he should be remembered.

With its mixture of official, popular, and personal artifacts, the Smithsonian's presidential collection captures the mixed feelings Americans have for their elected leaders, who are expected to be both ordinary and extraordinary, superior yet also one of the people. In the post-Watergate era, historians have reexamined the presidency with a more critical eye, as earlier historians did in the aftermath of World War I. As exhibitions incorporate old artifacts into new stories, a president's image is often complicated rather than simply enshrined and celebrated. Although Americans know that their leaders are indeed complex, flawed human beings, that is not necessarily how some want to remember them—nor how the presidents themselves may wish to be remembered. This debate, unresolved and ongoing since the days of George Washington, is thus preserved along with the presidential mementos in the Smithsonian.

Pin from the Truman White House bowling alley, about 1952. A president who cast himself as a man of the people, Harry S. Truman indulged his taste for bowling by having an alley installed in the White House basement during his second term. This pin, clearly well used, was salvaged by a White House employee when the bowling alley was dismantled after Truman left office in 1953. The employee passed it along to a friend at the Smithsonian, who kept it on his desk as a conversation piece for a few years before eventually donating it to the political history collections in 1960.

Gilded box presented to Ulysses S. Grant by the City of London in 1877. After leaving office in 1876, Grant and his family embarked on a two-year tour around the world. They were treated like royalty and received numerous gifts from foreign leaders. This small casket, presented by the City of London, sym- bolically conferred on Grant the "Freedom of the City." Grant's popularity overseas did not translate back home; he ran for president again in 1880 but failed to win the nomination. Many of the gifts Grant received on his travels came to the Smithsonian as part of a collection of Grant relics donated in 1886.

First Ladies

"There was opened to the public on February 1, 1914, a collection of feminine import, which is quite unique for this country in its largeness of scope and in part at least for its method of presentation."[34] Thus the Smithsonian Institution announced the debut of what would become one of its most popular and enduring attractions: the First Ladies Collection. Although some relics of Martha Washington had accompanied those of her husband into the National Museum in 1883, it was not until 1912 that the Smithsonian began actively collecting objects associated with the women of the White House. Notably, the people who initiated and engaged in this new collecting effort were not curators; they were not even on the Smithsonian payroll.

Cassie Mason Myers Julian-James, a wealthy Washingtonian, had first taken a personal interest in the National Museum in the late 1890s, when she began depositing family mementos in the collec-

Dressing a first lady mannequin, Arts and Industries Building, 1915. Cassie Julian-James (left) and Rose Gouverneur Hoes (right), founders of the Smithsonian's First Ladies Collection, dress a mannequin in a gown worn by Louisa Catherine Adams, wife of President John Quincy Adams. Part of the National Museum's historic costume exhibition, the mannequin, trimmed with a pair of white satin slippers, was displayed inside a glass case with another mannequin representing Abigail Adams.

Mary Harrison McKee's gown, 1889. McKee, the daughter of President Benjamin Harrison, wore this silk brocade gown at her father's inauguration in 1889. A political as well as a fashion statement, the dress—designed and made in the United States—reflected President Harrison's support for American industry. McKee loaned her gown to the Smithsonian in 1915 for the new first ladies exhibition. Thirty years later her children converted the loan to a gift, allowing the dress to remain a permanent part of the collection.

tions. As a member of the social elite, Julian-James shared with many of her peers a belief that the role of the upper classes was to uplift the public by educating them about good taste and good citizenship. Museums of art and history, which proliferated in the United States during the last quarter of the nineteenth century thanks to the generosity of Gilded Age millionaires, provided ideal opportunities for such cultural and civic instruction. By presenting American history through the biographies of virtuous and patriotic individuals, the Smithsonian and other museums aimed to inculcate those same traits in visitors. But as a woman, Julian-James was concerned that, among the historical figures honored at the National Museum, there were no women role models to be found.

Intending to remedy this, in 1912 Julian-James proposed that the Smithsonian establish a collection of American historical costumes to illustrate changes in women's fashion from the colonial era to the present day. Taking charge as the *de facto* costume curator (the all-male Division of History staff was no doubt only too happy to step aside), she set about mobilizing friends and acquaintances to clean out their attics and find old family clothing for the museum. One of the women asked to contribute was Rose Gouverneur Hoes, the great-granddaughter of President James Monroe. Together, Hoes and Julian-James came up with the idea for a special display of a particular category of historical costumes: dresses worn by first ladies. They collected their first gown from Helen Taft, the incumbent first lady, and by 1914, when the exhibition opened, the two women had acquired the costumes of thirteen other White House hostesses.

The Period Costume Collection was an instant success. Visitors marveled at the beautiful dresses, especially those of the first ladies, which were modeled by ivory-tinted plaster mannequins in classical poses. The mannequins' faces were the same, not individual portraits, but they had distinctive period hairstyles, and many were displayed with antique furniture and other accessories. Surveying her handiwork, Julian-James pronounced it "a most valuable collection of historic costumes of the great women of our country of whom we are so justly proud."[35]

With the installation of the First Ladies Collection, the Smithsonian for the first time accorded famous women a place of honor. The exclusion of women before 1912 reflected a traditional conceit that fame was a public enterprise, achieved by great deeds in war and politics and industry, arenas reserved for men alone. A woman's place was at home, tending the hearth and providing emotional and spiritual sustenance for her family. The belief that men and women belonged to separate spheres, public and private, pervaded nineteenth-century American society and supported the view that only great men—not women—made history.

Martha Washington's gown, 1780s. Made of salmon pink faille, Mrs. Washington's dress features a hand-painted pattern of flowers and insects. It was first displayed in the original First Ladies Hall, which opened in the Arts and Industries Building in 1914. On loan for many years, the dress became part of the permanent collections in 1929 and remains on view today in the current first ladies exhibition.

Florence Kling Harding's gown and wrap, 1920s. Evoking the flapper era, this iridescent dress, made of tulle adorned with pearlized sequins and gold beads, was worn by Mrs. Harding during her husband's administration (1921–23). Long in the possession of Mrs. Harding's granddaughter, the costume was donated to the Smithsonian in 1966.

Eleanor Roosevelt's inaugural dress, 1933. When Mrs. Roosevelt wore this lavender velvet day dress at her husband's first inauguration on March 4, 1933, the press dubbed the color "Eleanor blue." In 1945 she donated the dress to the Smithsonian along with the gown she wore to her husband's fourth inauguration.

Hillary Rodham Clinton's inaugural gown, 1993. This gown, a blue-violet beaded lace sheath with a mousseline overskirt, was created by the New York designer Sarah Phillips and made by Barbara Matera Ltd. Mrs. Clinton formally donated the gown and matching velvet coat, which she wore to eleven inaugural balls on January 20, 1993, to the National Museum of American History in 1995.

But by the turn of the twentieth century many American women had begun to stake a claim on the public sphere. They saw their domestic responsibilities as a justification for political action and initiated reform efforts to improve family life for all Americans, not just their own. More women attended college and entered the workforce. As they sought economic independence and social reform, they also sought political equality and demanded the right to vote.

It was therefore fitting that at just this moment the first ladies entered the National Museum. Historically, first ladies have occupied a unique position in society, somewhere between the private and public spheres that conventionally defined the worlds of men and women. As a wife and mother, the first lady was expected to conform to conventional ideals of womanhood, which were linked to notions of piety, purity, and domesticity. Yet as the wife of the president, she was not restricted to the private sphere of hearth and home but lived—and was expected to flourish—in the public eye. Her house was not a safe haven, insulated from the outside world, but rather an official residence where political affairs intruded on and even dictated domestic activities. Hers was a symbolic and highly visible role: mistress of the nation's home, mother to the American family.

In many ways the First Ladies Collection was a conservative response to the changing role of American women in the early twentieth century. In keeping with traditional gender roles and the uplifting agenda of the cultural elite, the Smithsonian commemorated first ladies as guardians of social graces, fashion sense, and moral virtue rather than for their intellectual or political activities. Yet, significantly, the collection also defined, promoted, and celebrated women as public figures. As women struggled to claim a place on the political stage, the First Ladies Collection claimed a place for them on the historical stage—a place that, however narrowly defined, in turn paved the way for women in the Smithsonian.

Over the years the First Ladies Collection has itself evolved in response to changing interpretations of women's place in history and the first lady's role. During Women's History Month in 1992, eighty years after Julian-James and Hoes collected their first White

Lalique "peace" pin presented to Edith Wilson in 1919 (above). The work of the French jewelry and glass designer René Lalique, this pin was a gift to Mrs. Woodrow Wilson when she accompanied the president to the Paris Peace Conference following World War I. Mrs. Wilson donated the pin to the Smithsonian in 1953.

Patricia Nixon party favor, 1960 (below). Many presidents' wives have participated in their husbands' political campaigns. In 1960 Patricia Nixon hosted women's teas and luncheons to enlist support for her husband, Richard Nixon, the Republican presidential candidate. This party favor is part of the Ralph E. Becker Collection of Political Americana, donated to the Smithsonian in 1961.

State china from the Lyndon B. Johnson adminis-tration, 1968. For her White House china pattern, designed by Tiffany and Company, Lady Bird Johnson chose American flowers, reflecting her interests in the environment. This dessert plate features an American Beauty rose, the official flower of the District of Columbia. Through her "Beautify America" campaign, the first lady urged citizens to clean up and improve their neighborhoods and planted flowers along the nation's highways and in public areas in the capital city. When Mrs. Johnson commissioned this china, she also had a special set produced for the Smithsonian's White House china collection.

House gown, a new exhibition opened at the National Museum of American History. Entitled *First Ladies: Political Role and Public Image,* the exhibition looked beyond the gowns and period rooms to better understand the lives and experiences of the women themselves.[36] While the ever-popular gowns are still there, the exhibition also features many more artifacts from the First Ladies Collection that together offer clues to their complex and multifaceted roles. Visitors see first ladies not only as fashion plates and hostesses but also as political campaigners, social activists, and diplomats. As women who simultaneously lived both public and private lives, first ladies embody the contradictions and conflicts that accompanied the changing role of women in American society. In a unique way their stories reflect debates over what it has meant to be an American woman.

Scientists and Inventors

Outside the political sphere of presidents and first ladies, the most celebrated figures at the Smithsonian Institution have traditionally been "men of progress"—scientists and inventors who have contributed to the intellectual and material advancement of the nation. As the historian Dixon Wecter explained in his book *The Hero in America* (1941), "The American Dream is one of improvement"; hence, Americans admire "the doers, 'habile' men, vigorous practical minds," those who applied their talents and skills to getting society closer to its dream.[37] The Smithsonian itself was conceived as an instrument of progress, a place for research and experimentation, for discovering truths about the world. It exists because an English scientist, who sought immortality through the "increase and diffusion of knowledge" carried out in his name, left his legacy to a country that he had never seen but that he identified with this progressive spirit.

Barbara McClintock's microscope, 1940s–50s. A pioneer geneticist, McClintock won a Nobel Prize in 1983 for her discovery in the 1940s and 1950s of moveable or "jumping" genes in corn plants. After her death in 1992, the Smithsonian began a search for objects related to her work. The Carnegie Institution of Washington, which had funded McClintock's research, donated her favorite microscope in the hope that it would "help to inspire generations of young people to emulate Dr. McClintock's dedication to science."

Although he never visited the United States, James Smithson no doubt appreciated what the young democracy represented—the freedom to reinvent one's self, to attain social distinction based on accomplishments, not inherited titles. Born the illegitimate son of the Duke of Northumberland in 1765, Smithson sought through science what the circumstances of his birth had denied him in British society. He never married or had children but instead spent his life in search of knowledge, conducting experiments, collecting specimens, and defining himself through his scientific work. When he died in Genoa, Italy, in 1829, the scientist had accumulated a sizable fortune along with a distinguished name. In providing for the Smithsonian Institution in his will, he used one to ensure that the other would never be forgotten. And by leaving his legacy to the United States, Smithson redefined himself once more, symbolically, as an American.

When Smithson's bequest finally arrived in Washington in 1838, accompanying the bags of British sovereigns was a small collection of Smithson's personal effects that had gone unclaimed by his relatives. They included scientific instruments; a mineral cabinet; an umbrella case; a riding whip; a sword belt; a portrait of Smithson's father, the duke; a silver plate bearing the coat of arms of the Northumberland family; and a portrait medallion of Smithson himself.[38] These relics were displayed with the National Cabinet of Curiosities at the Patent Office until 1857, when they were installed in the Regents' Room in the new Smithsonian Institution building. After most of the original Smithson relics were destroyed by a fire that swept through the Castle in 1865, the Smithsonian began a search for additional memorabilia to replace what had been lost. By 1880 it had accumulated a sizable collection of portraits, books, and documents, including Smithson's will.

But in January 1904 the Smithsonian acquired the most precious Smithson relic of all: James Smithson himself. Transported from Italy and ceremonially presented in a flag-draped coffin, Smithson's remains were placed on exhibit in the former Regents' Room along with the other mementos. In 1905 the remains were transferred to a specially built crypt at the north entrance to the Castle, where they have been enshrined ever since. [39]

The man responsible for Smithson's posthumous homecoming had himself gained fame through scientific pursuits. Alexander Graham Bell, inventor of the telephone, had received help with his invention early on from Smithsonian Secretary Joseph Henry. In 1879 Bell established a laboratory in Washington, D.C., where he began experimenting with sound recording. He became part of a circle of scientists centered around the Smithsonian, which served as a research library, experimental testing ground, and, through exhibits and publications, a showcase for new discoveries. In 1898 Bell assumed a leading role in the Smithsonian's affairs by joining the Board of Regents. When the

James Smithson portrait medallion, 1817. This medallion, which Smithson commissioned in 1817 from Nicolas Pierre Tiolier, the chief engraver at the Paris Mint, was among the personal effects brought back from England with the Smithson bequest in 1838. Evidently proud of the result, Smithson etched his name on the back and attached a handwritten tag identifying it as "my likeness." The portrait served as the basis for the first official Smithsonian seal, created in 1847 and used until 1893. One of the few Smithson relics to survive the fire of 1865, the medallion is now part of the National Numismatic Collection at the National Museum of American History.

regents learned in 1901 of the impending relocation of the Italian cemetery where Smithson was buried, Bell advocated transporting the remains to the United States. And in 1904 Bell himself traveled to Italy to retrieve the body of the Smithsonian's founder.[40]

During the last quarter of the nineteenth century, many American scientists became interested in recognizing the achievements of earlier scientists, the men on whose shoulders they stood. For the scientific community, identifying symbolic ancestors was an integral part of the quest for professional identity and legitimacy. The National Museum had already acquired a few artifacts relating to famous scientists, but when it announced in 1883 its new mission to collect the relics of distinguished Americans, the Smithsonian formally became a place not only to promote the growth of science but also to commemorate its past.[41]

In deciding which scientists to honor, the Smithsonian drew on the advice of professional organizations, its own institutional history, and the research interests of its curatorial staff, still composed almost entirely of scientists. (The first curator of the historical collections, A. Howard Clark, was an ichthyologist by training, although he also had an interest in genealogy.) The National Academy of Science, for example, generously donated in 1892 a complete collection of portraits and "autograph letters" of its members.[42] At the time the recognition of individual scientists at the museum was largely for the benefit of the scientific community, not the general public.

In 1900, however, a new standard for scientific achievement was set with the introduction of the Nobel Prize. The prize rewarded scientists who not only contributed to the professional community but also "conferred the greatest benefit on mankind." The National Museum has collected numerous objects associated with Nobel laureates, from apparatus used in their award-winning research to more personal items, such as Albert Einstein's pipe, that capture aspects of a famous scientist's image.

By the 1920s many of the scientists commemorated at the Smithsonian were explicitly linked to discoveries that had made a significant impact on society. Exhibits stressed the relevance of the scientist's work to visitors' lives. In 1922 the medical exhibit in the Arts and Industries Building featured portraits of sixteen "noted benefactors of the human race who have overcome the general skepticism regarding new medical doctrines and who have constructed a scientific basis for the cure of disease"; these included Louis Pasteur, the French pioneer of bacteriology; Robert Koch, the German discoverer of the causes of tuberculosis and cholera; Walter Reed, one of the American scientists who linked yellow fever to mosquitoes; and William Gorgas, an American "sanitarian" whose work made possible the construction of the Panama Canal.[43] Instead of academics in ivory towers, these were men of action, pioneers of progress who applied their knowledge to improve public health and the general condition of society.

Chemical flask used by Joseph Priestley, discoverer of oxygen, about 1800. This flask arrived at the Smithsonian in 1883, part of a shipment of material salvaged from Priestley's abandoned laboratory in Northumberland, Pennsylvania, where he lived from 1794 to 1804. Secretary Spencer Baird had collected the material on behalf of American chemists, who believed Priestley's "philosophical apparatus . . . should be held as one of the sacred relics in the history of American science." But the value of these relics had diminished by 1900, when W. W. Holmes, head curator, surveying the crates of mostly broken and unidentifiable material, pronounced them "in the main, worthless." After World War II, as advancements in chemistry increasingly improved life for Americans, Priestley was resurrected as a scientific hero. His relics appeared in several exhibitions during the 1970s and 1980s, including one at the Center for the History of Chemistry in Philadelphia that commemorated Priestley as an "Enlightened Chemist."

Ether inhaler invented by William T. G. Morton, about 1846 (below). Morton, a Massachusetts dentist, was one of several inventors with a good claim to being the inventor of anesthesia. This early ether inhaler came to the Smithsonian in 1911 from Morton's son, who, eager to secure Morton's place in history, donated it "in honor of my father." But as with so many inventions, others have a good claim to credit, too. Crawford Long, a Georgia physician, had used ether a few years earlier but had never published his experiment. When a Smithsonian radio show in the 1930s mentioned Morton as the inventor, the Institution received a sharp letter from Senator Richard Russell of Georgia: "We Georgians are very proud of Dr. Crawford W. Long's discovery." Long is one of two Georgians represented in the National Statuary Hall of the U.S. Capitol. According to the curator in charge of the medical collections, the Smithsonian had a simple lesson to learn from the Morton-Long debate: "the necessity of keeping clear of this and other like controversies."

Electromagnet devised by Joseph Henry, 1831 (above). Before becoming the first secretary of the Smithsonian in 1846, Henry was renowned in the scientific community for his studies of electricity and its practical applications. In 1831 he built this powerful electromagnet for a colleague at Yale University. Sixty years later, when the lightbulb, generator, telegraph, and telephone were transforming people's lives, Henry was recast as an electrical engineering pioneer. To honor him, Smithsonian curators assembled relics of his scientific career and created an exhibit of his discoveries in electricity. Some of Henry's apparatus had remained in the Smithsonian since his death in 1878; additional material was collected from Henry's daughters and from Yale, which donated this magnet in 1893.

An emphasis on the practical, applied aspects of science paralleled the rise of another type of American hero at the National Museum: the inventor. The object most commonly used to honor American inventors was the patent model. Since the early nineteenth century, patent models had been exhibited in the nation's capital as a monument to American ingenuity and progress. Submitted by inventors with their patent applications, the models illustrated the technological innovations and improvements that fueled the American industrial revolution. Each bore a tag, attached to the model with red string (the original red tape) and inscribed with the inventor's name, date, title of the invention, and its patent number. "By means of these models," declared an 1889 Washington, D.C., guidebook,

Patent model of Isaac M. Singer's sewing machine, 1854. Singer received his first patent for a commercial sewing machine on August 12, 1851. Three years later he introduced a domestic model that made him one of the wealthiest Americans of the century. As with many inventor-entrepreneurs, Singer's success came not from mechanical skills but from a genius for marketing: he aggressively advertised his sewing machines to women consumers and sold them through a nationwide chain of company stores, which featured demonstrations and offered repair service. This model was donated in 1960 by the Singer Manufacturing Company.

Model of Eli Whitney's cotton gin, about 1800. In 1794 Eli Whitney received one of the first patents granted under the new U.S. patent system for his cotton gin. He spent the next several decades fighting in court to win royalties from the many manufacturers who made similar devices. The Smithsonian's several Whitney gin models are not patent models but demonstration models used in court cases and collected later to replace models lost in the Patent Office fire of 1836. They came to the Smithsonian in 1908, when the Patent Office transferred its collection of models of "historical character."

"one can trace the progress of every line of industry, from crude designs to the perfected machine, wonderful in construction and almost human in action." The book went on to describe the Patent Office's Museum of Models as "a marvelous exhibition of human capability."[44]

In 1880 the Patent Office stopped requiring models with patent applications, and by the early twentieth century the Museum of Models had closed its doors. The Smithsonian accepted several thousand patent models for its collections; most of the remaining models were sold at auction. At the National Museum, patent models have been exhibited as historical relics, cherished for their associations with famous inventors and as significant steps in national progress.

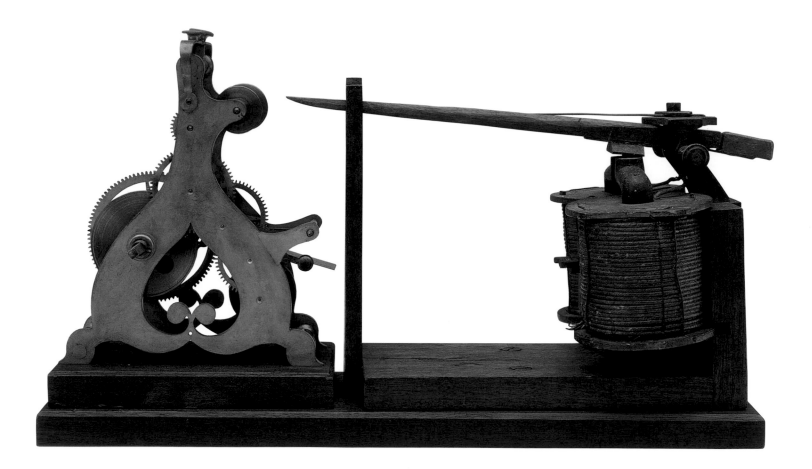

During the 1870s and 1880s the Smithsonian also began to present the history of technological progress, tracing the evolution of particular inventions across time as well as across cultures. While these synoptic series, as they were called, always culminated with the perfection of modern American machines, the emphasis was not on the inventor per se but on how the invention fit into the larger scheme of human progress. By the turn of the century, however, as industrial technology came to occupy an increasingly dominant role in American society, the individual inventor assumed an increasingly prominent role at the Smithsonian. In 1914 the curator of mechanical technology, George C. Maynard, said of his collection, "America may well be proud of the record here made of the achievements of her citizens. Within the period almost of a lifetime the industrial processes of the world have been revolutionized by the steam engine and the dynamo; the telegraph, telephone, and aeroplane; and the names associated with these epoch-making inventions are already, without the intervention of learned academies, inscribed with the immortals."[45]

This statement contained three crucial elements that defined an inventor as a quintessential American hero: progress, patriotism, and popularity. Inventors worked not only to advance civilization generally but also, specifically, to make America great; their contributions were judged not by academics but by the people. Thomas Edison, celebrated for his contributions to progress, epitomized this American inventor-hero. In *Middletown*, their classic 1929 sociological study of Muncie,

Patent model of Samuel F. B. Morse's telegraph register, 1849 (above). Morse began experimenting with electromagnetic telegraphy in the 1830s but did not achieve practical success until 1844, when he transmitted a coded message along a wire from Baltimore to Washington, D.C. This model of Morse's telegraph register was among the patent models transferred to the Smithsonian from the Patent Office in 1908.

Patent model of Margaret Knight's machine for making paper bags, 1879 (opposite top). Although Knight is credited with nearly ninety inventions and twenty-two patents, her patent models were not among those collected by the Smithsonian in the early 1900s. But in 1979, when curators were seeking objects related to women inventors, Knight's model was a prize find.

Edison lightbulb, about 1886 (opposite bottom). Thomas Edison patented more than a thousand electrical and mechanical inventions. The Smithsonian has collected many examples of perhaps his most famous—the electric lightbulb. This one, which features a bamboo filament, was donated by Princeton University's engineering department in 1961.

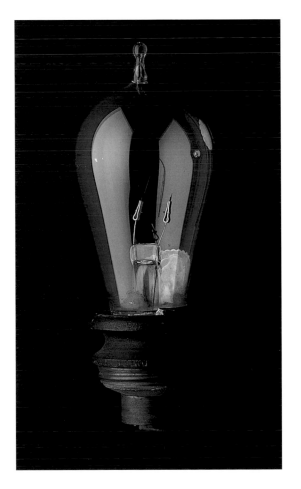

Indiana, Helen and Robert Lynd reported that many residents ranked Edison after Washington and Lincoln as the third greatest figure in American history,[46] and doubtless many other Americans felt the same way. Perhaps the most famous Edison admirer was the equally famous inventor Henry Ford, who began collecting memorabilia of his idol in 1905. This devotion reached its bizarre climax in 1931, when, as Edison lay on his deathbed, Ford asked the family to collect for him in a glass vial a sample of Edison's last breath. Along with this relic, Ford acquired Edison's hat and shoes and also most of his Menlo Park laboratory, which Ford had transported to his museum in Dearborn, Michigan.

Like the scientist-curators before them, the new curators of technology at the Smithsonian also came from the fields they documented. Several engineers joined the staff after World War I, and they made it their priority to secure historical recognition for their colleagues. In addition to preserving tools and other artifacts, Carl W. Mitman, a mining engineer who became chief curator of the technological collections in 1918, contributed 325 entries on American technologists, almost all engineers, to the *Dictionary of American Biography*. Concerned that his department did not receive the respect it deserved as one small part of the National Museum, Mitman proposed in 1920 the establishment of a separate Smithsonian museum devoted entirely to engineering and industry. Mitman's vision, which never materialized, included a hall of fame, where engineers would receive the credit they were due as leading figures in American history.[47]

Meanwhile, for women and minorities, recognition of their scientific and technological achievements often proved elusive. Only in recent decades has the Smithsonian made efforts to seek out and honor scientists and inventors who had been left out of the pantheon because of their race, gender, or ethnic background. In planning the new Museum of History and Technology during the early 1960s, curators collected antique equipment from major universities and colleges to document the history of American science education. Deborah J. Warner, a historian of science at the Smithsonian, noted that many of these major universities had traditionally excluded women. She set about collecting scientific material from women's colleges to demonstrate that in the nineteenth century, despite gender segregation, science education at the college level was essentially equal for both sexes. A woman at Vassar learned the same principles and used the same instruments as the men at Yale. Although science departments in women's schools often had to make do with less, the lessons they taught were universal, and many women found science liberating as well as enlightening. Scientific objects collected from women's colleges, such as the telescope used by the great astronomer Maria Mitchell at Vassar, call to mind Mitchell's own observation, made in 1878, about women's aptitude for scientific research: "The eye that directs a needle in the delicate meshes of embroidery will equally well bisect a star with the spider web of the micrometer."[48]

As curators have endeavored to include more women in the history of science and technology, they have also acquired new objects to document the contributions of minority scientists and inventors. In the case of Lewis Howard Latimer, an African American draftsman, inventor, and electrical engineer who worked with Thomas Edison, curators not only collected new artifacts but rediscovered ones that had previously been collected. When Latimer died in 1928, he was eulogized by the Edison Pioneers, Edison's elite research team, as one of their founding members: "of the colored race, [he was] the only one in our organization."[49] But the Smithsonian did not collect any Latimer material until 1962 and then only by happenstance, when it acquired a large collection of Edisoniana assembled by William J. Hammer, an electrical engineer who worked at the Menlo Park Laboratory. Among the hundreds of Edison-related papers and objects in the Hammer Collection were three electrical sockets invented by Latimer in the 1880s. At the time they received little attention from curators and were not placed on exhibit.

Seven years later an article appeared in the *Washington Evening Star* entitled "Lewis Latimer: Pioneer in Electricity." Reflecting new scholarship on black inventors that accompanied the rising interest in African American history during the 1960s, the article described how Latimer had been neglected by historians, his accomplishments overshadowed by Edison. Latimer attracted increasing attention during the 1970s and early 1980s, and several institutions, including Bell Labs,

Maria Mitchell and her student Mary Whitney in the Vassar College observatory, about 1877 (above). Mitchell (left), an astronomer and teacher, received international recognition for her discovery of a telescopic comet in 1847. A strong advocate for women's education, she taught at Vassar from 1865 to 1888. In 1963 the president of Vassar offered Mitchell's astronomical telescope, built by Henry Fitz in 1863, to the Smithsonian.

Drawing of an incandescent light fixture by Lewis Latimer, 1884 (opposite top). A skilled draftsman who worked with Thomas Edison and Alexander Graham Bell, Latimer was an accomplished inventor and engineer in his own right. In 1982 the National Museum of American History purchased ninety of his mechanical drawings, including this one, completed the year Latimer went to work for Edison.

Lewis Latimer puppet, 1998 (opposite bottom). This puppet likeness of Latimer was created by the Brewery Puppet Troupe for a performance commissioned by the National Museum of American History's Lemelson Center in 1998. After the show the puppets were added to the museum's cultural history collections.

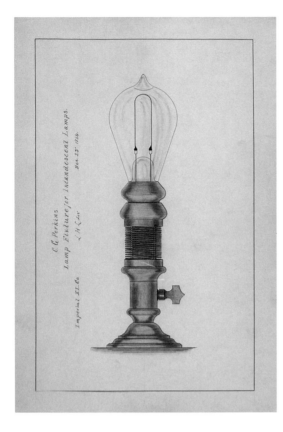

mounted exhibits to commemorate him. Responding to this new appreciation for Latimer's work, in 1982 the National Museum of American History purchased ninety sketches and watercolor drawings made by Latimer. Curators exhibited the newly acquired drawings along with the sockets, on view in the museum for the first time since their arrival twenty years earlier. In 1989 Latimer's objects were featured in an exhibit on black inventors at the Smithsonian's Anacostia Museum.

The most recent addition to the Latimer collection came in 1998. To celebrate Latimer's 150th birthday, the Jerome and Dorothy Lemelson Center for the Study of Invention and Innovation commissioned a play based on the inventor's life from the Brewery Puppet Troupe, an African American puppet company. The show, *Lewis Latimer: Renaissance Man,* was performed for schoolchildren at the Smithsonian and broadcast to schools nationwide. As the title suggests, the play portrayed Latimer as a man of diverse talents—not just an inventor but also a poet and activist, not wholly defined by his association with Edison but also a significant historical figure in his own right. Afterward the troupe presented its Latimer puppet to the popular culture collection, where it is preserved as a literal embodiment of the inventor's reinvented image.

While the National Museum of American History has continued to recognize the accomplishments of scientists, inventors, and engineers, in recent years the emphasis on individuals has given way to a more complex, collaborative story that better reflects the reality of invention and discovery in twentieth-century America. In an age when most scientific research and product development is conducted by teams of people working in different locations—sometimes on different continents—and funded by government as well as corporate agencies, it is often difficult to single out one person as the inventor or discoverer of a particular thing.

Some exhibitions at the museum, most notably *Engines of Change* (1986–present) and *Science in American Life* (1994–present), have downplayed individual genius in an attempt to portray the bigger picture of scientific and technological developments, the systems and networks that produce change. But museum programs also continue to emphasize the importance of the individual innovator to social progress. In 1995 the inventor and philanthropist Jerome Lemelson established the Lemelson Center for the Study of Invention and Innovation at the museum. The center conducts research and presents public programs on the history of invention, focusing particularly on the individual inventor. In the process it tells the stories of inventors—past and present, famous and relatively unknown—and aims to inspire new generations to enter this all-American profession.

George Armstrong Custer's buckskin coat, about 1875 (opposite). On June 25, 1876, Custer and many of his men were killed by an alliance of Sioux and Cheyenne at the Battle of Little Bighorn in Montana. The media painted him as a martyr, although many saw Custer's decision to attack a massive Indian encampment with his outnumbered regiment as a foolhardy rather than valiant maneuver. Years later, in 1912, Custer's widow, Elizabeth, donated this buckskin coat to the Smithsonian as a tribute to her husband. She also donated the uniform coat he wore at their wedding, saying, "I know how anything with sentiment attracts the young whom I am so anxious to gain as admirers of the general."

Hatchet presented to Davy Crockett in 1835 (below). A frontiersman-turned-congressman from Tennessee, Crockett gained fame for his tall tales of pioneer life. On the campaign trail Crockett received various gifts from political supporters, including this silver hatchet from the Young Men of Philadelphia. Its inscription—"Go Ahead Crockett"—echoed Crockett's famous motto, "Be sure you're right, then go ahead." Crockett eventually abandoned politics and plunged back into the wilderness he loved, ending up in Texas. After he died defending the Alamo in 1836, popular legend immortalized him as a frontier superhero. His silver hatchet was among the historical relics transferred to the Smithsonian from the Patent Office in 1883.

As innovators who break new ground, make new discoveries, and pave the way for progress, scientists and inventors tap into the American fascination with the pioneer spirit. Historians have long discussed and debated the powerful role of the frontier, as both myth and reality, in shaping Americans' national identity. From the first European settlers who imagined a virgin land waiting to be explored, mapped, and tamed, to the nineteenth-century urban readers of Wild West dime novels, to the Cold War nation that looked to space as "the New Frontier," as President John F. Kennedy described it, the notion of the frontier, however romanticized and idealized, resonates throughout American history. From this tradition has emerged what many regard as a uniquely American figure, the frontier hero: someone who ventures into unknown territory and clears a path in the wilderness for civilization to follow; someone who—through physical strength, intelligence, skill, or sheer bravado—challenges accepted ideas about what is possible, what can be achieved, how far the nation can go.

As an institution dedicated to increasing knowledge and promoting progress, the Smithsonian has been a natural place to honor frontier heroes. In building its natural history and anthropology collections, it has depended on the willingness of men and women to explore new territories and document their new discoveries. While the collections at the National Museum of Natural History serve as unofficial memorials to these explorers, the National Museum of American History preserves objects related to the individuals themselves. Its collections include mementos of military and scientific expeditions that opened up the continent and expanded our knowledge of the world. Many date from the nineteenth century, the era of the great geological and geographical surveys, although the museum has continued to collect objects from more recent expeditions to far-flung corners of the globe. Objects that crossed the frontier and came back to tell their tales not only pay tribute to the explorers who owned and used them but also evoke the wonder and romance of exploration itself.

Beyond those who made a living exploring the frontier, many others have made their living exploiting it. As images of the Wild West took hold of the popular imagination in the nineteenth century, they were accompanied and promoted by heroic figures who supposedly personified the rugged and romantic qualities of frontier life. An early example was Davy Crockett, who parlayed his wild Tennessee image into a wildly popular autobiography and a short-lived but successful political career. After the Civil War, the demand for western-theme entertainment gave rise to a host of frontier celebrities, such as Buffalo Bill Cody, whose Wild West Show captivated audiences with fetching female sharpshooters and staged gunfights between cowboys and Indians.

More sensational entertainment was provided by the real-life exploits of George Armstrong Custer, cavalry commander, Indian

fighter, and talented self-promoter. Reporters and photographers often tagged along on Custer's western adventures, finding the charismatic and often reckless army officer a rich source of material.[50] When Custer met his death at Little Bighorn, the news media painted him as a martyr.

After Custer's death, his widow, Elizabeth, dedicated herself to preserving and promoting her husband's heroic image. In 1912 she donated several items to the Smithsonian, including a buckskin coat, an emblem of Custer's flamboyant frontier style. In giving the relics to the museum, Mrs. Custer declared, "I have but one motive—that my husband may be put before our people whenever there is an opportunity." [51] Custer has certainly not been forgotten, but Americans continue to debate how Custer should be remembered. The National Park Service originally preserved Little Bighorn battlefield as a shrine to Custer's memory. Yet among Native Americans, Custer's Last Stand is remembered as a day of victory, the defeat of a hated enemy by Sioux and Cheyenne warriors. In 1991 the name of the park was changed from Custer Battlefield National Monument to Little Bighorn Battlefield National Monument, reflecting more recent efforts to understand the Wild West from the perspectives not only of those who tried to conquer it but also of those who fought to protect their land and culture from invasion.

By the early 1900s western images had found a new home on the silver screen, and the frontier hero was transformed into a movie star. The popularity of the western genre carried over into the new medium of television and launched the careers of many more entertainers. Since the National Museum of American History began collecting popular culture in the 1970s, it has acquired artifacts associated with celebrities who gained fame by crafting and cultivating a frontier image on the stage and screen. Many of these objects encompass both actual and fictitious aspects of an individual's identity, suggesting disjunctures between the myth and the reality. In addition to numerous cowboy hats worn by various cowboy actors, for example, the collections also include a hairpiece worn by John Wayne in the 1969 classic western *True Grit*. From the relics of real individuals who fought and died on the frontier to the props of actors whose only frontier experience was on a Hollywood soundstage, the museum's collections shed much light on this changing yet enduring icon of American history.

Yet while the Wild West has continued to survive in the popular imagination, at the end of the nineteenth century many Americans were just coming to grips with the idea that the frontier, as the U.S. Census Bureau announced in 1890, was closed. As politicians, entrepreneurs, and military leaders looked abroad in search of new frontiers that would allow the nation to keep expanding, some Americans sought to satisfy their appetite for pioneer adventures in other ways. The desire to go where no one had gone before evolved

Silver trophy awarded to Gertrude Ederle, the first woman to swim the English Channel, in 1926. Ederle's swim on August 6, 1926, broke the men's world record by nearly two hours and won her international fame. On her return to the United States, New York City celebrated its hometown hero with a ticker-tape parade, and William Randolph Hearst presented her with this elaborate trophy honoring her as "Most Popular Athlete." But the prize came at a cost: exposure to the channel waters damaged Ederle's hearing, leaving her permanently deaf. In 1991 Ederle's niece donated this trophy, along with the goggles Ederle wore during her famous swim, to the Smithsonian.

Evel Knievel's jumpsuit and motorcycle, 1970s. The ultimate American daredevil, Knievel thrilled audiences in the 1970s with his spectacular motorcycle stunts. Although he completed many death-defying jumps—over cars, buses, trucks, and other obstacles—he also crashed a lot. But his crashes seemed to make the fans love him more, for they proved he was the real thing, a man willing to risk life and limb to put on a great show. In 1994 and 1995 the Smithsonian collected one of Knievel's customized Harley Davidson motorcycles—one of the few to survive his career— and a star-spangled leather jumpsuit to document his unique place in American popular culture. Curators used these objects, along with a collection of toys and memorabilia donated by a fan, to create a special Evel Knievel display in the Road Transportation Hall.

into the desire to do what no one had done before—or at least do it faster.

Around the turn of the twentieth century, athletes and daredevils became the frontier heroes of the media age, their record-breaking stunts challenging the notions of what was possible, defining new standards for human achievement, and blazing new trails. With his famous flight from New York to Paris in 1927, Charles Lindbergh became the epitome of this type of frontier hero, and even before his plane touched the ground, Smithsonian curators were angling to collect it. Today the *Spirit of St. Louis* soars above the crowds at the National Air and Space Museum, along with the magical machines that made other historic flights. But the National Museum of American History has plenty of nonflying objects that commemorate similar kinds of pioneers. From Gertrude Ederle, the first woman to swim the English Channel, to the motorcycle daredevil Evel Knievel, these American heroes gained fame not just for their accomplishments but also for proving that the frontier is still open to those who dare to test the limits of physical strength, skill, and endurance.

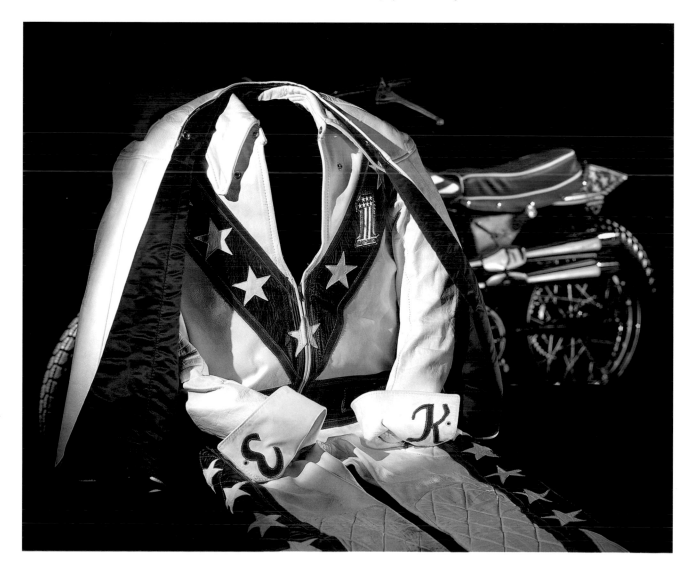

Soldiers and Military Relics

On the frontier and elsewhere, war has been a place where heroes are made. Through its collections the Smithsonian has paid tribute to many Americans who fought to establish and defend the country, expand its borders, and advance its causes around the world.

The National Museum began collecting military relics in 1883, the same year it started collecting presidential relics, and both came from the same man: George Washington. Although he was the nation's first president, Washington first won American hearts as a warrior, not a politician. The Smithsonian has numerous objects associated with his military career, including a field tent, camp chest, writing case, the uniform he reputedly wore when resigning his commission—and, of course, his battle sword. For many years the relics of Washington and Ulysses S. Grant, another warrior-president, constituted the star attraction at the National Museum, although they were soon joined by ceremonial pistols and swords, medals, uniforms, and equipage representing other distinguished U.S. soldiers, both historical and contemporary.[52]

Although relics of war have always been sought as patriotic memorials, in the aftermath of the Civil War the sacrifices and honors of soldiers achieved new levels of visibility on the nation's physical and emotional landscape. According to the historian Michael Kammen, the period 1870–1910 is unparalleled in American history for its focus on glorifying and enshrining warrior heroes.[53] The unprecedented number of veterans gave rise to powerful organizations like the Grand Army of the Republic (G.A.R.), which took responsibility for ensuring that history did not forget the Union cause and the men who fought and died for it. Memorial Day, initially sponsored by the G.A.R. in 1868, had by 1870 become an official holiday in thirty-one states. Monuments, plaques, and statues sprouted up to honor the dead and mark the sites of their heroic acts and final resting places. Displays of war relics appeared in various cities, and in 1878 the Military Service Institution of the United States established a war museum on Governor's Island, New York. The museum's treasures included Civil War objects such as General Philip Sheridan's rifle and his stuffed horse, Winchester, as well as relics from the Revolutionary War and the U.S.-Mexican War.[54] In 1922 this museum was closed, and its collections were transferred to the Smithsonian.

The public appetite for military relics continued to grow after the Centennial of 1876 with the emergence of heritage organizations, such as the National Society of the Daughters of the American Revolution, organized in 1890. Members of these groups preserved and exhibited relics of their fighting forebears as an expression of patriotic sentiment and ancestor worship. Used as tokens of entry into exclusive societies, these relics traced a bloodline back to the roots of American patriotism that frequently served to glorify the descen-

Continental Army uniform coat worn by Brigadier-General Peter Gansevoort Jr. during his command of Fort Stanwix, New York, in 1777 (above). After visiting the Smithsonian and seeing George Washington's uniform, Peter Gansevoort's granddaughter Catherine Lansing offered relics of her own ancestor, an American officer in the Revolutionary War. In 1912 she donated a collection of swords and uniforms that documented three generations of military officers in the Gansevoort family, from the Revolution to the Civil War. Curators promised to try "to give them an installation befitting their dignity and importance."

U.S. Army Medical Corps contract surgeon's uniform worn by Dr. Loy McAfee during World War I (opposite). This is one of nearly eighty uniforms collected by the National Society of the Colonial Dames of America to represent women's roles in World War I. Between 1918 and 1922 the society deposited the uniforms it collected in the Smithsonian. They remained on loan until 1997, when the collection was formally donated.

dant more than the warrior-ancestor. After the Smithsonian founded its historical collection in 1883, members of the Daughters of the American Revolution and other patriotic societies often used the National Museum as a showcase for family war relics. These objects were eagerly received by curators, several of whom also claimed membership in heritage organizations.[55]

In honoring individual American soldiers, the Smithsonian has often focused on commanding officers, the generals whose actions and decisions led the troops to victory. The collections include many spectacular trophies that commemorate battles won and express the admiration of a grateful nation, state, or hometown. General John J. Pershing, commander of the American expeditionary forces in France, was one of the most famous soldiers of World War I. For

George Washington's tent, 1776. During the Revolutionary War, General Washington and his staff used this tent, one of three made for Washington in 1776 by the Philadelphia upholsterer Plunkett Fleeson, for visitor receptions, meetings, and dining. In the early 1800s Washington's adopted grandson, George Washington Parke Custis, hosted dinner parties in it on the lawn of his Virginia estate, Arlington House. In 1844 Custis presented Washington's tent to the U.S. government, and it was displayed at the Patent Office museum for many years. It eventually came to the Smithsonian and has been exhibited at the National Museum of American History since 1964.

Lifetime pass to Steeplechase Park, Coney Island, presented to General John J. Pershing, about 1920 (right). This gift to Pershing from the people of New York is but one of hundreds of awards, trophies, and tokens presented to the beloved general in recognition of his leadership during World War I. Many of these artifacts came to the Smithsonian after Pershing's death in 1948.

Winchester, General Philip Sheridan's horse during the Civil War (below). War heroes are not always human, and the Smithsonian has several animal soldiers in its collection, including Stubby the dog, a decorated canine veteran who sniffed out mustard gas during World War I; Cher Ami, a carrier pigeon who flew missions in World War I and was wounded in action; and a famous Civil War veteran named Winchester. On October 19, 1864, Winchester, then named Rienzi, carried Sheridan from Winchester, Virginia, to the battlefield at Cedar Creek, where the general roused his troops to repel a Confederate attack. The horse was renamed in honor of the victory, and "Sheridan's Ride" was immortalized in popular poems, songs, and artwork. After Winchester died in 1878, Sheridan had the horse stuffed and mounted, and he presented It to the Military Service Institution's museum in New York. In 1922, when these collections were transferred to the Smithsonian, Winchester received a military escort to his new home in Washington, D.C.

years after the armistice, "Black Jack" Pershing was welcomed with victory parades in cities across America and Europe and presented with gifts from citizens, veterans, and government officials. Medals were struck in his honor, and his celebrated name was applied to everything from city squares to locomotives to cigars. Congress created a special rank, "General of the Armies," to accommodate the immensity of the man and the war he helped win. Meanwhile, Pershing used his fame to ensure that other soldiers were not forgotten; in 1923, at his request, Congress established the American Battle Monuments Commission to construct and oversee war memorials. After his death in 1948, Pershing's family passed many of his trophies on to the Smithsonian. The Pershing Collection features everything from ceremonial European orders and gold medals to a whimsical but heartfelt gift from the people of New York: a lifetime pass to Coney Island.

Another major collection devoted to World War I heroes came to the Smithsonian shortly after the war ended. The War and Navy Departments transferred to the Institution a vast collection of military artifacts that documented every aspect of the U.S. armed forces' involvement in the conflict. Uniforms, medals, trophies, weapons, tanks, planes, radio equipment, maps, manuscripts, and other objects filled the galleries and spilled out onto the National Mall. Although the war collections included material associated with famous generals and commanders, such as Pershing's map room, by and large they were intended not to glorify the leaders but rather to pay tribute to the ordinary soldiers, those who had enlisted to

fight for their country. Since the late nineteenth century, the anonymous, common soldier had become a fixture of American war memorials.[56] The great General Pershing himself dedicated his war memoirs to the Unknown Soldier, who was brought back from France in 1921 in a flag-draped casket and buried in Arlington Cemetery, the heroic symbol of all the young men who never came home. Similarly, Smithsonian curators described the World War I collections as "a most notable memorial to the patriotic individuals who have contributed to the preservation of civilization"—not just the generals but also the enlisted men in the trenches.[57]

One collection of memorabilia presented to the Smithsonian after World War I was unique, however, in that it honored not military men but military women. The National Society of the Colonial Dames of America, a patriotic women's organization devoted to preserving colonial heritage, had frequently deposited pre-Revolutionary relics in the museum to honor the ancestors of its members. Yet in 1918 the Colonial Dames assigned its relics committee to collect contemporary artifacts—namely, examples of uniforms worn by American women during World War I. Between 1918 and 1922 the organization acquired nearly eighty uniforms representing various branches of military and civilian service, including the U.S. Army and Navy Nurse Corps, Navy Yeoman (F), League of Catholic Women, National Land Army, Salvation Army, and Young Women's Christian Association. What prompted this new collecting initiative? Carolyn Gilbert Benjamin, committee chair, explained: "The World War that has so recently come to an end was of a different character. Already woman had achieved recognition in nearly every branch of man's work, and so with the advent of that great conflict, she was ready to do her part as efficiently as did her brother."[58] Blending patriotism and feminism, the Colonial Dames uniform collection became a symbol of two victories: the war in Europe and the battle for women's suffrage.

The women's uniforms collected by the Colonial Dames remained on loan to the Smithsonian until 1997, when they were formally donated. Curators' renewed interest in the collection reflected new efforts to document the long history of women in the U.S. armed forces—as members of auxiliary military corps and civilian war organizations, as soldiers, as officers, and, since Anna Hays first earned the rank in 1970, as generals themselves.[59]

Over the years the Smithsonian has displayed alongside the official memorials of victory the personal mementos of enlisted men and women who served their country and sometimes sacrificed their lives. While they often proclaim the patriotism and courage of their owners, these artifacts can also provide glimpses into the grim realities of war that gleaming trophies fail to convey. They suggest the impact of war on people's emotional and physical lives, documenting experiences on the front lines and on the home front. Perhaps the most moving exhibition ever created by the National Museum of

Hat worn by Anna Mae McCabe Hays when she became the first woman general in the U.S. Army, June 11, 1970. Hays, chief of the Army Nurse Corps, entered military service in 1942. Her career included combat experience in World War II and the Korean and Vietnam Wars. In 1997 the Smithsonian collected artifacts from Hays's promotion ceremony as part of an effort to document women in the military. Hays hoped to be remembered for, in her own words, "breaking down some glass ceilings."

U.S. Model 1866 carbine, 1881. U.S. soldiers captured this rifle from Sioux warriors fighting under Chief Low Dog at Poplar River, Montana Territory, in 1881. The rifle was exhibited at the Military Service Institution's museum in New York until 1922, when the museum closed and its collections were transferred to the Smithsonian.

Commodore Thomas MacDonough's pistols, 1820. MacDonough received these gold-mounted flintlock pistols from the state of Connecticut in honor of his victory in the Battle of Lake Champlain during the War of 1812. A scene depicting the battle is engraved on the gold plate. The Smithsonian acquired MacDonough's trophies in 1927 from the commodore's grandson and placed them on exhibit with other relics of U.S. Navy commanders.

American History is a display of artifacts left behind at the Vietnam Veterans Memorial in Washington, D.C. Collected and cared for by the National Park Service since the memorial opened in 1982, these sometimes anonymous and often intensely personal mementos capture the conflicting feelings that the Vietnam War still stirs up for many Americans. They honor the memories of those who served and died while also expressing sadness and anger about the war itself. They raise questions about what it means to be a hero, about the duties of citizenship and the price of loyalty.

Indeed, there are many objects in the Smithsonian's military history collections that may represent heroism to some Americans but not to others. As the national museum, the Smithsonian has celebrated the victories of the U.S. military over foreign foes, but in the case of wars that took place on American soil—the Civil War, the U.S.-Mexican War, the numerous wars waged against Indian tribes—the nation has itself been divided on how to remember those who fought on the opposing side.

Long before the Smithsonian began collecting relics of George Washington and other soldiers, portraits of Native American warriors were on display in the Castle as the central attraction of the fledgling art

gallery. Some were commissioned by the War Department and portrayed delegates who had come to Washington to meet with government officials and negotiate treaties. Others were scenes painted from life by artists who traveled out West and documented the cultures and customs of Indian tribes. As battles over western lands intensified after the Civil War, the War Department supplied the Smithsonian with numerous weapons, saddles, and other captured Indian trophies. Meanwhile, relics of U.S. soldiers who fought the Indians were also enshrined in the museum. In recent years, as the Smithsonian has devoted itself to including diverse voices and experiences in its story of America, the meaning of these artifacts has grown more complicated. Do they tell the stories of heroes or enemies? Of victimization or resistance? Of bravery or cruelty?

Similar issues arise in regard to relics of the Civil War. The place of Confederate artifacts in the National Museum has frequently provoked controversy and debate. Some military history curators refused to collect Confederate States of America uniforms and insignia, either because they deemed them unpatriotic or because they were not official U.S. military issue. Yet mementos of Confederate soldiers and officers still found their way into the collections; by the end of the nineteenth century such artifacts were frequently offered and accepted in the spirit of reconciliation between the North and South, of putting old divisions to rest by honoring the heroism of both sides. During the civil rights movement, however, the revival of Confederate imagery and rhetoric by white segregationists in the South again cast these artifacts in a controversial light. The controversy still rages today, as different communities continue to perceive Confederate artifacts in radically different ways: as proud emblems of their heritage, as relics of heroes or traitors (or both), or as painful reminders of an age of racism and slavery.

Traditionally the Smithsonian has collected and displayed relics of famous American soldiers in order to honor their bravery and patriotism, to cast them as heroes and glorify the national cause for which they fought. In the wake of the Vietnam War, however, the moral questions raised by armed conflict—what have Americans truly fought and died for?—have complicated how the nation remembers its soldiers. Old battles give rise to new ones as veterans and other groups struggle over the memory and meaning of war. As a guardian of military legacies, the Smithsonian itself often becomes a battleground; the 1990s controversy over the *Enola Gay* exhibition at the National Air and Space Museum is just one example of the difficulties that can ensue when museums challenge memory. The Smithsonian should be a place to honor those who fought for their country, but it should also be a place where the history of war can be explored in its complexity and from a variety of perspectives. To this end soldiers must not only be remembered as heroes; they must also be understood as human beings.

World War II GI's dog tags (above). These metal identification badges, one of many sets in the Smithsonian's military history collections, were worn by Johnnie V. Wilson of Council Bluffs, Iowa, during World War II. Used to identify a soldier wounded or killed in action, they are both personal and depersonalized, poignant symbols of modern warfare.

Combat boots left at the Vietnam Veterans Memorial in Washington, D.C., in 1989 (opposite). Since the Vietnam Veterans Memorial was dedicated in 1982, countless offerings have been left at "The Wall" in memory of the more than fifty-eight thousand soldiers whose names are engraved on its surface. The National Park Service, which collects and preserves these mementos, loaned many of them to the Smithsonian in 1992 for an exhibition marking the memorial's tenth anniversary.

Reformers: Fighting for Change

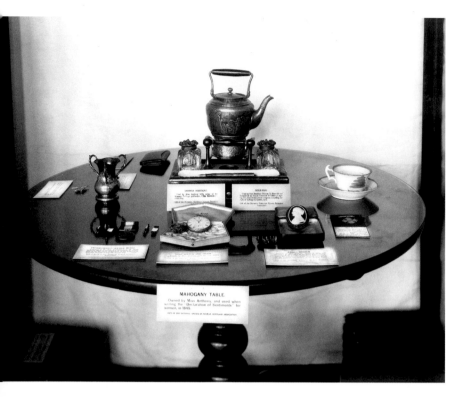

MAHOGANY TABLE.

Relics of Susan B. Anthony, Arts and Industries Building, 1920s (left). Donated by the National American Woman Suffrage Association to celebrate the passage of the Nineteenth Amendment in 1919, these mementos of Anthony and fellow suffragist leader Elizabeth Cady Stanton were given prominent display in the 1920s. This exhibit marked the first time that women had been honored in the National Museum for their political achievements.

Helen Keller's watch, 1890s (below). The story of Keller, the American author and lecturer who was born deaf and blind and learned to communicate through touch, has inspired people around the world. One of her admirers was John Hitz, consul general of the Netherlands, also blind, who met Keller in Washington, D.C., when she was a young girl and gave her his gold Swiss pocket watch, specially made with tactile features to enable a blind person to tell time. Keller treasured the watch and carried it with her for the rest of her life. After her death in 1968, her niece and nephew inherited the watch. In 1975 they donated it to the Smithsonian, believing that their aunt would have wanted the watch to be "placed where it would make the maximum impact" in raising public awareness about the blind.

I n the twentieth century the Smithsonian gradually began to recognize a new kind of American hero: not just those who fought to defend the country but also those who fought to change it, not just individuals who contributed to scientific and technological progress but also men and women who worked for social and political progress. Through protest and reform these individuals sought to make the nation a better place, to nudge it closer to its ideals of freedom and equality for all citizens.

Within days of the passage of the Nineteenth Amendment on June 4, 1919, women suffragists were ready to claim their place in history. After seventy years of struggle they had finally secured the constitutional right to vote, and they wanted to ensure that future generations never forgot the battles they had fought and the women who had fought them. Helen Gardener, vice chair of the National American Woman Suffrage Association, used her political contacts in Washington to obtain a meeting with Smithsonian officials. With some effort she convinced curators to accept relics of Susan B. Anthony, the association's former president, to commemorate the victory of the women's suffrage movement.

For the first time American women would be recognized in the Smithsonian as political activists. This donation included personal items such as a gold watch and tea cup Anthony had purchased with the first money she earned as a schoolteacher, a portrait, and her famous red shawl as well as items connected to the women's rights movement, such as the table on which Elizabeth Cady Stanton drafted the Seneca Falls Declaration of Sentiments and Resolutions for the first

Mary Walker advertising card, about 1910. The only woman to receive the Congressional Medal of Honor, Walker served as a Union Army surgeon during the Civil War and spent time in a Confederate prison. After the war Walker toured the country speaking on women's rights and dress reform. In 1974 her grand-niece donated a collection of Walker material to the Smithsonian, including this advertising card used on the lecture circuit.

MARY E. WALKER, M. D., N. P.

A. A. Surgeon, War of 1861-5.
With rank of 1st Lieutenant.

Author of Crowning Constitution Argument:
"The Opener of the Door For Woman's Votes."

President of United States Constitution Argument.

Member of American Peace Society.

Member of Woman's Democratic Club.

Great Grand Daughter of Revolution.

Woman's Rights Convention in Seneca Falls, New York, in 1848. Learning that her aunt's mementos would soon be on display at the National Museum, Lucy Anthony was overjoyed. "It will be a crowning glory to everything," she exclaimed.

Meanwhile, Gardener made it clear to curators that this donation was not to be taken lightly: "[A]bove all else this exhibit [should] be kept all together in the most suitable place you can prepare for it, because these few things that we have now sent will not be the end of the historic collection to show the origin and development of the greatest bloodless revolution ever known—the achieving of political and financial independence by one-half of the people without a drop of blood being shed."[60]

Despite Gardener's impassioned prediction, however, a women's history collection did not take root and flourish at the Smithsonian with the donation of the Anthony relics in 1920. At the time the Institution generally did not concern itself with contemporary politics or reform movements that challenged the social status quo; such controversial matters, many believed, had no place in a history museum. Indeed, in donating these relics to the Smithsonian, the National American Woman Suffrage Association took pains to distinguish itself from the more radical wing of the women's rights movement—particularly the National Woman's Party, headed by Alice Paul, who continued to agitate for an Equal Rights Amendment to the Constitution—and even warned curators not to accept any artifacts associated with those groups. The association's relics were displayed as a memorial to Anthony and other women leaders and to a cause that had supposedly ended with the passage of the Nineteenth Amendment. The women's rights movement, the exhibit implied, was history.

It would be nearly fifty years before this attitude began to change. In the 1960s and 1970s some of the most dramatic moments of the civil rights, antiwar, and women's movements unfolded right outside the Smithsonian's front door, on the National Mall. By the late 1960s curators were actively collecting materials from marchers and demonstrators, adding contemporary issues to the museum's political history collections. In 1975 many of these objects went on public view in the exhibition *We the People,* created in honor of the United States's Bicentennial. Spanning historical as well as contemporary politics, it included material such as Susan B. Anthony's shawl and the ivory cane given to John Quincy Adams by abolitionist supporters in 1844 as well as contemporary placards and banners from the Poor People's March of 1968 and Vietnam Veterans against the War. Objects such as clothing worn by those who participated in the fifty-four-mile voting rights march from Selma to Montgomery, Alabama, in 1965 honored the heroism of ordinary citizens who joined the struggle for civil rights.

Since the 1970s the National Museum of American History has continued to add to its civil rights collection by acquiring memorabilia of movement leaders as well as participants. Curators have sought to

expand the collection with historical as well as contemporary examples of American reformers. And political groups and communities have continued in the footsteps of the National American Woman Suffrage Association by nominating their heroes for inclusion. From Shirley Chisholm to Ed Roberts, from Roy Wilkins to Cesar Chavez—these individuals represent a range of causes yet also a shared belief in equality and freedom for all Americans. In trying to hold the nation to its highest ideals, they have expressed their patriotism through protest.

While the Smithsonian has collected mementos from many reformers active in recent civil rights and reform movements, some individuals have also emerged from the past to join their contemporary counterparts, reformers from earlier eras whose historical struggles resonate with issues today. The story of Mary Walker represents one such example of a rediscovered hero.

During her lifetime Dr. Mary Edwards Walker gained fame—and infamy—for challenging conventional gender roles. In 1855 she became one of the country's first women physicians and went on to serve as a contract surgeon during the Civil War. Although denied an officer's commission because of her sex, Walker sought and won recognition for her wartime service. In 1866 President Andrew Johnson awarded the Congressional Medal of Honor to Walker, the only woman ever to earn this military honor. Meanwhile, Walker gained a reputation as an eccentric for wearing men's clothing, which she preferred to the confining corsets and hoop skirts that were the women's fashion of the day. After the Civil War, Walker toured the country lecturing on dress reform and women's rights. But her radical and outspoken style made her an outcast in most suffragist circles. In 1917 Walker suffered the indignity of having her Medal of Honor revoked when Congress revised its standards to include only "actual combat with an enemy." She spent her last years fighting unsuccessfully to have her medal reinstated.

Although Walker was quite famous in her day, the Smithsonian did not add her to its pantheon until nearly sixty years after her death. As the women's liberation movement took hold in the early 1970s, interest in Mary Walker's story resurfaced. A grandniece launched a campaign to have Walker's Medal of Honor restored and contacted the

Cap worn by Roy Wilkins during the March on Washington for Jobs and Freedom in 1963 (left). Wilkins began his civil rights career in 1934 as editor of *The Crisis*, the magazine of the National Association for the Advancement of Colored People. From 1955 to 1977 he served as the organization's executive director and was a leading organizer of the 1963 March on Washington. Awarded the Presidential Medal of Freedom in 1969, Wilkins was praised by President Lyndon Johnson for helping "stir the Nation's conscience." In 1980, shortly before his death, Wilkins donated mementos from his career to the Smithsonian—the first major donation of artifacts associated with an African American civil rights leader.

Buttons supporting Shirley Chisholm for president, 1972 (opposite top). In 1969 Chisholm became the first African American congresswoman when she was elected to represent New York in the U.S. House of Representatives. A native of Brooklyn and a vocal supporter of women's rights, she was an advocate for her inner-city constituents and a hero to feminists nationwide. Under the slogan "Unbought and Unbossed" (the title of her 1970 autobiography), Chisholm made a bid for the Democratic presidential nomination in 1972 but lost to George McGovern. After the campaign the Smithsonian collected these buttons from Chisholm and her supporters.

Jacket owned by Cesar Chavez, 1980s–90s (opposite bottom). Chavez spent his childhood as a migrant worker in California, an experience that later inspired him to found the United Farm Workers union to fight for agricultural labor reform. In the late 1960s and early 1970s he gained national attention for leading a boycott of California grapes in support of the union. In 1993 Helen Chavez donated this jacket, decorated with the United Farm Workers emblem, to the Smithsonian in honor of her late husband.

MS. CHIS. FOR PRES.

CATALYSTS FOR CHANGE

AIM HIGH with SHIRLEY

CHISHOLM

UNBOUGHT AND UNBOSSED

SHIRLEY CHISHOLM FOR PRESIDENT

Smithsonian in 1974 to offer some of the mementos she had inherited. The curators Margaret Klapthor and Edith Mayo accepted the donation for the rapidly growing women's history collection and also joined the effort to restore Walker's medal. In a letter to the Army Board for the Correction of Military Records in 1976, the curators voiced their belief that "her contributions as the only woman to serve as a surgeon during the Civil War and her capture in the line of duty . . . warrant special meritorious recognition." In 1977 the U.S. Army agreed to reinstate the award, stating, "There is ample evidence to show distinguished gallantry at the risk of life in the face of the enemy. . . . [H]ad it not been for her sex, she would in all probability have been tendered a commission in 1861."[61]

Once again Mary Walker was in the news, attracting controversy and sparking debate. Numerous books, newspapers, and magazine articles told and retold her story, and a television miniseries about her life was planned. Many saw the restoration of her Medal of Honor as a correction of past injustices; others regarded it as an appropriate tribute to Walker's achievements as a woman in a man's world. But some objected to the army's decision. "There is no sound legal basis for it," fumed Jerry White, president of the Medal of Honor History Round Table. "The only reason this came up is women's lib."[62] In a sense White was right. Mary Walker personified the issues Americans were wrestling with in the 1970s: equality of the sexes and the changing nature of women's roles at home and in the workplace. By resurrecting Walker, women's rights advocates gained a focal point for their struggle, a symbolic ancestor for their cause, and an opportunity to remake history. In obtaining justice for a woman from the past, they expressed a desire for justice for women of the present and future.

Mary Walker's travels into, out of, and back into the public eye demonstrate how heroes from the past can be rediscovered, remade, and reused to suit the needs of the present. Sometimes different groups claim the same historical figure for different reasons and emphasize different aspects of his or her life. Since the women's movement of the 1970s, another group has claimed Mary Walker as its historical champion: for wearing men's clothing and standing up to societal persecution for crossing gender lines, Walker has earned the admiration of many gays, lesbians, and transgendered people who struggle with discrimination today. History thus provides an endless supply of role models and honorary ancestors for political organizations, ethnic groups, and other communities. In turn, many of these groups approach the Smithsonian, seeking national recognition for their heroes.

NO GRAPES

Cesar Chavez

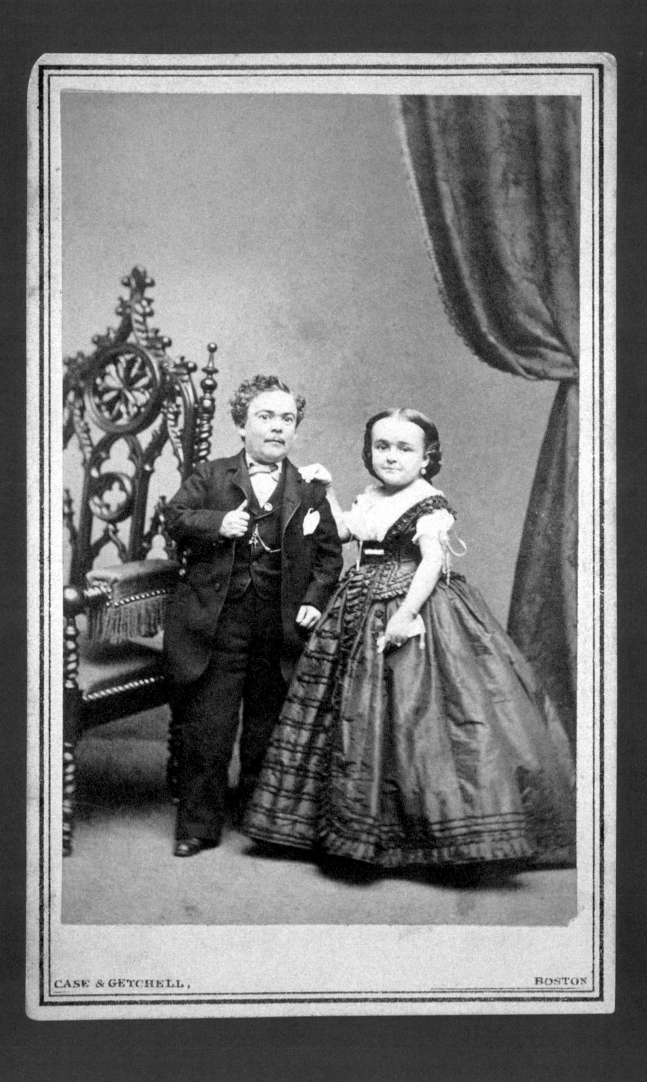

Popular Culture Stars

Photograph of Mr. and Mrs. Tom Thumb, about 1863 (opposite). After their 1863 wedding, the celebrity midget couple managed by P. T. Barnum became one of the most popular subjects for *carte-de-visite* (calling card) photographs. This one was donated to the Smithsonian in 1995 as part of a large collection of materials associated with the photographer George K. Warren.

Tom Thumb's top hat, about 1865 (above). When the Smithsonian began collecting popular culture artifacts in the 1970s and 1980s, curators looked for both contemporary and historical material. Tom Thumb's hat, purchased in 1985, represents "an early example of a true American star."

Lavinia Warren's wedding shoes, 1863 (below). These delicate silk shoes, embroidered with pink rosebuds, were worn by Tom Thumb's bride at their wedding in New York City in 1863. The Smithsonian acquired the miniature shoes in 1987.

In 1863, amid the turmoil and tensions of the Civil War, Abraham Lincoln interrupted a cabinet meeting to receive two special guests: a general and his wife, newlyweds on their honeymoon tour. The couple had come to Washington to attend a reception in their honor, given by the president and first lady. But this general was not of the Union Army or of the Confederate Army. In fact, he was not really a general at all; he just played one on stage. Besides, he was rather short for a general: only thirty-five inches tall, just three inches taller than his bride.

The marriage of General Tom Thumb and Mercy Lavinia Warren Bump on February 10, 1863, captivated the American people despite—or perhaps because of—the horrors of war going on around them. Pushing aside bloody reports from the battlefields, newspapers ran detailed accounts of the lavish ceremony, attended by government officials, military leaders, and New York's social elite; of the bride's beautiful white satin dress; and of the reception held at the Metropolitan Hotel, where the bridal table was heaped with presents from, among others, President and Mrs. Lincoln, the Astors, and the Vanderbilts. Photographic portraits of the midget couple sold by the thousands. It truly was a media frenzy.[63]

By 1863 Tom Thumb (born Charles Stratton in 1838) was at least as famous as Abraham Lincoln. Since embarking on his show business career in the 1840s, he had performed for European royalty, toured every region of the country, and become a household name. Yet when he died in 1883, his top hat did not enter the precious vaults of the Smithsonian. No relics of his were brought to the museum by admirers who wished to see his memory preserved, or if they were, the curators did not accept them. More than a hundred years would pass before Tom Thumb and his bride would be welcomed into the National Museum. Before then, they were considered the property of a different kind of museum.

In fact, Tom Thumb had already been "collected" by a museum—he spent most of his life as an exhibit, a curiosity curated by the one and only P. T. Barnum. In 1841 Barnum opened his American Museum in New York City, which he populated with a bizarre collection of stuffed creatures, mechanical contraptions, wax figures, and, most famously, human "freaks," including Tom Thumb. It was the stuff of Joseph Henry's nightmares, to be sure. But the public loved it. By 1850 there were generally two kinds of museums in America: museums that were based on the professional scientific model, were sponsored by government and academic institutions, and insisted on authenticity, order, and uplift, and museums that were based on the Barnum model and emphasized entertainment over education, spectacle over substance. The line between the two types of institutions, however, was not always clear.[64]

Fame meant something different at the Barnum museum. It was based on novelty and popular appeal rather than conformity to

heroic conventions. Although Barnum had his share of historical relics, he made them seem authentic (even though they often were not) by appealing to emotion rather than reason. One of the first curiosities Barnum acquired was Joice Heth, a slave woman who was reputedly the 161-year-old nurse of George Washington. Although she was eventually proved a hoax, Joice Heth enthralled audiences in the 1830s and 1840s with the tales she spun of Washington's boyhood. Unlike a mute object in a case, Joice Heth was a living relic. She provided a human connection to Washington, however imaginary, that made the past seem real, within reach, relevant to people's lives.

While official museums enshrined historic figures on a pedestal, at the Barnum museum living attractions mingled with dead artifacts, the fictional blended with the real, and the present mixed with the past. Fame was not permanent but subject to change without notice. Barnum's mannequins were made not of plaster and metal and wood but of wax so that yesterday's heroes could be easily melted down and recast into the latest man or woman of the hour. Whereas official museums promoted a singular, narrowly defined view of the nation and its past, Barnum's elastic museum could accommodate a variety of American stories and identities.[65]

In the twentieth century, movies, television, sports stadiums, and concert halls replaced Barnum's museum as the American sideshow, as sources of spectacle, novelty, and celebrity. But for most of the century, despite their pervasive and influential place in American life, popular culture and its stars remained beyond—were indeed considered beneath—the scope of the Smithsonian's collections. The Institution continued to support the mission of elite culture, plumbing the past for role models that would morally and intellectually uplift the public.

Then, in 1979, the Bunkers moved in, and there went the neighborhood. The decision to start collecting popular culture artifacts came out of the soul searching the Smithsonian underwent in preparing for the Bicentennial exhibition *A Nation of Nations*. With this exhibition the nation's museum redefined itself as a multicultural institution, a place to see a spectrum of American experiences, voices, faces, and identities. This meant including popular culture along with high culture, Sinatra along with Stradivari, the Bunkers'

Prize belt presented to John L. Sullivan, bare-knuckle boxing champion, in 1887 (above). The "Boston Bully," Sullivan was the most famous sports figure of his day. To honor their hometown hero, Boston fans raised $10,000 for this elaborate trophy. Encrusted with 350 diamonds (now lost) and decorated with Sullivan's portrait and crossed Irish and American flags, the gold-plated belt has this inscription: "Presented to the champion of champions by the people of the United States." In 1983 the Smithsonian acquired Sullivan's belt for its sports history collection.

Gloves and robe worn by Muhammad Ali, three-time heavyweight boxing champion, about 1975 (below). "The Greatest" gained fame for his boxing skills as well as the controversy he generated outside the ring. In 1976 the Smithsonian acquired Ali's boxing gloves and robe for an exhibition on American culture, *A Nation of Nations*. At the donation ceremony, before a crowd of reporters and cheering spectators, Ali predicted that his Everlast gloves would become "the most famous thing in this building."

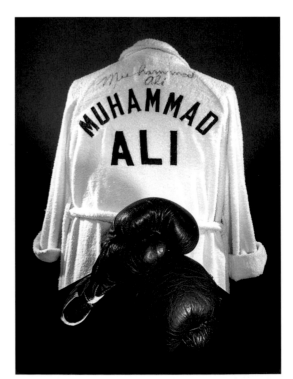

Array of autographed baseballs, 1950s–80s. For a baseball fan, getting a ball signed by a favorite player can be the ultimate thrill. Autographed balls also become valuable collector's items, with certain signatures fetching very high prices. The Smithsonian's sports history collection includes baseballs signed by many noted players. Some have come from memorabilia dealers, others from the fans who collected them.

Minnie Pearl's hat, 1970s (left top). Minnie Pearl, the great country comedienne and entertainer, made her debut at the Grand Ole Opry in Nashville, Tennessee, in 1940. Over the next forty years she appeared regularly onstage at the Opry, on tour with country music stars, and on the television series *Hee-Haw,* delighting audiences with her trademark greeting—"How-*dy!*"—and homespun humor. In 1993 Minnie Pearl (in real life Sarah Ophelia Cannon) donated mementos from her career, including her famous straw hat with the $1.98 price tag, to the Smithsonian.

Kermit the Frog, about 1970 (left center). The creation of the master puppeteer Jim Henson, Kermit the Frog is recognized worldwide as the star of the children's public television program *Sesame Street.* Kermit first came to the Smithsonian in 1979 for an exhibition in honor of the show's tenth anniversary. In 1994 Jim Henson Productions converted the loan to a gift, making Kermit a permanent member of the popular culture collection.

Indiana Jones's hat and jacket, 1980s (left bottom). The character of Indiana Jones, an archaeologist-turned-action hero, was first introduced in the 1981 film *Raiders of the Lost Ark*, produced by George Lucas and directed by Steven Spielberg, and reappeared in two successful sequels. In 1989 the actor Harrison Ford and Lucasfilm donated Indy's trademark brown leather jacket and fedora hat to the Smithsonian. Another famous accessory, a bullwhip, was collected in 1999.

Prince's Yellow Cloud guitar, 1989 (opposite). In 1992 Smithsonian curators, hoping to add more "distinctive, innovative" twentieth-century instruments to the musical history collection, contacted Prince, a musician known for his distinctive, innovative style. Prince's production company, Paisley Park Enterprises, donated the Yellow Cloud, built by Minneapolis craftsmen and designed by Prince himself. The guitar features fingerboard inlays in the shape of the artist's personal icon, a stylized combination of the male and female symbols. It later appeared in a 1997 exhibition on the history of electric guitars, *From the Frying Pan to the Electric V.*

chairs as well as Duncan Phyfe's. In documenting the history of movies, television, sports, and popular music, the museum has recognized the achievements of individuals of a variety of ethnic and racial backgrounds, people like Irving Berlin, Groucho Marx, John L. Sullivan, Celia Cruz, and Dizzy Gillespie, entertainers and athletes whose cultural contributions were previously excluded from the Smithsonian's canon. In addition to highlighting diversity, these objects also suggest things that hold Americans together. In a diverse nation, popular culture has provided a basis for shared experiences and a national identity.

In Smithsonian exhibition halls today, as in Barnum's museum before, the imaginary now mingles with the real. Along with the relics of real people, today the Institution also acquires the relics of fictional characters from film and television. And with these relics have come new kinds of pilgrims—the fans, who arrive hoping for a magical encounter with a favorite celebrity through props and mementos. Some fans have even donated their hard-won treasures—autographs, record albums, memorabilia collections—to the Smithsonian as a symbol of their devotion. In 1998 curators acquired a pair of latex ear tips worn by Leonard Nimoy as the alien Mr. Spock in the 1982 film *Star Trek II: The Wrath of Khan*. The donor had purchased the Vulcan ears at a Star Trek fan convention in 1987 but ultimately decided to give them to the Smithsonian "to share such a treasure with the many other Star Trek fans" who might visit the museum.[66]

The addition of popular culture relics also makes for some odd encounters in the storage vaults. Whereas a century ago curators collected locks of presidential hair, curators now collect John Wayne's hairpiece. The ceremonial silver hatchet given to Davy Crockett by the Young Men of Philadelphia in 1835 is joined by a coonskin cap produced in the 1950s for young fans of the *Davy Crockett* television show. Both artifacts reflect an idealized image of Crockett—one manufactured by the Whig Party, the other by Walt Disney—but derived from an image originally created by Crockett himself. Which is more real? Does it matter? While exposing the lie of the image— the ruby slippers are not slippers made of rubies but sequined tap shoes and just one of the several pairs Judy Garland wore in the film—such artifacts can also reinforce the fantasy by making the image tangible and real.

In opening its doors to popular culture stars, the Smithsonian has plugged itself into the most powerful fame generator of all: the mass media. The rise of television, with its immediate and pervasive images, changed the nature of fame in the twentieth century. In deciding whom to add to its collection of notable Americans, curators wonder how they can keep up, how they can determine who is really worth remembering amid the media's relentless bombardment of faces and names, where anything and anyone can be hugely important one minute and completely forgotten the next.

Lives Worth Remembering

Some would argue that it is not really the Smithsonian's role to be a hall of fame. It should be instead a place where ordinary Americans can see themselves. It should portray American history as something made in people's everyday lives—by families and communities, not just exceptional individuals. And when the Smithsonian does spotlight individuals, it should not simply celebrate them as heroes but show them as complex human beings, with flaws as well as strengths.

Since the 1950s the Smithsonian has in fact emphasized stories of everyday life, presenting history through the experiences of ordinary Americans, not just the rich and famous. But history is made up of the stories people tell themselves about the past, and every story has its heroes. Famous Americans play an integral role in society, supplying victories ordinary Americans can share in, words and deeds they can be proud of, embodying—whether really or ideally—the traits they like to imagine they share as a nation. The Smithsonian's artifacts are touchstones for telling their stories and honoring their achievements. Yet they can also be building blocks and jumping-off points, enabling Americans to reinterpret an individual's life and reconstruct his or her memory in a new way. Old artifacts always hold opportunities for new discoveries.

For over a century, then, the Smithsonian has been a shrine to famous Americans. Its exhibit cases and storage vaults brim with objects linked to individuals who have entered the national historical pantheon. Drawn from the worlds of politics and war, arts and education, science and technology, sports and entertainment, these representative men—and, beginning with the 1912 creation of the First Ladies Collection, representative women—have starred in the pageant of American history that has unfolded at the National Museum. They have been celebrated as worthy role models, their lives singled out as worth remembering. If, in the words of the historian Leo Braudy, a famous person is not so much a person as a story about a person, then the figures honored at the Smithsonian symbolize stories Americans have wanted to tell about themselves, experiences they have cherished and claimed as their own.[67] They personify American values, aspirations, and achievements. Their lives, connected to major events and illustrative of broader themes, have helped the Smithsonian tell the story of American history.

But mementos of the famous do not simply materialize on pedestals in the museum. Like all artifacts, they must be brought to the Smithsonian by someone who believes they belong here. While some, like Washington's sword and Franklin's cane, have been enshrined by government decree, most have come bearing letters from devoted family members and friends, organizations, and other admirers who hoped to see the memory of a particular hero preserved. Some artifacts, like Muhammad Ali's boxing gloves, arrived with their celebrity owners in a flurry of flashbulbs, television cam-

Ed Roberts's wheelchair, about 1978. Outfitted with the type of seat used in Porsche automobiles and a large headlight for traveling at night, this motorized wheelchair captures the unique personality of a man who dedicated his life to securing rights, freedoms, and improved quality of life for people with disabilities. Ed Roberts, who was paralyzed by polio at a young age, began his activist career in 1962 when he fought for the right to attend the University of California at Berkeley. He went on to help establish the first independent-living centers for disabled people in the United States and traveled the world campaigning for disability rights. Roberts died in 1995, and after a memorial service held for him in Washington, D.C., friends wheeled his chair to the Castle and left it there with a note explaining that this donation was a tribute to Roberts's "amazing life." The unexpected gift has inspired curators to research the history of disability and seek new ways to include people with disabilities in the Smithsonian's story of America.

eras, and cheering fans. Others arrived more quietly, such as the wheelchair of the late disability rights activist Ed Roberts, which was left at the Smithsonian Castle by Roberts's friends with a note attached: "[This] is an important story." Some individuals were still living when their possessions entered the Institution's vaults; others lived only in objects and memories. Many were actively sought out by curators to fill an empty niche in the pantheon of history. But others had to fight to get in the door, overcoming barriers of prejudice and ignorance to claim their place.

The Smithsonian's collections thus preserve not only the stories of famous people but also the stories of why those individuals were chosen to represent America and of the people who chose them. As the historian Barry Schwartz points out in his 1990 essay "Reconstructing Abraham Lincoln," "Memory-making is an act of enterprise: before any one individual can be regarded as worth remembering, other individuals . . . must deem that person commemorable and must have the influence to get others to agree with them."[68] Embedded in every personal relic collected by the Smithsonian is a conversation, a debate, or a declaration about who is worth remembering and why. The answers—expressed in artifacts from Washington's sword to first ladies' gowns, from Muhammad Ali's gloves to Ed Roberts's wheelchair—reflect diverse and changing definitions of what it means to be famous and what it means to be American.

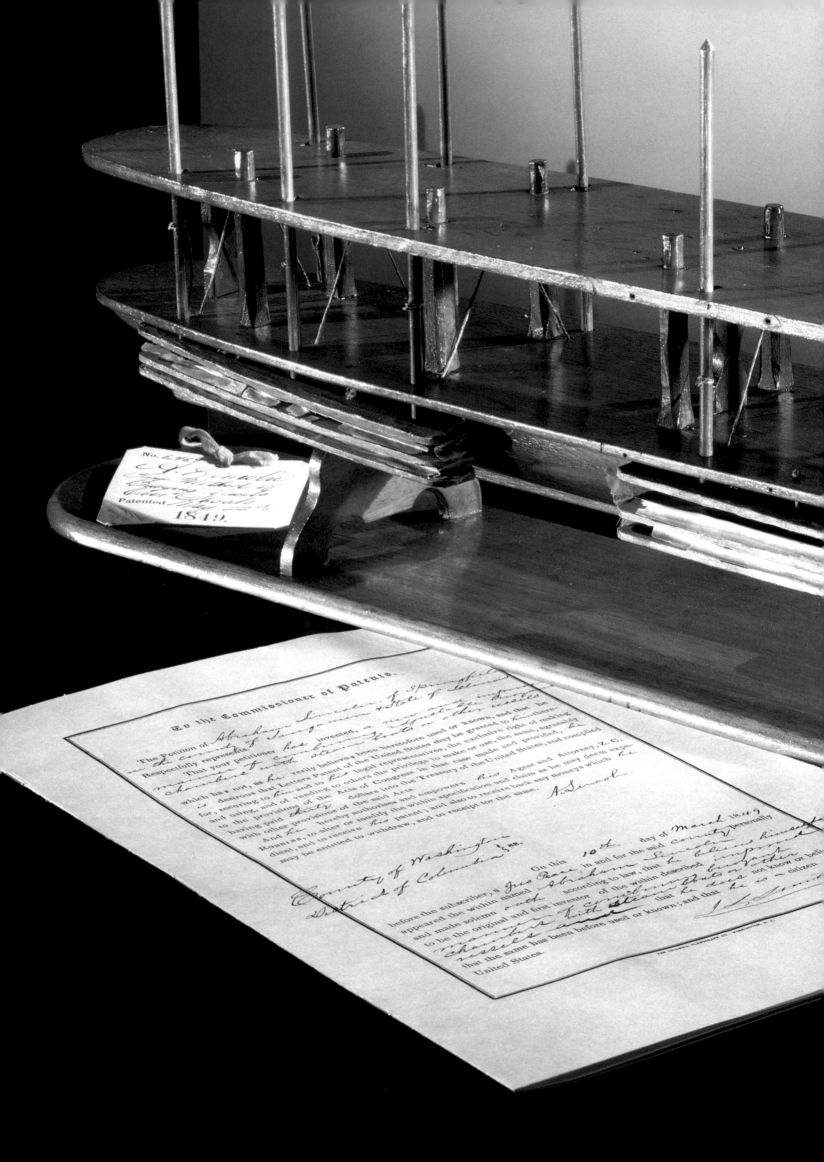

A Palace of Progress

Since its founding, the Smithsonian has reflected and promoted a gospel of progress. Its collections and exhibits have celebrated the material advances of modern society and honored the scientists and inventors who made these advances possible. Yet the Smithsonian has also long been a place where the nature of invention, innovation, and technological change has been debated.

Gilbert Chemistry Outfit for Boys, 1936. Children's toys often reflect widely held beliefs more clearly than the adult models on which they are based. The National Museum of American History's many science and technology toys, such as this chemistry set, collected in 1992, capture the essence of American beliefs about Yankee ingenuity.

Patent model and application submitted by Abraham Lincoln, "Method of Buoying Vessels over Shoals," 1849 (pages 120–21). The only American president to receive a patent, Lincoln came up with this idea in 1848, a result of being stranded on sandbars during his boat travels. Although his device was never manufactured, Lincoln held a life-long interest in technology and the inventive process. The Smithsonian acquired this model from the Patent Office in 1908.

I N MAY 1963 THE *WASHINGTON EVENING STAR* PULLED OUT ALL the stops for a full-page article on the newest Smithsonian building under construction on the National Mall: the Museum of History and Technology. Hailing the wonders of this "Museum with Widest Scope," the headlines announced that the "Big Marble 'Shrine' Is Coming Alive with First Exhibits," including the "Latest in Electronics." Splashed over the whole page, in the biggest type, was the bold proclamation: "New Smithsonian Unit to Be a Palace of Progress."[1]

At the helm of this monumental enterprise was the museum's director, Frank Taylor, described by the reporter as "a gentle, soft-spoken and modest man." Asked to comment on the significance of this "shrine of American pioneering and progress," Taylor replied that the new Smithsonian museum was a unique creation, "for under one roof it combines the history and technology of a Nation. In a country such as ours, we think these are inseparable because of the tremendous influence science has had on our way of living and our development."

The excitement surrounding the construction of the Museum of History and Technology invoked American attitudes toward science and technology that date back to at least the early nineteenth century. As a young nation founded on new ideas, the United States developed a national identity oriented toward the future, toward establishing, as the Constitution phrased it, "a more perfect Union." This willingness to experiment, to break with tradition and create new solutions to old problems, combined with an intense regard for individual freedoms, created a climate favorable to scientific and technological innovation. America gained a reputation as a land of invention, the home of Yankee ingenuity. Meanwhile, as industrial growth and new inventions began to revolutionize how Americans lived, worked, and played, many linked material progress to social progress, believing that advances in science and technology would in turn foster improvements in society.

Since its founding in 1846, the Smithsonian Institution has reflected and promoted this gospel of progress. Its collections and exhibits have celebrated the material advances of modern society and honored the scientists and inventors who made these advances possible. The museum has been a place to see how things improve over time, to compare the "primitive" devices of ancient days to the sleek, efficient modern designs of today. And, especially since the early twentieth century, it has been a place where American innovations and innovators take center stage, where progress is displayed to inspire patriotism and national pride.

Yet as a place dedicated to research in anthropology, the history of science and technology, and social and cultural history, the Smithsonian has also long been a place where the nature of invention,

Spinning frame from Slater Mill, Pawtucket, Rhode Island, 1790. This spinning frame, designed by Samuel Slater using an English model, was installed in Slater's Pawtucket mill, the first successful industrial mechanized textile mill in America. Preserved by the Rhode Island Society for the Encouragement of Domestic Industry, it was donated to the Smithsonian in 1883. "This relic," read the accompanying letter, "is most valuable—the first spinning frame ever started in America (1790)—the rude beginning of all that vast New England industry—cotton spinning and weaving." Although the society hesitated to let the spinning frame leave the state, it believed that the Smithsonian was the place "where the citizens of our Common Country may view it and learn of its history. No place offers a superior claim to your Department for the preservation of this valuable historical relic."

Gene gun, 1987 (lower right). Devised by John Sanford at Cornell University, the gene gun made it easier to introduce new genetic material into a cell. Genetic engineering, like so many other breakthroughs, raises important ethical and political questions. In recent years the National Museum of American History has tried to show both the technical and social side of scientific advance.

innovation, and technological change has been debated. In bringing artifacts into the collections and deciding how to display them, curators—among them scientists, anthropologists, engineers, and historians—have thought long and hard about the complex relationship of science and technology to people's lives and to American history. Their beliefs, scholarly research, and professional interests have shaped how the Smithsonian has collected and exhibited science and technology. In the 1880s scientists and anthropologists set the terms of the debate. By the early twentieth century, engineers made many of the decisions. In more recent years historians have had a larger say.

This chapter focuses on how the Smithsonian came to build a "palace of progress" on the National Mall. Politics and personalities shaped the way the National Museum told the story of science and technology. So too did changes in American culture: the conquering of the West and the related popular fascination with "vanishing" Native Americans; enthusiasm for technology at the turn of the twentieth century, when electricity and the telephone were changing American lives; world war concerns and Cold War fears; the questioning of technology in the 1960s and 1970s; and the fascination with electronics and computers in the 1990s. As a result of these social and cultural changes, the meaning of *progress* itself has changed, gaining new inflections and evoking different ideas. All along, the Smithsonian has reflected and helped shape the way Americans thought about science and technology.

Scientists and the Gospel of Progress

In its early days the Smithsonian Institution was a paradise for the scientist. Its first secretary, the great American physicist Joseph Henry, interpreted the Institution's mission—the increase and diffusion of knowledge—in purely scientific terms. With its lecture rooms and laboratories, the Smithsonian provided a place for scientists to conduct research and present their findings to the professional community. Indeed, especially with the expansion of government science after the Civil War, the Smithsonian became a critical hub of scientific activity in Washington, D.C., with many distinguished scientists making use of its facilities and contributing to its collections.

But there was more to the Smithsonian than lecture rooms and laboratories. Its collections were not to be kept only in storage drawers for scientists to study, although Secretary Henry might have preferred it that way. The U.S. National Museum was established as a part of the Smithsonian in 1858 to organize collections and display them

Transportation exhibition, National Museum (now the Arts and Industries Building), about 1890. In the late nineteenth century, the National Museum's technology collections included modes of transportation used by cultures around the world. Dog sledges from Alaska, wagons from New Mexico, elephant saddles from India, and a sled from Norway, complete with a reindeer, were displayed along with steam locomotives such as the *John Bull* (visible at the lower right).

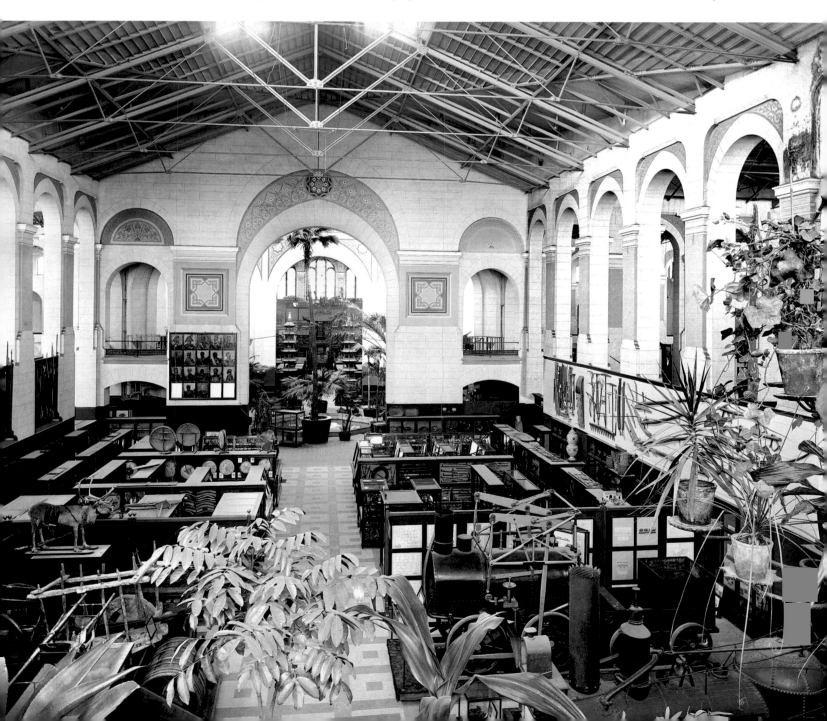

Photophone invented by Alexander Graham Bell and Sumner Tainter, 1880. In 1880 Bell established the Volta Laboratory in Washington, D.C., to undertake inventions beyond the telephone. That year he and his associate Sumner Tainter deposited at the Smithsonian two sealed tin boxes containing models and documentation of a device they called a photophone, which transmitted sound over a beam of light, and other apparatus. The inventors hoped that the sealed boxes would prove their priority in invention; they did not want to file a patent for fear of giving away secrets that would help competitors. When the boxes were finally opened in 1937, long after Bell's death, the inventions inside were historical relics, not technological breakthroughs.

for the public. And during the second half of the nineteenth century plenty of collections were coming in. Objects brought back by government exploring expeditions—not just flora and fauna but also tools, weapons, and cultural artifacts of indigenous peoples—were transferred to the Smithsonian's care. Anthropologists and naturalists went into the field and collected numerous specimens from the lands and cultures they studied, while amateur enthusiasts mailed in artifacts found in their own backyards. In 1876 thousands of artifacts left over from the Centennial Exhibition in Philadelphia were delivered to the Smithsonian.

For many years, however, the Smithsonian had precious little space to show off its collections. The exhibit galleries in the Castle were reserved mainly for natural history specimens, so most ethnological artifacts remained in storage, unorganized, because there was no room to display them. With the opening of the new National Museum Building in 1881 (known today as the Arts and Industries Building), curators finally had an opportunity to develop a comprehensive system for classifying and arranging human-made artifacts. They insisted that these artifacts, representing the technology and culture of humankind, should not be displayed in a random fashion but rather presented "in such a logical order that the great truths of human history may be told in the briefest and clearest way," according to the National Museum's 1898 annual report. Just what that "logical order" was proved a subject of endless debate among these early scientist-curators; it was "the all-important question."

More than any other individual, George Brown Goode helped shape the National Museum. Although by training a biologist, he was also a historian of science, genealogist, and, most important, curator and museum philosopher. Twenty-two years old when he joined the Smithsonian in 1873, he was put in charge of the Smithsonian exhibits for the Centennial Exhibition in Philadelphia just three years later. He also organized the Smithsonian exhibitions at many other fairs and was responsible, as assistant director of the National Museum, for installing exhibits in the Smithsonian's new National Museum Building in 1881. During the time he was at the Smithsonian, from 1873 until 1896, its collections grew from two hundred thousand items to more than three million. He was a true believer: "The degree of Civilization to which any nation, city, or province has attained," he wrote," is best shown by the Character of its public museums and the liberality with which they are maintained."[2]

Goode and his associates believed there were two basic ways to organize the Smithsonian collections. The first was geographical or ethnographical—the European method. Collections were grouped according to their tribal, national, or ethnic origin, thus transforming the museum into a miniature world. Moving through the museum, the visitor could "make his studies pretty much as he would make them in traveling from country to country." The second organizational scheme told the story "not of tribes or nations and their connection with particular environments" but rather the story of the "development of the race along the various lines of culture progress, each series beginning with the inceptive or lowest stages and extending to the highest."[3] Goode, as director of the National Museum in its new building, argued for this mode of display. Exhibits would be organized not by geography but by a functional or teleological approach, using classification schemes similar to the ones used in natural history. Like animals or plants, cultural artifacts would reflect evolution. Such was a biologist's way of thinking about history.

In the scientific jargon of the day, these exhibits were called synoptic series. (A *synopsis* is a table, chart, or exhibit that gives a general overview of a subject.) Each synoptic series "progressed" from the most "primitive" device to a recent example of a machine that performed that function. Techniques for making a fire, for example, ranged from a fire saw from Borneo and a lens for focusing sunlight from "Ancient Greece" (as the exhibit label read) to contemporary phosphorus matches and an electric gas lighter. A series of spoons included shells used as spoons in Mexico to a carved horn spoon from Alaska to a modern pewter spoon from England. Musical instruments progressed from a conch shell to a cornet. In 1898 the National Museum had on display eighty-one different synoptic series.

The focus on progress was apparent in every aspect of the collections. The instructions that Samuel Langley, Smithsonian secretary from 1887 to 1906, sent to his British agent in 1890 outlined the goal:

Boat Hall, National Museum, about 1890. Early National Museum collections combined technology and ethnology, documenting the inventions of various cultures and countries. The story of water transportation was presented through a comprehensive display that included Native American canoes, fishing boats from the West Indies and other parts of the world, and a series of models illustrating the evolution of nineteenth-century American fishing vessels.

SYNOPTIC HISTORY OF INVENTIONS
SPINDLES, SHUTTLES, AND LOOMS

"Make a collection of watch-movements calculated to show the principal steps in watch making from the beginning to comparatively recent times. . . . Only such are wanted as . . . are typical of the history of the watch, and calculated to instruct the public rather than to be of curious or professional interest."[4] Sylvester Koehler, curator of graphic arts from 1886 to 1900, wrote that "the technical process employed in the representation becomes the first thing to be considered, and the history of engraving consists in the record of the steps by which the various processes approached perfection."[5]

Goode, trained as a biologist but an ardent amateur genealogist immensely proud of the "purity" of his Anglo-Saxon ancestors, thought this scheme made good sense. It presented an evolutionary, almost genealogical, notion of progress: "Objects of a similar nature being placed side by side, musical instruments together, weapons together, &c., [are] arranged in such a manner as to show the progress of each idea from the most primitive type."[6] Each specimen in the synoptic series stood "not as an isolated product of activity, but for an idea— a step in human progress . . . and the order is such as to suggest to the

Synoptic series representing the invention of spindles, shuttles, and looms, National Museum, about 1890. This exhibit case depicting the history of textile manufacture is a typical synoptic series. On the far left in each of the three horizontal series is the most "primitive" example of the type. On the far right is a recent invention in the field from contemporary American industry. Looking from left to right, museum visitors could see each of the major advances, with examples drawn from China, Central America, Peru, Tibet, Finland, Germany, and the United States. Smithsonian curators believed that this kind of arrangement showed a fundamental truth about the progressive nature of technology while bringing together related artifacts in one case.

Tools for working leather and making shoes, manufactured by Wm. H. Horn and Brother of Philadelphia, 1884. World's fairs and expositions gave companies an opportunity to advertise their latest products and technologies, and the Smithsonian often helped collect and arrange objects to represent U.S. industries at these events. The Horn company sent a complete line of brand-new leather-working tools to the Smithsonian for inclusion in an exhibition at the World's Industrial and Cotton Centennial Exposition, held in New Orleans in 1884–85.

mind the broader truths of human history." In a glance a visitor could capture "the development of human thought and the gradual expansion of human interests."[7] The historian Arthur Molella calls this scheme a "progressivist vision of technical evolution."[8]

Not all of the National Museum's exhibits were in the synoptic style, however. Where there were duplicates of material for display, the museum created exhibits arranged by geography as well. By 1889, in fact, Goode described the museum as arranged by "a double system."[9] Otis Mason, the first curator of the museum's ethnology department, described his way of presenting both schemes: "Now, in a museum properly constructed it is possible to arrange the cases in the form of a checkerboard, so that by going in a certain direction the parallels of cases represent races or tribes or locations. By inspecting the same cases in a direction at right angles to the former, the visitor may study all the products of human activity in classes according to human wants."[10] Goode eventually decided that all of the museum's cases should be designed so that they could be easily moved from one organizational scheme to another. (This approach was not only ideologically useful but also practical: it allowed the cases to be rolled into the lecture room for lectures and squeezed more tightly together when space was needed for new collections.)

The debate over the proper arrangement of the cases, by technological evolution or by region, was more than a matter of personal whim or academic concern. Institutional politics played a role, as with all museum exhibits, but there were bigger issues at stake. In this instance, exhibit organization was a direct reflection of beliefs about the nature of civilization—beliefs about invention, technology, progress, and humanity. Smithsonian exhibits reflected widely held ideas. "Many intellectuals," writes the historian Steven Conn, "regarded museums as a primary place where new knowledge about the world could be created and given order." The world outside the museum might seem "increasingly chaotic and incomprehensible." But within its walls, "rationality and order could be maintained." Walking down the aisle of brightly-lit glass cases, museum visitors would learn that nature had an essential order, that technology evolved from simple to complex, and "that design could be revealed, understood, and controlled by rational science and scientists."[11] Americans were accustomed to "reading" the "language" of the artifacts around them and would find the rhetoric of the displays easily understandable.[12]

The foremost proponent of organizing the National Museum's exhibits by synoptic series and the curator who offered the fullest explanation of the idea was Otis Mason. A scholar of Mediterranean archaeology, he had taught anthropology and other subjects at Columbian Academy (now George Washington University) in Washington, D.C. In 1869 Mason came to work at the Smithsonian, becoming the full-time curator of ethnology in 1884. Here he developed his theories about the importance of invention, building a series of exhibits that showed the steps each civilization passed through as it rose "from savagery to barbarism to civilization." He believed that inventions should be classified, like natural creatures, along lines of evolution. "Anthropology," he wrote in 1899, "is the application of all the methods of natural history to the study of man."[13] This dependence on biological models made good sense at the Smithsonian of the 1880s and 1890s, when scientists were in charge and set the museum's tone—and its budgets.

Invention, as Mason saw it, was the story of the progress of the human race. He defined *invention* broadly, as a new implement, improvement, substance, or method in almost any field: "not only mechanical devices . . . but in the processes of life, language, fine art, social structures and functions, philosophies, formulated creeds and cults."[14] If the history of humankind was the history of invention, the inventor was the most important force in civilization. Inventors of a more "primitive" race might be inventing something already invented elsewhere, as they moved along the common path of progress and civilization, but they were nonetheless among the heroes of humankind. Mason rejected the myth of a few heroic inventors; to him all inventors were heroic.

A frequent subject of debate among nineteenth-century scientists was the creation of the human races, whether they descended from one common ancestor or were created separately. Mason believed the synoptic series demonstrated that the human mind everywhere produced the same inventions, that all races adhered to the same path of progress. The story of invention, Mason believed, traced all cultures back to a single source.

At the same time Mason thought it important to rank cultures on the basis of their inventiveness. Synoptic series could be read to show not just the overall progress of the human race but also the relative progress of the races. Indeed, synoptic series inevitably reinforced notions of racial hierarchy. "The Mediterranean race," Mason wrote, "is the most mechanical of all. . . . The Semite is much less so. The Mongolian is, perhaps, more ingenious with his hands. The Africans and the Papuans are more mechanical than the brown Polynesians; the Eskimo than the red Indians; and the Australians are the least clever of all." Yet even the Australians, Mason was quick to proclaim, had inventors among them. The boomerang, although an invention "of a humbler sort," had a history just as the rifle or the locomotive did.

Howe pin-making machine, about 1840. In 1910, when the son of a founder of the Howe Manufacturing Company offered the Smithsonian the first practical machine for making pins, curators jumped at the opportunity. The machine would "add a most interesting feature to the industrial collection," they noted, and would be a good first step in the "effort to build up a creditable collection to illustrate [the arts and industries], bringing out more strongly the practical side of the Museum."

"And there is not a patent office in the world," he added, "that would refuse to grant them" a patent on it.[15]

Gender, like race, was a key element in Mason's scheme of "culture progress." Women played a role not unlike the primitive races: they laid the foundations on which others built. "In that continental struggle called Progress or Culture," Mason wrote, "men have played the militant part, women the industrial [that is, productive] part." Mason studied "modern savagery" to understand "the activities of our own race in primitive times." "This teaches us," he wrote, "that women were always the first house builders and furnishers . . . the first clothiers. . . . They invented all sorts of . . . things employed in the serving [cooking] and consuming of food. . . ."[16] Woman's primitive work made possible man's more advanced work.

Technology exhibits at the Smithsonian reflected not only ideas about race and gender but also the politics of the day: the specter of communism and working-class radicalism. Mason and his colleagues assumed that invention and individualism went hand in hand, that inventors invented because they were rewarded for their inventions. In *The Origins of Invention: A Study of Industry among Primitive Peoples* (1895), Mason argued that "primitive" tribes were "kept behind in the march of civilization" because their cultures were not individualistic enough: "One of the greatest hindrances to more rapid progress among savages through the multiplication of inventions is their communistic system, their tribal intelligence and volition."[17] Mason saw individualism and self-interest as essential elements of invention and invention as the essential element in the progress of civilization. Visitors to the museum would certainly have gotten that message.

Fear of radicalism was also implicit in another way. General Pitt Rivers—founder of the Pitt Rivers Museum in Oxford, England, which was also organized by synoptic series and was a major influence on the Smithsonian—was explicit about the meaning of evolution in technology. According to Rivers, the sequential arrangement of a vast variety of artifacts proved that nature changes by slow evolution rather than by radical "jumps." An ignorance of this history meant that the working class was "open to the designs of demagogues and agitators." Visiting his museum and seeing the slow, evolutionary nature of change in civilization—proof through objects of the "law that Nature makes no jumps"—would encourage the working class to be wary of "scatter-brained revolutionary suggestions." The Smithsonian curators never ascribed such political power to their synoptic exhibits, which nevertheless carried the same message.[18]

Although Goode and Mason believed strongly in the synoptic style, the fruitfulness of analogies from evolution, and the universality of invention, their anthropological theory would not win out in natural history museums. The simpler style of organizing things by where they came from—generally by nation or tribe—was to triumph, partly because it provided the types of exhibits visitors most wanted to see.

Unlike Otis Mason, Franz Boas is still a well-known figure to anthropologists. Considered the founder of professional American anthropology, Boas worked at the Smithsonian as a consultant in 1894 and 1895 and then for several years at the American Museum of Natural History in New York City before abandoning museums for an academic career. He was a primary proponent of organizing ethnographic materials by tribe to emphasize the effects of the environment. Mason's model was basically biological; Boas argued for a historical and environmental model. In 1887 Mason and Boas exchanged views in a series of articles in the journal *Science*. Boas stressed uniqueness and individuality; Mason, system and unity. Mason saw the work of evolution everywhere, while Boas believed in cultural relativism and pluralism. Whereas Mason looked at generalities, Boas argued that each specimen needed to be studied in its own historical and environmental context. "Classification," Boas insisted, "is not explanation."[19]

Boas effectively demolished Mason's argument on logical grounds. Just because different cultures produced similar artifacts does not mean they had the same causes; analogy was not proof. Synoptic series, Boas argued, revealed more about the mind of the curator than the mind of the people being studied. For Boas, there was a larger principle at stake, too:

It is my opinion that the main object of ethnological collections should be the dissemination of the fact that civilization is not something absolute, but that it is relative, and that our ideas and conceptions are true only so far as our civilization goes. I believe that this object can be accomplished only by the tribal arrangement of collections. The second object, which is subordinate to the other, is to show how far each and every civilization is the outcome of its geographical and historical surroundings.[20]

Boas was primarily concerned not with general principles of technological or cultural development but with showing that cultures were different and that different cultures developed differently. He hoped to explain why those cultures developed—not by looking for general rules but by understanding each individual culture.

Although Mason never abandoned his theoretical arguments—and his protégé Walter Hough, who succeeded Mason as head curator of the anthropology department in 1908, continued to add to the synoptic series through the 1920s—Boas's arguments won the day. The Smithsonian started to add exhibits showing individual tribes. Life groups, or dioramas, were immensely popular, especially in the exhibits staged by the Smithsonian at the World's Columbian Exposition in Chicago in 1893.[21] Concern for the visitor, the historian Ira Jacknis suggests, helped push both Mason, at the National Museum, and Boas, at the American Museum in New York City, away from their theoretical positions and toward a similar attitude toward display. Mason included life groups, while Boas, realizing that his

Smithsonian exhibit, Louisiana Purchase Exposition, St. Louis, 1904. At most of the major world's fairs held in the United States in the late nineteenth and early twentieth centuries, the Smithsonian coordinated the U.S. government's exhibits and prepared displays of its activities and collections. In these exhibits the whole world was put in order, with ethnography, religion, and technology displayed according to carefully thought-out ideas about progress. The Smithsonian's exhibit at the Louisiana Purchase Exposition included the Langley aerodome, a model of a whale suspended from the ceiling, natural history exhibits, archaeological artifacts, and industrial machines.

audience was the general public, not anthropologists, added exhibits of "interest to the tradesman . . . showing the development of the trades of the carpenter, the blacksmith, the weaver, etc. in different cultural areas."[22]

While academic anthropology would leave Mason's naive evolutionary notions behind, aspects of his ideas would continue to shape Smithsonian exhibits for the next century. Exhibits can support only a fairly simple, straightforward narrative, and the concept of progress provides just that simple story. The myth of the autonomous progress of technology—proceeding according to its own evolutionary logic, shaping human culture but unshaped by it—would continue to provide the story line in Smithsonian displays. The theoretical base that Goode and Mason had built would disappear, but their ideology of progress would remain.

Men of Progress: Engineers and Experts

Otis Mason's *Origins of Invention* concluded with a paean to the primitive inventors who built the foundation for modern technological society: "The whole earth is full of monuments to nameless inventors."[23] But by 1895, when the book was published, the argument over display by synoptic series or by race or region was pretty much over, partly because of the triumph of Franz Boas's ideas and partly because the public was demanding livelier exhibits, especially dioramas. But for the story of the history of science and technology at the National Museum, another reason was even more important. Inventors and engineers had begun to gain prominence in American society, and curators were not interested in nameless inventors. Instead, they wanted to celebrate the "men of progress" who were transforming America.

Electromagnetic telegraph exhibit, Arts and Industries Building, 1930s. Although Samuel F. B. Morse and Joseph Henry, the first secretary of the Smithsonian, both claimed to have invented the telegraph, by the 1860s Morse was generally given credit and installed in the pantheon of American inventors. This exhibit included the first telegraph receiver, donated by Western Union to the Smithsonian in the 1890s; a portrait; and some of the many medals Morse received for his invention.

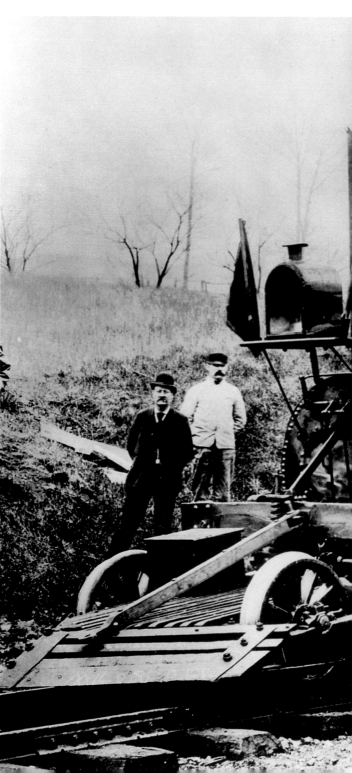

The *John Bull* locomotive on its way to the World's Columbian Exposition in Chicago, 1893. The Smithsonian agreed to loan the *John Bull*, which it had acquired from the Pennsylvania Railroad in 1884 (see pages 28–29), back to the railroad for display at the World's Columbian Exposition. The trip from Washington, D.C., to Chicago was a great public relations success; brass bands greeted the locomotive and its train at stops all along the way. At the fair thousands of visitors rode in cars pulled by the antique engine.

J. Elfreth Watkins was one of these men of progress. An 1873 graduate of Lafayette College in Easton, Pennsylvania, with a degree in civil engineering, he had gone to work as a construction engineer for the Pennsylvania Railroad. After an industrial accident cost him a leg, the railroad gave him a desk job. Becoming interested in the railroad's history, he published a history of one of its early lines on its fiftieth anniversary in 1884. Later that year the railroad allowed Watkins to work part-time at the Smithsonian as an honorary—that is, unpaid—curator of steam transportation. One of his first actions was to convince the Pennsylvania Railroad to transfer to the Smithsonian the *John Bull*, the "oldest complete locomotive in America."

The railroad industry liked seeing its history alongside the other national treasures at the Smithsonian. In the 1880s the railroads

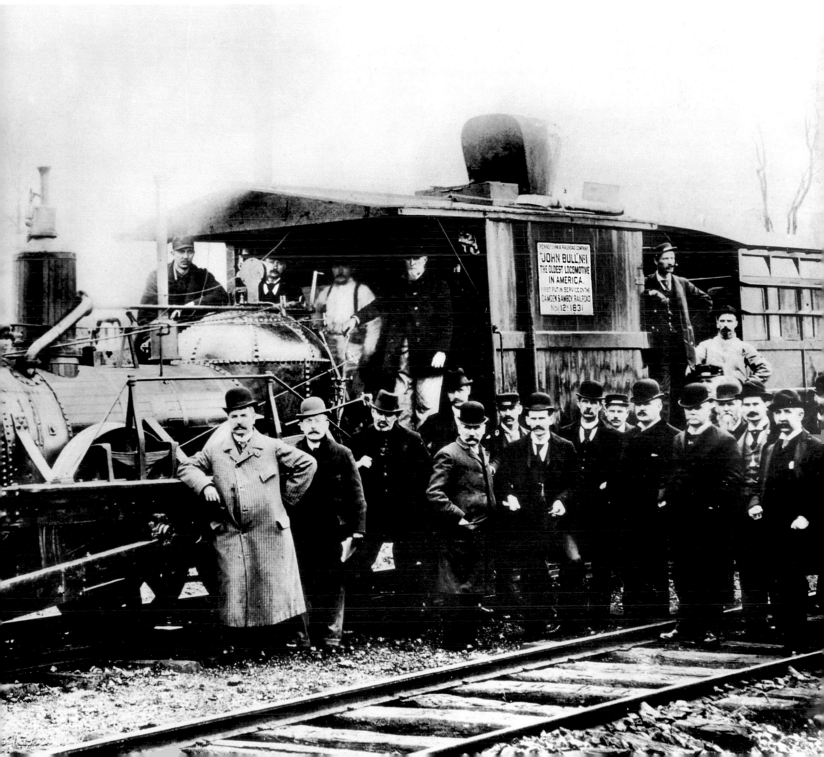

were the most powerful—and the most hated—corporations in the country. Watkins encouraged them to see the museum as a valuable public relations opportunity, a place to preserve and honor "the history of the Railway and Steamboat, the greatest civilizers of the century." In 1886 more than nine hundred railway officials petitioned Congress to add funds to the Smithsonian's budget for organizing a "Section of Steam Transportation" at the National Museum.[24] And railroad officials, used to flexing their muscles on Capitol Hill, knew how to get their way: "Under our system of Government, our representatives sometimes need a little pushing," is how one railroader put it.[25] Push they did, and Congress granted the extra funds to put Watkins on the Smithsonian payroll.

As curator, Watkins did the railroad industry proud. He sought out and brought to the National Museum both the relics of early American steam transportation and the latest technological advancements of the railroad industry. He wrote articles and books, including a history of railway track and a history of the Pennsylvania Railroad. He organized transportation displays at national and international fairs, such as the Ohio Valley Centennial Exposition in 1888 and the World's Columbian Exposition five years later, displays that in turn served as a basis for Smithsonian exhibits. Moreover, he continued to work on contemporary issues of interest to the railroad industry.

Watkins's collecting had far-reaching impact. He collected some of railroading's most precious relics: bits and pieces of pioneer locomotives. In addition to the *John Bull,* he found an original wheel of the *DeWitt Clinton,* a cylinder from the *Pride of Newcastle,* and the bell from the *Rahway.* He sent one of his assistants to explore the area around Honesdale, Pennsylvania, where the *Stourbridge Lion* had operated, and acquired the boiler and walking beam of that "first locomotive in the Western Hemisphere to run on a railroad built for traffic." (The *Stourbridge Lion* had little technological significance and was a practical failure, but as an American "first" it was enormously important to Watkins and the railroad history enthusiasts of his day.) In the 1880s, when Watkins began collecting, the first generation of railroaders was still alive. Watkins sought out people like Isaac Dripps, the mechanic who had assembled the *John Bull,* and pumped him for details about the early days of railroading.

In addition to historical relics, Watkins also collected the cutting-edge technology of his day. In 1889 David G. Weems, a Washington, D.C., inventor, built an electric locomotive that set a speed record; within a few years Watkins had acquired it for the Smithsonian. Some of Watkins's contemporary collections looked a lot like advertising. In 1888 the Allen Paper Car Wheel Company donated a cut-away version of its paper car wheel, originally built for the World's Industrial and Cotton Centennial Exhibition, held in New Orleans in 1884–85. The Pullman Palace Car Company, operators of a fleet of luxurious sleeping cars, were the largest users of the Allen wheel and great promoters.

Wheel from the *DeWitt Clinton* locomotive, 1831 (opposite top). In 1891 Smithsonian curators collected this early American railroad relic—a wheel from, according to the National Museum's 1891 annual report, the "first engine placed into service on . . . the oldest railway in the state of New York." On the wheel is inscribed "First Trip, August 9th 1831."

Allen Company paper car wheel, 1884 (opposite bottom). Invented by Richard Allen, a locomotive engineer, this railroad wheel featured a compressed paper disk that supposedly provided a smoother and quieter ride than cast-iron wheels. It was first displayed at the World's Industrial and Cotton Centennial Exposition in New Orleans in 1884–85 and collected by the Smithsonian four years later as an example of contemporary railroad technology.

Rail track cross sections, National Museum, about 1905 (below). Curator Watkins turned the anthropologist's synoptic series into a history of engineering. Rather than a progression from the most primitive type to the most advanced, his version of a synoptic series showed variations of modern types.

"Early notices of Pullman cars," writes the historian John White, "always seem to mention the wonderful paper wheels which silently and securely transported the car and its occupants across the country." And now they were on display at the Smithsonian.[26]

Although Watkins adopted some of the theories of invention that Goode and Mason had developed, especially in the "study series" he created to illustrate aspects of the technological evolution of the locomotive, he applied these theories in a very practical way. He collected like an engineer, not an ethnologist. He celebrated particular inventors, not anonymous invention. And he went beyond invention to celebrate the engineers, innovators, businessmen, and entrepreneurs who applied invention in the real world. Watkins was not a philosopher of collections, although he was a true believer. "I believe it true," he wrote, "that history perpetuated by things is more authentic, more valuable, than history recorded in words."[27] In his eyes railroad relics were as valuable in their own way as George Washington's sword or Ulysses Grant's medals. And early railroaders were national heroes, technological counterparts to the presidents and politicians enshrined in the Smithsonian's history collections.

Through Watkins's efforts, the story of technological progress told at the Smithsonian became primarily a story of national progress. Unlike his scientist predecessors, Watkins focused on the American story, using the English locomotives on which American ones were based as a preamble and paying little attention to primitive forebears. Watkins quite consciously tied technological progress to the progress of American democracy. Technology, he wrote, not only improved the "world's material progress" but especially benefited America: "Nowhere upon the face of the globe does mankind partake of the benefits of personal liberty to as great an extent as in free America. Without the railway and the telegraph . . . this enviable condition could not have been reached." The railroad in particular was

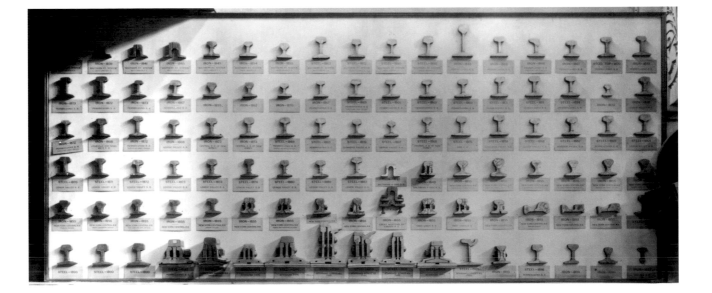

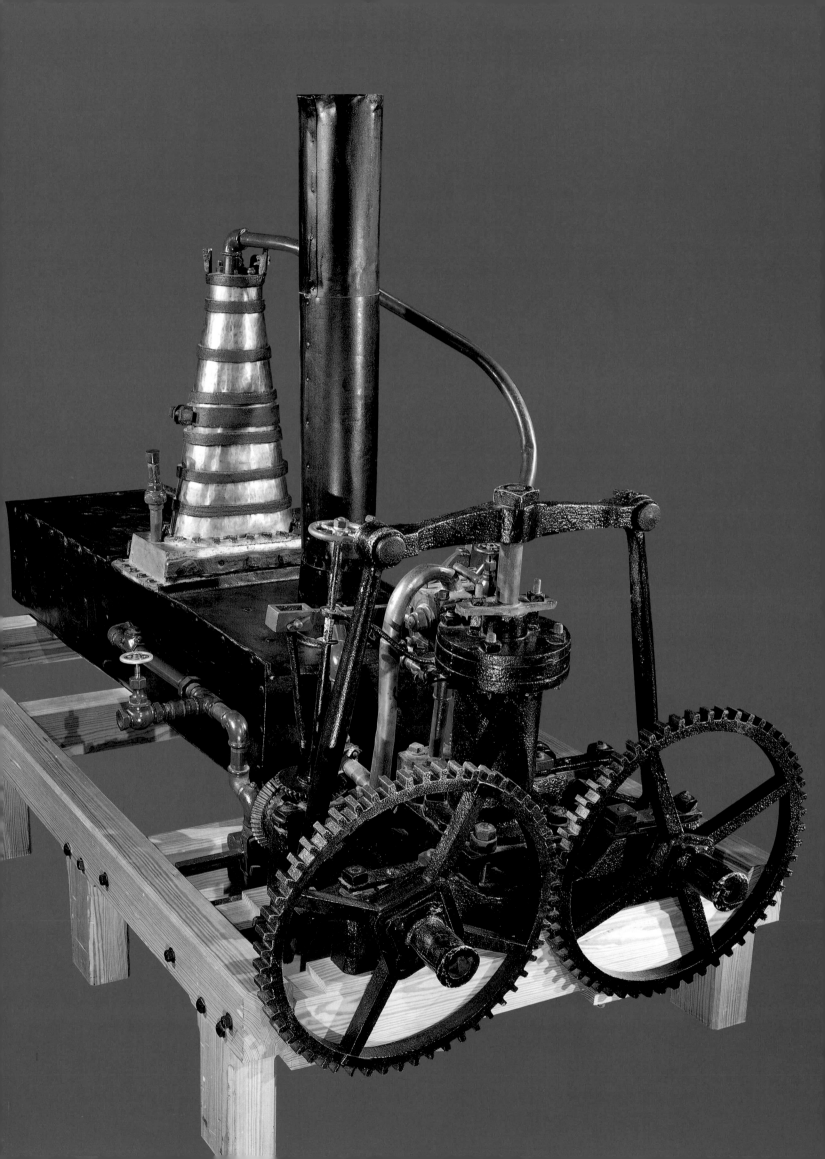

Alexander Graham Bell's telephone prototypes, 1876. Prototypes—working models that allow an inventor to think through the problems of bringing an idea to life—document the inventive process. In 1908 Bell presented to the Smithsonian a collection of his early telephone apparatus. Included were the 1876 liquid transmitter that relayed Bell's famous command to "Mr. Watson," and these devices, made a few months later, which he showed off at the 1876 Centennial Exhibition in Philadelphia.

Steam engine and boiler designed by John Stevens, 1804 (opposite). John Fitch, James Rumsey, Robert Fulton, and John Stevens all claimed credit for the first successful American steamboat, and material relating to each of their boats has been saved as relics at the Smithsonian. This engine and boiler, from Stevens's *Little Juliana*, represent the first successful use of a screw propeller. The "oldest surviving steam power plant built in America," according to its exhibit label, Stevens's engine was displayed at the World's Columbian Exposition in Chicago in 1893 and then sent to the Smithsonian.

responsible for bringing the country together: "We have become one people—speaking one language, actuated by a common impulse 'with malice toward none and charity for all.'" Watkins exalted the democratic power of technology, declaring that "the birth of the steamboat and locomotive were coeval with the establishment and first growth of this great Republic, and that by them were secured eternal Liberty! Union!! Peace!!!"[28]

Watkins was only one of the new breed of technology specialists at the National Museum. Joseph William Collins, a former Gloucester fishing-schooner master, applied his knowledge of fishing boats to build the National Watercraft Collection, begun in 1884. He had helped set up exhibits on American fisheries at international expositions and believed that half-hull models were a good way to illustrate "the progress of ideas and enterprise."[29] Thomas W. Smillie, hired as the Smithsonian's first official photographer in 1870, began to document photographic history and contemporary photography in the 1880s by collecting images and equipment. In 1888 he acquired Samuel F. B. Morse's daguerreotype camera, the first used in America. In 1917 Frederick Lewton, a curator of textiles who had temporary charge of the medical collections, urged the American Pharmaceutical Association to preserve at the Smithsonian the "many unique and irreplaceable objects" illustrating the early history of American pharmacy.[30] George Colton Maynard, curator of the electricity collections from 1885 to 1918, had been chief operator for Western Union in Washington, D.C., and had organized the city's first telephone exchange system. He used his connections to obtain material from Western Union, American Telephone and Telegraph, and inventors and engineers.

This next generation of curators had even less interest in the inventions of "uncivilized" peoples than did Watkins. Maynard proclaimed himself uninterested in "man the handicrafter" and focused instead on the artifacts of "civilized man," "man the mechanic."[31] For these new curators, the step from historic inventions to contemporary industry was a small one. As industry increased in importance and complexity and as technology became more removed from everyday experience, it seemed appropriate to provide more space for contemporary industrial displays.

Indeed, companies and trade associations provided the Smithsonian with numerous industrial exhibits during the early twentieth century. In 1905, for instance, the Libbey Glass Company of Toledo, Ohio, donated a display showing off its latest industrial techniques and products. Examples of modern American ceramics and glass, representing the application of industry to artistic pursuits, were eagerly sought by curators who considered it their mission "to educate the public taste, and to . . . forward the growth of the arts of design."[32] By 1924 the Smithsonian's annual report noted with pleasure that national trade associations "are becoming more appreciative of the National Museum as a means of informing the American public of the importance and scope of great American industries." The Rubber Association of America donated specimens to show rubber production, rubber manufacturing operations, and the role of rubber in communications, transportation, power, firefighting, clothing, health, home, toys and sports, and warfare. The American Brush Manufacturers' Association donated a representative series of animal fibers and specimens of brushes made from them. The National Boot and Shoe Manufacturers' Association and the United Shoe Machinery Corporation donated 119 specimens illustrating the production of woman's shoes. Displayed at the National Museum, these collections celebrated the achievements of modern American industry.[33]

During World War I, the National Museum created a number of exhibits at the request of the U.S. War Department, Red Cross, and U.S. Food Administration. Visitors could learn how to knit and crochet articles of clothing for soldiers, discover new ways to use fats and oils, and get advice on conserving food. Experts from the U.S. Department of Agriculture built a model kitchen and gave demonstrations for housekeepers and war workers. Lectures included "Food for the Family on $2 per Day," "What Becomes of the Consumer's Dollar?" "What Do You Give Your Children to Eat?" and other equally pragmatic topics.[34] Meanwhile, the lobby and exterior grounds of the new Natural History Building were filled with a large collection of World War I artifacts, including weapons, uniforms, and captured enemy equipment—an immensely popular exhibit. (At the start of World War II, some of the captured German weapons were melted down for the war effort, yielding one hundred tons of steel.)

The National Museum of the 1910s and 1920s was, in many respects, a place dedicated to progress. It educated the public not only about the history of science and technology but also about how modern inventions and industries could benefit Americans in their own lives. Its exhibits embodied the spirit of the Progressive Era, a time of widespread education and reform efforts aimed at improving how Americans lived, worked, and played. By applying the lessons of science and technology to daily life, many reformers believed that the social problems of crime, poverty, disease, overcrowded cities, and

Glass platter, Libbey Glass Company, about 1904.
From an exhibit illustrating the manufacture of glass, this platter depicts the process of glass cutting and engraving. The exhibit demonstrated the links between art and industry as well as "national pride," noted the Libbey Glass Company of Toledo, Ohio, which presented the platter to the Smithsonian in 1905.

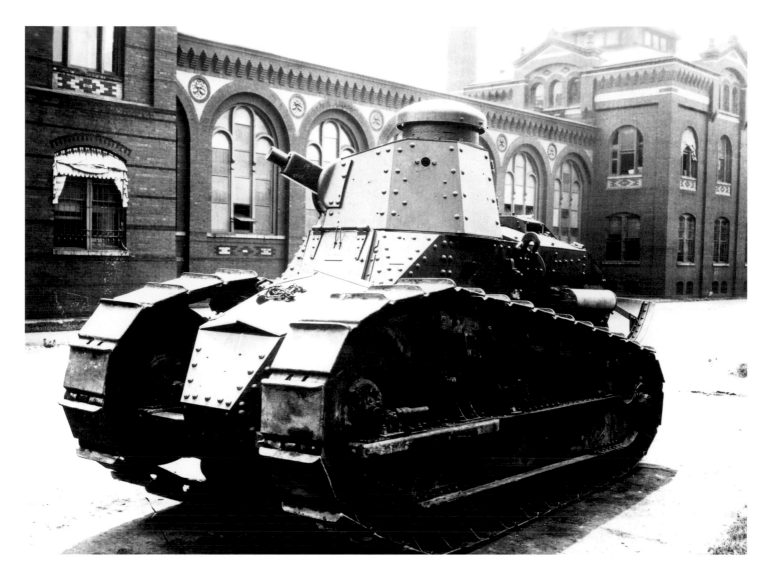

Allied tank outside the Arts and Industries Building, about 1920. After World War I the Smithsonian collected war artifacts and exhibited them in and around the Arts and Industries Building and in the rotunda of the Natural History Building. The Smithsonian's 1919 annual report underscored the importance of "graphically illustrating the military, naval, and aerial activities not only of our own side of the conflict but of that of our opponents as well."

unsafe working conditions could be alleviated, thus enabling the nation to progress to a new level of health, wealth, and happiness. Consider this 1925 display, a model village to "illustrate in allegory the never-ceasing struggle of health against disease":

A section of a village is shown with a wall obstructing the entrance of diseases represented as beasts, from a dark and gloomy forest. This model emphasizes the fact that disease prevention is everybody's work, and that each individual owes it to himself and the community to render active assistance in this struggle to increase the life span and make the world a better place in which to live by complying strictly with all health laws and regulations.[35]

By dispensing advice on hygiene, housekeeping, and nutrition, demonstrating new and improved industrial machinery, or illustrating the arsenal of modern weapons developed to fight America's enemies—be they germs or Germans—the Smithsonian offered visitors abundant evidence that technological progress was indeed making the world a better place.

Proposed: A National Museum of Engineering and Industry

Into this Smithsonian—where Walter Hough was still producing synoptic series for exhibition, George Colton Maynard was collecting the latest from the telephone and electric power industry, and an increasing amount of display space was given over to popular education and contemporary industry—came Carl Mitman. An engineer, Mitman became chief curator of the museum's technological collections in 1919, focusing his energies not on invention, industry, or transportation but on engineering and science. Mitman's "highest priority," writes Arthur Molella, "was to provide the American engineer a recognized and respectable place in history"—to give engineers a place among the others in the Smithsonian shrine. To this end he wrote many biographies of engineers for the *Dictionary of American Biography*, refocused exhibitions so that the history they presented would address contemporary issues and explain the principles of engineering, and worked to establish a new museum at the Smithsonian: a National Museum of Engineering and Industry.[36]

The time was ripe for a new museum. The 1920s and 1930s were an "extraordinary era of transformation for older American museums, and of genesis for new ones," writes the cultural historian Michael Kammen.[37] Both engineers and museum experts argued that the United States, as an industrial nation, particularly needed museums of technology and industry.

Proposed design for the Museum of History and Technology, 1957. Carl Mitman's proposed National Museum of Engineering and Industry was not to be. But thirty years later, in 1955, his protégé Frank Taylor would succeed in winning congressional approval for a new Museum of History and Technology. Taylor's museum would combine scientific, engineering, and technological collections with collections of social, cultural, and political history. In this 1957 architectural rendering of the new building, a classical female figure represents History, a classical male figure Technology; they are shown proudly separate, History on the left side of the building, Technology on the right. In another proposal from the same date, they stand together in the center of the façade. Within the museum, collections and exhibitions reflected both attitudes.

Those who envisioned new American museums of industry and engineering were inspired by Europe's industrial museums. The Deutsches Museum in Munich—first proposed in 1903 and formally opened in 1925, with more than 250,000 square feet of exhibits—was the model for most of the new American industrial museums. The Technisches Museum in Vienna, Science Museum in London, and Conservatoire des Arts et Métiers in Paris also presented attractive models. Indeed, competition with these European museums and a chauvinistic sense that the United States needed to lead in this field helped encourage proponents of an American industrial museum. Charles Richards, director of the American Association of Museums, wrote in 1925:

We are today one of the foremost industrial countries of the world. Can we afford to omit from our educational program the story of what has made us? We have developed a high type of industrial organization and as a people we are the first to utilize the fruits of new inventions. Shall we leave other nations to grow wise through the study of our achievements, and ourselves neglect their meaning and their inspiration?[38]

In cities across the country industrialists began planning new museums, including the Franklin Institute in Philadelphia, Henry Ford Museum outside Detroit, Museum of the Peaceful Arts in New York City, and Museum of Science and Industry in Chicago. Henry Ford had been collecting materials since about 1920 for his museum, which he founded in 1928 and opened to the public in 1933.[39] The Museum of Science and Industry, which also opened in 1933, was founded by the Sears, Roebuck and Company magnate Julius Rosenwald. Rosenwald had visited the Deutsches Museum in 1916 and had been enormously impressed by his fourteen-year-old son's fascination with its interactive exhibits. "American inventive genius needs greater stimulation and room for development," Rosenwald said. "I would like every young growing mind in Chicago to be able to see working models, visualizing developments in machines and processes which have been built by the greatest industrial nation in the world."[40]

Almost all of these museums made a remarkable choice. Not only would they teach about technology and industry; they would teach in large part through history. Why did industrial museums turn to history?

Industrial museums' turn to history was part of a national turn to history. During this period, the historian Michael Kammen notes, there was a general feeling that a nation's culture must inevitably be derived from its history. In an era when it seemed that things were spinning out of control, many intellectuals and politicians believed that history taught in museums might help connect Americans to a shared past, a larger purpose, a common heritage. Museum experts argued strongly for museums' role as educational institutions and for their place in improving American's sense of history and citizenship. Museums offered a chance, as Henry Ford put it, "of preserving at least a part of our history and tradition."[41]

Engineers looked to museums of technology and industry to secure their own place in history. Engineers in the 1920s experienced a new sense of importance and power, but they continued to suffer from status anxiety, a feeling that they needed to prove their value to the country. They believed that museums of technological and industrial history would showcase the importance of engineering to the nation.

Industrial museums also turned to history for educational purposes. "There is little question," wrote Charles Richards, "that a comprehension of modern highly developed processes and apparatus can best be gained by displays that first set forth the primitive method, or at least the simplest embodiment of an idea, followed by the important progressive steps in their historic order." By using history, an industrial museum could claim for modern industry all of the improvements of past, telling the "amazing story of the inventions, devices, machines, and methods that the nineteenth and twentieth centuries have brought to bear upon our daily life."[42]

Moreover, curators argued, history could benefit modern industry. Richard F. Bach, associate in industrial art at the Metropolitan Museum of Art, urged that the distinction between high art and industrial design be abolished and that museums cooperate with the producers of American industrial art. The manufacturer should regard the museum as "an addition to his own facilities of production" and for that a new definition of progress was needed: that "the new thing is better because it is based upon study of the old."[43] Even Henry Ford, notorious for his disdain for conventional written history, appreciated this argument. "Whatever is produced today has something in it of everything that has gone before. Even a present-day chair embodies all previous chairs, and if we can show the development of the chair in tangible form we shall teach better than we can by books."[44]

But industrial museums could do more than just teach history and technology, improve design, and impress visitors with the importance of industrialists and engineers. They could also make museumgoers better people, better citizens. Charles Gwynne, of the New York State Chamber of Commerce, expressed a widely held fear that the modern industrial system "narrowed" people: "Each man and woman, specializing in some phase of a single industry and living within the

Coal mine model, Arts and Industries Building, 1920s. Smithsonian curators planning a mining exhibit in 1914 aimed "to prepare a model reproduction of each important type of mineral industry operating in the field, tracing conditions and processes from natural occurrence to finished products." This exhibit, on display for thirty years, was dismantled in the 1940s because the processes it showed were "technologically obsolete."

confines of that industry, forgets that there is anything else important in life outside it."[45] Industrial museums, by revealing the bases of American economy, would help people understand the workings of the modern world. In contrast with the Far East or even the West's recent past, Richards wrote, "The processes of production that underlie the civilization of today are hidden behind factory walls where only the specialized factory worker enters." In a museum these important processes could be revealed and explained to the public "in the simplest and clearest possible fashion."[46]

Carl Mitman, head of the National Museum's mechanical and mineral technology department, drew on all of these arguments in his proposal for a new Smithsonian museum. He devoted years to his attempt to persuade the Smithsonian, Congress, and the engineering community to support the proposed National Museum of Engineering and Industry. Mitman's address to the Smithsonian Board of Regents in 1920 touched chords patriotic, chauvinistic, and institutional:

The commanding place in the world which the United States has reached in the short space of seventy-five years is due largely to the full development and utilization of mechanical power in the exploitation of her natural resources. It is this that has made it possible for the people of the United States to enjoy a standard of living far and above that under which the people of the rest of the world exist and still no public sign of appreciation either national or otherwise is to be found anywhere. What more suitable monument could there be, therefore, than a Museum of Engineering, and where could there be found a more logical place for it than as part of the great National Museum?[47]

Mitman and the engineers who supported him had grand plans for the new museum. They wanted an engineers' "hall of fame," which would demonstrate that "engineers, inventors, and scientists have played as important a role in the nation's history as diplomats, politicians, and generals."[48]

A technological museum—an engineers' museum—would teach technology and boast of its importance to modern society. It would display machines sectioned, to show their inner workings, along with re-creations of coal mines and other industrial settings. It would use historic examples to explain technological processes but would not explore the way technology shaped and was shaped by society and culture. There would be, Molella points out, "no attempt to address inherent social problems." A National Museum of Engineering and Industry would carry a straightforward message of technological progress.[49]

Mitman's new museum never came to fruition. One reason was simply the Smithsonian's conservatism, what Mitman called its "old fogyism." Another was that the Smithsonian leadership had decided to give priority to a proposed museum of history and art (which also ultimately failed to materialize). In addition, Mitman never got the political or economic support he needed. By 1930 the proposed National Museum of Engineering and Industry was dead.[50]

A Museum of History and Technology

uring the 1930s and 1940s the expansive mood of previous decades receded. The Smithsonian's secretaries during this period—the astrophysicist Charles G. Abbott, who served from 1928 to 1944, and the ornithologist Alexander Wetmore, who served from 1944 to 1952—were more interested in research than exhibits. Museum exhibits and collections remained focused on contemporary science and industry. Visitors in 1940 encountered graphic panel displays on such topics as "Why the Scientist Studies Skim Milk and Whey." The Ford Motor Company contributed specimens "demonstrating the utilization of soybeans as raw material in the automobile industry." Four dioramas depicted steel making.

Technology curators concentrated on creating a "chronological record of the nation's industrial progress" by collecting various machines, devices, tools, and products that illustrated various milestones of invention and innovation.[51] In the 1940s, for example, medical technology curators acquired the first Emerson iron lung, the first portable X-ray machine known to have been operated successfully on the battlefield, and one of the earliest American X-ray machines; in a more traditionally historic mode, they also acquired the Squibb pharmacy collection, which included an entire eighteenth-century apothecary.[52]

But Carl Mitman's grand plans were not forgotten. Frank Taylor, who had been Mitman's assistant in the 1920s, succeeded him as head of the engineering and industry department in the 1940s. In 1946 Taylor proposed a National Museum of Science, Engineering, and Industry. Instead of focusing on historic machines, Taylor's proposed museum would feature "real exhibits which will memorialize the pioneers and venturers and offer instruction in history as well as current information in its fields." These exhibits, designed for the average visitor as well as the student and scholar, would be organized in a new way. Rather than just a "step-by-step chronological development of subjects," they would encompass a variety of topics, historical and technical. The museum's maritime section, for example, would include traditional exhibits such as *The Small Sailing Craft of New England* and *What Was a Clipper Ship?* But it would also address issues of more contemporary interest, with exhibits such as *The Need for International Agreement on the Eight-Hour-Day at Sea*.[53]

Taylor's museum, like Mitman's, was not to be. But the Cold War inspired a renewed emphasis on American history and on technology. Engineering groups once again lobbied the Smithsonian for a technology museum to show off their successes. The result was a compromise: a museum that included not just engineering and industry but also the political, military, and European and American collections—everything except art, natural history, anthropology, and aviation. On June 20, 1955, the U.S. Congress appropriated funds for a Museum of History and Technology, the "palace of progress" that would eventually open in 1964.

1913 Model T Ford (opposite). After twenty-two years Harvey Carlton Locke could hardly bear to part with his 1913 Model T Ford. "I wish to see her," he wrote the the Smithsonian, "in some museum where she will be looked after as I have done all these years." The Smithsonian needed a Model T to illustrate the development of the automobile and accepted his offer. With this sign on the back of the car, Locke drove it from his home in upstate New York to Washington, D.C., to deliver it to the Smithsonian (see page 228).

European apothecary, 1400s–1800s (above). In 1945 the Smithsonian acquired its European Apothecary Collection, a loan from E. R. Squibb and Sons, which had displayed it at the 1933 Century of Progress world's fair in Chicago and then in its corporate museum in New York City. The "Ancient Apothecary," as its label referred to it, included among its 1,100 artifacts pharmaceutical containers, mortars and pestles, scales, and other equipment from throughout Europe, dating from the fifteenth through the nineteenth centuries. The company later donated the collection to the Smithsonian.

Hall of Health, Arts and Industries Building, 1957 (below). Replacing the old Public Health gallery was the new Hall of Health, which featured a clear plastic figure of a woman that made use of electronics, light, and sound to show the female body's major organs. The hall's theme was "Through the Ages, Man's Knowledge of His Body."

The name of the new museum reflected the compromise: history *and* technology. The relationship of the technological collections to the rest of the Smithsonian remained a matter of debate. Should they be separate, judged in technological terms, and exhibited on their own? Or should they be part of the bigger story of history, judged in historical terms, and exhibited in context to illustrate larger themes? Over time Smithsonian collections and exhibits have reflected different answers.

Planning for the new Smithsonian museum involved hiring new staff and renewed collecting of historic scientific and technological artifacts. In some fields, such as iron and steel and petroleum, curators thought it appropriate to display models of contemporary industrial plants, contrasting them with models of earlier technologies. Curators responsible for railroad and civil engineering history hired model makers to create models of the most significant breakthroughs in their fields, producing exhibits that were time lines of technological advance—in essence, modern synoptic series. In other fields, such as mining, curators turned to collectors and companies for artifacts, acquiring several hundred mining lamps, several dozen rock drills, and hundreds of linear feet of archives. Some artifacts came from universities; for example, both the University of Pennsylvania and the University of Illinois donated historic dental equipment. Physics departments across the country donated old teaching apparatus. Agents were hired to roam the countryside, visiting mines and mills and factories, asking for old machines.

The curators who built the collections in the 1950s and 1960s had strong feelings about history, technology, and what was important in the history of technology. For the most part they defined *history* as ending about 1900. *Technology* meant the machines themselves, not the bigger industrial systems that encompassed those machines. Moreover, the curators tended to gauge importance in a narrowly technical way. Articles associated with famous names were highly valued, as were those representing more advanced, high-technology industries. Collections emphasized the "early" and "important" over the ordinary and typical. For example, the early machine tool industry, a key to American industrial growth and representative of the most skilled industrial labor, was well represented by numerous pre-1860 lathes, milling machines, and planers. The curators' personal interests also played a role. One curator's experience in the Connecticut brass industry led to the acquisition of several dozen early machines representing that area. Such standards, reinforced by dependence on donations by industrial firms and the traditions of collector communities, shaped the bulk of the technological collections at the Museum of History and Technology.

Contemporary and cutting-edge technology also remained an important focus of the collections. Curators acquired numerous objects to represent recent breakthroughs in medicine, computer science,

chemistry, physics, and other fields. Prototypes of noteworthy inventions offered insight into the inventive process as well as potential inspiration to young Americans, who during the Cold War competition were being encouraged to pursue careers in science and technology. As in the past, industries and government agencies helped promote the gospel of progress at the Smithsonian. In 1959, for example, as curators planned the Hall of Nuclear Energy for the new museum, the Arts and Industries Building hosted *You and the Atom*, a traveling exhibition developed by the Atomic Energy Commission and staffed by local high school students recruited to demonstrate portions of it to visitors.[54] Through such popular programs and exhibits, the Smithsonian continued to cultivate the role it had established during the early twentieth century as a place where Americans could learn about the benefits science and technology brought to their lives and see themselves as the fortunate citizens of a nation of progress.

Although the new museum featured many new objects, many of its exhibit galleries continued to tell the same kinds of stories that J. Elfreth Watkins had first started telling at the Smithsonian in the 1880s: stories of technological progress. The Hall of Petroleum illustrated "the history of the advances made in the technology of prospecting, well drilling, and the refining of petroleum." The Coal Hall—never built—would have depicted "the evolution of mining methods" as well as the "development of mine safety methods." The Hall of Iron and Steel revealed "the development of methods for the production and fabrication of these basic commodities."[55] Techniques might be better and interpretation more didactic, but the story told was the same. The curator of the new Hall of Civil Engineering insisted that "it is absolutely essential that the exhibits be attractively displayed, and most vital, arranged with some sort of continuity and interpretation . . . a story must be told, and told effectively." But the story was a very simple technological one: a chronological sequence based on materials, variation in structural type, and the "progress of theoretical and practical knowledge."[56]

Science exhibits, meanwhile, picked up where Otis Mason had left off, tracing the development of scientific knowledge across cultures and times, telling a single story of human progress that culminated in the achievements of modern Western civilization. Displays on the history of physics and astronomy, for example, began with the Egyptians and then touched on Chinese, Babylonian, Greek, and Islamic contributions before moving on to the scientific revolution of seventeenth-century Europe. Chemistry exhibits started with the medieval alchemists and then progressed to the chemical revolution of the eighteenth century before showing "working models and original early products of chemical plants."[57]

Yet just as Mason's synoptic series had shared the stage with Franz Boas's life groups a half century earlier, there were exhibits in the

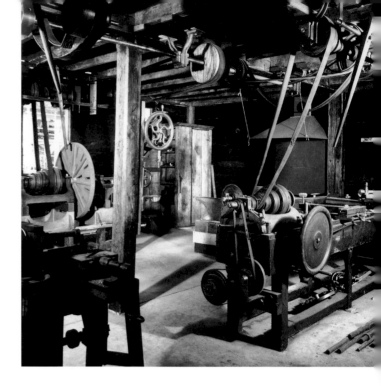

Machine shop, 1850s, Museum of History and Technology, about 1965. While some exhibits at the new Museum of History and Technology displayed objects in cases, many featured period settings: furnished rooms, shops, even factories. This machine shop was set up more as a showcase for the museum's fine collection of early machine tools than as a reproduction of a typical shop of the period.

Agriculture Hall, Museum of History and Technology, 1960s. The technology halls of the new museum included full-size artifacts, models, photographs, and bold graphics. This exhibit on the development of the reaper highlighted technological changes and improved labor efficiencies.

Moorish astrolabe, 1691. Collections of early scientific instruments, the cornerstone of the great European science museums, were eagerly sought by the new Museum of History and Technology, and in 1959 the Smithsonian acquired the Samuel Verplanck Hoffman astrolabe collection. "We have some wonderful collections of late American scientific instruments and technical devices," wrote Smithsonian Secretary Leonard Carmichael to IBM, asking for funds to acquire the collection. "We are, however, rather lacking in collections to illustrate the early development of man's thought in regard to exact measurement and calculation.... This collection as a whole is one of the finest ever accumulated of these typical scientific instruments and really early calculating devices as developed in Medieval and Renaissance Europe and the Near East."

new Museum of History and Technology that suggested different ways of understanding technology. Numerous period settings were created to show machines and tools in their original context as part of a historical environment rather than simply lined up in chronological order or categorized according to form and function. These exhibits illustrated places for invention, production, and use of technologies: old-fashioned machine shops, clock shops, laboratories. The Hall of Medical Sciences alone featured an eighteenth-century German apothecary, an 1890s American drug store, an early-twentieth-century bacteriology laboratory, a late-nineteenth-century hospital ward, and reconstructions of three dental offices.[58]

Although popular with visitors and curators alike, these period settings still remained more illustrative than interpretive. They were designed to serve, as the official museum proposal described them, as "chronological exhibits of the growth of our American civilization"; they provided snapshots of "important steps in our agricultural and industrial development" rather than detailed considerations of how technology fit into the lives of the people who made and used it.[59] Visitors could push a button, study a diagram, or watch a demonstration to discover how a machine worked as well as examine a diorama depicting an environment in which the machine was made or used.

But ultimately visitors were encouraged to draw two simple conclusions from these displays: technology had improved, and technological progress had made life better. In their plan for the new museum, curators anticipated that the Hall of Textiles, for example, would convey a strong message of progress: "No one who thinks of our modern world can fail to realize the role that the sewing machines of factory and home have played in the emancipation of women from monotonous toil.... The thoughtful visitor who studies them learns not only a mechanical but also a sociological lesson of importance."[60] When curators related technological discoveries to everyday life, it was mainly to demonstrate the labor- or life-saving properties of modern inventions. Overall, exhibits and collections emphasized the machines, processes, and great inventors who developed them; machines, not people, provided the context for understanding the history of science and technology. In essence, the new exhibits reinforced the old narrative of progress and technological evolution.

The Search for Firsts

The Museum of History and Technology, in short, developed out of long-established Smithsonian traditions. Although the old synoptic series had disappeared and the collections included a broader range of material, many old attitudes and practices remained. In part, this was symptomatic of the inertia fostered by large collections, extensive exhibitions, and a government bureaucracy. Yet the Institution also remained true to well-entrenched cultural notions of technology. It was difficult to overcome the fascination with progress, and few saw any reason to try.

In his *Catalogue of the Mechanical Engineering Collection in the United States National Museum* (1922), Carl Mitman had written:

> The primary object of these collections is to visualize broadly the steps by which advances have been made in each field up to the present day; to show the layman the fundamental and general principles which are the basis for the developments, and to familiarize the engineer with other branches of engineering than his own.[61]

Steps, advances, developments—much of Mitman's catalogue, like many exhibitions, was devoted to sorting out firsts. Firsts were less important in synoptic series, but when curators began to assign credit for invention and innovation, sorting out firsts become critical—and controversial.

Smithsonian curators were not interested in telling a story of the typical and the everyday; they were telling a story of progress. And they were telling it by looking backward, finding the technological innovations that brought the path of technology toward its present state. They were looking for firsts. In a 1921 letter to a disgruntled inventor, Charles Abbot, then assistant secretary, explained the purpose of the Smithsonian's exhibits:

> The Museum's chief desire is that its exhibits, along technical lines particularly, shall visually portray the history of progress in that line so far as the same may be done by displaying well labeled authentic devices or apparatus or copies thereof. In view of the limitations of space it is necessary to limit such exhibits to the devices marking the most important steps in the art.[62]

The appeal of firsts is clear. Consider this 1970 letter from Claude S. Beck, professor of surgery at Case Western Reserve University, to the Smithsonian:

> I have in my possession the defibrillator that first reversed death in the human heart. This occurred in 1947. This is an historical achievement upon which all heart surgery is based. It is the basis for reversal of the fatal heart attack. If the Smithsonian Institute *[sic]* cares to accept this defibrillator, I shall present it to the Institute.[63]

How could one turn down such an offer? At the same time, however, Beck's work was only one step in a long history of defibrillation

Oliver Marsh pocket watch, about 1852 (above). The first firm to mass-produce watches by machine was the American Waltham Watch Company. Marsh, one of the firm's founders, designed and made this watch as a prototype. The watches the company produced in volume were much simpler. In 1974 the owner, believing that so important a watch belonged in the nation's museum, donated it.

Hookless fastener no. 2, 1914 (below). The zipper was not the result of a single flash of inspiration: the process of invention took at least forty years and included many "firsts"—first patent, first successful design, first commercial use. This design, the first commercially successful zipper and the basis for later ones, was invented by Gideon Sundback in 1913 and patented in 1917. In 1962, in response to a visit from a Smithsonian curator looking for artifacts for the new Museum of History and Technology, the manufacturer Talon donated a large collection of zippers, including this one.

Roper steam velocipede, about 1869 (below). Was this the first motorcycle? Sylvester H. Roper of Roxbury, Massachusetts, built this steam velocipede and exhibited it around New England. However, credit for the first commercially successful motorcycle usually goes to Gottlieb Daimler of Germany or Edward Butler of Great Britain. The Smithsonian collected this artifact in 1956.

Electronic Numerical Integrator and Computer, developed for the U.S. Army by J. W. Mauchly and J. Presper Eckert, 1945 (bottom). Most historians recognize ENIAC as the first electronic, programmable, general-purpose, commercially successful digital computer—although the debate continues. The Smithsonian collected elements of ENIAC in the 1960s.

research and technology. His machine, like any first, can tell only a small piece of a complex story. The search for technological firsts yields a history of progress, a history that seeks out the steps that seem—although only in retrospect—to lead to the present day. The search for firsts can explain neither the reasons for technological change nor the direction it takes.

Mitman's catalogue was liberal in its allocation of firsts, as evidenced, for example, by its section on locomotives. The "first practical locomotive engine designed to run on rails" was built in 1804 by Richard Trevithick in southern Wales, whereas the "first self-propelled vehicle to run on American soil" was designed by Oliver Evans, also in 1804. The *Locomotion* (1825) was "the first locomotive built for the first railway in the world constructed for general traffic." The *Rocket* (1829) "laid the foundation for the successful future of railway transportation." The South Carolina Railroad Company was "the first in the world to decide that its railroad should be operated by steam locomotives." The "first locomotive in the Western Hemisphere to run on a railroad built for traffic" was the *Stourbridge Lion* (1829). The "first American-built locomotive for actual service" was the *Best Friend* (1830). Not all of these locomotives still survived, of course, but the National Museum did its best to get relics of the locomotives that remained. If it could not, it settled for a drawing or photograph or had a model made.[64]

Why this fascination with technological firsts? In part, it goes back to notions of value, of treasure. If old things are valuable, then firsts—the oldest of their kind—are most valuable. But the search for firsts is also driven by the idea of progress. Identifying firsts is a way to map the course of progress, to show the origins and turning points that guided an invention toward its present form. If the history of technology is interpreted as the story of inevitable development along a path toward the latest machine, then the curator's job is to collect and display artifacts that represent the milestones on that path.

Model of William N. Whiteley's reaper, 1877. Whiteley, of Springfield, Ohio, was an inventor and entrepreneur whose Champion Binder Company, founded in 1852, was one of the largest producers of farm machinery in the late nineteenth century. In 1877 Whiteley received a patent for an "Improvement in Harvesters," represented by this unusually attractive model that he submitted with his application. Whiteley's reaper is one of several thousand patent models the Smithsonian acquired from the Patent Office in 1926.

The Smithsonian's fascination with firsts was compounded by the acquisition, in several stages, of thousands of models from the U.S. Patent Office. As a system set up to assign legal priority to inventions, the Patent Office might seem a natural place to look for historic firsts. But in trying to understand an invention's historical significance, the standards of the patent system do not necessarily apply. With patent models, as with all artifacts, there is always more to the story than what first meets the eye.

The Patent Act of 1790 required that every patent applied for be accompanied by a model as well as drawings, a requirement that held until 1880. The patent models were exhibited at the Patent Office from 1810 to 1836, when a fire destroyed nearly the entire collection. Construction began on a new Patent Office building in 1837, and the Museum of Models opened to the public in 1842. Another fire in 1877 destroyed 76,000 of the models, but even so by 1880 more than 150,000 models were crammed into the museum. These were expensive to store and increasingly of historical rather than technological interest, and so in 1908 Congress offered the collection to the Smithsonian, which took about 1,000. The rest were supposed to be auctioned off, but in fact most were stored until the 1920s, when once again Congress tired of paying for storage space. In 1926 the Smithsonian was again offered its choice and again accepted a few thousand more, some of which it eventually gave away.

The Patent Office sold off the rest of the patent models. Over the years the Smithsonian has recovered more from the various owners of the collection, individuals, and other museums.[65]

It is hard to reconstruct how the curators interpreted the 1926 law that required the Smithsonian to accept all models of "historical character" and distribute the rest to appropriate organizations. The patent commissioner at the time thought this meant that the Smithsonian should accept only "epoch-making models" or only those of famous inventors. And indeed the Smithsonian selected many patent models submitted by the likes of Thomas Edison and George Westinghouse. The Smithsonian curators, though, interpreted the requirement more generously—perhaps because of the Institution's long-standing fascination with incremental invention.[66]

While Smithsonian curators had only their historical interests and philosophical predispositions to blame in looking too hard for firsts, other collectors—often those on whom the curators depended—had other agendas. Inventors and companies, of course, were eager to claim priority and wanted the recognition that came with Smithsonian notice. Sometimes companies just wanted to be associated with firsts. In 1956 the Smithsonian acquired one of the first X-ray tubes used by Wilhelm Konrad Roentgen, discover of the X-ray. It was purchased by the General Electric Company, flown to Washington by Trans World Airlines, and greeted with a special presentation ceremony at Washington National Airport.[67]

In its eagerness to sort out the steps of progress, the Smithsonian often found itself in trouble. Some of the controversies over firsts were to haunt the Institution for years. The Wright Brothers refused to donate their *Flyer* (1903) until a dispute over conflicting claims of "first flight" was settled—a fight that dragged on for more than thirty years. Admirers of Nikola Tesla, inventor of electrical devices, have long fought with the Smithsonian over its failure to give him "proper" credit for inventions.

One of the most complicated cases of firsts was that of C. Francis Jenkins. Hundreds of pages of letters and correspondence in the Smithsonian archives tell the story of Jenkins, his one-time partner Thomas Armat, and a succession of Smithsonian staff trying to sort out just who should get credit for the invention of the motion picture projector.

The historian H. Mark Gosser has untangled the twisted story—a tale of deceit, bureaucratic inertia, and legal wrangling. It starts with a first, or at least a claim of a first: "the world's first *paid* projections," at the Cotton States Exposition held in Atlanta in September 1895. Jenkins and Armat, both students at Bliss Electrical School in Washington, D.C., formed a partnership to combine Jenkins's revolving-lens camera and other ideas with Armat's money and design skills. They attempted several movie projection devices but without great success. Still they managed to project movies at the Atlanta exposition, even if only by repairing the damaged film after each show. The strain broke up the partnership, and Jenkins claimed that he was the sole inventor of the projector. He tried to prove this in court, showing drawings that he claimed were done in 1890; however, Armat's lawyers proved that the paper they were on was not manufactured until 1894.[68]

Thwarted by the courts and rejected by the Patent Office, Jenkins turned to museums to get credit for his "inventions." Philadelphia's prestigious Franklin Institute voted Jenkins its Elliot Cresson medal, based at least in part on fraudulent information Jenkins provided but also on the institute's long-standing beliefs about the importance of the solitary inventor. Armat protested the prize, but his protest was rejected.

Now the Smithsonian got into the act. In 1896 Thomas W. Smillie, the Smithsonian's photographer who was now also acting as curator of photography, curated the first exhibition of motion picture apparatus. Jenkins donated several pieces of apparatus to the Smithsonian

Rotary lens apparatus for C. Francis Jenkins's motion picture camera, 1896. One of the first pieces of motion picture technology collected by the Smithsonian, this lens was donated by Jenkins in 1897, along with other devices supposedly invented by him. For more than twenty years the Smithsonian displayed Jenkins's machines as important achievements in film technology. But in 1921 another inventor—Thomas Armat, Jenkins's former partner—set out to prove that Jenkins's "inventions" were in fact "unoriginal and unimportant devices, some of them faked"; he called the display "false and libelous." While Armat did not achieve his goal of "sweeping the entire Jenkins collection out of the Museum," he did convince curators to change labels and remove several objects from exhibit.

and convinced Smillie to add in 1898 one of his projectors, with the label "Intermittent film projector / Invented by C. Francis Jenkins."

The exhibit remained on display for many years. Jenkins donated more early equipment in 1912 and continued to claim credit for fundamental inventions. In 1920 he wrote "A History of the Motion Picture," which restated in even bolder terms his priority in invention. In this article he referred to the exhibits at the Smithsonian and the Franklin Institute as evidence of the importance of his inventions.

That may have been the last straw for Thomas Armat. He wrote a very long letter to the Smithsonian listing in copious—and accurate—detail the inaccuracies in the museum's exhibit of motion picture apparatus. The Smithsonian promised to investigate. And investigate it did for some eight years. Jenkins continued to supply new evidence, much of it fabricated. And while the Smithsonian did change some labels and in 1923 returned some of Jenkins's apparatus to him, it continued to give Jenkins more credit than he deserved.

Armat brought such famed inventors as Orville Wright and Thomas Edison into the argument on his side. Both Armat and Edison refused to donate their motion picture inventions to the Smithsonian until "this matter has been cleared up to our satisfaction." Finally, his patience at an end, Armat threatened legal action and, as a last resort, a congressional investigation. Unless the Jenkins exhibits—"improper, faked and fraudulent"—were removed and labels changed, Armat wrote in 1928, "I am of the opinion that the matter will eventually find its way before certain Committees in Congress."[69] The Smithsonian backed down.

The Jenkins-Armat controversy revealed some of the problems with identifying a particular invention, a certain artifact, as "the first." Artifacts, more than a picture or a written description, seem important. They are solid—so they seem like solid evidence. Their presence in the Smithsonian makes them seem more important than other inventions that for whatever reason were not saved. But, paradoxically, their very existence can also disprove their importance.

Consider one of the hoariest myths of American invention—the notion that Eli Whitney produced muskets using interchangeable parts in 1798. Holland Thompson's book *The Age of Invention*, published in 1921, gives the story in a form not too different from that still found in many textbooks: that in his shops at Whitneyville, Connecticut, Whitney worked out the "principle of standardization or interchangeability in manufacture ... [the] foundation today of all American large-scale production." Thompson repeats the story that Whitney proved the interchangeability of his guns to government officials who had advanced him funds by assembling guns from piles of parts, "an achievement which was looked on with amazement."[70]

The artifacts tell a different story. In the 1960s Edwin Battison and Robert Woodbury, Smithsonian curators, decided to see if the muskets really were interchangeable and if the famous Whitney milling machine supposedly used to make them interchangeable was in fact used for that purpose. Close examination of the artifacts—their measurements and tool marks—and re-examination of the archival record thoroughly debunked the Whitney myth. The artifacts, long used to certify a first, in fact proved the exact opposite.[71]

Another icon of American invention, the Kelly converter—long used as evidence that William Kelly, proprietor of an iron furnace in Kentucky, had invented the Bessemer process before Henry Bessemer, a British iron manufacturer, did—also contained the seeds of its own debunking. In the late 1840s Kelly experimented with ways to improve the process of producing iron. His "pneumatic process" saved fuel but lowered quality and was never adopted. However, when Kelly learned of Bessemer's patent, he claimed prior invention and in 1857 received a patent for "Improvement in the Manufacture of Iron." In the early 1860s the Cambria Iron Works bought the rights to Kelly's patents, and Kelly did some more experiments there—building a device called a converter, intended to convert iron to steel—although again without

Whitney musket, about 1812 (opposite). Popular legend has long held that the muskets Eli Whitney produced for the U.S. Army beginning in 1798 used interchangeable parts. However, close examination and detailed measurement of the guns showed evidence of filing and hand fitting, which meant that their parts were not interchangeable. This musket, along with many other early guns, came to the Smithsonian in 1922, when the Military Service Institution transferred its collections.

Kelly converter, 1860s, Arts and Industries Building, 1950s (opposite). William Kelly, proprietor of an iron furnace in Kentucky, claimed to have invented the Bessemer process before Henry Bessemer did—a claim advantageous to American steel makers, who did not want to pay royalties on Bessemer's patents. Kelly built this converter in the 1860s, but although it was widely hailed—and displayed at the Smithsonian—as a great icon of American backwoods inventiveness, recent tests have shown that it was never successful. The Kelly converter was loaned to the Smithsonian in 1955 for the exhibition *Iron and Steel in America* and has been on display ever since.

useful results. Still, Kelly and his patent proved invaluable to American steel makers—not technologically but financially. They pointed to Kelly's experiments as proof that Bessemer was not the first inventor of a steel converter and refused to pay Bessemer royalties on his patent. Kelly even applied for a new patent—based on Bessemer's work.

The Kelly converter was displayed at the World's Columbian Exposition in Chicago in 1893 and then at the Johnstown, Pennsylvania, offices of the Bethlehem Steel Company. On it was written this legend: "Kelly Steel Converter used at Cambria Iron Works 1861–1862 the Pioneer Converter of America." In 1955 the Kelly converter was loaned to the Smithsonian Institution for use in an exhibition on steel making and has been on display ever since, until recently with the century-old claim that it was indeed the first pneumatic steel-making device.

The object, in its solidity, seemed proof of Kelly's success. But the object could also disprove its own mythology. In 1990 the historian and metallurgist Robert Gordon tested residues in the converter and discovered that it was never used to produce steel. The entire story had been fabricated to get around the Bessemer patents. The myth of the Kelly converter, "enlarged upon and repeated with patriotic fervor in later years," had been given substance by the museum artifact. But the artifact, under closer examination, supported a more accurate revisionist history.[72]

The search for firsts misleads. It warps one's understanding of the development of technology. And it is particularly problematic for a museum that for almost 150 years has been collecting firsts and greats. The presence of these artifacts seems to demand a certain kind of history—a history of progress, of breakthrough, of the celebration of great inventors. To get to a history that is more than just a history of firsts, a simple and reductive tale of progress, the museum had to move beyond the technological artifacts themselves to the people and politics that shaped them. In 1980, when the museum changed its name to the National Museum of American History, it had a new opportunity to do just that: to make science and technology part of history, not separate from it.

A Messy Technological Story

FOR A REAL LIFT get a **TEXACO** check-up!

The stories that visitors took home from the new Museum of History and Technology were not all that different from those that Carl Mitman had wanted to tell or, for that matter, those that visitors took away from the synoptic series. Visitors saw technological objects arranged with similar objects. They saw chronological order. They saw progress, either explicit or implicit. Because there was little historical context, it would be difficult for them to see anything other than technological change: progress, improvement, evolution. And technological progress implied social, political, and economic progress. Museum exhibits showed—at least they implied—that everything was getting better for everyone.

After all, the artifacts were still, for the most part, arranged to emphasize the technological story. Artifacts organized in technological categories do that. Each machine is more powerful, more productive, or simply newer and shinier than those before. They tell a story of progress. John Staudenmaier, a historian and philosopher of technology, makes the distinction between "clean exhibits" and "messy exhibits." Clean exhibits, with their "sanitised aesthetic," he argues, define contemporary technical museum practice. They avoid the messy political side of technology, suggesting a "vision wherein all victims are temporary down payments for future blessings and all critics those who fear to face the future." And they ignore "the essential ambiguity of every technical endeavor" by avoiding "questions of power and exclusion, of who wins and who loses." Staudenmaier calls for exhibits that leave visitors "with a deeper sense of the essential humanity of the technological endeavour, aware that technological choices reflect the full range of humanity, intelligence and stupidity, nobility and venality."[73]

To tell this messy story would mean looking at more than firsts, improvements, progress. It would require that curators ask different kinds of questions. In recent years curators have argued that the only way to overcome the obvious messages of the machinery is to

Roadside billboard mock-up produced by the Cunningham and Walsh advertising company for Texaco, mid-1950s (above). Cunningham and Walsh, now a subsidiary of N. W. Ayer, was one of the first American advertising agencies. The Smithsonian began collecting material from N. W. Ayer and related firms in 1975 and continues to receive donations, such as this mock-up, acquired in 1996. An inside glimpse into the world of advertising since 1849, the N. W. Ayer Advertising Agency Collection shows how the mass media has marketed technology as a consumer product.

Auto plant worker's badge, hat, and notebook, 1989 (opposite). Identification badges and hats were standard for workers at the New United Motor Manufacturing (NUMMI) plant in Fremont, California, one of the first factories in the United States to adopt Japanese mass-production techniques. In 1989 Smithsonian curators traveled to the plant to collect artifacts for an exhibit on the history of work and management. To decide whose uniforms would be donated to the Smithsonian, the company held an employee essay contest on the topic of teamwork; the winners were Judy Weaver, from the engineering department, and Rick Madrid, from the quality control department. These artifacts were donated by Madrid.

focus on other stories. Exhibits should use technology to tell stories about politics or people first and technology second. Artifacts must be placed in a human rather than a technological context.

To tell historical stories, curators had to go beyond simply collecting the object. They had to collect a complex story around the object. And in recent years curators have been doing just that. They have filmed machines in action. They have interviewed designers, managers, and workers. They have collected production drawings, prototypes, work records, and even financial information about the companies where the machines were used. All help tell a more complicated story. It might still be, in technological terms, a story of progress. But it is a much more complex and interesting story of progress than simply one machine following another. It is a human story of social and cultural as well as technological change.

In the 1980s a new wave of exhibit ideas swept the museum community. The new social history—history "from the bottom up"—had found a favorable reception in history departments in the 1970s and eventually in history museums, especially in exhibits about everyday life. Industrial, scientific, and technological exhibits resisted a bit

Delegate's badge from American Federation of Labor convention in Kansas City, Missouri, 1898 (above). Telling the story of work means telling the story of unions too. In 1989 the son of the labor union leader John Brown Lennon donated more than one hundred badges and other memorabilia from labor organizations to the National Museum of American History. This collection joined several large collections of labor memorabilia acquired in the late 1980s.

Machinist's tool chest, about 1949 (left). John Emile Lovret, who went to work at age fourteen to support his family, became a skilled machinist and inventor, working for various companies before setting up his own shop in New York. He decorated his tool chest with family photos and a playing card he considered his good-luck charm. In 1998, when ill health forced him to close his shop, his daughter contacted the Smithsonian. Curators chose to collect this chest because "for a machinist the tool chest is the embodiment of the person. . . . Mr. Lovret is important not because he is the first, the only, or the best but because he provides us anecdotes to tell the common, the usual, and the ordinary."

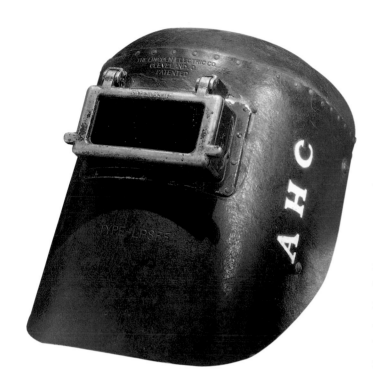

longer, but in the 1980s and 1990s these collections and exhibits began to reflect a more historical, less technological view. They began to address, in Staudenmaier's terms, a messier story.

One way the new exhibits did this was to look at the story of a single machine in great detail. The object's story was told on its own, not as a representative of a type or as part of a story of technology. So a sawmill would not be shown with other sawmills but rather with other artifacts that told the story of that particular sawmill. Where was it located? Who owned it? Who worked there? What did it produce? Who bought the product? The artifact becomes its own story, not a bit player in the story of technological advance. It is surrounded by the messy details that tell a social story.

A related way that the new breed of exhibits got beyond the machines was to examine not the technology or even the effects of technology but rather the *shaping* of the technology. How did the machines get to be the way they were? Asking this question—and answering it with information about labor, politics, and work—meant that the machines were no longer being taken for granted. Instead of machines begetting machines, machines develop within a social and

Augusta Clawson's welding mask, 1943 (above). In 1943 Augusta Clawson, a recent Vassar graduate and specialist with the U.S. Office of Education, was given an undercover assignment at the Swan Island Shipyard in Portland, Oregon, to learn why women recruited as welders were quitting as soon as they finished their training. Her two months' experience as a welder became the basis of her book *Shipyard Diary* (1944). In 1988 Clawson donated her welder's face mask, photographs, and copies of her reports to the Smithsonian, where they have been used to help tell the story of women war workers.

Furnace salesman's kit, 1920s (right). Walter G. Bennett used this demonstration kit to sell Holland warm-air furnaces to homeowners during the 1920s. In 1981 Bennett's son offered his father's kit to the Smithsonian. Appropriately, his letter began with a sales pitch: "Has the Museum ever commemorated that great American institution, the salesman? ... I hope you can use this kit; it would please me to know that some part of my father's life was made a part of this country's history."

Vials of polio vaccine, 1954 (left). Contemporary medical advances have always been of interest to the curators of the Smithsonian's medical collections. These vials of poliomyelitis vaccine were produced for the first national trials in 1954. On April 12, 1955, the new vaccine was declared safe and effective, and its developer, Dr. Jonas E. Salk, became an international hero. Twelve vials of the trial polio vaccine were donated to the Smithsonian between 1956 and 1958 by the National Infantile Paralysis Foundation and the laboratories that manufactured the vaccine.

Jarvik-7 artificial heart, 1985 (below). In August 1985 at the University Medical Center of the University of Arizona, Dr. Jack G. Copeland implanted this Jarvik-7 artificial heart in Michael Drummond, a patient awaiting a heart transplant. The Jarvik-7 kept Drummond alive until a donor organ became available one week later. Within months of the surgery, the medical center offered this artifact to the Smithsonian, which accepted it as a successful example of "spare parts"—devices or machines designed to function in place of a body part or organ—and an illustration of one of the controversies accompanying advanced medical technology.

cultural setting. Society and culture, not machines, were granted the privileged position. In recent years technological collections have begun to tell stories of work and management, business, and economics.

Work is a topic that has always been closely related to technology, but for many decades it was rarely addressed at the Smithsonian. The stories of people who actually used the machines received less attention than stories about the machines themselves. Yet machines are shaped by the work that people perform with them and by ideas about the nature of work. Industrial machinery in particular takes on political and cultural significance when considered from the perspective of the workers who used it on the factory floor. As curators became more interested in the stories of workers, objects in the collection acquired new meanings. Tools told the story not only about new technology but also about the development of occupational skills and identity. Industrial machines invited questions about worker health and safety, the rules and culture of the workplace, and the relationship between human and machine. The National Museum of American History's role as a palace of progress began to mesh with its role as a mirror of America.

Business and economics also became an explicit part of the technological story. Traditionally, business history was written from business archives—letter books, corporate minutes, payroll accounts—and the National Museum of American History began to collect these. But business has a material culture too. Marketing and advertising, the materials that link technology and business to consumers, became a strength of the museum's collections with the acquisition of the Warshaw Collection of Business Americana and the N. W. Ayer Advertising Agency Collection.

Technology had other than business contexts; it also had a larger political story to tell. The last quarter of the twentieth century saw a recognition that technology had politics, that it did not proceed simply on its own technological logic. The National Museum of American History collected artifacts about immigration and the consumer movements, material protesting the nuclear arms race, and material

Prototype for a LED (light emitting diode) electronic watch, about 1972 (above). During the 1960s research teams from watch companies around the world raced to develop an electronic watch. This LED assembly was acquired in 1994 from John Bergey, a Hamilton Watch Company engineer.

Superconducting Super Collider electromagnet prototype on exhibit in _Science in American Life_, 1994 (below). The SSC, which would have been the world's largest particle accelerator, was cancelled because of costs. In this exhibition the prototype is shown with material from communities fighting both for and against the project.

documenting the environmental movement, macrobiotics, and alternative medicine.

In 1994 the National Museum of American History opened its first new exhibition on the history of science in many years, _Science in American Life._ The exhibition's main label announced the curators' intentions to portray science and technology as "right in the thick of American history," an integral part of people's daily lives, and a subject of political controversy and debate.

Not everyone was happy with the new exhibition. Scientists, used to their work being lauded as progress, as the driving force of positive social change, were upset to see science considered simply an aspect of culture. But by capturing science in its social and cultural context, _Science in American Life_ in fact helped explain science in a way that an exhibition that isolated science never could. It helped visitors recognize science and technology as something shaped by people's ideas, beliefs, and political agendas, not as an independent and impersonal force. It emphasized that society shapes and controls science and technology, not the other way around. And it encouraged visitors to understand progress, not simply celebrate it. [74]

Back in 1963 the _Washington Evening Star_ introduced the Museum of History and Technology as "A Palace of Progress." Today progress is still central to many of the stories the National Museum of American History tells, but science and technology are no longer isolated in a separate part of the palace. The palace now holds many kinds of stories, and more thoughtful, complex—and, yes, messy—understandings of science and technology are presented as components of the whole story of American history.

"Industrial Progress" poster, 1945 (left). In the 1980s, as the National Museum of American History began to expand its collections beyond technology to include labor, it also began to collect artifacts representing business and management, including work incentive posters common in factories from World War I to the present. The museum had collected similar posters during World War II to illustrate industry's contribution to the war effort and as graphic art. In the 1960s it acquired some ten thousand World War I and II posters from Princeton University Library. Posters like these portray corporate and government attitudes toward workers, technology, and industry.

DDT samples, 1940s and 1950s (below). Since the invention of DDT in 1939, the Smithsonian has acquired various samples of this controversial pesticide. Its collections include the first pound of DDT manufactured in the United States as well examples of farm and garden products containing DDT.

Nuclear arms protester's mask, 1985 (left). This mask was made and worn by sixteen-year-old Justin Martino for the Peace Ribbon March on the Pentagon in Washington, D.C., a 1985 demonstration for nuclear disarmament and world peace. Decorated with peace signs and a nuclear warhead that has missed its target, the mask symbolized Martino's belief that "the arms race has no end except the end of life." As a teenager concerned about the proliferation of nuclear weapons, Martino participated in several protests during the 1980s. After the Pentagon march, he and his father offered this mask to the Smithsonian to represent a young activist's perspective.

"Ecology Now" poster, 1970s (right). By calling attention to pollution, destruction of wildlife habitats, and declining natural resources, the environmental movement has challenged conventional American ideas about science, technology, and progress. Curators collected this poster and other environmental materials for the *Science in American Life* exhibition in 1994.

Macrobiotic food, 1990s (below). In 1997 curators collected organic food samples from Michio Kushi, a founder of the American macrobiotic movement, as part of efforts to document alternative health and medical practices of the late twentieth century.

A Mirror of America

More than just emblems of diversity, cultural artifacts collected by the Smithsonian are connected to people's lives, to their experiences, values, and beliefs. They reflect different and changing ideas about what it means to be American. And when history is examined from the point of view of the people who made and used these artifacts, new kinds of stories emerge.

Table made by Peter Glass, about 1860. Inlaid with more than thirty thousand pieces of wood, this table combines traditional European designs with patriotic American motifs, including portraits of U.S. military generals. It also features the name of its maker: Peter Glass, a German artisan who became a farmer in Wisconsin but continued to make award-winning marquetry furniture in his spare time. Glass's granddaughter donated this table and other material representing his work to the Smithsonian in 1968.

Neon signs, about 1940–70 (pages 168–69). To vividly illustrate the concept of a multicultural twentieth-century America in the Bicentennial exhibition *A Nation of Nations*, curators created a dazzling display of colorful neon signs from ethnic restaurants. In exchange for donating their old signs, restaurant owners were given brand new ones, courtesy of the Smithsonian.

SINCE ITS EARLIEST DAYS the Smithsonian has contended with a fundamental question: How should the nation's museum represent the nation? Whose experiences and beliefs should be included in the story of the American past? What is the true American heritage? Cultural artifacts collected by the Smithsonian—many sought out by its curators, many more offered by outside individuals and groups—reflect various answers to these questions. Over time the Smithsonian's reflection of America has included certain kinds of people and excluded others. Different kinds of objects, collected at different times and for different reasons, express changing ideas about museums, history, and what it means to be American.

Opening the Doors

On October 8, 1911, an event took place that an official described as one of the most important in the history of the National Museum: the beginning of Sunday visiting hours. For the first time, Assistant Secretary Richard Rathbun noted with pride, "the privileges of the establishment were extended equally to all classes," particularly those working people who, in an era of six-day work weeks, had only Sundays free for leisure activity. The Sunday hours extended only from 1:30 to 4:30 and applied only to the new Natural History Building, completed in June 1911, which had a budget large enough to cover the added security and heating costs. Still it did represent a significant milestone, and the first Sunday's turnout of more than fifteen thousand visitors did much to convince administrators they were on the right track. Hoping to extend the policy to other Smithsonian galleries, they continued to lobby for extra funds. Finally, in 1925, a congressional appropriation enabled the Arts and Industries Building also to remain open seven days a week, adding historical relics, technology, and decorative arts to the array of collections available to Sunday afternoon visitors.[1]

Officials had long expressed a desire to keep the National Museum open on Sundays, to make its treasures available to a broader public—not just tourists and scholars but local residents as well. Realizing this vision took decades, largely because of tight budgets and the glacial pace of the federal bureaucracy. The drive gained new momentum around the beginning of the twentieth century, as other museums across the country began welcoming the public into exhibition galleries on Sundays. Among them were the new city art museums established by wealthy philanthropists during the last quarter of the nineteenth century. The Boston Museum of Fine Arts, which opened in 1876 to serve "all classes of our people," offered free admission on Sundays as an incentive for working-class visitors; the Metropolitan Museum of Art, prompted by strong pressure from local politicians to make the collections available to all New York City residents, hosted its first Sunday opening in 1891. While some elites blanched at the thought of exposing precious paintings and statues to the unrefined masses, many museum leaders considered it their duty to do just that: expose the general public to high culture in hopes of educating and uplifting them, both morally and intellectually.[2]

Indeed, the National Museum's Sunday hours signified more than just an opportunity for more people to learn about art, nature, technology, and history. A moral agenda accompanied the museum's democratic rhetoric and framed the exhibits within. To cultural leaders, museums symbolized a wholesome alternative to the new amusement parks and nickelodeons competing for the time, money, and souls of the working class. In Rathbun's words, "It is hoped that the provision of an additional place to which people may resort on Sundays for instruction and diversion has not been without some

Visitors outside the National Museum (now the Arts and Industries Building), about 1900. The belief that museums could improve the lives of ordinary people and make them better citizens guided Smithsonian exhibits and collections at the turn of the twentieth century. In the National Museum's 1890 report, George Brown Goode, director from 1881 to 1896, proclaimed that museums were "not intended for the few, but for the enlightenment and education of the masses."

moral influence."[3] The idea of the museum as a refuge from societal evils—vice, poverty, poor working conditions, overcrowded and unsanitary cities—and as a means by which ordinary people could educate and improve themselves reflected the reform-minded spirit of the Progressive Era. Through exhibits on industrial technology, public health, and decorative arts, the National Museum offered itself as a source of moral and cultural instruction for the general public. Curators used the scientific and technological collections not only to demonstrate the progress of Western civilization but also inspire that progress in people's daily lives.[4]

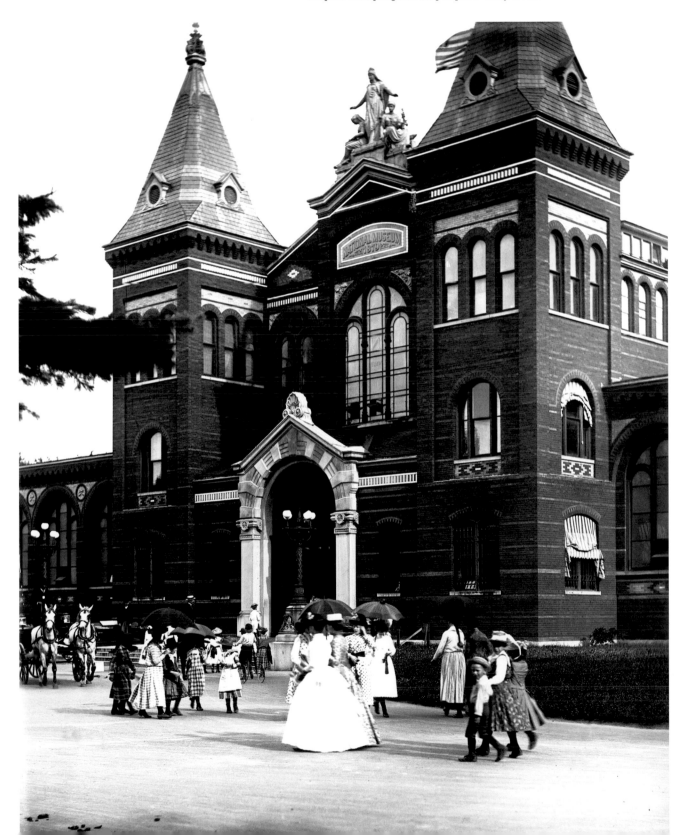

Founding Families

As the National Museum advertised the wonders of the modern age, it also commemorated the past that had supposedly made all this progress possible. In 1883, after receiving from the Patent Office extensive memorabilia of George Washington and other founders, the museum formally established a Section of Historical Relics. Expanding beyond its traditional focus on natural history, the National Museum was now also responsible for national history, charged with collecting new kinds of objects to honor key individuals and events and represent the cultural heritage of the American people.

Wooden mirror, probably 1700s. The letter that accompanied this mirror when it arrived at the Smithsonian in 1890 declared, "This looking glass came over in the May Flower." Many other artifacts have come to the museum with similar stories connecting them to one of America's founding families, but in this case curators have been unable to document the donor's claims. Stylistic evidence—particularly the mirror's shape, which is similar to that of so-called courting mirrors produced in northern Europe and imported to the colonies in the late seventeenth and eighteenth centuries—suggests the mirror may not have arrived in New England until more than a century after the *Mayflower*.

Silver shoe buckles, about 1779. These buckles, worn by Lieutenant Colonel Thomas Posey of the Seventh Virginia Regiment during the Revolutionary War, were donated to the Smithsonian by his granddaughter in 1921. In her letter to curators, she wrote that her grandfather "Danced at Stony Point in these buckles." Stony Point, New York, was the site of a Continental Army victory in 1779.

But the heritage represented at the National Museum at this time did not reflect that of all Americans, especially not the working-class people encouraged to come on Sundays. On the contrary, curators purposefully constructed a narrow view of the American past. The Hall of Period Costume, illustrating women's fashions since colonial times, opened in the Arts and Industries Building in 1914 and soon became one of the most popular exhibits. Yet the costumes on display, curators were quick to point out, "do not include those of the lowly, but belong entirely to at least the well to do, and mainly to the wealthy and distinguished, the classes to which the term 'fashion' seems solely to appertain." In addition to gowns, the hall also exhibited jewelry, combs, and "dainty lots of exquisite needlework and other family relics," all of which, according to curators, demonstrated "the great taste with which our ancestors provided articles for their personal use."[5]

At the National Museum, as in other museums at the turn of the twentieth century, American history was made available to all but truly belonged to only a few. Exclusive ownership of the national heritage was claimed by those who could trace their family roots back to the earliest days of the republic or, even better, the earliest days of English colonial settlement. Amid the influx of immigrants from countries outside western Europe, the impulse to draw ethnic, racial, and generational boundaries around American identity was strong among the native-born Anglo Americans.[6]

To stake their claim on the American past, they donated family heirlooms to museums, formed preservation societies, and contributed funds to build monuments and save historic structures, ensuring that the individuals, events, and artifacts they valued would also be valued and remembered by the nation as a whole. The numerous heritage organizations that formed during this era, such as the National Society of the Daughters of the American Revolution (D.A.R) and the National Society of the Colonial Dames of America, defined their membership by colonial bloodlines. Members of these societies often donated heirlooms to the National Museum to pay tribute to their ancestors and demonstrate their patriotism. The D.A.R. and Colonial Dames also created historical collections of their own and occasionally staged special exhibits at the National Museum. Favored heirlooms ranged from jewelry, china, clothing (shoe buckles were especially popular), furniture, and needlework to military gear and church silver. The collection of Washburn family relics, donated by a Philadelphia woman in 1913, included a tile inscribed with the "Washbourne" coat of arms, salvaged from the ruins of an English abbey—tangible proof of the family's Anglo-Saxon roots.[7]

In the National Museum's historical exhibits, then, many visitors saw not themselves or their own ancestors but rather the ancestors of the white, Anglo-Saxon, Protestant upper class—the people who, in the eyes of their descendants as well as museum curators, best

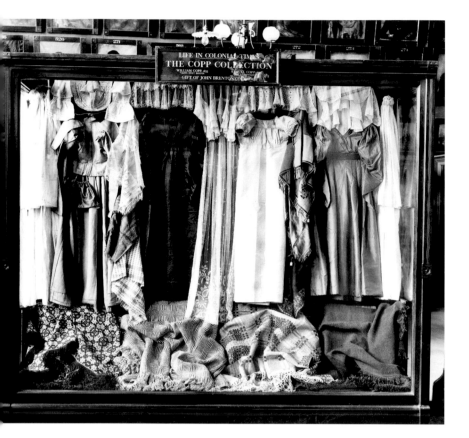

represented America. In some cases curators themselves were descendants of these founding families. George Brown Goode, director of the National Museum from 1881 to 1896, was a scientist by training but also an amateur genealogist who was immensely proud of his Anglo-Saxon ancestry. Goode designed the logo for the Daughters of the American Revolution, which he based on his grandmother's colonial spinning wheel; he also donated the heirloom itself to the D.A.R.

During his tenure as director, Goode eagerly solicited relics of historic American families for the National Museum. His most impressive acquisition was the Copp Collection, a large assortment of housewares, textiles, and furniture used by the Copp family of Stonington, Connecticut, from the mid-seventeenth to mid-nineteenth centuries. Like other members of the cultural elite, Goode believed that he was entrusted with a sacred responsibility to impart the true meaning of the American heritage to the public, to guard and celebrate his ancestors' values and tastes as the core of a national culture. At Goode's memorial service in 1896, William Lyne Wilson, U.S. postmaster general, eulogized him thus:

The study of the past, the study of the lives of those who have been eminent and useful men in the past, is a potent influence ... [and an] intelligent, patriotic effort in the present. The *noblesse oblige* of a patriotic and substantial ancestry, not only for the individual but for the country itself, is a power whose influence we can scarcely exaggerate.[8]

The Copp Collection, National Museum, about 1900 (above left). The collection of clothing, textiles, and household items used by the Copp family of Stonington, Connecticut, from about 1650 to 1850 is one of the museum's largest family-based collections. Displayed at the 1893 World's Columbian Exhibition in Chicago, the collection was later donated by John Brenton Copp to the National Museum, where it was exhibited to represent life in colonial times.

Silver wine cup belonging to William Bradford, first governor of Plymouth Colony, 1634 (above right). Although the Smithsonian has widened its scope to include a diversity of American ancestors, the Pilgrim fascination persists. This cup remained in the Bradford family until the 1980s, when it came up at auction. Encouraged by S. Dillon Ripley, secretary of the Smithsonian and himself a Bradford descendant, curators moved to bid on the relic. Because of the cup's rarity and expense, the National Museum of American History formed a partnership with the Pilgrim Society of Massachusetts to purchase it in 1985. The museums now share ownership of the cup and take turns displaying it.

Gunboat *Philadelphia*, 1776. The *Philadelphia* was one of a fleet of Continental gunboats that stopped the advance of British forces on Lake Champlain during the Battle of Valcour Island in 1776. Sunk during the battle, it was discovered and raised in 1935 by Lorenzo F. Hagglund, a civil engineer who for many years exhibited it as a tourist attraction. In 1939 a Smithsonian curator proposed buying the *Philadelphia*, citing a naval historian who called it "the most amazing thing of the sort that he has seen." But the idea was rejected by museum officials, who balked at the price and thought the gunboat better off in its "original surroundings." Twenty years later the curator, Frank Taylor, had become the director of the new Museum of History and Technology, and he still wanted the Revolutionary War relic for the collections. In 1961 the Smithsonian acquired the gunboat and brought it to Washington, D.C., where it was displayed along with other naval artifacts salvaged from the lake bottom. In 1991 detailed drawings of the gunboat were used to make a replica, the *Philadelphia II*.

When the National Museum first began collecting from founding families in the 1880s and 1890s, artifacts were valued mainly for their historical associations. If they happened to be visually attractive too, so much the better. But even tarnished shoe buckles or a glassless wooden mirror, as long as it was connected to an old and prominent American family, was generally accorded as much respect as jewelry and silver. By the early twentieth century, however, curators and collectors alike were looking for something more from the past: style. As the United States began to claim its place on the world stage through war and diplomacy, nationalist feelings compelled many to search for evidence of a unique American culture, distinct from European cultures. As contemporary artists cultivated styles that were self-consciously American, they looked to early American artifacts for inspiration. What was it in the design of a Paul Revere teapot or a Philadelphia tea table that reflected American tastes, values, and traditions?

Meanwhile, many Americans not only wanted to preserve their colonial heritage; they also wanted to furnish their homes with it. Antique collecting became a passion among the upper and middle classes alike, and for those who could not afford the real thing or find antiques that matched their décor, furniture factories began reviving colonial styles for their new product lines. Museums presented colonial objects as decorative arts, emphasizing their beautiful design and craftsmanship over their purely historic value, and used them to define an "American" style—as opposed to the styles of immigrant cultures—that the public was encouraged to appreciate and emulate. Thus, in 1914 the National Museum's Hall of Period Costume offered not just relics of founding families but also evidence that the nation's founders had "great taste."[9]

A new type of museum exhibit, the period room, evolved to meet the demand for artistic antiques and provided an opportunity for Americans with colonial pedigrees to showcase their inheritance. Pioneered in 1907 at the Essex Institute in Salem, Massachusetts, the nation's oldest historical society, the period room made its biggest public splash in November 1924 at the Metropolitan Museum of Art in New York. The Metropolitan's new American Wing exhibited a lavish array of decorative arts and furnishings within "authentic" room settings, constructed from the salvaged architectural details of historic houses; many of the period rooms and their contents had been donated by wealthy patrons as a tribute to their own patriotism and good taste.[10] Here American history was framed as art, and the value of artifacts derived from their aesthetic rather than associational qualities.

That same year another wealthy antique lover selected the National Museum as the repository for her tasteful legacy. Gertrude D. Ritter presented curators with the pine paneling from the parlor of a mid-eighteenth-century Springfield, Massachusetts, house she

had purchased in 1923, along with a collection of colonial artifacts to furnish the room. It was the first period room acquired by the museum, and curators were quite excited to receive it. Ritter intended the room as the first step in her grand plan to assemble a "complete Early American House" at the National Museum. After the colonial parlor was installed, Ritter herself took an active role in managing the exhibit. As a condition of her gift, she reserved "the right to replace any articles of furniture or furnishing in said room with other similar articles which may seem to me to improve the quality of the collection for museum purposes." She selected objects for the room from an extensive antique collection stored at her Vermont home, Yester House. In 1930 Ritter visited the National Museum and was very upset with the condition of "her" room; she spent four hours cleaning the furnishings and demanded that a wood expert be brought in to repair the deteriorating paneling. By the 1930s officials were balking at Ritter's original plan for a complete house to be erected in the museum, citing cost and space concerns. Disappointed, Ritter changed her will and left her Yester House collection to her alma mater, the University of Michigan.[11]

By the 1920s some Americans were openly challenging the founding families' exclusive claim on the nation's heritage. They criticized the worship of Puritan ancestors and the textbooks that granted New England a privileged place in national history while downplaying the contributions of other regions.[12] With the onset of the Great Depression, the elite literally lost their grip on the past as many once-wealthy collectors were forced to sell off their antiques; as prices dropped, more Americans could afford their own piece of history.[13]

In this and many other ways throughout the 1930s, history was gradually becoming more accessible to and reflective of the people. Automobiles brought museums and historic sites within reach of more Americans, and more sprouted up to serve the tourists who rolled into town on the new highways. Meanwhile, as the federal government expanded to contend with the nation's economic crisis, it also assumed an unprecedented responsibility for the nation's history. In 1934 the National Archives was created to house and preserve government records and historic documents of national significance, including the Declaration of Independence and the Constitution. The National Park Service, established in 1916 to protect the country's natural treasures, now turned its attention to cultural treasures as well by acquiring, surveying, and preserving historic sites and buildings. Through New Deal work-relief agencies such as the Works Progress Administration (WPA), the government hired writers and photographers to document the histories of people not ordinarily showcased in museums, such as former slaves and migrant workers. For the Index of American Design, part of the WPA's federal art project, artists produced detailed watercolor images of thousands of antique arts and crafts—not famous objects associated with founding

COLONIAL ROOM, U. S. NATIONAL MUSEUM, SMITHSONIAN INSTITUTION

The Colonial Room as exhibited in the Natural History Building in the 1930s, in the Museum of History and Technology in the 1970s, and in the National Museum of American History in the 1980s (above, opposite top, and opposite bottom). Since it was acquired in 1924, this pine-paneled room has been exhibited in a variety of contexts, reflecting changing interpretations of American history and new historical evidence. The room was originally believed to be the parlor from the house of Reuben Bliss, a joiner who lived in Springfield, Massachusetts. In 1981 Edward F. Zimmer, an architectural historian, discovered that the room did not match the dimensions and design of the Bliss house. He speculated that the room came instead from the house of the merchant Samuel Colton, constructed in Longmeadow, Massachusetts, in the 1750s and demolished in 1916. These findings shaped the new display of the room in the 1985 exhibition *After the Revolution*.

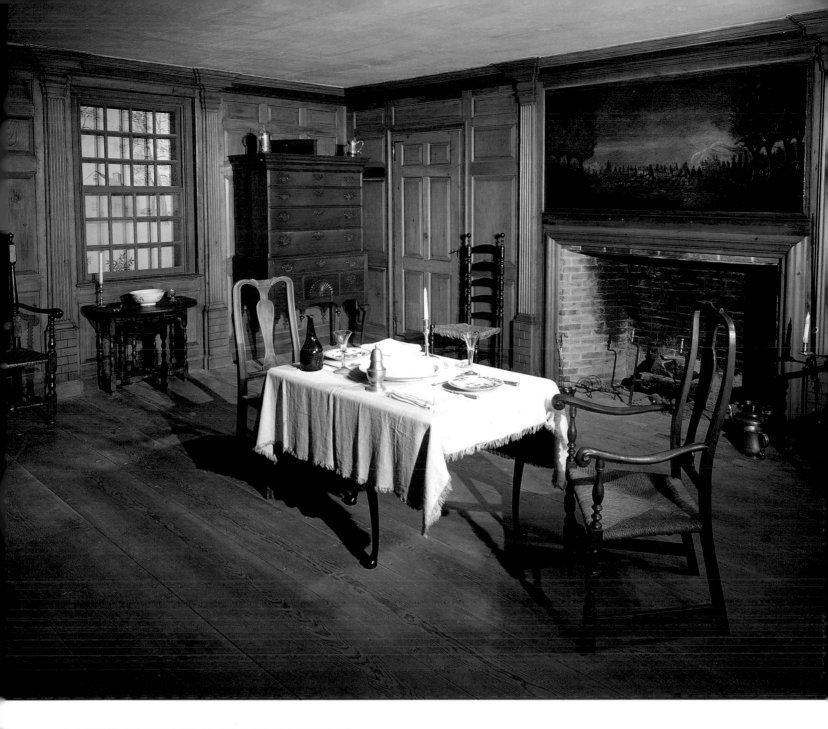

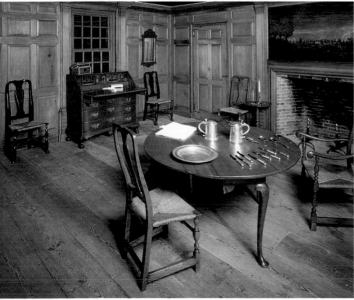

families but the creations of largely anonymous artisans and folk artists whose work represented the varied craft traditions of the United States.[14]

The Smithsonian lent its support to many of the federal government's historic preservation programs during the 1930s. With the WPA, it codirected the Historic American Merchant Marine Survey, whereby numerous models, plans, photographs, and drawings of historic watercraft were produced and deposited in the National Museum collections. The museum also hosted WPA exhibits, featuring the Index of American Design and state guidebooks produced by the Federal Writers' Project. Yet within its own historical collections, little evidence of this movement toward a more democratic, inclusive view of the American past could be detected. National history at the National Museum still consisted mainly of political relics and antiquarian treasures. After World War II, however, things began to change, slowly but surely, and the changes started in Gertrude Ritter's period room.

Everyday Life and Ordinary People

The Colonial Room, as it was called, remained in the National Museum as Ritter had left it until 1949, when a new curator named C. Malcolm Watkins requested permission to make some changes. Recently arrived from the Wells Historical Museum in Sturbridge, Massachusetts (predecessor of Old Sturbridge Village), Watkins, a Harvard-educated expert in the history of technology and decorative arts, had come to the Smithsonian with certain ideas about how museums should interpret the American past.[15] First and foremost, he insisted that history exhibits "conform to scientific standards of accuracy expected of the U.S. National Museum."[16] As for the Colonial Room, its eclectic mix of eighteenth- and nineteenth-century decorative arts and furnishings may have constituted an accurate representation of a 1920s antique collector's living room, but it reflected little of the room's original 1750s function or appearance. To remedy this, Watkins suggested that historically inappropriate items be removed and replaced with more authentic ones that matched the room as he understood it to be: the parlor of a typical farmer-artisan in mid-eighteenth-century New England.

Watkins valued museum objects more as historical evidence than as artistic creations; he wanted them to speak to truths about how people lived in the past rather than simply serve contemporary notions of good taste. Moreover, the Americans whose history Watkins believed the National Museum should tell were the anonymous ordinary folk, those whose craft traditions and rural, preindustrial ways of life were celebrated by 1930s projects such as the Index of American Design. To bring about this new vision of the American past, Watkins brought in a wealth of new artifacts, starting in 1949 with the collection of Arthur and Edna Greenwood. The Greenwood Gift, as it became known, consisted of more than two thousand objects used in rural New England households, schools, and farmsteads between 1630 and 1830. For Watkins and those who shared his appreciation for everyday life, the value of these artifacts was based not on fine lines or precious materials but rather on their historic character, the fact that they were actually part of people's daily lives: "The age of each piece is intrinsically obvious—stretchers, arms, lids show wear that only time and use can produce. None has been scraped or shellacked; each has been preserved in its original state."[17] The collection epitomized the concept of Americana; according to Edna Greenwood, her collection of folk art, furnishings, and utensils was "the best demonstration of what America *was* that makes it what it *is.*"[18]

The Greenwood Gift provided Watkins with the building blocks for a new exhibition gallery, the Hall of Everyday Life in Early America, which opened at the Natural History Building in 1957. It was intended to convey, "by means of authentic home furnishings, tools, and other objects," a comprehensive view of the cultural history of the United States from colonial times to the early nineteenth century, including

Bed warmer, 1700s (opposite top). This is just one of more than two thousand objects donated to the Smithsonian in 1949 by Arthur and Edna Greenwood, collectors of antique household items and folk art of rural New England. Curators used many of these artifacts to tell a new story of the American past, one that emphasized ordinary people and everyday life instead of famous individuals and founding families.

Bellarmine jug made in Frechen, Germany, mid-1500s (opposite bottom). This jug—decorated with a bearded face, a popular Frechen motif—is from a large collection of northern European plates, jugs, and other utilitarian stoneware presented to the Smithsonian in 1959 by Wiley T. Buchanan Jr., former ambassador to Luxembourg. At the time archaeologists were discovering remnants of similar jugs in colonial American sites such as Williamsburg, Jamestown, and Marlborough, Virginia.

Drawknife, early 1800s (below). This drawknife, a common tool used by cabinetmakers in the early nineteenth century, was one of many antique hand tools donated to the Smithsonian in 1962 by members of the Early American Industries Association. Founded in 1933 to collect and preserve "the tools and implements used by our forefathers," the group supported the museum's efforts to represent the past through everyday objects and to honor the ingenuity and hard work of American artisans.

"the various European origins of the early settlers; their housing, trapping, and planting; their trade with the Indians, their domestic and community life; their arts and crafts; and the life of the child."[19] The hall featured several period rooms, including a nineteenth-century New England schoolroom and an updated version of the eighteenth-century parlor donated by Gertrude Ritter, as well as rooms from a two-story, seventeenth-century Massachusetts Bay Colony house (a 1955 addition to the Greenwood Gift). Many of the artifacts were culled from the Greenwood Gift, while others were collected from individuals and groups such as the Early American Industries Association, founded in 1933 for "preserving for posterity the tools and implements used by our forefathers."[20] As displayed in the museum, antique hand tools identified a new set of American ancestors: not the wealthy owners of ornate silver, ceramics, furniture, and glassware but the artisans who designed and made these artifacts as well as the pioneers and farmers who fashioned their houses and furnishings with their own hands.

To assemble and furnish the rooms in the Hall of Everyday Life, curators had conducted extensive historical research, consulting probate records and other archives to identify objects that would represent the time periods as accurately as possible. The exhibition was further informed by archaeological research conducted by Watkins and other Smithsonian curators during the 1950s in Virginia, Maryland, Delaware, and New England. Archaeological techniques, traditionally used to excavate the remains of ancient civilizations, were by the mid-twentieth century also being applied to sites of colonial settlements. To scientifically minded historians like Watkins, pottery shards, glass fragments, buttons, weapons, utensils, and various other items salvaged from the soil represented important historical data that could be used to reconstruct everyday life in early America. Instead of relying on artifacts that had been selectively preserved and handed down through generations, archaeologists went back to the places where early Americans had lived, worked, and played in search of clues to what the past was really like. Through what the archaeologist James Deetz called "small things forgotten," historians aimed to piece together the forgotten

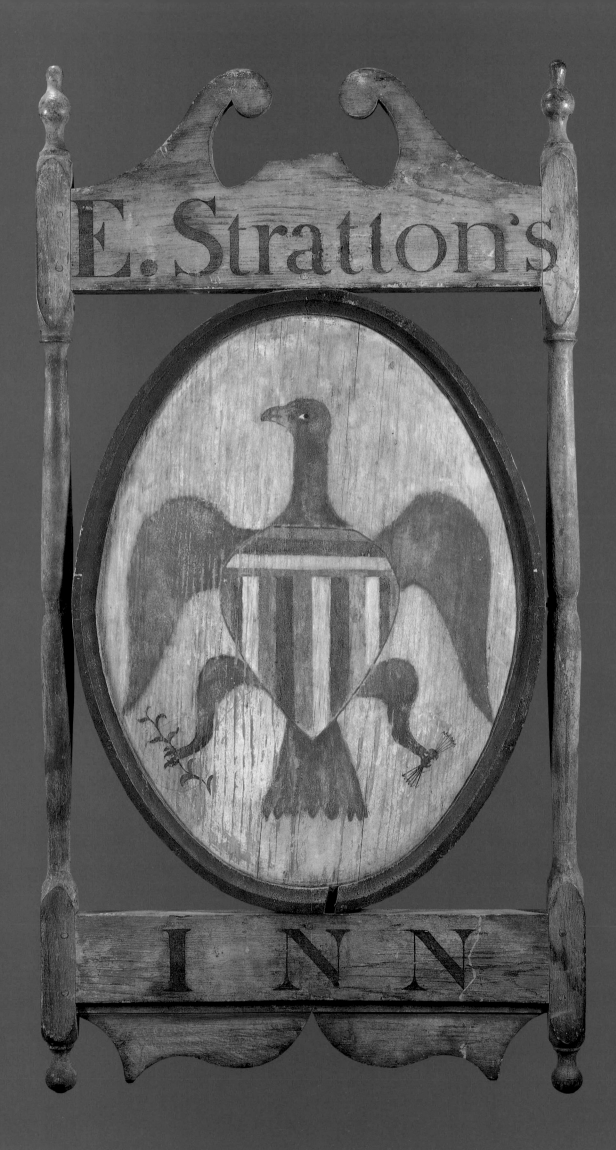

Dollhouse, 1900–1950 (above). Representing the home of a large, affluent American family of about 1910, this dollhouse was built by Faith Bradford, who spent more than a half century accumulating and constructing the miniature furnishings for its intricately detailed rooms. When she donated the dollhouse to the Smithsonian in 1951, she wrote a lengthy manuscript describing the house and the lives of its residents and for years afterward kept up a "correspondence" with the doll family, sending them holiday cards and letters. When Bradford died in 1970, curators paid tribute to her by placing miniature flowers and a memorial ribbon in the dollhouse exhibit.

Tavern sign, early 1800s (opposite). As the machine age filled American lives with mass-produced goods, historians and collectors came to value folk art for its handcrafted, unique character, as a nostalgic reminder of a simpler, preindustrial past, and as a symbol of the nation's artistic heritage. In 1964 the Smithsonian acquired the large folk art collection of Eleanor and Mabel Van Alstyne. Many of the pieces, including this tavern sign, were featured in *The Art and Spirit of a People*, a 1965 exhibition at the Museum of History and Technology.

and neglected history of ordinary people, those whose stories were not customarily preserved in books or museums.

With the opening of the Hall of Everyday Life, which was reinstalled in the new Museum of History and Technology in 1964, American history at the Smithsonian became the story of ordinary people. A 1965 exhibition of American folk art, *The Art and Spirit of a People*, aspired "to illustrate values, attitudes, and interests prevalent in nineteenth-century America."[21] But who were these "ordinary" Americans, exactly? According to museum curators in 1973, they were "those most responsible for the building of America—the anonymous farmers, artists, artisans, ministers, seafarers, storekeepers, ranchers, and homesteaders, who comprised the dominant American middle class."[22] The values and experiences of the middle class were now identified as quintessentially American, a change inspired by social and cultural changes surrounding World War II.

The widespread prosperity of the postwar era, combined with the defense and promotion of the "American way of life" as a counterpoint to communism during the Cold War, shaped how Americans saw themselves in the past as well as the present. At a time when pressures for social conformity and consensus were high, the National Museum supplied a vision of American history that emphasized the typical, the normal, the mainstream. Whether they watched television or visited the Smithsonian, Americans during the 1950s and early 1960s saw the image of a prosperous, conservative, contented nation reflected back to them. But beyond suburban living rooms and outside the museum doors, America was looking very different indeed.

Opening the Doors Wider

Nearly six decades after the National Museum made history by keeping its doors open on Sunday, another official kept the doors open in hopes of changing history altogether. In the summer of 1968, thousands of activists began arriving in Washington, D.C., for the Poor People's Campaign. A movement launched by the Reverend Martin Luther King Jr. to raise awareness of poverty, job discrimination, and racial injustice, the Poor People's Campaign was more than just a march. It was an encampment, a live-in demonstration. Protesters built a temporary village on the National Mall, nicknamed Resurrection City, U.S.A. As the canvas tents and plywood shelters began to fill the grassy spaces between the Smithsonian museums, including the new Museum of History and Technology, officials held a crisis management meeting to formulate a plan of action. Only a few months earlier, angry riots had ripped through the nation's capital in the wake of King's assassination. Fearing another outbreak of violence, some administrators urged closing the museums to protect exhibits and staff. The residents of Resurrection City, after all, bore little resemblance to the typical Smithsonian visitor.[23]

But S. Dillon Ripley, secretary of the Smithsonian, ordered the doors to stay open. Ripley had taken office in 1964, the same year that the Museum of History and Technology had opened. He made clear his appreciation for symbolic acts the following year, when he had the bronze statue of the Smithsonian's first secretary, Joseph Henry, rotated to look outward to the National Mall rather than toward the Castle, as it had done since 1883. Since then, Ripley's conviction that the Smithsonian must serve the needs and interests of the people had been fortified by the events he had witnessed from his Castle window.

Poor People's Campaign demonstrators in front of the Smithsonian Castle, 1968. In the late 1960s Smithsonian curators began to actively collect materials from civil rights, antiwar, and other contemporary political movements. One of the first events they documented was the Poor People's Campaign, held in Washington from May 13 to June 24, 1968. Led by the Southern Christian Leadership Conference, the live-in demonstration protested poverty, unemployment, and racial discrimination.

Nineteenth-century New England schoolhouse, Museum of History and Technology, 1970s. In 1966 the museum collected a one-room schoolhouse from Stonington, Connecticut, for the Hall of Everyday Life. It went on display in 1969, during a time when protesters were flooding the streets of Washington, D.C., demonstrating against the Vietnam War and for civil rights. For Ellen Boggemes, who taught at the school from 1911 to 1913, the exhibit was a "reminder of peaceful, happy days," a contrast to the social turmoil of the present. In a letter to Curator C. Malcolm Watkins, she expressed her hope that "our little school" would inspire visitors to recognize that "public schools [are] the strength of this nation!"

Throughout the 1960s civil rights and antiwar demonstrators marched through the streets of Washington and gathered around the monuments, demanding social change and criticizing government policy. Some of these protests were marred by violent confrontations with authorities and counterdemonstrators. Along with the rest of America, Ripley had been greatly disturbed by the conflicts erupting in Washington and across the nation. But unlike some cultural leaders, he viewed the civil unrest not as the cause of the country's problems but rather as a symptom of something much larger. Instead of condemning the protesters, Ripley looked to himself—and the institution under his control—to understand and help resolve the national crisis.

In his annual report for 1968, Ripley announced what he had discovered: "In a year of convulsive impact on the people of America, one theme, I think, has been borne upon the Smithsonian Institution. This theme is that the Institution has a moral responsibility to consider its exhibits for the effect that they may have upon all sorts and conditions of people."[24] Like his predecessors, Ripley believed the Smithsonian could help repair and strengthen the American social fabric, and, as earlier officials had done in making their case for Sunday hours, he used this argument to justify keeping the Museum of History and Technology open during the Poor People's Campaign and again during a massive antiwar demonstration in November 1969. Ripley

compared the Smithsonian and other museums to medieval monasteries "removed from the warfare that surges round about"; by helping ensure that these facilities remained "open havens where the public comes and goes as it will," Ripley expressed his hope that perhaps "something of value to all our people will brush off in the process."[25]

Curator Malcolm Watkins shared Ripley's faith in the social value of the museum. As more than eighty thousand people wandered through the Museum of History and Technology during the November 1969 peace march, Watkins's wife noticed a group of protesters sitting "spellbound" in front of the nineteenth-century New England schoolroom in the Hall of Everyday Life. "This is real," she overheard them say. Watkins interpreted the story as a sign of the times: "One of the problems afflicting us today and troubling our young people, I believe, is the enormous scale and complexity of everything, transcending human values and simple human relationships. The scale of the [schoolroom] is human, with individual relationships implied by those little benches and slates and the tiny building itself."[26] As a cultural historian, Watkins saw solutions to current problems in the contemplation of the past, recognition of shared values, and celebration of a simpler way of life.

Yet while Secretary Ripley believed that the Smithsonian could be part of the solution to the nation's social crises, he demanded that it first recognize itself as part of the problem. Despite the shift in focus to the history of ordinary people, exhibits and collections in the new Museum of History and Technology still featured many of the objects favored by curators over the years: exquisite decorative arts, elegant costumes, ornate furniture. Moreover, the museum continued to define typical Americans as white Americans and the story of American history as the story of northern European colonists and their descendants. The experiences of other Americans—Native Americans, African Americans, immigrants, the working class—were virtually excluded.

Ripley saw these elements as evidence of what he termed "the preservation trap": a distorted, "gussied up" view of the past that perpetuated a "myth that all our ancestors were upper middle-class Protestant whites who lived like ladies and gentlemen." Although Ripley's own ancestors were, in fact, wealthy Protestant whites—among them was William Bradford, the first governor of Plymouth Colony—he did not believe he and his peers should hold a monopoly on American heritage. The museum's "moral responsibility" in the late 1960s, according to Ripley, was not to present an ideal vision of the past for the public to emulate but rather offer a "true historical picture" of the nation and its diverse population, to "tell it like it is." The most important thing for Americans—all Americans, people of diverse ethnic and racial backgrounds—to see in exhibits and collections was not pretty antiques but artifacts that reflected their own heritage and offered "evidence that they are part of the stream of history of the United States."[27]

Cittern made by John Preston, London, England, about 1770. A metal-stringed instrument akin to the lute, the cittern is played by plucking the strings with a plectrum. Popular in Europe during the Renaissance, it was revived as the "English guitar" in the mid-eighteenth century. In 1896, when this cittern was acquired, the National Museum was collecting objects from around the world to illustrate the cultural evolution of the human race. For its synoptic series of musical instruments, which emphasized technological development, the instruments were classified according to how they were played and the type of sound they produced.

Past Plural: Cultural Diversity

I n fact, cultural diversity had long been on exhibit at the National Museum—just not in the American history halls. Starting in the 1870s curators of ethnology, the branch of anthropology dedicated to the comparative study of human culture, set out to transform the museum into a miniature world by collecting artifacts of various ethnic groups, past and present. Artifacts representing indigenous peoples were collected by anthropologists, explorers, and traders who ventured into territories still untouched by white civilization. Many ethnological objects were also acquired in Europe and the Far East by curators, professional collectors, and wealthy American tourists doing the "Grand Tour." Others, such as the medical drug collection established in the 1870s, were acquired from foreign government exhibits at the numerous world's fairs and industrial expositions of the last half of the nineteenth century. Once in the National Museum, these artifacts were categorized according to tribal, racial, or national origin and placed in comparative frameworks according to their design, function, and level of "culture progress."

Moravian girl's costume, about 1900. Many European countries have a national costume, symbolic of the ethnic identity of the dominant culture. Such costumes were generally developed in the nineteenth and early twentieth centuries and reflected emerging nationalist sentiments as well as new interests in folk culture and tradition. During this time the National Museum acquired many examples of European ethnic costumes for its ethnology collection. This Moravian costume was donated in 1909 by the Czecho-Slav Ethnographic Museum in Prague along with other examples of "the true Slav folk-art." In exchange, the Prague museum requested anthropological specimens from the Smithsonian's collections—including skulls and bones to show the "anatomical peculiarities" of Native Americans, African Americans, and Egyptians— and an instrument for measuring cranial capacity.

This classification and comparison of cultures initially focused on technological artifacts. But in the late 1880s a Jewish scholar named Cyrus Adler led new efforts to expand the National Museum's purview to include religion. Since the early 1800s, European scholars had been studying religion as a product of human development and culture— something that, like technology, evolved over time and place in response to the needs and values of a particular society. Adler, who received a Ph.D. in Semitics from Johns Hopkins University in 1887, brought these ideas with him when he came to the National Museum that year as an honorary curator of oriental antiquities. Soon after his arrival, Adler began to collect Jewish ceremonial objects, the first ever to be placed in the museum. With these artifacts he began to lay the groundwork for a comparative religions depart- ment, which would focus not on the religions of what ethnolo- gists defined as "prehistoric cults" or "semicivilized or bar- barous tribes" but rather on those "historic"

religions that in Adler's mind formed the basis of modern Western civ- ilization: Judaism, Christianity, and Islam. In 1893 Adler's collection of Judaica became the basis of the National Museum's new Section of Religious Ceremonials (later called the Section of Historic Religions), comprising artifacts representing Jewish, Islamic, and Christian reli- gious practices, collected from around the world and classified accord- ing to ceremonial function.[28]

In establishing the religious history collection, Adler, the grandson of German Jewish immigrants, was guided not only by scholarly interests but also by a personal and political agenda. Between 1880 and 1920 millions of Jews fleeing persecution in eastern and south- ern Europe and seeking economic opportunity immigrated to the United States. Once in this country, however, they continued to face discrimination from Americans who saw Jews as a threat to Christian values. Adler and other Jewish cultural leaders believed that this prej- udice could be countered by educating the public about Jewish his- tory and traditions and by framing Jewish culture as an integral part of the larger history of Western civilization. As the National Museum's collection expanded to include other religions, Adler hoped that Catholics, Orthodox Christians, Muslims, and members of other per- secuted sects would also benefit from having their customs explained and placed within a historical context.

The museum presented Jewish ceremonial objects in the context of biblical archaeology, a subject of great fascination in the last quarter of the nineteenth century that was fueled by new archaeological discoveries as well as a Protestant religious revival in the United States. For the most part, however, the artifacts Adler collected did not date from Old Testament times but rather came from the households

Russian Eastern Orthodox icon, 1800s (above). In 1891 George Kunz, an agent for Tiffany and Company, was sent to Russia to acquire exotic arts and crafts for American collectors. Among his purchases were 350 copper-alloy icons that reflected the persistence of Eastern Orthodox worship practices formally abandoned in the late 1600s. Smithsonian curators bought many of these for the new religious history collection.

Shofar, early 1800s (opposite top). This shofar, a Jewish ceremonial instrument made from a ram's horn, was the first object of Judaica collected by Cyrus Adler for the National Museum in 1889. Adler's grandfather, Leopold Sulzberger, brought it with him to the United States when he emigrated from Germany in 1838.

"Star-Spangled Banner" scroll, 1914 (opposite bottom). This scroll, donated to the Smithsonian in 1921, symbolizes how Jewish immigrants adapted their cultural traditions to fit their new lives in America. Inside the scroll are a patriotic hymn in Hebrew, written by the donor, Israel Fine; portraits of Washington and Lincoln; excerpts from Lincoln's second inaugural address; and the phrase "E Pluribus Unum."

of his friends and relatives and from synagogues in Europe and America. Like Native American culture, Jewish culture was considered by ethnologists an example of "living archaeology"; the ceremonial practices and artifacts of the present day were believed to closely resemble those of ancient times, handed down over the centuries relatively unchanged. While not scientifically accurate, this view encouraged tolerance and respect for modern Jews by portraying them as the guardians of a common Judeo-Christian heritage, one described and legitimized in the Bible.

Adler worked against anti-Semitism by collecting artifacts that represented the biblical roots of modern-day Jewish traditions. Yet one of the ceremonial artifacts collected at this time reflects another way many Jews sought to overcome prejudice—by identifying themselves as Americans. In 1921 Israel Fine, a prominent member of Baltimore's Jewish community, presented to the Smithsonian a scroll he had made in honor of the one hundredth anniversary of Francis Scott Key's poem "The Star-Spangled Banner." Decorated with American flags and a Hebrew inscription, this patriotic artifact suggests how Fine, a native of Lithuania, adapted his cultural traditions to his adopted homeland, enlisting one to express loyalty to the other. Rather than rejecting his ethnic heritage, which foreign newcomers were often expected and urged to do to be properly "Americanized," Fine, like many other immigrants, made his Jewish identity an integral and inseparable part of his American identity.[29]

Nevertheless, for years after Israel Fine donated his emblem of multicultural American identity, most ethnic traditions remained segregated from the Smithsonian's conventional narrative of American history. Ironically, the narrative that emphasized founding families also excluded people whose ancestors had been in America long before the Colonial Dames's oldest family tree was planted on New World soil. At the turn of the twentieth century, two sets of Americans were represented in the museum: native Americans, native-born descendants of the early white settlers, whose heritage was preserved as American history; and Native Americans, the continent's original inhabitants, whose heritage was preserved as American ethnology.

Long before the Smithsonian established its historical collections in the 1880s, it had been collecting and documenting the history of Native American cultures. Exploring expeditions, following the expanding U.S. border westward during the first half of the nineteenth century, brought back to Washington, D.C., evidence of the human and natural worlds they encountered. On its founding in 1846, the Smithsonian became the official repository for the government's treasures and soon went on to sponsor its own expeditions into Indian territory. After the Civil War, the emergence of the new scientific disciplines of anthropology and ethnology, combined with American scientists' renewed and enhanced interest in the Americas, made Native Americans a primary subject of investigation among curators charting the cultural evolution of the human race.[30] Over the next fifty years, storage vaults and exhibit cases were filled with millions of artifacts representing the customs and beliefs of North American Indian tribes.

In collecting these objects, the Smithsonian aimed to preserve ways of life that many believed were destined to disappear. Indeed, while Indian artifacts were pouring into museums during the nineteenth century, the tribes themselves were rapidly disappearing from the landscape, forced off their homelands and onto reservations and killed off by war and disease. Although part of the "civilization" process responsible for this devastation, many curators, artists, government officials, and others who documented Native American culture believed they were in fact helping "save" the Indians. George Catlin, whose paintings are preserved in the Smithsonian American Art Museum, wrote from the Dakota territory in 1832 of his feelings for the endangered "noble races of red men":

I have flown to their rescue, not of their lives or of their race (for they are 'doomed' and must perish), but to the rescue of their looks and their modes . . . [so that] phoenix-like, they may rise from the 'stain on a painter's palette' and live again upon canvas and stand forth for centuries yet to come—the living monuments of a noble race.[31]

Many scientists also believed that studying Native American culture was a heroic pursuit as well as an intellectual exercise. According to

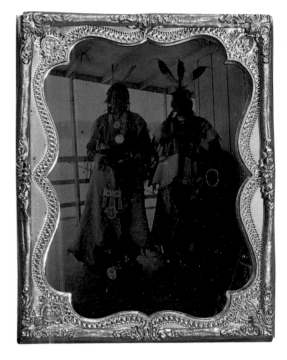

Ambrotype of two Yanktonai Indians, Bone Necklace and Lazy Bear, mid-1800s. This photograph of two Yanktonai men posing in their finest clothes on the deck of a boat is from a group of daguerreotypes and ambrotypes accumulated by the Bureau of American Ethnology, a branch of the Smithsonian devoted to the study of Native American cultures. When these portraits were discovered in a bureau employee's office in 1932, they were valued more as examples of early photographic technology than for their subject matter and so were transferred to the National Museum's history of photography collection. But recent research has revealed their greater significance: they are now believed to be the earliest known photographs made of a Native American delegation sent to Washington, D.C., to negotiate treaties and meet with the "Great Father."

Shoe made by a Sioux student at Carlisle Indian School, 1885. Under the slogan "Into Civilization and Citizenship," Captain Richard Henry Pratt, founder of the Carlisle Indian School, took thousands of Indian children off the reservations and away from their families for academic, vocational, and moral instruction. In 1885 he presented the National Museum with several pairs of shoes made by students to show how his school was transforming Indians into "acceptable productive citizens."

Smithsonian Secretary Joseph Henry, it was "a sacred duty which this country owes to the civilized world."[32]

As anthropologists hastened to collect and preserve Native American artifacts, others encouraged Indians themselves to discard their traditions and join the "civilized world." Could the Native American, as a member of a "savage" race, be assimilated into white society? This question shaped policy debates throughout the nineteenth century and inspired government officials, missionaries, and educators to undertake various "civilizing" projects, both on and off the reservations. The U.S. Indian School at Carlisle, Pennsylvania, founded in 1879, was one of several institutions where Indian children were brought to learn domestic, agricultural, and industrial skills as well as English, arithmetic, geography, and history. In 1885 Richard Henry Pratt, the school's founder and superintendent, presented the National Museum with several pairs of shoes made by a Sioux student as proof of the school's good work in transforming Indians into "acceptable productive citizens." To Pratt the products of the Carlisle School were more appropriate objects for the museum than traditional tribal artifacts; instead of "exalting Indianisms," he believed the government should focus on "advancing Indian civilization and merging them into citizenship."[33]

Pratt and other white reformers believed that only through removal of all traces of native culture could the Indian gain equal rights and become assimilated into white society. Yet for many Carlisle graduates, the future did not live up to Pratt's promises. Those who hoped to use their education to advance in society faced discrimination from whites and were often barred from government jobs and other opportunities. Most returned to the reservation. Some chose to marry whites and raise families outside the tribe; others sought to reclaim their Indian identity and rejected white society. Some, like the Sioux activist and author Luther Standing Bear, one of the Carlisle School's first students, drew on their experiences to educate and urge understanding and respect for Indian culture. Recalling the "white man's clothes" he and his fellow students were forced to wear as part of their transformation at Carlisle, Standing Bear wrote in his 1933 autobiography, "To clothe a man falsely is only to distress his spirit and to make him incongruous and ridiculous, and my entreaty to the American Indian is to retain his tribal dress."[34]

A pistol made by Salola, a Cherokee blacksmith, and presented to the U.S. government in 1845, was also intended to illustrate "the mechanic arts and progress of improvement among the Indians."[35] But the donor, William Holland Thomas, hoped the pistol would help convince the government that the Cherokee, as a "civilized" people,

Silver peace pipe, 1814 (opposite). General William Henry Harrison presented this peace pipe to the Delaware Indians in recognition of their agreement to fight for the United States against Great Britain during the War of 1812. Many objects in the Smithsonian's collections reflect the military and political alliances forged between Native American tribes and the U.S. government during the eighteenth and nineteenth centuries. This pipe, now in the National Museum of Natural History, came to the Smithsonian in 1931 as part of a large bequest from Victor J. Evans Jr., a collector of Indian relics.

Cherokee pistol, 1843 (above). The inscription on this pistol identifies its maker as Salola (Squirrel), a blacksmith in the Oconaluftee settlement of Quallatown, North Carolina, who provided all the settlement's axes and plows. In addition, he manufactured "a number of very superior rifles and pistols," as a white visitor who met Salola in 1848 noted. "A specimen of his workmanship . . . may be seen at the Patent Office in Washington, where it was deposited by Mr. Thomas [in 1845]; and I believe Salola is the first Indian who ever manufactured an entire gun. But when it is remembered that he never received a particle of education in any of the mechanic arts but is entirely self-taught, his attainments must be considered truly remarkable." Salola's pistol was part of the Patent Office collections transferred to the Smithsonian in 1883.

deserved the same rights and treatment as white citizens. In 1838 seventeen thousand Cherokee Indians were forcibly removed from their homelands in North Carolina, Tennessee, Georgia, and Alabama and marched west to Oklahoma to clear lands for white settlement. Thousands perished during the long and arduous journey, known as the Trail of Tears. As the U.S. Army prepared to relocate the remaining Cherokee, Thomas, a white businessman who had dealings with the Oconaluftee Cherokee of western North Carolina, lobbied the federal government to allow the tribe to stay on their land. He brought Salola's pistol to Washington in 1845 as part of his lobbying efforts. His campaign ultimately succeeded, and the Oconaluftee, known today as the Eastern Band of Cherokee, were able to retain their lands and their sovereignty.

After the turn of the century, the defining issue for Native Americans turned from civilization to citizenship. With the outbreak of World War I, American Indians joined other ethnic Americans who, with the government's encouragement, enlisted in the military to prove their patriotism and, they hoped, secure citizenship and equal rights. Even as they faced racial discrimination, injustice, and impoverished conditions on reservations, many Native Americans strongly desired to be recognized as loyal citizens. When her son went off to fight in World War I, Nez Baza, a Navajo woman, wove a blanket in the pattern of a forty-eight-star U.S. flag to honor his service. After he returned home, she donated the blanket to the Indian school at Shiprock, New Mexico, where it was raffled off as a fundraiser. The raffle winner presented the blanket to Cato Sells, head of the Bureau of Indian Affairs, who in 1920 gave it to the Smithsonian.[36]

Objects such as the Cherokee pistol, Carlisle shoe, and Navajo flag blanket told stories different from those told by Indian artifacts collected by anthropologists. Rather than representing ancient tribal traditions on the verge of vanishing, they instead revealed the ways Native American cultures reacted and changed in response to encounters with white society. In a sense these artifacts were less authentic, less culturally "pure"—they did not fit conveniently into the ethnological categories that scientists had established. As a result, most ended up in the collections of the National Museum of American History rather than the National Museum of Natural History with the tribal artifacts collected by anthropologists. Like Israel Fine's "Star-Spangled Banner" scroll, they are multicultural artifacts. They record the struggle of Native Americans to redefine their identity both as sovereign tribes and as U.S. citizens. They show Indians as Americans, as part of the nation and its history rather than outside it.

Navajo flag-pattern blanket, about 1919 (below). Native Americans have long incorporated the image of the U.S. flag into their traditional arts and handicrafts. While some have used the flag to express their patriotism, others have used it in very different ways—as a prize of war, an entreaty for government aid and protection, an appeal to the white tourist market, or a symbol of political protest. According to the Bureau of Indian Affairs, which presented this blanket to the Smithsonian in 1920, it was woven by a Navajo woman in honor of her son's service in World War I.

Pennsylvania German plate, early 1800s (opposite). The German inscription on this red earthenware plate translates as "I have been riding over hill and dale / And everywhere have found pretty girls." It was purchased for the National Museum in 1898 for a synoptic series on the history of American ceramics manufacturing. In the 1950s and 1960s, as curators became interested in illustrating the ethnic origins and folklife of the American people, the plate was reinterpreted as an example of craft traditions brought to Pennsylvania by German colonists and kept alive by their descendants.

Sergeant Major Christian A. Fleetwood's Congressional Medal of Honor, 1865 (below). Fleetwood, a native of Baltimore who served in the Fourth U.S. Colored Troops, was one of thousands of African Americans who fought in the Civil War in hopes of gaining equality, freedom, and citizenship for their race. For his bravery in defending the U.S. flag during a battle at Chapin's Farm, Virginia, Fleetwood was awarded the Congressional Medal of Honor in 1865. In 1948, after his daughter Edith convinced curators to accept his medals for the military history collection, Fleetwood became the first African American veteran to be honored in the National Museum.

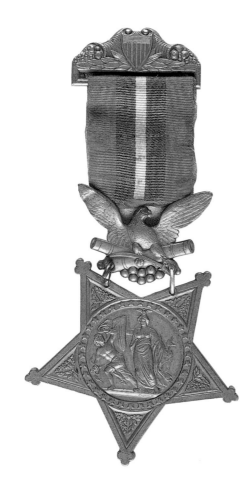

In the early 1900s objects that reflected a more diverse and complex American cultural identity, like the Cherokee pistol and the "Star-Spangled Banner" scroll, were the exception rather than the rule in the National Museum's collections. Yet by midcentury things began to change. World War II had taught deadly lessons about notions of ethnic purity. In positioning itself against the oppressive regimes of Eastern Europe during the Cold War, the United States began to embrace, at least rhetorically, its pluralistic heritage as a symbol of democratic freedom and tolerance.[37] Gradually these ideas started to filter into the National Museum, pushed ahead by individuals both inside and outside it.

In 1947 curators received a letter from a resident of Washington, D.C., offering a donation. The writer was Edith Fleetwood, the daughter of Sergeant Major Christian Abraham Fleetwood, a decorated Civil War veteran who had served with the Fourth U.S. Colored Troops and in 1865 had received the Congressional Medal of Honor. Edith Fleetwood had inherited her father's medals and in 1947 decided to offer them to the National Museum, where she had seen an array of military medals honoring U.S. soldiers of various wars but none representing African American soldiers. In fact, the museum's history collections had few African American objects of any kind.

Although African Americans took steps to document their own history in the late nineteenth and early twentieth centuries by establishing libraries, archives, and art museums at black universities, during this time the National Museum made no special effort to collect objects representing that history. Some objects were acquired by happenstance, such as several examples of African American pottery bequeathed as part of a larger collection in the 1920s. Others were collected to document the survival of "primitive" customs among modern populations for ethnological studies; for example, in the 1890s a curator visited Central Market in Washington, D.C., and purchased folk remedies from African American vendors for the medical collection. But even in the 1930s, when the federal government sponsored a number of cultural history projects including documentation of African American folklore and interviews with former slaves, African Americans remained essentially excluded from the Smithsonian's view of the nation's past.[38]

In offering her father's medals, Edith Fleetwood was directly responding to this exclusion, which implied that African Americans were not part of the nation's history and thus not truly part of the nation. What better evidence to counter this view than a black veteran's medals, tangible proof of the service and sacrifices African Americans had rendered as patriotic citizens? "The display of these medals would be a departure in some respects from precedent," Fleetwood tactfully noted in her letter to curators. Then she went on, invoking the ideals of World War II to plead her case: "But do you not agree that there has never been a time in America's history when such a

'first' could be more readily sustained and justified than now, during the nation's renewed and determined emphasis on true democracy?" Here, implied in this genteel African American woman's letter, was the glaring disparity between rhetoric and reality, between what America was supposed to be and what it actually was, between a museum that was supposed to represent the nation and a collection that reflected only white faces, white lives, white history.

The point was not lost on curators. While some supported the Fleetwood donation, others expressed concerns. Theodore Belote, head of the history department, worried that if the National Museum accepted one black soldier's medals, it would be inundated with hundreds of offers from other black veterans. Some even accused Edith Fleetwood of trying to seek publicity and create a media stir. To reassure officials that this was not the case, she agreed not to publicize the donation. Finally, albeit begrudgingly, the museum accepted the medals and quietly placed them on exhibit in 1948.

When Fleetwood went to see the medals in June 1948, however, she discovered that the exhibit label omitted the fact that her father was black. Once more she wrote to curators: "I find myself in a dilemma. . . . History will never know, through your legend, that Christian Abraham Fleetwood was a colored man." Claiming that she donated the medals "to serve my race rather than to glorify my father," Fleetwood argued: "For those who fought in the Civil War, color should be recognized. I believe this, even while impatiently awaiting the day when all reference to color has become superfluous." A month later the label was changed.[39]

The heroic battle Edith Fleetwood fought to have her father's medals included in the National Museum echoed the historic struggles of

Spanish colonial dwelling, Hall of Everyday Life, Museum of History and Technology, 1960s. The architectural elements and furnishings for this eighteenth-century period room were collected in New Mexico during the mid-1960s by the Division of Ethnic and Western Cultural History, which was created to expand the Smithsonian's view of American history beyond its traditional focus on Anglo Americans in the northeastern United States.

Face jugs attributed to a slave potter in Edge-field, South Carolina, about 1850. The origins of the face jug, a folk tradition among African American potters in the South, remain obscure. Some historians have linked these jugs to African ritual artifacts, others to imported European figural vessels. These two face jugs came to the Smithsonian in 1922 from the estate of a wealthy collector. At the time they received little attention from curators and were viewed as examples of "primitive" art. In the 1960s emerging scholarship in African American history inspired new interest in face jugs and the skilled slave potters who made them. The museum has since collected many examples of pottery from Edgefield, a center of nineteenth-century stoneware manufacture that relied heavily on slave labor, including jars made by the slave artisan David Drake.

African Americans to claim their rightful place as citizens of the nation. Unfortunately, as in the Civil War and both world wars, victory in battle did not translate into victory at home. The museum's acceptance of Christian Fleetwood's medals remained an exception to the rule; contrary to his daughter's hopes, it did not immediately inspire collection of more artifacts to represent the heritage and achievements of African Americans. Even in the 1950s, when Curator C. Malcolm Watkins began expanding the ethnic definition of "ordinary" Americans beyond Anglo-Saxon bloodlines in the Hall of Everyday Life, history collections and exhibits remained focused on the "various European origins of the early settlers."

When the Museum of History and Technology opened in 1964, many of the ethnological artifacts collected during the late nineteenth century were transferred here to represent the ethnic heritage of the American people. But only northern and western European ethnology was considered appropriate; most of the African, Asian, and Native American collections remained at the Museum of Natural History. At the Museum of History and Technology, cultural artifacts were featured in the Hall of Everyday Life and also in another major gallery, The Growth of the United States, a series of exhibits detailing the history of the nation and its people. Remembering his visit in 1966, Ralph Rinzler, a cultural historian, recalled that of the hundreds of artifacts he saw on exhibit, "the only objects there to detail the richness of Afro-American culture were a single coiled grass basket, an instrument, and Asante gold weights. I was appalled."[40] These few objects were displayed together in one small case, which also contained the only Native American artifacts in the entire gallery.

Ten years after Ralph Rinzler first visited the Growth of the United States gallery, it was gone. In its place was a brand-new exhibition, designed in honor of the U.S. Bicentennial in 1976, that also told the story of the growth of the United States. Yet its title indicated that a new and different image of America was emerging at the museum: *A Nation of Nations.*

Along with the country itself, the Smithsonian underwent a tumultuous and sometimes painful process of change during the 1960s. In 1954, seven years after Edith Fleetwood campaigned to integrate the military history collection with her father's medals, the U.S. Supreme Court ruled in *Brown vs. Board of Education* that the nation's longstanding tolerance of racial segregation under the aegis of "separate but equal" was unconstitutional. This watershed decision set in motion a series of turbulent and bloody struggles over what vision of America would prevail: exclusive or inclusive, segregated or integrated. When Secretary Dillon Ripley declared in his 1968 report that it was time to change the Smithsonian's reflection of America, "to

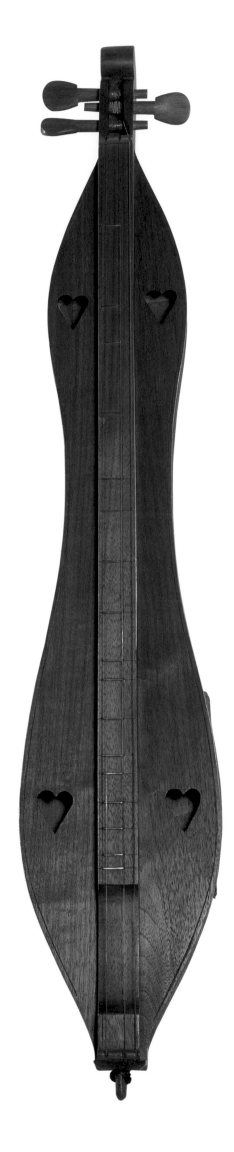

give the true historical picture, to describe the whole panorama of our cultures," he was explicitly aligning the Institution with the spirit of change and inclusion fostered by the civil rights movement.

By the mid-1960s that spirit was already influencing the work of Smithsonian curators who were reaching beyond traditional European ethnology to examine the folk traditions of diverse regions and racial and ethnic groups. Some went out into the field, collecting artifacts to represent the Chinese in California, Hispanics in New Mexico, rural life in Appalachia, and handicrafts of African Americans in the South. In 1967 the Smithsonian hosted its first Festival of American Folklife on the National Mall, where the arts and crafts of a diverse array of American communities were presented and celebrated. The festival became an annual event, one that has filled the museum with numerous examples of the cultural traditions that comprise the nation's heritage.[41]

The lessons of the civil rights movement inspired the Smithsonian to find ways to connect with new audiences, not just by keeping its doors open and collecting new objects but by creating alternative places for people to encounter the past. In 1968 the Smithsonian opened the Anacostia Neighborhood Museum to reach beyond the National Mall and bring African American history and culture into the

New Mexican *retablo*, about 1825 (top right). In the late 1960s, in an effort to expand the Smithsonian's traditional focus on the history of the eastern United States, curators actively sought out artifacts to represent regional cultures of the West and Southwest. *Retablos,* images of Catholic saints painted on flat wooden panels, were highly prized. This *retablo* depicting the Virgin Mary as the Divine Shepherdess was probably made by the artist José Aragon. It is part of a major collection originally assembled by Colonel Daniel Burns Dyer, a nineteenth-century entrepreneur who decorated his Kansas City home with Indian and Hispanic artifacts. The museum acquired the collection in 1966 from the colonel's grandniece, who had inherited it.

Laotian *ping purt*, 1985 (opposite left). This bamboo instrument was made by Lay Sivilay, a Laotian (Kmhmu) immigrant to California, during the Smithsonian's Festival of American Folklife in 1985. Since 1967 the annual festival on the National Mall has served as a living exhibition of the many ethnic cultures and traditions that make up the United States. In 1985 Laotian bamboo craftsmen shared the stage with Puerto Rican mask makers, a recreated Indian bazaar, and zydeco musicians from Louisiana.

Appalachian dulcimer, 1965 (opposite right). As part of the Smithsonian's growing interest in American folklife, Scott Odell, museum musicologist, traveled to the mountains of southwestern Virginia and North Carolina to document Appalachian musical traditions. He recorded performances of folk songs and also collected several instruments, including this dulcimer, made for the Smithsonian in 1965 by Jethro Amburgey of Hindman, Kentucky.

Sprayers from a Chinese American laundry shop, about 1900 (bottom right). Finding themselves barred from most industrial jobs and deprived of U.S. citizenship in the late nineteenth century, many Chinese immigrants started their own businesses as a means of survival. Smithsonian curators purchased these brass water sprayers, used in a Chinese laundry shop in Washington, D.C., to help tell stories of immigrant labor in the 1976 exhibition *A Nation of Nations*.

"Squash-blossom" necklace and earrings made by a Zuni silversmith in New Mexico, 1973 (left top). For Native Americans the sale of jewelry, blankets, and other handicrafts has been a source of both economic and cultural survival. The Smithsonian has collected examples of these artifacts to tell this story and document the influence of Indian styles on mainstream American fashion. These pieces were donated in 1996 by white admirers of Native American jewelry, who bought them in 1973. The intricate pattern of tiny, inlaid turquoise pieces, called needlepoint, is characteristic of Zuni workmanship.

"In-out" sewing basket made by a Gullah craftsperson, Sea Islands, South Carolina, 1974–75 (left bottom). Descended from slaves brought to the South Carolina and Georgia coast, Gullahs have kept their West African heritage alive through language, food, religious rites, handicrafts, and other folk traditions. In the 1970s Gregory K. Day, a cultural anthropologist, collected examples of Sea Islands basketry for the Smithsonian to document the survival of African traditions in contemporary African American life.

Arabic coffee maker, about 1920 (opposite top). This silver-and-brass coffee maker was bought and used by an Arab immigrant family in the early twentieth century. Coffee sets, symbols of hospitality, were a staple of the Arab American household, providing a link to immigrants' native identity. During the 1980s the historian Alixa Naff donated to the Smithsonian hundreds of artifacts and documents relating to Arab American life between 1880 and 1940.

Chalice from a Slovenian-American Catholic church, 1915 (opposite bottom). The Church of the Holy Cross in Bridgeport, Connecticut, was built in 1915 to serve a community of several hundred Slovenian immigrants and their descendants. In 1972, when the church was about to be demolished and rebuilt in a new location, a parishioner contacted the Smithsonian and asked for help in saving the ceiling paintings, the work of the Slovenian artist Ivan Gosar. Curators ultimately collected the paintings, stained glass windows, and ceremonial objects, including this gilded chalice, which was displayed in the 1976 exhibition *A Nation of Nations*.

local Washington, D.C., community. In the 1980s a movement got underway to establish on the Mall a Smithsonian museum dedicated to African American history and culture, one similar to the National Museum of the American Indian. In June 1993 the House of Representatives unanimously passed legislation authorizing creation of the National African American Museum, but the legislation died in the Senate the following year. Since then, the African American Museum Project, established in the late 1980s, has merged with the Anacostia Museum to form the Anacostia Museum and Center for African American History and Culture. With its pioneering exhibits centered on storytelling and multiple interpretations of cultural objects, the center has opened up new avenues to understanding black history.

At the Museum of History and Technology, the concept of America's multicultural identity was dramatically and vividly illustrated in *A Nation of Nations*. The exhibition celebrated the diversity of American heritage, telling of "the contribution of varied streams of people to the making of a new nation with a new identity" and expressing the idea that "each of these people has woven his own evolving uniqueness into the fabric of a common nation."[42] Dating from the pre-Columbian cultures of Native Americans to the present day, embodying the values, beliefs, and experiences of many peoples, the objects brought together in *A Nation of Nations* defined a new image of America and in the process a new image of the museum. In Secretary Ripley's words, the Institution had become "the repository for many thousands of artifacts which were family heirlooms, treasured possessions, and creations of the American people of every ethnic, racial, and religious origin."[43]

As it celebrated American diversity, however, the Bicentennial exhibition also emphasized what Americans held in common. What was the glue that bound these many groups together as one nation? In trying to answer this question, curators looked first at traditional topics—education, work, politics—and collected objects to represent the shared, cross-cultural experiences these provided. Instead of the nineteenth-century New England schoolhouse, *A Nation of Nations* featured a room from a public school in Cleveland, Ohio, dating from the beginning of the twentieth century, to reflect how immigrant

children in urban areas learned what it meant to be American. An American flag assembled from political buttons, emblazoned with a variety of ethnic names, symbolized how immigrants and their descendants claimed U.S. citizenship through participation in the democratic process.

But perhaps the most compelling and exciting evidence for a common national identity to appear in *A Nation of Nations* came from a world that had traditionally been left out of the museum's collections: popular culture. By the 1970s historians were beginning to study and appreciate popular culture as an integral and dynamic force in American life. When they attended a baseball game, went to the movies, or listened to music, Americans were not simply entertaining themselves but participating in a group experience, absorbing cultural values and tastes, and forming collective memories. When objects like a ticket booth from Yankee Stadium, Irving Berlin's piano, Muhammad Ali's boxing gloves, and Judy Garland's ruby slippers came into the museum in the 1970s, they brought that magical energy along with them. In these familiar icons of stage, stadium, and screen, Americans saw their own lives and experiences reflected back to them. Collecting popular culture objects has helped make the Smithsonian into a place not just for the people but also of the people.[44]

As *A Nation of Nations* helped open up new areas of collecting, it also reinvigorated old ones. In the Hall of Everyday Life, established in the 1950s, time essentially stopped at 1900. In the 1970s curators began to seek out objects to represent daily life in the modern age. In

Drawing from *Steamboat Willie*, 1928 (above). In 1988, to celebrate the sixtieth birthday of its most famous cartoon character, the Walt Disney Company donated to the Smithsonian several original drawings from Mickey Mouse's first film, *Steamboat Willie*.

Carnival mask made in Ponce, Puerto Rico, 1980s (left). Puerto Rican artisans are renowned for their elaborate and colorful papier-mâché masks, made for the annual Carnival celebration and as tourist souvenirs. This mask is one of more than 3,200 artifacts in the Teodoro Vidal Collection of Puerto Rican Material Culture, donated in 1997.

Lunch boxes, 1950s–80s (opposite top). For a 1989 exhibition on the history of television, Smithsonian curators scoured flea markets and garage sales in a search for lunch boxes depicting popular shows and characters.

Yankee Stadium ticket booth, 1923, on exhibit at the Museum of History and Technology in 1976 (opposite bottom, left). Before the original Yankee Stadium was demolished in 1973, the Smithsonian persuaded Yankee officials to donate some artifacts, including this ticket booth (with real graffiti).

***60 Minutes* stopwatch, 1970s–90s** (opposite bottom, right). In 1998, in honor of the show's thirtieth anniversary, CBS News and Don Hewitt, producer, donated this famous timepiece to the Smithsonian.

Fiestaware, about 1940 (above). Introduced by the Homer Laughlin China Company in 1936, Fiestaware appealed to many consumers with its bright colors, modern design, and affordable price tag. For the family of Charles and Bessie Morrison of Pennsylvania, who scraped and saved to purchase these dishes during the Great Depression, Fiestaware symbolized the American dream of a tasteful middle-class home. When Smithsonian curators collected the Morrisons' Fiestaware in 1998, they also collected the story of how the family bought and used the dishes.

Improved Veg-O-Matic II, 1975 (left). "This is Veg-O-Matic, the world-famous food appliance! ... the only appliance in the world that slices whole, firm tomatoes in one stroke, with every seed in place.... French fries? Make hundreds in one minute! ... Isn't that amazing?!" The inventor, Samuel J. Popeil, also created the frenzied ads that made his product a late-night-television sensation in the late 1960s and 1970s. In 1986 Popeil's family donated this Veg-O-Matic II, along with a recording of a commercial.

Girl Scout uniform, 1970s (above). In documenting popular culture and everyday life, the Smithsonian has collected objects that represent Americans' participation in social, educational, and civic organizations. In 1987 curators created a special exhibition in honor of the seventy-fifth anniversary of the Girl Scouts of America, featuring uniforms and memorabilia donated by former Girl Scouts and the organization itself.

Cast-iron fire engine, about 1900 (below). Mass-produced toys like these were often sold through mail-order catalogs, or "wish books," during the early 1900s. In 1972 Sears, Roebuck and Company, one of the original mail-order stores, donated more than two thousand antique cast-iron and tin-plate toys to the Smithsonian, which featured them in the 1972 exhibition *A Children's World*.

contrast to hand tools, folk art, and other objects collected to symbolize life in the preindustrial past, domestic objects collected in recent decades reflect how greatly daily life in the twentieth century has been informed by industrialization, urbanization, and the mass media. They document significant material changes in the home, at school, and in the workplace. While curators still collect kitchen utensils, everyday life in the modern American kitchen is represented by electric toasters, Veg-O-Matics, and Fiestaware rather than butter churns and pewter teapots. The material culture of childhood, formerly the province of samplers and hornbooks, now includes cast-iron toys from a mail-order catalogue, lunch boxes decorated with television characters, Girl Scout uniforms, and Barbie dolls. In redefining everyday life to include not just the distant past but also objects that evoke visitors' own memories and personal experiences, the museum has provided more ways for people to feel connected to history.

After a fifteen-year run, *A Nation of Nations* finally closed in 1991, but the National Museum of American History keeps its doors open, striving to present a history that includes all Americans. To help achieve this goal, the museum has sought the advice and expertise of scholars, artists, activists, and political leaders representing communities that have historically been excluded or underrepresented. It has established ongoing programs dedicated to bringing new voices and experiences into the museum, such as the Program in African American Culture (1982), American Indian Program (1986), and Encuentros series of public programs on Latino culture (1998). These efforts have been supported and supplemented by Smithsonian-wide programs including, in addition to the Center for African American History and Culture, the Center for Latino Initiatives and the Asian Pacific American Studies Program, both founded in 1997. Through exhibitions, programs, and collections dedicated to representing American cultural diversity, more communities have gained opportunities to have their stories told as part of the nation's story.

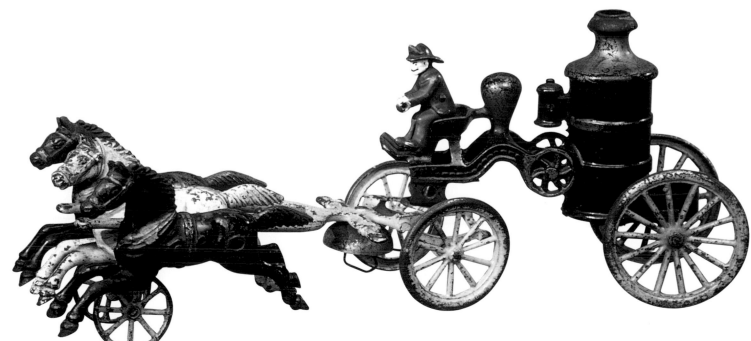

Telling It Like It Was

In 1968, when Secretary Ripley urged curators to "tell it like it is," he wanted the Smithsonian to include the traditions and contributions of diverse ethnic and racial groups. Since then the Smithsonian has collected many artifacts to construct a multicultural image of America, one that celebrates diversity as an enduring and defining characteristic of national life. Regarded together and from a distance, these objects suggest a variegated tapestry, a common national fabric woven of many colorful strands. And in 1976, a year intended to symbolize the reuniting of a country fractured by a decade of conflict and dissent, such pluralistic unity was the overwhelming message of *A Nation of Nations*. Yet objects are more than just emblems of diversity; they offer more than just stylistic evidence of ethnic origins. They are connected to people's lives, to their experiences, values, and beliefs. And when history is examined from the point of view of the people who made and used these artifacts, to include not only their faces but also their own voices and stories, American history—and America itself—begins to look very different. New kinds of stories emerge—stories not of national unity and prosperity but of conflict and inequality, of injustice and discrimination, of a nation that did not always live up to its promises.

Button from March on Washington for Jobs and Freedom, 1963. One of the first artifacts of the civil rights movement collected by the Smithsonian, this button was brought in by an employee who participated in the march.

On August 28, 1963, more than a quarter of a million Americans, black and white, came together in Washington, D.C., to march for racial equality. They gathered at the Lincoln Memorial and listened to a speech by the Reverend Martin Luther King Jr., which would forever echo through the nation's conscience. King described his dream of what America should be, contrasting that vision with the current reality of a nation plagued by racism, poverty, and inequality, a nation where blacks and whites inhabited separate and unequal worlds, where children of different races were educated in separate and unequal schools, where black workers were kept out of better jobs and paid unequal wages. They listened as he urged all Americans to close the gap between dream and reality, to hold the nation to its highest ideals.

While his "I Have a Dream" speech focused on the future, the backdrop for King's message, the giant marble statue of Abraham Lincoln, symbolically cast the civil rights movement as a historic struggle and the March on Washington as a historic moment. The march was one more step in a long series of steps toward racial equality; the journey was not yet complete, but by participating the marchers claimed their place in line, their place in history. Indeed, many wore this sense of historic importance on their sleeves in literal form: metal buttons emblazoned with the date of the march.

One woman who participated, a Smithsonian employee, believed so strongly she had helped make history that she brought her buttons into work and presented them to a curator, hoping the meaning and message of that day would be preserved in the museum's historical collections. But the message of these buttons was far different from the message presented by the Smithsonian in 1963. The new Museum of History and Technology, then under construction on the National Mall, promised to be a place where visitors to the nation's capital would find "a stimulating permanent exposition that commemorates

Anti-Vietnam War poster by Sarah Beach, 1970s.
When Beach, an artist and activist, visited the National Museum of American History in 1976 to see *We the People*, an exhibition on American politics, she was surprised to find herself part of the show. A Smithsonian photographer had snapped her picture at an antiwar rally, and curators had turned the image into a life-size figure for a display about political protest. Although pleased to be included in the exhibition, Beach did not agree with the slogan on the sign attached to her mannequin. Curators agreed to change the sign, and in 1977 they also collected two posters Beach had made and used in antiwar demonstrations, including this newsprint collage.

our heritage of freedom and highlights the basic elements of our way of life."[45] Yet as civil rights activists pointed out, the nation's heritage also included the struggle of African Americans and other groups for the freedom that had been granted to others but denied to them. Would this story also have a place in the museum of American history? Did it belong there?

Traditionally, as shown here, the answer had been no. The Smithsonian did not tell those kinds of stories. In the aftermath of the Civil War, amid the influx of immigrants at the turn of the century, and during the patriotic fervor of the two world wars, many Americans had looked to history as an escape from present-day problems and a way to promote patriotism and national unity. And the Smithsonian had responded by furnishing a celebratory, homogeneous, and conflict-free view of the American past. Now, at the height of the Cold War,

Antislavery medallion, about 1787 (opposite top). This jasperware cameo, made at Josiah Wedgwood's factory in Staffordshire, England, features the motto adopted by the British Committee to Abolish the Slave Trade in 1787: "Am I Not a Man and a Brother?" An active abolitionist, Wedgwood sent one of these cameos to Benjamin Franklin in 1788, hoping to promote American support for the antislavery cause. This medallion originally came to the Smithsonian in 1968 as part of a large loan from Lloyd Hawes, a prominent collector of English ceramics. The medallion was featured in a major exhibition, *After the Revolution*, and in 1987 the loan was converted to a gift.

Equal Rights Amendment charm bracelet, 1972–74 (left). Alice Paul, a feminist who spent her life campaigning for women's rights, originally proposed the Equal Rights Amendment (ERA) in 1923 as the leader of the National Woman's Party. In 1972 the ERA was reintroduced, and Paul, now in her eighties, again actively campaigned for its passage and ratification. The charms on her bracelet represent states that ratified the amendment; however, not enough states did so, and the ERA never became law. In 1987 the Alice Paul Centennial Foundation donated a large collection of memorabilia, including this bracelet, to honor the 100th anniversary of her birth.

many Americans wanted a national history museum that would encourage consensus at home and project a unified and prosperous national image abroad. As long as consensus remained the museum's goal, its view of American history would have to exclude certain groups—African Americans, Native Americans, immigrants, the working class—whose experiences raised troubling issues of social inequalities and cultural differences.

But by the 1960s these troubling issues were becoming increasingly visible and difficult to ignore. Television broadcast into American living rooms jarring images of protest and violence, of civil rights

"Longest Walk" poster, 1978 (opposite bottom). In the 1970s, as Native Americans mobilized to demand tribal rights, protest treaty violations, and call attention to economic devastation on the reservations, the Smithsonian documented their activities by collecting buttons, pamphlets, posters, T-shirts, and other material. This poster from the Longest Walk, a pan-Indian civil rights march from California to Washington, D.C., was acquired from the march's Washington headquarters in 1978.

THE LONGEST WALK

SUPPORT

NATIVE AMERICANS

IN THEIR STRUGGLE
AGAINST THE 11 BILLS
IN CONGRESS, AND
IN THEIR CONTINENTAL
WALK FOR ALL LIFE

STOP THE GENOCIDE

WASHINGTON D.C.

JULY 15, 1978

BRING FRIENDS

PLEASE SEND FUNDS
& NATIONAL INFORMATION REQUESTS TO:
P.O. BOX 409
DAVIS, CALIFORNIA 95616
PHONE 915-415-5300
NATIONAL A.I.M. 612-331-5390

FOR REGIONAL INFORMATION
PLEASE CONTACT
LOCAL MOVEMENT
&
NATIVE AMERICAN ORGANIZATIONS
D.C. PHONE 202-544-3060/1

POSTER COURTESY OF E.V.O.K.E. (EAST VILLAGE ORGANIZATION FOR A KINDER EARTH)
A R.E.S.P.O.N.S.E. (RESPECT & PROTECT OUR NATURAL & SPIRITUAL ENVIRONMENT) PROJECT

demonstrators being attacked by dogs and sprayed with fire hoses; of assassinations, strikes, and riots; of the war in Vietnam and the war over Vietnam. Everywhere Americans looked there seemed to be chaos, discord, rebellion. And when they came to the Smithsonian and saw visions of a prosperous, harmonious national past, a people sharing common values and traditions, many wondered what was happening to their country, what had gone wrong.

Confronted with this disparity, a handful of curators in the late 1960s decided that the answer was not to retreat further from conflict and protest but to embrace it. In 1968, as the Poor People's Campaign set up tents on the National Mall, Keith Melder, a curator in the political history division—which up to this point had consisted mostly of presidential relics, first ladies' gowns, and campaign memorabilia—ventured out and collected banners, placards, even a plywood shelter painted with slogans. From then on, whenever civil rights and antiwar protesters flooded the streets of Washington, curators often followed, picking up flags, posters, and other mementos of the demonstrations. And as the women's liberation movement got under way in the early 1970s, Edith Mayo, curator, attended rallies and political caucuses to collect material. It was the first serious attempt to document contemporary women's issues since 1920, when the National American Woman Suffrage Association had donated relics of Susan B. Anthony to commemorate the passage of the Nineteenth Amendment.

Curators did more than simply document what was going on outside the museum's front door; they also began to seek out artifacts that spoke to the presence of similar conflicts in the nation's past. Contrary to what the conventional picture of American history suggested, political protest was not a modern invention. Racism, poverty, and inequality were not just current problems; they had roots stretching back to the earliest days of the republic and beyond. In the 1960s and 1970s a new crop of historians, many of them women and minorities, started to probe the depths of racial, ethnic, class, and gender divisions in American society, to make connections between past and present struggles. Their discoveries in turn shaped the museum's work, giving rise to new ideas about what was worth saving from the nation's past and what stories were important to tell.

In 1980 the Museum of History and Technology was officially renamed the National Museum of American History. In the decade that followed, the museum opened a series of new exhibitions focusing on the historical experiences of women and minorities. *Field to Factory,* curated by Spencer Crew—one of the museum's first African American curators and in 1994 its first African American director—opened in 1987 and told the story of the migration of African Americans from the rural South to the industrial North during the first decades of the twentieth century. Among the featured artifacts were a sharecropper's cabin, a Ku Klux Klan robe, and a set of doors marked "White" and "Colored," symbols of the racism and segregation African Americans confronted in their daily lives. The same year the museum unveiled *A More Perfect Union,* an exhibition about the internment of Japanese Americans during World War II. Sponsored by Congress to commemorate the bicentennial of the U.S. Constitution, the exhibition focused on a time when constitutional guarantees were denied to some Americans because of their ethnic ancestry. Curators collected numerous artifacts for the exhibition from former internees and their descendants in collaboration with the Japanese American Historical Society. A third exhibition, *From Parlor to Politics,* which opened in 1990, traced women's involvement in the reform and suffrage movements of the Progressive Era. It featured artifacts acquired for the women's history collection, ranging from a wagon painted with suffragist slogans to a tiny pin commemorating the jailing of suffragists who picketed the White House in 1917 as well as artifacts documenting women's work in settlement houses, education, labor reform, nursing, and the antiwar movement.

These new exhibitions aimed to tell the story of America from a new point of view, to give new perspectives on familiar events, and to raise awareness of social inequalities, past and present. This effort continued with the 1992 exhibition *American Encounters,* which took as its inspiration the 500th anniversary of Columbus's arrival in the New World and explored the centuries of encounters between Native Americans, Hispanics, and Europeans that shaped the history of modern-day New Mexico. The curators undertook extensive field research, conducting oral history interviews and collecting both contemporary and historical artifacts. Through these artifacts the exhibition challenged traditional interpretations of encounters between Indians and Europeans;

"Acid Test" signboard, about 1964. The adventures of the Merry Pranksters—a band of artists, writers, and students who embraced free expression, defined a lifestyle opposed to mainstream American values, and traveled the country in a psychedelic schoolbus—were popularized in Tom Wolfe's 1968 book *The Electric Kool-Aid Acid Test*. Led by the novelist Ken Kesey, the group became a symbol for the counterculture based in San Francisco during the 1960s. In the early 1990s Smithsonian curators contacted Kesey hoping to acquire the famous bus, named Furthur, but it was badly deteriorated. In 1992 they collected archival material and this colorful plywood panel, which the Pranksters used to advertise concerts and poetry readings. Fittingly, Kesey signed the deed of gift with a Day-Glo marker.

Jar made by David Drake, a slave artisan, 1862 (left). The poem inscribed on this glazed stoneware reads "I made this jar all of cross / If you don't repent, you will be lost" and is signed "Dave." David Drake worked at the pottery operated by his owner, Lewis Miles, at Stoney Bluff Plantation in Edgefield, South Carolina, from the 1830s to the 1860s. He is the only slave potter known to sign and date his work, defiantly proclaiming his education in a state that outlawed literacy among slaves. In 1996 the Smithsonian purchased two of Dave's "poem jars," highly valued as artistic works and material evidence of the skills, beliefs, and daily lives of enslaved African Americans.

"Jailed for Freedom" pin, 1917 (below). Between 1917 and 1919 suffragists, demanding votes for women, picketed the White House, and many were arrested and jailed. The women later wore pins representing a prison cell door to commemorate their imprisonment and call attention to the injustice of being "jailed for freedom." The National Museum of American History has collected several of these pins. The first was donated in 1963 by Lucille Agniel Calmes, a government secretary who served a five-day term in the District of Columbia workhouse for picketing in 1919. This pin belonged to Alice Paul of the National Woman's Party, who led the first picket in 1917; it was acquired in 1987 from the Alice Paul Centennial Foundation.

Barracks sign from Manzanar relocation center, California, 1942–45 (above). During World War II thousands of Japanese immigrants and Japanese American citizens were evacuated from their homes on the West Coast and relocated to internment camps because the U.S. government considered them a threat to national security. This wooden sign identified the residence of Michibiku Ozamoto in the Manzanar camp; the numbers stand for block 24, barracks 4, apartment 3. The Smithsonian collected this sign and other artifacts from former internees and their families for its 1987 exhibition *A More Perfect Union*. In 1988 Congress formally apologized to Japanese Americans and granted cash reparations to surviving internees.

for example, the exhibition described not only the conversion of Native Americans to Catholicism but also the adaptation of Catholicism to accommodate Indian customs and beliefs—what curators described as the "Indianizing" of Christianity.[46] Many objects collected for *American Encounters,* such as a beaded doll depicting a white tourist made by a Zuni Pueblo artist, symbolize the Native American point of view that has traditionally been excluded from collections and exhibitions.

Another point of view the museum has worked to address in recent years is that of workers, the people who made and used the machines and tools that have long been part of the technology collections. In 1989 these efforts were given a tremendous push forward by Scott Molloy, a labor activist and historian at the University of Rhode Island, who offered to the museum his vast collection of artifacts documenting the history of organized labor. In arguing for the acceptance of the Molloy Collection, curators noted that "the inclusion of labor materials, and the inclusion of working-class history, in our collection is vital if we are to fulfill our responsibility as a museum for all the American people."[47] Since then, the museum has continued to add to its labor history collection, particularly artifacts that represent crucial intersections of race, ethnicity, class, and gender issues.

In 1998 a groundbreaking exhibition exploring these issues opened at the museum. *Between a Rock and a Hard Place: A History of American Sweatshops* originated when curators, already planning an exhibition on low-paid labor, learned of a police raid on a sweatshop on El Monte, California, in 1995 and decided to collect artifacts documenting the incident. In the exhibition Peter Liebhold and Harry Rubenstein, curators, used the El Monte raid as an opportunity to trace the history of sweatshops in America and raise questions about why these illegal and abusive labor practices have persisted despite extensive reform efforts. In addition to relating the historic stories of immigrants, mostly women, who have worked in sweatshops, the exhibition also included the contemporary voices of El Monte workers, local authorities, manufacturers, and labor unions.[48]

Since *A Nation of Nations,* the National Museum of American History has approached history not only from the bottom up but also from the outside in. It has collected artifacts that show America from the perspectives of individuals and communities who were not always included or accepted by society at large. From a carved sun stone that was part of the first Mormon Temple to a panel from the AIDS Memorial Quilt, these objects preserve experiences and beliefs that were at one time regarded as outside the mainstream. Some groups fought for social acceptance; others, like the 1960s counterculture group the Merry Pranksters, preferred to drop out and create their own society. Yet they all defended their right to be themselves, to be Americans on their own terms. In the process of defining their place in the nation, they challenged, adapted, and redefined ideas about what place the nation occupies in people's lives.

Re-creation of El Monte sweatshop, National Museum of American History, 1998 (opposite top). On August 2, 1995, authorities raided a sweatshop in El Monte, California. Inside the fenced-in compound they found seventy illegal Thai immigrants who had been forced to work sixteen hours a day, seven days a week, sewing garments that would eventually be sold in major chain stores around the country. Smithsonian curators saw the incident as "an iconic event in American work history" and collected material from former workers and agencies involved in the raid.

Mormon sun stone, 1844 (opposite bottom, left). Drawn from a dream vision of Joseph Smith, the founder of Mormonism, sun stones and other celestial carvings adorned the Mormon Temple built at Nauvoo, Illinois, in 1844. But the elaborate temple was destroyed soon after by people opposed to Mormons and their religious beliefs. To escape further persecution, the Mormon community moved west and settled in Utah. This sun stone, salvaged from the ruined Nauvoo temple and preserved by a local historical society since 1913, was offered to the Smithsonian in 1989. To Richard Ahlborn, the Smithsonian's religious history curator, it represented a chance to explore "the complexity of our nation's spiritual origins."

Panel from the AIDS Memorial Quilt, 1987 (opposite bottom, right). This panel, one of more than forty thousand made since 1987 to memorialize people who have died of AIDS, is dedicated to Roger Lyon, an AIDS activist who testified before Congress in 1983. A new interpretation of a traditional American craft, the quilt aims to change Americans' view of the AIDS epidemic—not as a moral or lifestyle issue but as a global health crisis. This panel was sent to the Smithsonian in 1990 by The NAMES Project, which maintains and displays the quilt. At the time many considered AIDS too politically sensitive a topic for the Smithsonian to address. However, as the quilt was displayed several times on the National Mall and grew ever bigger, public concern also increased. In 1998 the panel became a permanent part of the museum's medical sciences collection, which in recent years has tried to document not just medical technology but also the political, social, and cultural aspects of health and medicine.

WASH. D.C.
AUG. 2, 1983

San Francisco Examiner

U.S. health aides acting failing to ask more AIDS funds

Don't let epitaph be: 'I died of red tape'

'I CAME HERE TODAY TO ASK
THAT THIS NATION WITH ALL ITS
RESOURCES AND COMPASSION
NOT LET MY EPITAPH READ
HE DIED OF RED TAPE'

Roger *Gail* *Lyon*

CINDY Mc

History and Identity

It is an interesting question: When *do* Americans consciously think of themselves as American? Times of conflict—war, economic crisis, increased immigration, political protest—can trigger expressions and redefinitions of national identity. Special events, such as holidays, elections, and sports events, even vacations abroad, also raise awareness of being American. The National Museum of American History has collected numerous objects that speak to these feelings. A jersey worn by a member of the U.S. hockey team in the 1980 Olympics is a souvenir of the "miracle on ice" victory over the Russian team, a victory that inspired a massive surge of patriotism among Americans at a time of heightened international tensions. But in daily life, in the places where Americans live, work, and play, national identity often merges, overlaps, and interacts with many other kinds of identities. Objects that reflect the interplay among individual, community, and national identities—a traditional straw hat worn by a Puerto Rican delegate to the 1996 Democratic National Convention, for example—can help illuminate the forces that have shaped American history.

In deciding to include stories of conflict and inequality in its story of America, the National Museum of American History has sparked some conflicts of its own. Many Americans—politicians, social organizations, community leaders, visitors—have criticized what they perceive as negative, discomforting, even unpatriotic reflections of the nation's history at the Smithsonian. Why do curators seem to focus on issues and events that divide Americans rather than pull them

U.S. Olympic hockey team jersey, 1980. Coming at the height of Cold War tensions between the two superpowers, a hockey match at the 1980 Olympic Winter Games in Lake Placid, New York, became a cause for national celebration. The underdog American team defeated the Soviet Union in the semifinal game and went on to win the gold medal. In 1984, through the efforts of *Sports Illustrated* magazine, team members donated jerseys and other memorabilia from the "miracle on ice" to the Smithsonian.

Puerto Rican *pava*, **1996.** This *pava*, a peasant straw hat, was worn by a Puerto Rican delegate to the 1996 Democratic National Convention, held in Chicago. A cultural symbol, it also represents how the people of Puerto Rico, as both U.S. citizens and residents of a self-governing commonwealth, continue to deal with the issue of national identity. Smithsonian curators attending the convention collected this *pava* along with other materials representing a variety of delegates and causes.

together? Why do they challenge conventional views of the past? These questions have generated conflict within the Smithsonian itself; curators and administrators have battled over how to interpret complicated historic events, from westward expansion to the dropping of the atomic bomb.[49] At the heart of these conflicts lie different ideas about the role history should play in Americans' lives and thus the kind of place a national history museum should be. Should it be a place to study the past or celebrate it? A place to display objects or interpret their meaning? A place that tells it like it was or as people wish it had been?

There is no right or wrong answer. Different people want the museum to be all of these things some of the time—and need it to be some of these things all of the time. But controversial topics and unpleasant memories will never completely disappear from the museum floor, and they should not. The shoes made by a Sioux student at Carlisle Indian School are as much a part of the national legacy as the ruby slippers; the desk on which Jefferson penned the Declaration of Independence, the Mormon sun stone, and the Woolworth's lunch counter from the Greensboro sit-ins all pass on powerful messages about American ideals and the struggle to realize them. If Americans cannot confront the dilemmas and injustices in their nation's history, how can they face the trials of the present? How can they plan for the future without learning from the past? By uncovering the roots of social and cultural conflict, history can also inspire the seeds for change. In revealing the disparity between national ideals and the reality of many Americans' lives, history can also illuminate potential ways to close that gap.

These are among the fundamental beliefs that guide the work of the National Museum of American History today. To that end the museum must continue to include diverse voices, memories, and beliefs; as hard as it may sometimes be, yes, the doors must stay open. Only by fostering dialogue about the collective and complex legacy inherited from this nation's past can the museum help people truly understand what it means to be American.

From Artifacts to America

When objects come into the museum, they are transformed in many ways. But they also have the power to transform us. By revealing new truths and telling new stories, they can enrich, challenge, and change our understanding of American history. And in changing our view of the past, they can also change our view of ourselves.

NASCAR stock car driven by Richard Petty during his 200th Grand National victory, July 4, 1984 (pages 216–17). The title for this Pontiac racing car was transferred to the National Museum of American History at the Talladega Speedway in Alabama, several weeks after Petty won his 200th Grand National race. The first NASCAR stock car to enter the museum collections, the Petty car is one of several vehicles curators have collected to represent the popular sport of automobile racing.

Shoes worn during the voting rights march from Selma to Montgomery, Alabama, 1965. Juanita T. Williams, a civil rights activist, wore these shoes when she and twenty-five thousand other protesters marched the fifty-four miles from Selma to Montgomery to demand equal voting rights for African Americans in March 1965. Since 1975 Williams's shoes and other mementos of the Selma march have been displayed in the National Museum of American History to help tell the story of African Americans' struggle for freedom and citizenship.

THIS BOOK HAS FOCUSED on how various artifacts have come to be in the National Museum of American History, recounting the ideas and circumstances—and sometimes struggles and debates—that brought them into the collections. The museum's artifacts reflect changes in what we Americans have valued, whom we have honored, how we have related the past to the present, and how we have seen ourselves as a nation. They document the ways individuals and groups have used the Smithsonian to lay claim to the American heritage, to insert themselves into the national story, and to promote, defend, or challenge traditional notions of American identity.

As focal points for debates and declarations about what is important and who is included in American history, museum objects embody struggles for power, authority, and recognition. In seeking a place for their cherished objects in the nation's museum, diverse individuals and communities have sought to contribute to the Smithsonian's national legacy their own beliefs about what it means to be American. The museum's artifacts therefore represent more than just "the past": they capture particular ideas about the past and about American identity. Their collective story tells a history of American history.

Of course, as far as the museum is concerned, deciding what to collect is just the beginning. Once artifacts arrive, they present curators with a host of new challenges. As new additions to the collection, they must be identified, numbered, and catalogued. As physical objects, they need space to be stored. And as old and fragile things, they require special care and treatment to survive. But most of all, artifacts in the museum demand to be put back into history. They want to tell their stories, to be made meaningful again.

This final chapter is about how the museum puts artifacts back into history. It explores the vital process of interpretation, through which old artifacts take on new meanings as part of larger historical stories. In looking at the way the museum has interpreted its collections over time, one fact is especially worth noting: the same object is never put back into history in exactly the same way. While an object may have been collected to tell one story, eventually it will be analyzed from a different perspective or placed in a different context; it will tell a new story. Through this ongoing process of interpretation and reinterpretation, the museum reveals the fundamental value of artifacts as links to the American past. More than a place where artifacts are preserved, the museum is a place to discover why artifacts matter.

Why Artifacts Matter

Mourning picture, about 1815. Susan Winn, a student at Linden Hall Seminary in Lititz, Pennsylvania, embroidered this memorial to her sister, Caroline, who died in 1806. The scene depicts Susan and other members of her family grieving at the urn, a symbol of the deceased. In 1938 the Smithsonian acquired a large collection of antiquarian items, including this picture, from the estate of Albert Adsit Clemons, a Washington, D.C., collector.

Faced with countless collecting possibilities, museums choose objects on the basis of ideas about what stories are worth telling. But in recent years some critics have asked, Why collect objects at all? They have questioned the importance of objects for a museum, seeing them in many cases as unnecessary, even obsolete.

In this age of excitement over the virtual, as the world witnesses the awesome power of technology to simulate, replicate, and even improve on reality, it is understandable that the value of museum artifacts, as the quintessential real things, would be challenged. Maxwell Anderson, director of the Whitney Museum of American Art, points out that when seen firsthand the museum artifact may seem much "less remarkable than it appeared in the brochure, television program, or web page."[1] As museums make use of new media technologies to attract and engage visitors, offering interactive encounters with virtual objects, the real object, kept isolated and out of reach behind glass, might seem secondary to the museum experience. Indeed, many museums are using artifacts less and less, opting for other ways to tell the stories they want to tell. Some museums have found artifacts unnecessary altogether. A rising number of museums have also shed the constraints of an actual building, creating virtual exhibits that exist only in cyberspace.

Many museum professionals see this as a positive, liberating trend. No longer tethered to artifacts, they are free to explore topics for which suitable objects may not exist. Through virtual exhibits and programs, they are able to reach out to new audiences who might otherwise never visit the museum. Elaine Heumann Gurian of the

Liverpool pitcher, about 1790 (opposite). Between the 1780s and 1820s British potteries capitalized on American patriotism by producing and exporting pieces that celebrated the new nation and its heroes. This transfer-printed creamware pitcher lists the population figures recorded by the first U.S. Census in 1790. In 1978 the Smithsonian purchased this pitcher and several other Liverpool pieces from a Pennsylvania collector.

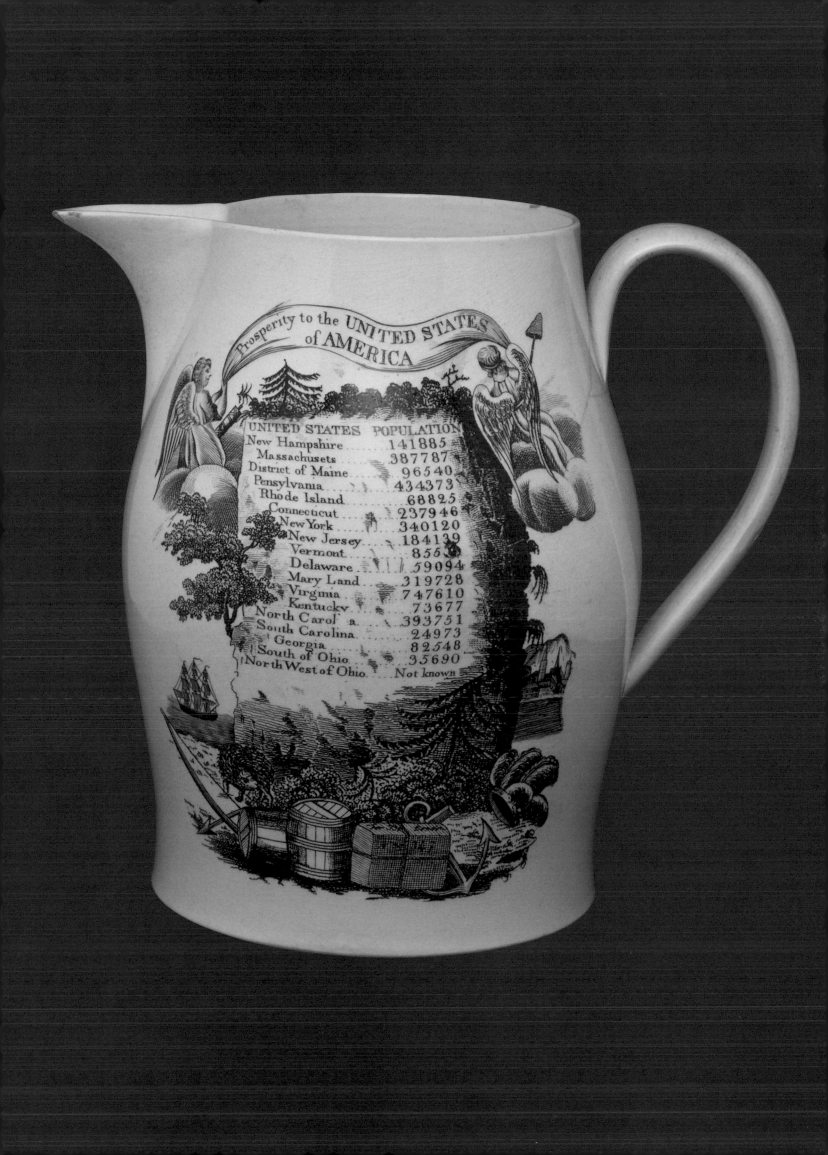

Prosperity to the UNITED STATES of AMERICA

UNITED STATES	POPULATION
New Hampshire	141885
Massachusets	387787
District of Maine	96540
Pensylvania	434373
Rhode Island	68825
Connecticut	237946
New York	340120
New Jersey	184139
Vermont	855
Delaware	59094
Mary Land	319728
Virginia	747610
Kentucky	73677
North Carolina	393751
South Carolina	24973
Georgia	82548
South of Ohio	35690
North West of Ohio	Not known

Cranbrook Institute of Science is just one critic who argues that museums should abandon their dependence on artifacts. Museums, she contends, have too long focused on things, missing "the essential meaning (the soul if you will) of the institution that is the museum." They no longer need objects "to justify their work." Rather, Gurian suggests, a museum should be understood as "*a place* that stores memories and presents and organizes meaning in some sensory form."[2] This definition frees museums from their traditional duty of collecting and preserving artifacts—what one museum director calls the "salvage and warehouse business"—and promotes instead what many view as the real business of museums: educating the public, building and strengthening communities, providing visitors with memorable experiences.[3]

In this context, artifacts can be construed as not only unnecessary but also counterproductive to a museum's mission. By focusing on objects alone, some argue, museums lose sight of the bigger picture. They fail to communicate larger ideas and issues, accommodate diverse points of view, or respond to visitors' interests and needs. They present a history of things rather than a history of people. In doing so, one museum professional claims, museums lose their relevance and value and instead come to be regarded as "out of touch, musty store-houses of relics of a dead past."[4]

A Smithsonian curator expressed a similar sentiment more than a century ago. In 1889 George Brown Goode, director of the National Museum, outlined his philosophy of museums, hoping to inspire some changes in how curators thought about objects and how the museum presented its collections to the public. Long before the phrase conjured up visions of people sitting in front of computer screens or wearing virtual reality goggles, Goode described his own ideal "museum of the future," arguing that the "museum of the past must be set aside, reconstructed, transformed from a cemetery of bric-a-brac into a nursery of living thoughts."[5] Like many critics today, Goode wanted to free museums from the tyranny of the object; he believed a good exhibit consisted of a series of labels illustrated by a few specimens, rather than the other way around. Ideas, not objects, were what mattered most in the modern museum. Objects had value only as illustrations of larger intellectual truths, truths that Goode believed he and his fellow scientist-curators alone were empowered and obligated to convey to the public.[6]

Goode wanted to limit the number of objects in the National Museum and limit the meanings attached to those objects. Curators have traditionally wanted visitors to see objects as they see them: as demonstrations of scientific principles, as proof of technological progress, as examples of good taste, as historical evidence. Museum exhibits generally use objects to convey a particular message, to tell

Bridal shower doll, 1930s. "This is Anna in miniature / Armed for new duties to be sure. / Her dress will make your tumblers shine / Her veil will make a duster fine." So begins the typewritten poem that accompanies this remarkable doll, discovered at an antiques store in Kensington, Maryland, in 1989. Her face a painted wooden spoon and her hair a mop, "Anna," wearing a cheesecloth veil and a dish-towel gown and holding a biscuit-cutter bouquet, symbolized the domestic duties that awaited a bride-to-be in the 1930s. The doll's original owner is not known; how it managed to survive intact and unused all these years remains a mystery.

a single story. Yet in reality, whether encountered in museum cases or in daily life, objects are invested with multiple and often conflicting meanings. They are by nature powerful and provocative things.

According to the anthropologist Daniel Miller, objects "continually assert their presence as simultaneously material force and symbol. They frame the way we act in the world, as well as the way we think about the world."[7] The words on the exhibit label mingle with visitors' own perceptions, knowledge, and memories to produce an understanding of the object that may differ drastically from what the curator intended. And that process, many curators are slowly starting to realize, is what truly makes artifacts worth saving.

In her search for the soul of the museum, Gurian eventually comes back to objects: "Objects, in their tangibility, provide a variety of stakeholders with an opportunity to debate the meaning and control of their memories."[8] While the museum may be the storehouse for memory and meaning, artifacts are the touchstones that bring those memories and meanings to life. They make history real, but it is a reality that can and should be viewed from different perspectives. When museums choose not to enshrine and isolate an artifact but instead open it up to new interpretations and different points of view, they provide opportunities to challenge and enhance people's understanding of the past. If artifacts are to remain a vital part of the museums of the twenty-first century, curators and visitors alike must acknowledge their multiple and conflicting meanings and embrace them.

Artifacts have had to fight for their place in a changing museum world. We wish to join that fight on the side of the artifact—not the artifact as a simple, unproblematic thing, a thing with one story and one role to play in history, but the artifact with its many stories and the complex, diverse meanings it has held for many people, past and present. We wish to defend artifacts not simply as the real thing—authentic, original, genuine, actual, unquestioned, and unquestionable—but rather as bits of contested history. Artifacts are valuable tools for exploring the past precisely because of their complexity, the contest and conflict they embody, the way they combine use and meaning. When museums take seriously Miller's notion that artifacts are "simultaneously material force and symbol," they become the key to understanding the complexity—the history—of the real world.

Surveyor's level, about 1785. Made by Benjamin Rittenhouse, a leading instrument maker in eighteenth-century America, this level was originally owned by George Gilpin, chief surveyor of the Potowmack Canal Company. In 1786 the company, headed by George Washington, began constructing a series of canals to improve navigation along the Potomac River. After Gilpin's death in 1813, Thomas Ellicott, son of the surveyor Andrew Ellicott, purchased the level, which remained in the family until 1997, when it was donated to the National Museum of American History. It is the earliest American-made surveyor's level in the collections.

The Afterlife of Artifacts

Of course, once objects enter a museum, they are not in the real world anymore. Removed from their natural habitat, so to speak, preserved in drawers or placed on pedestals under spotlights, objects are no longer held to the same rules. They become artifacts, specimens to be catalogued and classified. They are no longer useful, at least not as they once were. A hammer in a museum is no longer used to drive nails. A bed is no longer slept in. Shoes are no longer worn or clicked together three times. Their story of use comes to an end. In *Eccentric Spaces* (1977), the architecture critic Robert Harbison writes, "The result museums seek is an end to change, a perfect stasis or stillness; they are the final buildings on the earth.... In order to enter, an object must die."9

An object may have to die to enter a museum, but—to continue Harbison's metaphor—when it dies and becomes part of the collection, it begins an afterlife. One is tempted to say it dies and goes to heaven. From a conservation standpoint this is certainly true. With its specially tailored environmental conditions and attentive physical care, a museum must seem like heaven to an artifact. But in fact it is more purgatory than heaven, for in this afterlife artifacts find a new life— not in use or activity but in meaning. The value of a museum artifact is measured not by how well it does what it was originally made to do or how much money it is worth to a collector but by the stories it can help tell about the American past.

One type of story centers around the object's own history. When was it made? What is it made of? Who made it? How was it used? These kinds of questions establish basic information about the object; they help identify and locate it in time and place. A related issue is that of provenance: Who owned the object? Whose hands did it pass through between the day it was made and the day it came into a museum? Provenance is very important for curators and collectors alike, both of whom are concerned with verifying the authenticity of artifacts. Technological marvels of virtual exhibits aside, visitors still come to museums expecting to see the real thing; the powerful appeal of actual pieces of history, of encountering the past in person, draws millions of tourists to the Smithsonian and other museums and historic sites every year.10

While it is possible in some cases to document a chain of ownership dating to the object's original owner, more often than not curators must rely on their own knowledge and judgment to determine whether an object is authentic. But in a museum, authenticity is itself a tricky concept. Does restoring an object to its original appearance— patching up holes, removing extra layers of paint, scrubbing off the patina—make it more authentic or less authentic? If the object is missing a piece, should the piece be reproduced or left missing? Which object—the restored, polished, and complete one or the decayed and tarnished one—provides a more accurate picture of life in the past?

Silver peace medal, 1801. The practice of giving medals to Native American tribes to promote diplomatic relations began during the early colonial era and continued up to the late nineteenth century. Presented by explorers, military officers, and government officials, the U.S. medals bore the likeness of the current president and various symbols of peace and friendship. To the chiefs and delegates who received them, the medals were prized possessions, badges of power and status that were often buried with them. This silver peace medal, issued under President Thomas Jefferson, was given to an Osage chieftain and passed down to Chief Henry Lookout, the last hereditary chief of the Oklahoma Osage tribe. In 1952 Lookout loaned the medal to the Smithsonian, and in 1990 his heirs allowed it to become a permanent part of the numismatics collection at the National Museum of American History. Of the many peace medals in the museum's collection, this is the only one known to have been presented to a Native American.

Phrenology model, 1860s. For much of the nineteenth century, Americans looked to the pseudoscience of phrenology to decipher the mysteries of human behavior and personality. As this model illustrates, phrenologists believed the brain was divided into thirty-seven distinct physical organs, each responsible for a different trait such as acquisitiveness, benevolence, or spirituality. By "reading" the bumps on a person's head, a phrenologist could determine which characteristics were most prominent. While emphasizing the link between biology and behavior, phrenology also held that, through intellectual and moral exercise, individuals could alter the size and shape of their brain and thus improve their character. This bust, created by Lorenzo Niles Fowler, a leading manufacturer of phrenological paraphernalia, was purchased in 1961 for the medical history exhibition in the new Museum of History and Technology.

Curators continue to wrestle with these questions as they try to balance the demands of historical accuracy with visitor expectations of an authentic museum experience.

Examining an object under a microscope—literally or figuratively—can reveal many fascinating facts about the object's own history. But when museumgoers start to imagine the artifact not in a spotlight by itself but against a variegated backdrop of people, places, and events, many more interesting stories emerge. They begin to understand the role an object played in people's lives, the meanings it held to different individuals and communities, the way it reflected the knowledge, values, and tastes of a particular era. In short, they see the object as part of American history.

When placed in context, artifacts become passageways into history. Through a single object, viewers can connect to a moment in time, a person's life, a set of values and beliefs. To take advantage of the opportunities artifacts offer, one must first be aware of their nature: how they function in people's lives and how they become invested with meaning. Consider these four statements: *Artifacts connect people. Artifacts capture moments. Artifacts reflect changes. Artifacts mean many things.* These are simple phrases, but they suggest the enormously complex relationships that exist between people, artifacts, and history. By keeping these ideas in mind when looking at an artifact—whether found in a museum case, an attic trunk, or a store window—viewers open themselves up to new meanings, new stories, and new perspectives on the past. They discover new reasons why artifacts are worth saving.

The life of an object and the way it came to be in a museum is a story of provenance. Its afterlife, though, is a story of possibility. In the real world an object's meaning is fixed to a particular time and place. But once the object enters a museum, it can be inserted into a variety of stories, examined from diverse points of view—it can become, in essence, many different objects. "By emphasizing the narrative possibilities of artifacts rather than their specific provenance," write Spencer Crew, director of the National Museum of American History, and James Sims, exhibit designer, "exhibitions can encourage visitors to think more broadly about things and their meanings. They can help to demystify objects. . . . Artifacts so framed make an immediate claim on the visitor's time and can turn a museum visit into an encounter with past lives."[11] In a museum, artifacts move beyond provenance to possibility. There are opportunities for new interpretations, new contexts, new stories. An object can transcend its own history; it can become a symbol of common experiences or cultural beliefs, or it can become an icon of an era or event; it can highlight important themes in history or personify an individual, a community, even a nation. The artifact sitting in a museum storage cabinet is not dead; it is a story waiting to be revealed.[12]

Silver teapot, 1752. Artifacts connect people. As artifacts are made, used, and passed on, they create a web of relationships. This silver teapot, centerpiece of the social ritual of taking tea, also linked family members across generations. It was made by the silversmith Samuel Casey, assisted by his apprentices, for Abigail Robinson, the daughter of a wealthy Rhode Island planter, on her marriage in 1752. Seventeen months later Abigail died, childless, at age twenty-two. Her husband remarried and had a daughter, Mary Wanton, to whom he gave the teapot as a wedding gift in 1782. The teapot was passed down in the family until 1979, when the Smithsonian purchased it at auction.

Kodak Brownie camera, about 1910. Artifacts capture moments. They preserve memories and embody the tastes, lifestyles, and technical knowledge of their times. On April 15, 1912, seventeen-year-old Bernice Palmer, a passenger aboard the *Carpathia*, used this camera to document the ship's rescue of survivors of the *Titanic*. In 1986, when she donated her camera and photographs to the National Museum of American History, she recalled the tragic moments she had captured on film: "After all the survivors were safe on board our ship, the *Carpathia*, it sailed all around the area where the *Titanic* struck and sank. It was then when I saw the floating deck chairs . . . did I realize the terrible disaster which had happened. . . . There is much more which I will never forget. "

Remington typewriter, about 1875. Artifacts reflect changes. They provide opportunities to compare past and present, to consider how and why change occurs. At the time it was produced, this typewriter, manufactured by E. Remington and Sons about 1875, reflected changes in the workplace that accompanied the rapid growth of corporations during the late nineteenth century. By opening up white-collar employment for women, the typewriter also became an agent of social change. In 1912, when the Remington Typewriter Company donated this one to the Smithsonian, it illustrated progress. Described as "one of the very first models of the writing machine ever manufactured," it suggested how far technology and design had advanced since the 1870s.

Negro Leagues baseball, 1937. Artifacts mean many things. More than just material things, they communicate ideas, symbolize values, and convey emotions. Consider the changing meanings invested in this baseball from the Negro Leagues East-West all-star game of 1937. Buck Leonard, first baseman for the Homestead Grays, hit a home run to help the East win, 7–2, and kept this baseball as a souvenir of the game. In 1947, when racial integration of major-league baseball effectively ended the need for the Negro Leagues, this baseball became a piece of history. In 1972 the ball became a collector's item when Leonard was inducted into the Baseball Hall of Fame. Leonard saved this ball for nearly forty-five years before finally donating it to the Smithsonian in 1981.

Exhibitions and Juxtapositions

One artifact presents countless possibilities for exploring the past, but what kinds of stories can two artifacts—or three, or five, or a dozen—tell together? Museum exhibitions are places to find out. The art of the exhibition is the art of selection and juxtaposition, of choice and context. Juxtaposed one against the other, multiple artifacts generate stories more interesting, more complex, more provocative than any single object can tell. Artifacts comment on and raise questions about others, encouraging viewers to compare and contrast styles, functions, and meanings. Displayed side by side, artifacts can suggest causes and consequences, changes over time, or conflicts and inequalities. As museumgoers contemplate a group of artifacts, they begin to form connections, discern patterns, make sense of them as a whole. What ties the artifacts together? What is the story that links them? What does it all mean? Juxtaposition, a powerful storyteller and generator of meaning, can open up history in ways never imagined.

Consider a single object—for example, a Model T Ford. During the 1960s, a Model T Ford was displayed at the first-floor entrance to the Museum of History and Technology. What did this car mean? What story did it tell? For some visitors it may have brought back memories of a car they or someone in their family had once owned. For those without a personal connection to a Model T, the antique car might have simply represented "the past." As an object standing alone, the Model T depended largely on viewers' imaginations for its meaning and value.

But what happens when a second vehicle is placed next to the Model T? If the second object is a horse-drawn wagon from 1880, the Ford becomes a symbol of great technological progress. The two objects together suggest that in just a few decades clever folks invented this amazing car. On the other hand, if the second object is an automobile from a few decades after the Model T, the older car suddenly seems primitive, a reminder of how far automobile technology has advanced. Meanwhile, a different car from that same period can also tell a range of stories. A Rolls Royce makes the Model T look tiny and frail and raises the question of who can afford what car. A Chevrolet—the car that General Motors introduced to compete with the Model T—begins to tell a story about the changing car market, the shift in focus to sales and design, and Ford's failure to keep up. In turn, putting the Model T next to a radically different kind of car—perhaps a 1970s low rider from New Mexico, lovingly customized—could inspire visitors to contemplate the meaning of automobiles generally in American culture.

Juxtaposing the Model T Ford with objects other than vehicles opens up another wide range of possibilities. A piece of the factory assembly line initiates a story of Ford's innovation in production, while a mannequin holding a tool from the production line suggests

Model T Ford on display at the entrance to the Museum of History and Technology in 1971 and in the Road Transportation Hall, National Museum of American History, in 1992 (above and opposite top). A single artifact can tell many stories. Its context within an exhibition—displayed with an array of other artifacts, within a period setting, against a backdrop of images—helps bring those different stories to light. Since this 1913 Model T was donated in 1935 by Harvey Carlton Locke (see page 148), the museum has displayed and interpreted the car in a variety of ways: as a technological milestone, as an icon of American history, and as a cultural artifact.

"Dave's Dream" low rider, 1978 (below). The 1990 acquisition of this low rider, a 1969 Ford LTD customized by David Jaramillo and friends in Espanola, New Mexico, caused some controversy at the National Museum of American History. Acquired for *American Encounters*, the 1992 exhibition on New Mexico's cultural history, it was dramatically different from previously collected automobiles, mainly standard models or prototypes. An example of technology transformed into a work of art, "Dave's Dream" was not an anonymous machine but an image of its owner's cultural identity and personal tastes.

a story of labor. An array of different kinds of tools shifts the focus to the skills of the mechanic or the car owner. A jacket, scarf, and goggles announce a story on driving and fashion, while a variety of sheet music featuring the Model T suggests the automobile's place in popular culture. The Model T hooked up to a washing machine—one of the many ingenious uses people found for the cars—may lead to a story on rural life, housework, or gender relationships.

The point is simple: an artifact, properly couched—properly coached?—can tell a thousand stories. When artifacts enter the museum, opportunities are created for dialogue with other artifacts, representing other beliefs, values, and experiences. In exhibitions, curators bring objects together to construct a bigger picture, to raise and answer bigger questions about the nation's past. Through juxtaposition new stories are told, new meanings are discovered, and new truths may be revealed.

Telling a National Story?

Stars-and-stripes quilt, 1861. The names of Union generals are stitched into the stars of this patriotic quilt, made by Mary Rockhold Teter of Noblesville, Indiana, for her son George, who served in the Civil War. In 1920 George Teter presented the quilt to his grandson's wife, Martha Brown Teter, in honor of her own military service during World War I. The family donated the quilt to the Smithsonian in 1940.

O ver the years the National Museum of American History and its predecessors have used artifacts to tell many, many stories. But while they have encompassed a wide range of topics, at a fundamental level these stories have all been stories about America. The museum, after all, is the *national* museum. Its job is not just to collect and preserve the artifacts of American history; its job is to make sense of them as part of a national story and to imagine the nation through them. Through the artifacts it has collected and the exhibitions it has created, the museum has preserved many individual memories and thus constructed a place for contemplating the meaning of those memories. In the conversation between donors and curators, it has become a forum for discussing what it means to be American.[13]

But how well does the National Museum represent the nation? Is the history it preserves a truly national one? This book has focused on what is here in the museum, on the objects that have been identified as worth saving over the past 150 years. Yet it is equally important to consider what is not here and why.

Obviously, it is physically impossible to collect every single object from the American past. Relatively few artifacts have survived to be collected at all. Some historic treasures, like landscapes, bridges, or cities, are simply not collectible; they must be preserved by other means. As for artifacts that can be collected but are not in the Smithsonian, many millions can be found in other museums and private collections throughout the world. Some of these were desperately

Tintype, about 1890 (opposite). The National Museum of American History's photographic history collection includes more than three thousand tintypes, also known as ferrotypes, an inexpensive and popular format used in the second half of the nineteenth century. Many are unidentified studio portraits acquired from private collectors and antique dealers, such as this picture of an African American couple, part of a collection of twenty tintypes acquired in 1976. These anonymous images were collected to represent the medium's technical and cultural history rather than tell a specific personal story.

Paper negative made by William Henry Fox Talbot, 1839. The National Museum of American History has one of the most significant collections of material associated with Talbot, the British inventor of the negative-positive process that became the basis for modern photography. Talbot artifacts had been eagerly sought since the nineteenth century, and by 1965, when Eugene Ostroff, curator of photography, traveled to the Talbot home to look for additional materials, all he found were hundreds of faded negatives that other museums had considered not worth collecting. Thinking they might be useful in his own research, Ostroff purchased the negatives, which historians now value as revealing records of Talbot's inventive process.

desired by Smithsonian curators but were unavailable, offered to another institution, or lost to a higher bidder. (Every curator has a story of the one that got away.)

But the more compelling missing artifacts are those that could have been collected but at the time were simply regarded as not worth saving. Perhaps no one offered them, no one asked for them, or they were turned down for lack of space, time, or money. In retrospect, rejection of these artifacts may seem like lack of vision, but more often it was a case of selective remembering. Although it was called the nation's museum, the Smithsonian traditionally reflected a very narrow view of the nation's past.[14]

Looking back on what was not collected as well as what was makes the point once again: ideas about what is worth saving have changed over the years. History has a history. And we Americans are shaped by that history of history, just as we are shaped by history itself. Michel-Rolph Trouillot, an anthropologist and historian of his native Haiti, makes this point in his *Silencing the Past: Power and the Production of History* (1995). History is a production that has many steps: chronicling, archiving, interpreting. And each of them, Trouillot insists, creates not only facts but also what he calls "silences." It is impossible to record or collect everything, and so what is recorded and collected necessarily reflects the collector's interests. Museum collections are created—constructed—according to the values of individual curators as well as the social and cultural mores of the time. Even though the collector may try to be as thorough as possible, there will always be silences, unrecorded moments. In shaping a collection, decisions have to be made, boundaries have to be drawn. "Historical production," Trouillot concludes, "is itself historical." Again, history has a history.[15]

History museums certainly show the biases of their creators, as many critics pointed out in the 1980s and 1990s. "Most history museums," notes Michael Wallace, historian and museum critic, "were constructed

by members of dominant classes, and embody interpretations that supported their sponsors' privileged positions."[16] In the battle over what is worth saving and what stories the National Museum should tell, a key is, to use Trouillot's expression, who gets to make the rules. Who creates the collections, and who determines how they should be used? The historian David Hollinger, writing about the creation of American national culture, notes that this has been traditionally done "by empowered white Americans."[17] And for the most part that is a fair description of the curators who have made choices about artifacts for the Smithsonian collections over the past 150 years. It is not surprising, then, that the story those collections seem to tell best is the story of empowered white Americans.

But objects, remember, are more complex than sometimes acknowledged, and objects collected to tell one story can tell another—indeed, many others. In *Telling the Truth about History* (1994), Joyce Appleby, Lynn Hunt, and Margaret Jacob admit, "Any history is always someone's history, told by that someone from a partial point of view." "Yet," they continue, "external reality has the power to impose itself on the mind; past realities remain in records of various sorts that historians are trained to interpret."[18] Like records, artifacts can suggest new stories, stories that the collectors might never have imagined. By imposing themselves on the mind, they demand explanation. "Objects arouse curiosity, resist implausible manipulation, and collect layers of information about them."[19]

Artifacts, because of their layers of information, their complexity, can lead to many stories. Curators may have collected tools and machines to tell a story of technological progress, but those same artifacts can also tell stories of work, skill, and industrial organization. A first lady's gown might have been collected to tell a story of fashion and upper-class sensibility, but it also can tell a story of the dressmaker who made the gown. Collections brought to the museum for one reason can be reinterpreted; they can tell new stories. Archives and collections may have their "silences," but good historians and curators learn to listen to those silences and use them to better understand the past. In the museum, artifacts move from provenance—their own story—to possibility—a role in many stories. Perceptions of objects and the meanings derived from them are shaped by the context in which they are shown.

That is the point made by two of the most interesting and provocative history exhibitions of recent years. As explorations of the power of juxtaposition, they placed old objects in unusual settings to tell new stories. In *Mining the Museum,* a 1992 exhibition at the Maryland Historical Society in Baltimore, the artist and curator Fred Wilson juxtaposed objects in startling ways. Slave shackles were shown next to exquisite silver work in a case labeled "Metalwork 1793–1880." "Cabinetmaking 1820–1960" included both elegant chairs and a whipping

Gown made by Elizabeth Keckley for Mary Todd Lincoln, about 1864. Originally collected in 1916 for its associations with Mary Todd Lincoln, this purple velvet gown has received new attention from historians because of its connection with Elizabeth Keckley, an African American dressmaker and confidante of Mrs. Lincoln's. Born a slave in 1818, Keckley worked as a dressmaker in St. Louis, using her skills to buy freedom for herself and her son. After moving to Washington, D.C., in 1860, she built a successful career and became a prominent figure in the black community, organizing relief and educational programs for emancipated slaves. In 1868 she published *Behind the Scenes*, a memoir of her relationship with the first lady.

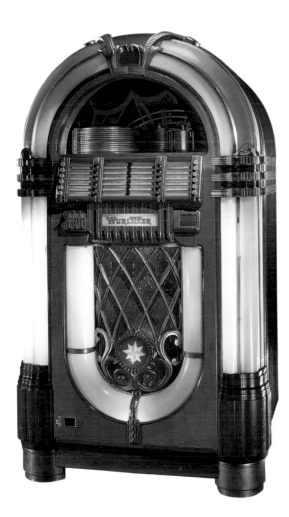

Wurlitzer jukebox, 1946. In 1970 the Smithsonian contacted the Wurlitzer Company for help in locating a vintage jukebox for a new exhibition on American popular music. The Roth Novelty Company, a Wurlitzer distributor, came up with this restored Model 1015, known as "The Bubbler." A big hit with museum visitors, the colorful music machine was also a staff favorite. When the jukebox first arrived, fully stocked with 78-rpm records, eager employees lined up to put in their nickels and play their favorite songs.

post. A Ku Klux Klan robe was shown in a baby carriage. *Mining the Museum* was about "not *what* the objects mean but *how* they mean." Wilson called attention to the making of meaning: "The meaning changes depending on the environment where it is located. The context is critical. My work is all about context and the underlayers of context."[20]

Another exhibition—Susan Vogel's *ART/artifact,* held in 1988 at the Center for African Art in New York City—demonstrated how different contexts affect the meaning of artifacts and shape the lesson the visitor takes away. She reproduced some of the ways that African artifacts have been displayed in museums over the last century: "a 1905 curiosity room, a natural history museum presentation complete with diorama, a reverential art museum presentation, and a contemporary art gallery installation." According to Vogel, "The exhibition stressed that these different styles reflected differences in attitude and interpretation, and that the viewer was manipulated by all of them."[21]

Manipulated? That is a strong word. Guided? Encouraged to perceive the artifacts in a certain way? Perhaps even educated? After all, museums can only suggest meaning; visitors will build their own meaning from what they see, what they feel, and what they already know. "Like the dictionary," writes Robert Harbison, "a museum cannot be enjoyed passively. The spectator must decide what is background and what foreground. Nothing tells him he is not supposed to look at everything; he must learn it is not feasible." Even if the museum were to attempt to manipulate or push too hard, it rarely works. Visitors experience the museum as they wish, choosing what galleries to enter, what labels to read, what objects to inspect. [22] In any case, Harbison continues, "deliberate juxtapositions are usually less effective than the ones a spectator finds for himself."[23]

This last point—the noncoercive nature of the exhibition—might seem to be a weakness. In fact, though, it is a strength. It allows the visitor to partake of the work of history, to make his or her own meaning. And just as there is more to history than simply telling politically useful stories, there is more to history museums than the bias that critics occasionally note. Meanings in a museum are made not just in exhibit labels but also beyond them, in the thoughts and conversations that flow from and around the objects. And meanings continue to be made outside the museum, in the public dialogues and debates about history that exhibits and collections may spark. The National Museum of American History is a place to get Americans thinking and talking about the past, to consider why we save the things we save and what value history holds for our lives today. It is a place to search for truth, for explanations of the past that help us better understand ourselves. The flexible nature of artifacts—which can be interpreted and reinterpreted, viewed and reviewed, and used to tell many different stories—enables everyone to participate in that search. And that is particularly important when a national museum imagines the nation.

National Museums, National History

Especially since the nineteenth century, museums have played a central role in imagining the nation, in defining and reinforcing a national identity. In bringing together objects from all places and times, classifying them in relation to the nation's own culture and achievements, and arranging them for the viewing pleasure of visitors, the national museum testifies to the power of the concept of the nation. It presents the world from a nation-centered perspective and encourages visitors to share that view, to tap into that power.[24] Moreover, the museum also documents the nation itself. It identifies objects that represent a national way of life and symbolize key values, beliefs, and experiences. And, most significant, it creates a narrative of national history. It organizes people and events into a more or less coherent story, one that emphasizes patterns and connections, demonstrates causes and consequences, and suggests the unfolding of a national destiny. During times of social instability and conflict, the museum supplies a reassuring vision of national unity. It proclaims the existence of a common identity and purpose, rooted in a shared national past.[25]

One of the first museums to explicitly express its intent to define a national identity was the Germanisches Nationalmuseum, established in Nuremberg, Germany, in 1852. It set out to show *romantisher Historismus*, "the history of our romantic past."[26] In the younger United States, various museums emerged to take on the challenge of defining and preserving a national history, a project that also generated romantic visions of the past. Among the earliest was Charles Willson Peale's early-nineteenth-century Philadelphia Museum, which featured portraits of Revolutionary War heroes and statesmen. Displayed amid the neatly classified natural specimens that constituted the bulk of Peale's museum, the heroic portraits served, as the historian Gary Kulik writes, "to make the Revolution tamer, more respectable, and more orderly than it ever could have been."[27]

In the early twentieth century, in response to the influx of new immigrants from southern and eastern Europe, more American museums made conscious efforts to construct a national identity based on a shared past. The Metropolitan Museum of Art's American Wing, which opened in 1924, was designed to be "invaluable to the Americanization of so many of our people to whom much of our history has been hidden in a fog of unenlightenment."[28] Henry Ford was equally explicit about his goals for his museum, which opened in Dearborn, Michigan, in 1933. Just as the Ford Motor Company would "Americanize" its immigrant workers through English classes, Ford's museum would Americanize its visitors. In collecting and displaying antique American artifacts, Ford was driven by his desire to "convey traditional Anglo-Saxon values to new generations of Americans, regardless of where they were born." "Danger to our country," Ford wrote, "is to be apprehended not so much from the influence of new things as from our forgetting the values of old things."[29] Like Ford's

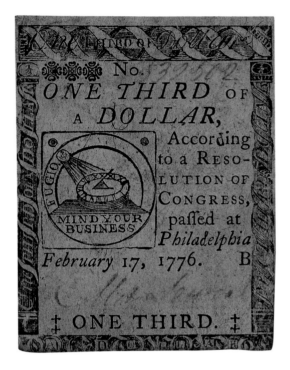

Continental currency, one-third dollar, 1776. In 1775 the Continental Congress authorized the issuance of paper money to finance the American War for Independence. These notes, known as "Continentals," would be redeemable only after the colonies won their independence. Overprinted and distrusted by the public, they declined rapidly in value, giving rise to the popular expression "not worth a Continental." Today, of course, they are worth a great deal to collectors and historians. Through the efforts of Vladimir and Elvira Clain-Stefanelli, who headed the National Numismatic Collection from the 1950s to the 1980s, the Smithsonian acquired many examples of American colonial currency as well as hundreds of thousands of coins, medals, and notes from around the world.

Kerosene lamp, 1876 (opposite). This table lamp, featuring a metal base shaped like the Liberty Bell, was made by the Benedict and Burnham Manufacturing Company of Waterbury, Connecticut. Displayed at the 1876 Centennial Exhibition in Philadelphia to showcase American brassware, the lamp was included in the large collection of industrial and cultural artifacts shipped to the Smithsonian after the exhibition closed.

museum, John D. Rockefeller's Colonial Williamsburg, which opened in 1932, also aimed to construct—and instruct—a national identity. According to Rockefeller, the restored buildings and living history exhibits at Williamsburg illustrated "the patriotism, high purpose, and unselfish devotion of our forefathers to the common good."[30]

Since it formally began collecting American history in 1883, the Smithsonian Institution has also aimed to imagine the nation, to be a mirror of America. But for many years, as shown in the previous chapter, this was an exercise in exclusion. The National Museum dedicated itself to drawing boundaries around national identity, defining the nation as much by what it left out as by what it collected. After World War II, however, that narrow view began to be challenged. More Americans began to claim their place in the National Museum. They demanded a history that would include rather than exclude, that would portray diversity as a defining characteristic of American identity. Slowly but surely, the museum responded. Collections and exhibitions began to imagine the United States as a nation of nations, a nation encompassing a multitude of cultures, values, and experiences.

Yet the inherent difficulty of creating a national collection, of telling a national story, resides in the inevitable silences and exclusions that will always exist. No collection, no exhibition, no museum can truly represent the entire nation in all its diversity and complexity. There will always be missing pieces, missing faces, missing voices. Still, the National Museum of American History has retained the concept of a national collection as an ideal to strive for; it has continued to try to tell the national story, to explore what it means to be American, to identify common experiences and shared values. In recent years, however, the very notion of constructing a national history and identity has been controversial. In multicultural America, historians speak of the impossibility of a single "master narrative" that tells a national story everyone can agree to. Moreover, some critics have questioned whether a national history is even desirable.

The "history wars" of the 1990s—the debates over museum exhibits, school textbooks and curriculums, all forms of public presentations of the past—were fought in large part over the issue of the master narrative. Some Americans have argued for a new, more inclusive master narrative, one that weaves many cultures and peoples into a common history. Others have wanted to reinforce a conventional master narrative. They have protested the addition of new stories to history museums and textbooks, especially ones that emphasize the experiences of minority groups and women, and the loss of more traditional

stories, those they remember from their own experience, from popular culture, or from school history classes. Meanwhile, some have suggested that historical truth can be found only in numerous small stories, each focused on a single group or community. They have rejected the nation as a basis for understanding the past, believing that it promotes generalization and obscures critical differences among different social and cultural groups. Is there such a thing as national history, or are there just many different American histories? What is gained from trying to tell history on a national scale, and what are the pitfalls?[31]

The historian William H. McNeill argues in *Mythistory* (1986) that a nation needs a national history because in large part a national history makes a nation. As a source of common values and experiences, history provides a much-needed source of unity:

A people without a full quiver of relevant agreed-upon statements, accepted in advance through education or less formalized acculturation, soon finds itself in deep trouble, for, in the absence of believable myths, coherent public action becomes very difficult to improvise or sustain. . . . [W]hat a group knows and believes about the past channels expectations and affects the decisions on which their lives, their fortunes and their sacred honor all depend."[32]

But a national history is easily abused. "Nations keep their shape," write Appleby, Hunt, and Jacob, "by molding their citizens' understanding of the past, causing its members to forget those events that do not accord with its righteous image while keeping alive those memories that do." National histories, notes the historian Gerda Lerner in *Why History Matters: Life and Thought* (1997), have been used since the Renaissance by governments as a tool "for legitimizing power and for creating a common cultural tradition based on that history." "National histories," she continues, were "often mythical aggregates of facts and inventions," used to create "a symbolic universe in which various contesting groups could shelter under a shared awning."[33]

When history becomes political, it gains one kind of value—it becomes more useful—but can lose another—its independence, its trustworthiness. "Frequent abuse of national history for tendentious political purposes," argues the historian and political commentator Michael Lind, "makes many suspect of the very enterprise." Indeed, some have dismissed the possibility of a national history altogether. Michael Oakeshott, the conservative English political philosopher, is one of these: "We may be offered 'A History of France,' but only if its author has abandoned the engagement of an historian in favor of that

Plutonium-239 sample, 1941. In 1940 a team of scientists at the University of California, Berkeley, used a sixty-inch cyclotron to discover and create plutonium, a radioactive element that provides the explosive component for nuclear weapons and fuel for nuclear reactors. A sample of the plutonium isotope Pu-239, produced in 1941, was preserved in a cigar box and stored at the university for many years. In 1966 Glenn T. Seaborg and Emilio Segré, Nobel Prize–winning physicists who had participated in the discovery, presented the sample to the Museum of History and Technology. Curators of the museum's new Hall of Nuclear Energy praised plutonium as promising "unlimited electrical power for an energy-hungry world."

Phaser prop from *Star Trek*, 1966–69. Launched on NBC in 1966, the television show *Star Trek* followed the adventures of the starship *Enterprise* on its five-year mission to explore new worlds and "boldly go where no man has gone before." Although the original series lasted for only three seasons, it generated a host of film and television spin-offs and a devoted community of fans. In 1987 a *Star Trek* memorabilia collector presented the Smithsonian with a prop he had acquired in the late 1970s: a hand phaser. Modeled after the classic ray gun of science fiction, the phaser was the weapon of choice for the *Enterprise* crew—its various settings included "stun," "heat," "disrupt," and "overload"—and a popular example of the show's futuristic technology.

of an ideologue or a mythologist shall we find in it an identity—*La nation* or *La France*—to which the differences that compose the story are attributed."[34]

Community histories, on the other hand, also define national identity, as communities use history to secure their role in the national story. "We construct symbolic communities," writes Lerner, "based on ethnicity, religion, race or any other kind of distinguishing mark, setting ourselves apart from those different from us, in order to find and enhance our own identity. We look to a past community, our 'folk' of whatever definition, and our stories weave a collective myth into our own narrative."[35]

Yet community histories, too, are easily abused. The historian David Hollinger uses the term "the will to descend" to refer to "the deep-seated drive to claim politically potent historical artifacts for a contemporary descent-community." This fight for inclusion in national identity is an aspect of the desire for noble ancestors, the pride people take in the cultural contributions of their kin and their larger descent-community. Each group claims, for their ancestors, contributions to civilization whose value is recognized by the community at large. So, Hollinger writes sarcastically, "Isn't it wonderful that Copernicus was Polish? And that Columbus was Italian? And how truly wonderful, as Madison Grant proclaimed in 1916, that Jesus Christ was 'Nordic.'" Hollinger calls this "empowerment through genealogy." It can lead to some dubious history, such as claims by Russian historians of the 1920s that most modern technologies were invented in Russia; theories of nineteenth-century scholars that Ancient Greece was the origin of Western civilization, erasing its African and Asian foundations; or, more recently, the controversial book *Black Athena* (1991), by the Cornell professor Martin Bernal, which focuses only on Ancient Greece's African foundations.[36]

History can be used to create and strengthen national identity and also to challenge and subvert it. History and national identity, write Appleby, Hunt, and Jacob, are "always in tension with each other. Nations use history to build a sense of national identity," but at the same time, as a quest for truth, "history can trample on cherished illusions."[37] Just as easily as it can spin stories of proud and triumphant moments, virtuous heroes, and a unified and prosperous nation, history can also turn up evidence of conflict and inequality, of a nation that failed to live up to its ideals, of broken promises and bitter divisions. History can remind people of a past some would rather forget. (Historians, according to the British historian Eric Hobsbawm, are the "professional remembrancers of what their fellow citizens wish to forget."[38]) It can show images of ourselves we Americans would rather not see. By revealing the presence of social fragmentation and dissent, in both the past and the present, it can shake our confidence in the very idea of a nation and cause us to wonder if Americans have ever truly shared a common identity.

Imagining the Nation

So is the nation real or just a product of people's imagination? The National Museum of American History is a place to search for the answer. Throughout our history we Americans have expressed ideas and raised questions about our national identity. We have declared and also debated what it means to be American, what it means to be part of a nation, and whether the nation includes all or only some of us. These questions and ideas are a vital part of our national legacy, and they come down to us from the past in the form of words, images, and, often most powerfully, artifacts. This museum, with its artifacts that capture and evoke ideas about American identity, is one place where the nation, as something defined, defended, and contested by diverse individuals and communities over time, becomes real—not in the definitive sense but in the suggestive and possible sense.

To define national identity, to say what it means to be American, is not the National Museum of American History's responsibility. In a nation that has so many ideas about just what its identity is or is not, this approach can only get curators into trouble. And even if they did try, would anyone believe them? As curators now realize, meaning in the museum is not imposed from the top down; no matter how desperately they may wish to believe otherwise, messages are not transplanted intact from exhibit labels into visitors' brains. Meaning in the museum is generated through the fluid and unpredictable interaction between people, objects, and ideas, a process that takes place both inside and outside the exhibit galleries. As visitors move through the museum, they create their own stories; as they make connections between the history on display and their own personal histories, they discover for themselves what it means to be American.

On the subject of national identity, the National Museum of American History's role is not to supply the answers but to raise the questions. By bringing objects and people together, the museum creates opportunities for conversations between Americans, past and present, about the values, experiences, and beliefs that have shaped us as a nation. We can ask what it has meant to be American and then consider artifacts as possible answers. When we do, suddenly the storage drawers and exhibit cases are filled not with objects but with expressions, ideas, voices, all clamoring for an opportunity to be heard and added to the conversation. They all have different things to say, different experiences to relate, yet the fundamental message conveyed by these artifacts, by virtue of their presence in the nation's museum, is, in the words of the poet Langston Hughes, "I, too, am America."[39] These objects demand to be included, recognized, and understood as part of the nation, as part of the American legacy: a high school girl's patched jeans; brass water sprayers used by Chinese American laundrymen at the turn of the century; a metal toy gun demanding "Chinese Go Home"; a straw hat worn by a Puerto Rican

Dizzy Gillespie's trumpet and case, 1970s (right). In 1984 the National Museum of American History received a letter from a jazz fan in Webster, Texas, suggesting a new addition to its musical history collection: "the trademark diagonal trumpet of the great Dizzy Gillespie." Curators acknowledged that the story and sound of jazz, an indigenous and vital American art form, belonged in the nation's museum, but no concerted effort had been made to collect the instruments of famous jazz artists. In 1985 the museum acquired Gillespie's custom-made King Silver Flair trumpet and case, and since then it has collected the memorabilia of many other jazz greats, including Duke Ellington, Benny Goodman, and Ella Fitzgerald.

Chinese American woman's dress, 1930s (opposite). Many objects collected by the National Museum of American History document how ethnic traditions are preserved, passed on, and adapted. In 1992 curators acquired a collection of artifacts used by the family of Lee B. Lok, who immigrated to the United States from China in 1881 as a young boy. The collection also includes oral history interviews with Lee's children about their experiences growing up as Chinese Americans in New York City's Chinatown. This embroidered satin dress, representative of 1930s Chinese styles, was worn by one of Lee's six American-born daughters for formal occasions and holidays.

delegate to the Democratic National Convention in 1996; a jar made by a slave potter in Edgefield, South Carolina, inscribed with a poem and his name, "Dave"; a woman shipyard worker's welding mask from World War II; an inlaid marquetry table made by a German immigrant in Wisconsin in 1860, decorated with patriotic symbols; a schoolbus window shattered by a rock thrown by whites protesting the integration of Boston public schools; a panel from the AIDS Memorial Quilt. They all say the same thing: *We, too, are America.* Our greatest challenge—not as curators or as museumgoers but as Americans—is to imagine a nation that encompasses all of these pieces of history, a nation that is not weakened by diversity, contradiction, or conflict but defined and enlarged by it.

When objects come into the museum, they are transformed in many ways. But they also have the power to transform us. By revealing new truths and telling new stories, they can enrich, challenge, and change our understanding of American history. And in changing our view of the past, they can also change our view of ourselves. "All truths wait in all things," wrote Walt Whitman, the poet who first described America as "a teeming nation of nations," in 1855.[40] Whitman's message grows ever more meaningful as we contemplate our national legacy and imagine what truths still await us in the things we have saved from our nation's past.

Notes

WHAT IS WORTH SAVING?

1. Dolley Madison, *Memoirs and Letters of Dolly Madison, Wife of James Madison, President of the United States, Edited by her Grand-niece* (1886; reprint, Port Washington, N.Y.: Kennikat, 1971), 108–11. **2.** The history of the Smithsonian has been documented in numerous publications. The most useful works are George Brown Goode, ed., *The Smithsonian Institution, 1846–1896: The History of Its First Half Century* (Washington, D.C.: Government Printing Office, 1897); Paul H. Oehser, *Sons of Science: The Story of the Smithsonian Institution and Its Leaders* (1949; reprint, New York: Greenwood, 1968); Geoffrey T. Hellman, *The Smithsonian: Octopus on the Mall* (1967; reprint, Westport, Conn.: Greenwood, 1978); and, especially for its pictures, James Conaway, *The Smithsonian: 150 Years of Adventure, Discovery, and Wonder* (Washington, D.C.: Smithsonian Books; New York: Knopf, 1995).

A TREASURE HOUSE

1. *America's Smithsonian: Celebrating 150 Years* (Washington, D.C.: Smithsonian Institution Press, 1996). For the rationale for the selection process, see Richard Kurin, *Reflections of a Culture Broker: The View from the Smithsonian* (Washington, D.C.: Smithsonian Institution Press, 1997), 29–48. **2.** Stephen Greenblatt, "Resonance and Wonder," in *Exhibiting Cultures: The Poetics and Politics of Museum Display*, ed. Ivan Karp and Steven D. Lavine (Washington, D.C.: Smithsonian Institution Press, 1991), 42. **3.** Frederick William True, "The United States National Museum," in *The Smithsonian Institution, 1846–1896: The History of Its First Half Century*, ed. George Brown Goode (Washington, D.C.: Government Printing Office, 1897), 359–61. **4.** *Smithsonian Annual Report* (1850), 50; quoted in Helena E. Wright, *Prints at the Smithsonian: The Origins of a National Collection* (Washington, D.C.: National Museum of American History, 1996), 50. For a description of the art at the early Smithsonian, see William J. Rhees, *An Account of the Smithsonian Institution* (1859; reprint, New York: Arno, 1980), 16–18, 27, 74. On the history of print collecting at the Smithsonian, see Wright, *Prints at the Smithsonian*. **5.** The debate is summarized in Steven Conn, *Museums and American Intellectual Life, 1876–1926* (Chicago: University of Chicago Press, 1998), 192–232; the quote on page 205 is from Winifred Howe, *History of the Metropolitan Museum of Art* (1913; reprint, New York: Arno, 1974), 59. More generally, see Lawrence W. Levine, *Highbrow/Lowbrow: The Emergence of Cultural Hierarchy in America* (Cambridge, Mass.: Harvard University Press, 1988), 146–55. **6.** *Smithsonian Annual Report* (1886), 27. **7.** On the value of the past more generally, see David Lowenthal, *The Past Is a Foreign Country* (Cambridge, England: Cambridge University Press, 1985), 52–63. **8.** Tom Crouch, "Capable of Flight," in *Exhibiting Dilemmas: Issues of Representation at the Smithsonian*, ed. Amy Henderson and Adrienne L. Kaeppler (Washington, D.C.: Smithsonian Institution Press, 1997), 103. **9.** Adam Smith, *An Inquiry into the Nature and Causes of the Wealth of Nations* (London: Methuen, 1904), bk. 1, sec. 4:13 **10.** Georg Simmel, *The Philosophy of Money* (1907; reprint, London: Routledge, 1978), 67; quoted in Arjun Appadurai, "Introduction: Commodities and the Politics of Value," in *The Social Life of Things*, ed. Arjun Appadurai (Cambridge, England: Cambridge University Press, 1986), 3–4. **11.** Bowers and Ruddy Galleries, *Rare Coin Review* 25 (spring 1976): 32. Advertisement for Robert L. Hughes, *The Numismatist* (June 1977): 1,216. **12.** Elvira E. Clain-Stefanelli, *Highlights from the Money Collection of the Chase Manhattan Bank* (Washington, D.C.: National Museum of History and Technology, Smithsonian Institution, 1979), 27–28. **13.** Charles Mackay, *Extraordinary Popular Delusions and the Madness of Crowds* (1841; reprint, New York: Noonday, 1932), 695. **14.** Carl Guthe, *The Management of Small History Museums*, 2d ed. (Nashville, Tenn.: American Association for State and Local History, 1964), 26–27. **15.** G. Ellis Burcaw, *Introduction to Museum Work*, 2d ed. (Nashville, Tenn.: American Association for State and Local History, 1983), 180, 187. **16.** Mark Twain, *The Adventures of Huckleberry Finn* (1885; reprint, New York: Bantam, 1981), 247. **17.** Brooke Hindle, "How Much Is a Piece of the True Cross Worth?" in *Material Culture and the Study of the American Life*, ed. Ian M. G. Quimby (New York: W. W. Norton, 1978), 6. **18.** Lowenthal, *The Past Is a Foreign Country*, 43. **19.** Rachel P. Maines and James J. Glynn, "Numinous Objects," *The Public Historian* 15, no. 1 (winter 1993): 10. **20.** Quoted in Lowenthal, *The Past Is a Foreign Country*, 44. **21.** The Liberty Bell in Philadelphia is a rival for the Declaration of Independence as a symbol of the founding of the United States. Its history as a national treasure is even less ancient than the Jefferson desk; see Robey Callahan, "The Liberty Bell: From Commodity to Sacred Object," *Journal of Material Culture* 4, no. 1 (1999):57–78. **22.** Margaret W. Brown, "The Story of the Declaration of Independence Desk and How It Came to the National Museum," *Smithsonian Annual Report* (1953), 455. **23.** Pauline Maier, *American Scripture: Making the Declaration of Independence* (New York: Knopf, 1997), ix–xii. **24.** Ibid., 98–99. **25.** Ibid., 168. **26.** Ibid., 170–75. For changing ideas about the Revolution during this period, see Michael Kammen, *Season of Youth: The American Revolution and the Historical Imagination* (New York: Knopf, 1973), 41–49. **27.** Quoted in Maier, *American Scripture*, 179. **28.** Thomas N. Brown, "Some Uses of History in the Early Republic," in *Witness to America's Past: Two Centuries of Collecting by the Massachusetts Historical Society* (Boston: Massachusetts Historical Society, 1991), 9. This is also the source for the quotation in the caption on page 40. See also Robert E. Streeter, "Association Psychology and Literary Nationalism in the *North American Review*, 1815–1825," *American Literature* 17 (1946): 243–54. **29.** Silvio A. Bedini, *Declaration of Independence Desk: Relic of Revolution* (Washington, D.C.: Smithsonian Institution Press, 1981). The quotation in the caption on page 39 is from *Congressional Record*, April 22, 1880, p. 2,640; quoted in Bedini, *Declaration of Independence Desk*, 2. **30.** Maier, *American Scripture*, 187. **31.** Martin E. Marty, foreword to *Sons of the Fathers: The Civil Religion and American Revolution*, by Catherine L. Albanese (Philadelphia: Temple University Press, 1976), vii–viii. **32.** Albanese, *Sons of the Fathers*, 182–92; the quotation is from page 192. For more on the declaration's role in civil religion, see Michael Kammen, *Mystic Chords of Memory: The Transformation of Tradition in American Culture* (New York: Knopf, 1991), 66–68. **33.** John Seelye, *Memory's Nation: The Place of Plymouth Rock* (Chapel Hill: University of North Carolina Press, 1998), 23–32. **34.** Kammen, *Mystic Chords of Memory*, 64–65. **35.** *Smithsonian Annual Report* (1899), 17. **36.** William Yeingst and Lonnie G. Bunch, "Curating the Recent Past: The Woolworth Lunch Counter, Greensboro, North Carolina," in *Exhibiting Dilemmas*, 150–51, 155. **37.** Ellen Roney Hughes, "The Unstifled Muse: The 'All in the Family' Exhibit and Popular Culture at the National Museum of American History," in Henderson and Kaeppler, eds., *Exhibiting Dilemmas*, 158. **38.** Ibid., 165. Robert McCormick Adams, "Smithsonian Horizons: Our Collections May Include Some Trivia, but the Real Emphasis Is on More Enduring Achievements," *Smithsonian* 16, no. 4 (July 1985): 10; quoted in Hughes, "The Unstifled Muse," 169. The quotation in the caption on page 47 is from John Weisman, "Enshrined under Plastic: How Archie's Chair Got to Its Final—and Appropriate—Resting Place," *TV Guide* (February 1, 1979): 37; quoted in Hughes, "Unstifled Muse," 159, 161. **39.** John Steinbeck, *The Grapes of Wrath* (1939; reprint, New York: Penguin, 1992), 120. **40.** Burcaw, *Introduction to Museum Work*, 180, 187. **41.** Mihaly

Barbie doll, 1958. First introduced by Mattel in 1958, Barbie soon became American girls' most popular mass-produced playmate. Criticized for its unrealistic anatomical proportions and for promoting gender stereotypes, the doll has remained a must-have toy for many children. In recent years Barbie has also become a valuable commodity on the collector's market. This doll, the earliest model, was given to the Smithsonian by a Washington, D.C., family in 1988, the year Barbie turned thirty.

Csikszentmihalyi and Eugene Rochberg-Halton, *The Meaning of Things: Domestic Symbols and the Self* (Cambridge, England: Cambridge University Press, 1981), 16. **42.** Susan Stewart, *On Longing: Narratives of the Miniature, the Gigantic, the Souvenir, the Collection* (Durham, N.C.: Duke University Press, 1993), xii. **43.** Annete, "The Patchwork Quilt," *The Lowell Offering: Writings by New England Mill Women (1840–1845)*, ed. Benita Eisler (New York: Harper Colophon, 1977), 153; quoted in Susan Strasser, *Waste and Want: A Social History of Trash* (New York: Metropolitan, 1999), 56. **44.** Stewart, *On Longing*, 151. **45.** Appadurai, "Introduction," 26, 44–45, 47. **46.** Accession file 160281, National Museum of American History. On tourist art, see N. H. Graburn, ed., *Ethnic and Tourist Arts* (Berkeley: University of California Press, 1976). **47.** Susan M. Pearce, "Collecting Reconsidered," in *Interpreting Objects and Collections*, ed. Susan M. Pearce (London and New York: Routledge, 1994), 196. **48.** All quoted in Ruth Formanek, "Why They Collect: Collectors Reveal Their Motivations," in Pearce, ed., *Interpreting Objects and Collections*, 328–29. **49.** Marjorie Akin, "Passionate Possession: The Formation of Private Collections," in *Learning from Things: Method and Theory of Material Culture Studies*, ed. W. David Kingery (Washington, D.C.: Smithsonian Institution Press, 1996), 108–14. **50.** Quoted in Akin, "Passionate Possession," 110. **51.** Roy Rosenzweig and David Thelen, *The Presence of the Past: Popular Uses of History in American Life* (New York: Columbia University Press, 1998), 19, 25, 34–36. **52.** *Symbolic capital* is Pierre Bourdieu's term; see Bourdieu, *The Field of Cultural Production: Essays on Art and Literature*, ed. Randal Johnson (New York: Columbia University Press, 1993), 41. See also Thorstein Veblen, *The Theory of the Leisure Class: An Economic Study of Institutions* (1899; reprint, New York: Mentor, 1953), 64. **53.** For the changing meaning of *patina* as a measure of value, see Grant McCracken, *Culture and Consumption: New Approaches to the Symbolic Character of Consumer Goods and Activities* (Bloomington: Indiana University Press, 1990), 31–43. **54.** Quoted in Lowenthal, *The Past Is a Foreign Country*, 43.

A SHRINE TO THE FAMOUS

1. "Proceedings in Congress on the Occasion of the Presentation by Samuel T. Washington of the Sword of George Washington and the Cane of Benjamin Franklin to the Congress of the United States, February 8, 1843," *Congressional Globe* 12 (1843): 254–56; reprinted in Theodore T. Belote, *American and Euro-pean Swords in the Historical Collections of the United States National Museum*, Bulletin no. 163, U.S. National Museum, Smithsonian Institution (Washington, D.C.: Government Printing Office, 1932), 151. The quotation from Franklin's will in the caption on page 64 appears in *The Writings of Benjamin Franklin*, ed. Albert Henry Smyth, 10 vols. (New York: Haskell House, 1970), 10:508. **2.** "Proceedings . . . ," 152. **3.** Accession file 68016, National Museum of American History. For more on the history of relics in Christianity, see Leo Braudy, *The Frenzy of Renown: Fame and Its History* (New York: Vintage, 1997), 179–80, and Patrick Geary, "Sacred Commodities: The Circulation of Medieval Relics," in *The Social Life of Things: Commodities in Cultural Perspective*, ed. Arjun Appadurai (Cambridge, England: Cambridge University Press, 1986), 169–91. **4.** See Douglas E. Evelyn, "A Public Building for a New Democracy: The Patent Office Building in the Nineteenth Century" (Ph.D. diss., George Washington University, 1997). **5.** See Alfred Hunter, *A Popular Catalogue of the Extraordinary Curiosities in the National Institute, Arranged in the Building Belonging to the Patent Office* (Washington, D.C.: A. Hunter, 1855), 22–24. The National Institute, organized in 1840 as the National Institution for the Promotion of Science, was founded by Joel Poinsett, secretary of war under President Martin van Buren. It served as caretaker for the government's collections in the Patent Office and also assembled historical and scientific collections of its own. Poinsett hoped Congress would award the James Smithson bequest to his institute but lost out when officials opted to create the Smithsonian Institution in 1846. After the institute's charter expired in 1862, its collections were transferred to the Smithsonian. **6.** With an eye on the National Cabinet of Curiosities, Henry warned that a museum catering to political or popular demand would rapidly devolve into "a heterogeneous collection of objects of mere curiosity" instead of maintaining the preferred "complete definite collections arranged for scientific purposes." *Smithsonian Annual Report* (1849), 173. On the debate over national collections, see Joel J. Orosz, "Disloyalty, Dismissal, and a Deal: The Development of the National Museum at the Smithsonian Institution, 1846–1855," *Museum Studies Journal* 2 (spring 1986): 22–24. **7.** Hunter, *A Popular Catalogue*, 29–32. **8.** Quoted in Michael Kammen, *Mystic Chords of Memory: The Transformation of Tradition in American Culture* (New York: Knopf, 1991), 55. **9.** Braudy, *Frenzy of Renown*, 452, 452n. **10.** On the ways that Peale used his museum to define the nation, see Laura Rigal, *The American Manufactory: Art, Labor, and*

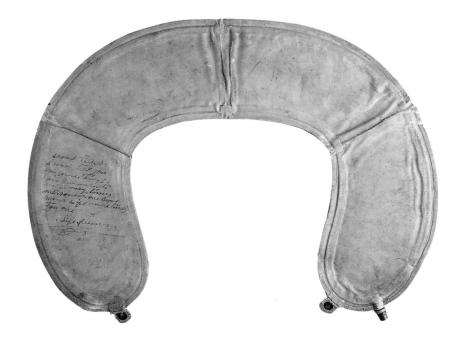

Life preserver worn by Major John Wesley Powell during exploration of the Green and Colorado Rivers, 1869. The donation of this life preserver in 1908 came about when Powell's friends sought to settle a debate over whether the valiant major had actually worn one on the expedition. By way of an answer, William R. Hawkins, one of the last surviving members of the exploring party, presented this life preserver to the Smithsonian. The inscription reads: "I can't talk or I would tell you some queer things. I have been under the water many times and saved one Brave Man's life more times than one."

World of Things in the Early Republic (Princeton, N.J.: Princeton University Press, 1998), 92–113. **11.** Quoted in Kammen, *Mystic Chords of Memory*, 19. **12.** Accession file 13152, National Museum of American History. **13.** Braudy, *Frenzy of Renown*, 452–53. **14.** Quoted in Braudy, *Frenzy of Renown*, 455. **15.** Kammen, *Mystic Chords of Memory*, 96. **16.** *United States National Museum Annual Report* (1890), 141. **17.** The National Museum of American History shares its role as America's "hall of fame" with its sister museum, the National Portrait Gallery, which bases its selection of paintings, sculptures, and photographs of famous Americans on both historical importance and artistic merit. For more on the founding of that museum, see Marcia Pointon, "Imaging Nationalism in the Cold War: The Foundation of the American National Portrait Gallery," *Journal of American Studies* 26, no. 3 (1992): 357–75. **18.** Quoted in Barry Schwartz, "The Reconstruction of Abraham Lincoln," in *Collective Remembering*, ed. David Middleton and Derek Edwards (London: Sage, 1990), 103. **19.** Schwartz, "The Reconstruction of Abraham Lincoln," 103. **20.** The evolution of Washington's image was the subject of a 1982 National Museum of American History exhibition; see Margaret Brown Klapthor and Howard Alexander Morrison, *G. Washington, A Figure upon the Stage: An Exhibition in Celebration of the 250th Anniversary of His Birth* (Washington, D.C.: Smithsonian Institution Press and National Museum of American History, 1982). These themes were also explored in the 2000 exhibition *Exhibiting George Washington,* curated by Lisa Kathleen Graddy, about how Washington has been memorialized through relics in the Smithsonian collections. **21.** Adams to Rush,

July 25, 1808, *The Spur of Fame: Dialogues of John Adams and Benjamin Rush, 1805–1813,* ed. John A. Schutz and Douglass Adair (San Marino, Calif.: Huntington Library, 1966), 113. **22.** Adams to Rush, March 19, 1812, *The Spur of Fame,* ed. Schutz and Adair, 211–12. **23.** Pavel Svinin, *A Picturesque Voyage across North America* (1815); quoted in Abbott Gleason, "Pavel Spin'in, 1787–1839,"in *Abroad in America: Visitors to the New Nation, 1776–1914,* ed. Marc Pachter (Reading, Mass.: Addison-Wesley in association with the National Portrait Gallery, 1976), 21. **24.** Barbara J. Mitnick, *The Changing Image of George Washington* (New York: Fraunces Tavern Museum, 1989), 9. **25.** Ibid., 11. **26.** William E. Woodward, *George Washington: The Image and the Man* (New York: Boni and Liveright, 1926), 453. **27.** Dixon Wecter, *The Hero in America: A Chronicle of Hero-Worship* (Ann Arbor: University of Michigan Press, 1963), 438. **28.** Accession file 20084, National Museum of American History. **29.** Quoted in Wecter, *The Hero in America,* 261. **30.** Accession file 38912, National Museum of American History. **31.** Ibid. **32.** Ibid. **33.** Keith Melder, *Hail to the Candidate: Presidential Campaigns from Banners to Broadcasts,* prologue by Ralph E. Becker (Washington, D.C.: Smithsonian Institution Press, 1992), 2. **34.** *Smithsonian Annual Report* (1914), 23. **35.** Cassie Mason Myers Julian-James, foreword to *Catalogue of American Historical Costumes, Including Those of the Mistresses of the White House as Shown in the United States National Museum,* comp. Rose Gouverneur Hoes, (Washington, D.C: n.p., 1915), iv. **36.** See Edith P. Mayo and Denise D. Meringolo, *First Ladies: Political Role and Public Image* (Washington, D.C.: National Museum of American History, 1994).

37. Wecter, *The Hero in America,* 415. **38.** Hunter, *A Popular Catalogue,* 28. **39.** Cynthia Field, Richard E. Stamm, and Heather P. Ewing, *The Castle: An Illustrated History of the Smithsonian Building* (Washington, D.C.: Smithsonian Institution Press, 1993), 135–36, 169n. **40.** Robert V. Bruce, *Bell: Alexander Graham Bell and the Conquest of Solitude* (Ithaca, N.Y.: Cornell University Press, 1973), 139, 337, 350. **41.** On the early history of science at the Smithsonian, see Sally Gregory Kohlstedt, "George Brown Goode, 1851–1896," in *The Origins of Natural Science in America: The Essays of George Brown Goode,* ed. Kohlstedt (Washington, D.C.: Smithsonian Institution Press, 1991), 15–18, as well as Goode's essays in that volume; and Pamela M. Henson, "'Objects of Curious Research': The History of Science and Technology at the Smithsonian," *Isis* 90 (Supplement, 1999): 249–69. **42.** *Report of the U.S. National Museum* (1892), 116. **43.** *United States National Museum Annual Report* (1922), 100. **44.** Joseph West Moore, *Picturesque Washington: Pen and Pencil Sketches* (Providence, R.I.: J. A. and R. A. Reid, 1888), 216. **45.** *Annual Report of the U.S. National Museum* (1914), 40. **46.** Cited in Wecter, *The Hero in America,* 417. **47.** Arthur P. Molella, "The Museum That Might Have Been: The Smithsonian's National Museum of Engineering and Industry," *Technology and Culture* 32, no. 2, pt. 1 (April 1991): 248, 254. On the increasing concern of engineers with their heritage and their recasting of engineers as heroes, see Ruth Oldenziel, *Making Technology Masculine: Men, Women and Modern Machines in America, 1870–1945* (Amsterdam, Netherlands: Amsterdam University Press, 1999), 48–49, 116–18. **48.** *Maria Mitchell: Life, Letters, and Journals,* comp.

Phebe Mitchell Kendall (1896; reprint, Freeport, N.Y.: Books for Libraries, 1971), 238. **49.** Accession file 1983.0458, National Museum of American History. **50.** See Braudy, *Frenzy of Renown*, 507–8. **51.** Accession file 54045, National Museum of American History. **52.** On the history of military collecting at the Smithsonian, see Joanne M. Gernstein London, "A Modest Show of Arms: Exhibiting the Armed Forces and the Smithsonian Institution, 1945–1976" (Ph.D. diss., George Washington University, 2000). **53.** Kammen, *Mystic Chords of Memory*, 115. **54.** Ibid., 105–6, 118–19. **55.** Both George Brown Goode, director of the National Museum from 1881 to 1896, and A. Howard Clark, first curator of the historical collection, were enthusiastic genealogists and active in the Sons of the American Revolution. For more on Goode and the Smithsonian's early focus on founding families, see chapter 4, Mirror of America. A detailed analysis of the very complicated history of the Washington tents can be found in J. I. H. Eales, "The Washington Tents" (December 1978), reference files, Armed Forces History Collection, National Museum of American History. **56.** See Kirk Savage, *Standing Soldiers, Kneeling Slaves: Race, War, and Monument in Nineteenth-Century America* (Princeton, N.J.: Princeton University Press, 1997), 162–208. **57.** *Annual Report of the U.S. National Museum* (1919), 19. **58.** See National Society of the Colonial Dames of America, *Uniforms of Women Worn during the War*, Report of the Committee on Relics, submitted by Carolyn Gilbert Benjamin, chairman (Washington, D.C.: NSCDA, 1922). **59.** See *Brigadier General Anna Mae McCabe Hays, ANC, Chief Army Nurse Corps*, a video biography produced by the Armed Forces History Collection, National Museum of American History. The quotation from General Hays in the caption on page 104 is from this video. **60.** Accession file 64601, National Museum of American History. **61.** Accession file 309870, National Museum of American History. **62.** Ibid. **63.** Neil Harris, *Humbug: The Art of P. T. Barnum* (Boston: Little, Brown, 1973), 163–64. Robert Bogdan, *Freak Show: Presenting Human Oddities for Amusement and Profit* (Chicago: University of Chicago Press, 154–56. **64.** For a comparison of the two kinds of museums, see Joel J. Orosz, *Curators and Culture: The Museum Movement in America, 1740–1870* (Tuscaloosa: University of Alabama Press, 1990), 140–79. For Barnum's mix of entertainment and education, see Harris, *Humbug*, 173–81. **65.** Braudy, *Frenzy of Renown*, 502. **66.** Accession file 1999.0102, National Museum of American History. **67.** Braudy, *Frenzy of Renown*, 592. **68.** Schwartz, "The Reconstruction of Abraham Lincoln," 102.

A PALACE OF PROGRESS

1. Herman Schaden, "New Smithsonian Unit to Be a Palace of Progress," *Washington Evening Star*, May 23, 1963, sec. A, p. 16. **2.** G. Carroll Lindsay, "George Brown Goode," in *Keepers of the Past*, ed. Clifford L. Lord (Chapel Hill: University of North Carolina Press, 1965), 127–40. See also Sally Gregory Kohlstedt, "History in a Natural History Museum: George Brown Goode and the Smithsonian Institution," *The Public Historian* 10, no. 2 (spring 1988): 7–26. **3.** *Report of the U.S. National Museum* (1898), 25–26. **4.** Samuel P. Langley to Messrs Wesley and Company, August 9, 1890, in files of Division of the History of Technology, National Museum of American History. **5.** S. R. Koehler, *Etching: An Outline of Its Technical Process and Its History* (New York: Cassell, 1885), 191; quoted in Helena Wright, "The Exhibition Program," in *Clio in Museum Garb: The National Museum of American History, the Science Museum and the History of Technology*, Science Museum Papers in the History of Technology 4 (1996): 3. **6.** *United States National Museum Annual Report* (1884), 14–15. **7.** *Report of the U.S. National Museum* (1898), 25–27. For the Smithsonian's role in early anthropology, see Curtis Hinsley, *Savages and Scientists: The Smithsonian Institution and the Development of American Anthropology, 1846–1910* (Washington, D.C.: Smithsonian Institution Press, 1981). **8.** Arthur P. Molella, "The Museum That Might Have Been: The Smithsonian's National Museum of Engineering and Industry," *Technology and Culture* 32, no. 2, pt. 1 (April 1991): 241. **9.** George Brown Goode, "The Museums of the Future," in *A Memorial of George Brown Goode* (Washington, D.C.: Government Printing Office, 1901), 259. **10.** Otis T. Mason, "The Occurrence of Similar Inventions in Areas Widely Apart," *Science* 9 (1887): 534–35. **11.** Steven Conn, *Museums and American Intellectual Life, 1876–1926* (Chicago: University of Chicago Press, 1998), 5–15. **12.** Katherine C. Grier, *Culture and Comfort: Parlor Making and Middle-Class Identity, 1850–1930* (Washington, D.C.: Smithsonian Institution Press, 1997), 13–17. **13.** Otis T. Mason, "The Educational Aspect of the United States National Museum," in *Notes Supplementary to the Johns Hopkins University Studies in Historical and Political Science* (November 1899): 64. **14.** Mason, *The Origins of Invention: A Study of Industry among Primitive Peoples* (London: Walter Scott, 1895), 13–14. **15.** Ibid. **16.** *Smithsonian Institution Annual Report* (1896), 635. **17.** Mason, *The Origins of Invention*, 27. **18.** William Ryan Chapman, "Pitt Rivers and Typological Tradition," in *Objects and Others: Essays on Museums and Material Culture*, ed. George Stocking, History of Anthropology, vol. 3 (Madison: University of Wisconsin Press, 1985), 39. Pitt Rivers's museum had an elaborate scheme of "typographical" arrangement, showing the evolutionary development of technology in a series of concentric circles. See also David K. Van Keuren, "Museums and Ideology: Augustus Pitt-Rivers, Anthropological Museums, and Social Change in Later Victorian Britain, *Victorian Studies* 28 (1984): 171–89. "Goode was explicit about the role of the Pitt Rivers Museum as a model for the National Museum; see Goode, "Museums of the Future," 259. Note that the evolutionary approach to invention could be read in exactly the opposite way: Karl Marx too believed that invention is an evolutionary process, arguing that technological advance did not require heroic inventors or capitalists. See George Basalla, *The Evolution of Technology* (Cambridge, England: Cambridge University Press, 1988), 21. **19.** Franz Boas, "The Occurrence of Similar Inventions in Areas Widely Apart," *Science* 9 (1887): 485–86. **20.** Ibid., 485–86. **21.** Ira Jacknis, "Franz Boas and Exhibits: On the Limitations of the Museum Method of Anthropology," in *Objects and Others*, ed. Stocking, 81–83. **22.** Quoted in Jacknis, "Franz Boas," 87. **23.** Mason, *The Origins of Invention*, 413. **24.** Molella, "The Museum That Might Have Been," 242. See *Report of the Proceedings of the 19th Annual Convention of the American Railway Master Mechanics' Association, June 1886* (Cincinnati: Aldine, 1886), 178–79, and J. Elfreth Watkins, "Report on the Section of Steam Transportation in the U.S. National Museum for the Year Ending June 30, 1886," *United States National Museum Annual Report* (1889), 133–40. **25.** *Report of the Proceedings*, 179. **26.** Helena E. Wright, "George Pullman and the Allen Paper Car Wheel," *Technology and Culture* 33, no. 4 (October 1992): 764. Quote from John H. White Jr., *The American Railroad Passenger Car* (Baltimore: Johns Hopkins University Press, 1978), 535. **27.** J. Elfreth Watkins, *The Camden and Amboy Railroad: Origin and Early History* (Washington, D.C.: Gedney and Roberts, [1892]), 61. **28.** Ibid., 61–63. **29.** *Smithsonian Institution Annual Report* (1894), pt. 2, 25–26. **30.** *Journal of the American Pharmaceutical Association* 7 (1918): 376–77, 466; quoted in Sami Hamarneh, *History of the Division of Medical Sciences*, Contributions from the Museum of History and Technology, Paper 43 (Washington, D.C.: Smithsonian Institution, 1964), 277. **31.** Molella, "The Museum That Might Have Been," 247. **32.** *Annual Report of the Smithsonian Institution* (1886), pt. 1, 27. **33.** *Annual Report of the U.S. National*

Museum (1924), 97–106. **34.** *Annual Report of the U.S. National Museum* (1919), 118. **35.** *Annual Report of the U.S. National Museum* (1925), 98. On health exhibits, see Hamarneh, *History*, 278. **36.** Molella, "The Museum That Might Have Been," 249. On the context of early science and technology museum proposals, see Michael Wallace, "Progress Talk: Museums of Science, Technology and Industry," in *Mickey Mouse History and Other Essays on American Memory* (Philadelphia: Temple University Press, 1996), 75–85. **37.** Michael Kammen, *Mystic Chords of Memory: The Transformation of Tradition in American Culture* (New York: Vintage, 1991), 306. **38.** Charles R. Richards, *The Industrial Museum* (New York: Macmillan, 1925), 48. **39.** Kammen, *Mystic Chords of Memory*, 355. On the origins of the Ford Museum, see Conn, *Museums*, chapter 5, and *An American Invention: The Story of the Henry Ford Museum and Greenfield Village* (Dearborn, Mich.: Henry Ford Museum and Greenfield Village, 1999). **40.** Jay Pridmore, *Museum of Science and Industry, Chicago* (New York: Harry N. Abrams in association with the Museum of Science and Industry, Chicago), 21. For the story of the museum's origins, see Waldemar Kaempfert, *From Cave-Man to Engineer: The Museum of Science and Industry Founded by Julius Rosenwald, An Institution to Reveal the Technical Ascent of Man* (Chicago: The Museum of Science and Industry, 1933), 3–11. **41.** Kammen, *Mystic Chords of Memory*, 306. See also Conn, *Museums*, chapter 1. Ford quote in Kammen, *Mystic Chords of Memory*, 353. **42.** Richards, *The Industrial Museum*, 4–5. **43.** Richard F. Bach, "Museums and the Factory: Making the Galleries Work for the Art Trades," *Scribner's Magazine* 71 (June 1922): 763–68; quoted in Kammen, *Mystic Chords of Memory*, 306. **44.** Henry Ford, interview by S. J. Woolf, *New York Times*, January 12, 1936, sec. 7, p. 1; quoted in Kammen, *Mystic Chords of Memory*, 352. **45.** Charles Gwynne, *Museums for the New Age: A Study of World Progress in Industrial Education* (New York: Association for the Establishment and Maintenance of Museums of the Peaceful Arts,

[1927]), 8–9; quoted in Molella, "The Museum That Might Have Been," 258. **46.** Richards, *The Industrial Museum*, 1–2. **47.** *United States National Museum Annual Report* (1920), 141; quoted in Molella, "The Museum That Might Have Been," 250. **48.** Porter to Mitman, December 27, 1924, record unit 297, box 8, Smithsonian Institution Archives; quoted in Molella, "The Museum That Might Have Been," 254. **49.** Molella, "The Museum That Might Have Been," 254–57. **50.** Ibid., 259. **51.** *United States National Museum Annual Report* (1961), 6. **52.** Hamarneh, *History*, 285–87; Judy M. Chelnick, "Bristol-Myers Squibb Eighteenth-Century European Apothecary," *Caduceus* 13, no. 3 (winter 1997): 37. **53.** Frank Taylor, "A National Museum of Science, Engineering and Industry," *The Scientific Monthly* 63, no. 5 (November 1946): 360–61. **54.** *United States National Museum Annual Report* (1959), 37. **55.** *United States National Museum Annual Report* (1963), 214–15. **56.** Robert M. Vogel, "Assembling a New Hall of Civil Engineering," *Technology and Culture* 6, no. 1 (winter 1965): 61, 64. **57.** *United States National Museum Annual Report* (1963), 209, 211. **58.** Ramunas Kondratas, "150 Years of Collecting Medical History at the Smithsonian Institution," *Caduceus* 13, no. 3 (winter 1997): 10. **59.** Joint Congressional Committee on Construction of a Building for a Museum of History and Technology for the Smithsonian Institution, 87th Cong., 1st sess., June 12, 1961, S. Rpt. 365; quoted in *United States National Museum Annual Report* (1961), 9. **60.** *United States National Museum Annual Report* (1963), 212. **61.** Carl W. Mitman, *Catalogue of the Mechanical Engineering Collection in the United States National Museum: Motors, Locomotives, and Self-Propelled Vehicles* (Washington, D.C.: Government Printing Office, 1922), 3. **62.** C. G. Abbot to Thomas Armat, August 9, 1921, record unit 192, Smithsonian Institution Archives. **63.** Judy M. Chelnick, "From Stethoscopes to Artificial Hearts," *Caduceus* 13, no. 3 (winter 1997): 17. **64.** Mitman, *Catalogue of the Mechanical Engineering Collection*, 63–89. **65.** Robert C. Post, "From Pillar to Post: The Plight of the Patent Models," *IA:

The Journal of the Society for Industrial Archeology* 4, no. 1 (1978): 58–60. See also Barbara Suit Janssen, *Technology in Miniature: American Textile Patent Models, 1819–1840* (Washington, D.C.: Smithsonian Institution Press, 1988), and Janssen, ed., *Icons of Invention: American Patent Models* (Washington, D.C.: Smithsonian Institution Press, 1990). **66.** Accession file 89797, National Museum of American History. **67.** Ramunas Kondratas, "Medical Imaging," in *Caduceus* 13, no. 3 (winter 1997): 23. **68.** H. Mark Gosser, "The Armat-Jenkins Dispute and the Museums," *Film History* 2, no. 1 (1988): 1–2. For the Smithsonian collection, see John Hiller, "The Movie-Machine Collection: National Museum of American History," *History of Photography* 24, no. 1 (spring 2000): 60–62. **69.** Thomas Armat to C. G. Abbot, November 14, 1928, record unit 192, Smithsonian Institution Archives. **70.** Holland Thompson, *The Age of Invention: A Chronicle of Mechanical Conquest* (New Haven, Conn.: Yale University Press, 1921), 180–82. **71.** Edwin A. Battison, "Eli Whitney and the Milling Machine," *Smithsonian Journal of History* 1 (1966): 14; Battison, "A New Look at the 'Whitney' Milling Machine," *Technology and Culture* 14 (1973): 592–98; and Robert S. Woodbury, "The Legend of Eli Whitney and Interchangeable Parts," *Technology and Culture* 1 (1960): 235–53. **72.** R. B. Gordon, "The 'Kelly' Converter," *Technology and Culture* 33 (1992): 769–79. **73.** John M. Staudenmaier, "Clean Exhibits, Messy Exhibits: Henry Ford's Technological Aesthetic," *Industrial Society and Its Museums, 1890–1990: Social Aspirations and Cultural Politics*, ed. B. Schroeder-Gudehus (Chur, Switzerland: Harwood, 1993), 62–63. See also Michael Wallace, "Industrial Museums and the History of Deindustrialization," in *Mickey Mouse History*, 88–100. **74.** For the curators' view of the controversy, see Arthur Molella and Carlene Stephens, "Science and Its Stakeholders: The Making of 'Science in American Life,'" in *Exploring Science in Museums*, ed. Susan Pearce (London: Athlone, 1996), 95–106. For an outsider's review, see Alan J. Friedman, "Exhibits and Expectations," *Public Understanding of Science* 4 (July 1995): 305–13.

Albert Einstein's pipe, about 1948. A man whose theory of relativity and other work in theoretical physics radically revised concepts of space, time, and matter, Einstein received the Nobel Prize for Physics in 1921. Einstein gave this pipe—one of his signature tobacco pipes—to his secretary, Gina Plunguian, as a memento in 1948. The Smithsonian acquired it in 1979.

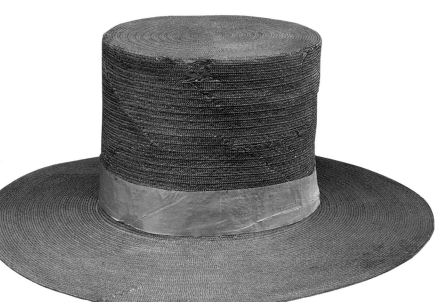

Henry Clay's straw hat, about 1840s. Although defeated five times in his bid for the presidency, Clay achieved lasting fame for his service as U.S. representative and senator from Kentucky, speaker of the house, and secretary of state. Known as "the Great Compromiser," Clay helped formulate legislation, including the Compromise of 1850, intended to moderate sectional conflicts and prevent civil war. In 1926 the Smithsonian added Clay's straw hat to its growing collection of artifacts associated with distinguished political figures.

A MIRROR OF AMERICA

1. *Annual Report of the U.S. National Museum* (1912), 15; *Annual Report of the U.S. National Museum* (1926), 23. **2.** Lawrence Levine, *Highbrow/Lowbrow: The Emergence of Cultural Hierarchy in America* (Cambridge, Mass.: Harvard University Press, 1988), 145–49, 182–87. The quotation about the Boston Museum of Fine Arts is from the speech of Mayor Cobb delivered at the dedication ceremony on July 3, 1876; quoted in Levine, *Highbrow/Lowbrow*, 146. **3.** *Annual Report of the U.S. National Museum* (1912), 16. **4.** For example, in 1886, Romyn Hitchcock, curator of foods and textiles, expressed his belief that the National Museum could be of assistance in helping "the poorer classes to exercise more economy in living" by providing "instruction in the art of cooking as well as in the selection of proper food" *(Report of the U.S National Museum* [1886], 117). **5.** *Annual Report of the U.S. National Museum* (1914), 23, 31. **6.** For a detailed exploration of the changing role of history in American life during this period, see Michael Kammen, *Mystic Chords of Memory: The Transformation of Tradition in American Culture* (New York: Knopf, 1991), 100–278. In her preface to *After the Revolution: The Smithsonian History of Everyday Life in the Eighteenth Century* (New York: Pantheon and National Museum of American History, 1985), based on the museum's 1985 exhibition, Barbara Clark Smith analyzes the Smithsonian's changing interpretation of colonial America in the context of larger social and cultural trends. For the cultural politics of the movement, see Michael Wallace, "Visiting the Past: History Museums in the United States," in *Presenting the Past: Essays on History and the Public*, ed. Susan Porter Benson, Stephen Brier, and Roy Rosen-zweig (Philadelphia: Temple University Press, 1986), 137–161. **7.** Accession file 55119, National Museum of American History. **8.** *Report of the U.S. National Museum* (1896), pt. II, 14–15. **9.** Michael Kammen describes this growing interest in an "American aesthetic" in *Mystic Chords of Memory*, 324–25; see also Smith, *After the Revolution*, ix–xx. For a cultural history of the American colonial revival, see Karal Ann Marling, *George Washington Slept Here: Colonial Revivals and American Culture, 1876–1986* (Cambridge, Mass.: Harvard University Press, 1988). **10.** Kammen, *Mystic Chords of Memory*, 160–61, 349–51. **11.** Accession file 71679, National Museum of American History. Gertrude Ritter's colonial room is discussed in Smith, *After the Revolution*, ix–x, xiv–xv, and analyzed in Edward F. Zimmer, "A Study of the Origins of the Connecticut Valley Parlor in the National Museum of American History, or Ignorance Is Bliss," Report for the National Museum of American History, Smithsonian Institution, September 1981. **12.** Kammen, *Mystic Chords of Memory*, 379. **13.** Ibid., 461. **14.** Kammen examines the New Deal government's new role as a custodian of national memory in *Mystic Chords of Memory*, 458–79. For an overview of the Works Project Administration art and history projects, particularly the index, see Edwin O. Christensen, *The Index of American Design* (New York and Washington, D.C.: Macmillan and the National Gallery of Art, 1950). **15.** On Watkins's career at the Smithsonian and his connection to the historic preservation movement in New England, see Briann Greenfield, "Constructing History: Public Memory in Deerfield, Massachusetts, Salem, Massachusetts, Providence, Rhode Island, and the Smithsonian's Museum of History and Technology, 1926–1975" (Ph.D. diss., Brown University, forthcoming). **16.** Acces-sion file 71679, National Museum of American History. **17.** *Annual Report of the U.S. National Museum* (1951), 10. **18.** Accession file 182022, National Museum of American History. **19.** *Annual Report of the U.S. National Museum* (1957), 8. **20.** S. C. Wolcott, ed., "What Is the Association?" *Chronicle of the Early American Industries Association* 1 (October 1, 1933); reprinted in William K. Ackroyd and Elaine B. Winn, "Sixtieth Anniversary History, 1958–1993," Supplement 51 (May 1998). **21.** *Smithsonian Year* (1966), 254. More generally, see Peter C. Welsh, "Folk Art and the History Museum: The Van Alstyne Collection at the Smithsonian Institution," *Curator* 10, 1 (1967): 60–78. For a scholarly review of the subject, see the Winterthur Museum publication *Perspectives on American Folk Art*, ed. Ian M. G. McQuimby and Scott T. Swank (New York: W. W. Norton, 1980). **22.** "Conceptual Script for Revision of the Hall of Everyday Life in the American Past," April 9, 1973, Hall of Everyday Life in the American Past exhibition files, Division of Social History, National Museum of American History; quoted in Smith, *After the Revolution*, xv. **23.** Ripley's decision to keep the museums open during the Poor People's Campaign is recounted in Fath Davis Ruffins, "Mythos, Memory, and History: African American Preservation Efforts, 1820–1990," in *Museums and Communities: The Politics of Public Culture*, ed. Ivan Karp, Christine Mullen Kreamer, and Steven D. Lavine (Washington, D.C.: Smithsonian Institution Press, 1992), 573–74. **24.** *Smithsonian Year* (1968), 1. **25.** *Smithsonian Year* (1970), 1. **26.** Interview with C. Malcolm Watkins, Oral History Collection, Smithsonian Institution Archives; C. Malcolm Watkins to Ellen Boggemes, December 3, 1969, C. Malcolm Watkins Papers, Smithsonian Institution Archives, record unit 7322.

27. *Smithsonian Year* (1968), 2–4. **28.** Cyrus Adler and I. M. Casanowicz, "The Collection of Jewish Ceremonial Objects in the United States National Museum," *Proceedings of the United States National Museum* 34, no. 1,630 (1908): 701–46. For the history of another Smithsonian collection of religious artifacts, see Richard Eighme Ahlborn and Vera Beaver-Bricken Espinola, eds., *Russian Copper Icons and Crosses from the Kunz Collection: Castings of Faith* (Washington, D.C.: Smithsonian Institution Press, 1991). A detailed history and catalogue of the Smithsonian's Judaica collections, focusing on the career and contributions of Cyrus Adler, is provided in Grace Cohen Grossman with Richard Eighme Ahlborn, *Judaica at the Smithsonian: Cultural Politics as Cultural Model* (Washington, D.C.: Smithsonian Institution Press, 1997). On the context of Adler's work, see Barbara Kirshenblatt-Gimblett, "Exhibiting Jews," in *Destination Culture: Tourism, Museums, and Heritage* (Berkeley: University of California Press, 1998), 79–128. **29.** See Grossman and Ahlborn, *Judaica*, 37, 215–17. **30.** For a history of the study and interpretation of Native American cultures at the Smithsonian, see Curtis M. Hinsley, *The Smithsonian and the American Indian: Making a Moral Anthropology in Victorian America* (Washington, D.C.: Smithsonian Institution Press, 1994). **31.** Quoted in *Annual Report of the Smithsonian Institution* (1885), pt. II, 719. **32.** *Annual Report of the Smithsonian Institution* (1857), 36. After an 1865 fire destroyed many of the Indian portraits on display at the Smithsonian, Henry was among those who advocated using the camera rather than the paintbrush to document Native Americans. For more on nineteenth-century photographs of Native Americans, see Paula Richardson Fleming and Judith Luskey, *The North American Indians in Early Photographs* (New York: Dorset, 1988). The information in the caption on page 190 is from Paula Richardson Fleming, "An 'Accumulation' of Native American Portraits," *History of Photography* 24 (spring 2000): 57–58. **33.** Richard Henry Pratt, *Battlefield and Classroom: Four Decades with the American Indian, 1867–1904*, ed. Robert M. Utley (New Haven, Conn.: Yale University Press, 1964), 303–4, 335. **34.** Luther Standing Bear, *Land of the Spotted Eagle* (1933; reprint, Lincoln: University of Nebraska Press, 1978), 191. **35.** *Fourth Bulletin of the National Institute for the Promotion of Science, Washington, D.C.* (February 1845–November 1846), 484. Thomas presented Salola's pistol to the National Institute, which in 1845 was still the official custodian of the government's collections. The quotation in the pistol caption on page 192 is from Charles Lanman, *Letters from the Alleghany Mountains* (New York: G. P. Putnam, 1849), 111; quoted in *Nineteenth Annual Report of the Bureau of Ethnology, Smithsonian Institution* (1902), 166–67. **36.** See Rayna Green with Melanie Fernandez, *The British Museum Encyclopaedia of Native North America* (London: British Museum Press, 1999), 64. **37.** See Eric Foner, *The Story of American Freedom* (New York: W. W. Norton, 1998), 236–47. **38.** For an account of African American history collecting at the Smithsonian and other American museums, see Ruffins, "Mythos, Memory, and History."**39.** See accession file 178781, National Museum of American History. **40.** Quoted in Ruffins, "Mythos, Memory, and History," 573. **41.** On the history and politics of the Smithsonian's Festival of American Folklife, see Richard Kurin, *Reflections of a Culture Broker: The View from the Smithsonian* (Washington, D.C.: Smithsonian Institution Press, 1997). For a catalogue of the Smithsonian's collection of religious folk art from New Mexico, see Richard E. Ahlborn and Harry R. Rubenstein, "Smithsonian Santos: Collecting and the Collection," in *Hispanic Arts and Ethnohistory in the Southwest: New Papers Inspired by the Work of E. Boyd*, ed. Marta Weigle with Claudia Larcombe and Samuel Larcombe (Santa Fe, N.M.: Ancient City, 1983), 240–79. **42.** *Smithsonian Year* (1973), 110. **43.** *Smithsonian Year* (1974), 173. **44.** See Ellen Roney Hughes, "The Unstifled Muse: The 'All in the Family' Exhibit and Popular Culture at the National Museum of American History," in *Exhibiting Dilemmas: Issues of Representation at the Smithsonian*, ed. Amy Henderson and Adrienne L. Kaeppler (Washington, D.C.: Smithsonian Institution Press, 1997), 156–75. **45.** Joint Congressional Committee on Construction of a Building for a Museum of History and Technology for the Smithsonian Insitution, 86th Cong., 1st sess, May 20, 1959, S. Rpt. 301; quoted in *Annual Report of the Smithsonian Institution* (1959), 3. **46.** Howard Morrison and Richard Alhborn, et al., *American Encounters: A Companion to the Exhibition at the National Museum of American History, Smithsonian Institution* (Washington, D.C.: National Museum of American History, 1992), 34. **47.** See accession file 1989.0693, National Museum of American History. **48.** The exhibition is described in Peter Liebhold and Harry R. Rubenstein, *Between a Rock and a Hard Place: A History of American Sweatshops, 1820–Present* (Los Angeles, Calif.: UCLA Asian American Studies Center, 1999). For the politics of the exhibition process, see Peter Liebhold, "Experiences from the Front Line: Presenting a Controversial Exhibition during the Culture Wars," *The Public Historian* 22, no. 3 (summer 2000): 67–84. **49.** Much has been written on these issues in recent years, particularly the controversy over the Enola Gay at the National Air and Space Museum; see Edward T. Linenthal and Tom Engelhardt, eds., *History Wars: The Enola Gay and Other Battles for the American Past* (New York: Metropolitan, 1996); Henderson and Kaeppler, eds., *Exhibiting Dilemmas*; Michael Wallace, *Mickey Mouse History and Other Essays on American Memory* (Philadelphia; Temple University Press, 1996); Philip Noble, *Judgment at the Smithsonian— The Bombing of Hiroshima and Nagasaki: The Uncensored Script of the Smithsonian's Fiftieth Anniversary Exhibit of the Enola Gay* (New York: Marlowe, 1995); Martin Harwit, *An Exhibit Denied: Lobbying the History of the Enola Gay* (New York: Copernicus, 1996); and Steven C. Dubin, *Displays of Power: Memory and Amnesia in the American Museum* (New York: New York University Press, 1999), especially chapters 5 and 6.

FROM ARTIFACTS TO AMERICA

1. Maxwell L. Anderson, "Museums of the Future: The Impact of Technology on Museum Practices," *Daedalus* 128, no. 3 (summer 1999): 141. **2.** Elaine Heumann Gurian, "What Is the Object of This Exercise? A Meandering Exploration of the Many Meanings of Objects in Museums," *Daedalus* 128, no. 3 (summer 1999): 165–7 (italics in original). **3.** The phrase "salvage and warehouse business" originated with Barbara Franco, director of the Historical Society of Washington, D.C.; quoted in Stephen E. Weil, "The Ongoing Transformation of the American Museum," *Daedalus* 128, no. 3 (summer 1999): 229. The other notions of the proper business of the museum can be found elsewhere in Weil's article. **4.** Donald Duckworth, president of Honolulu's Bishop Museum; quoted in Emlyn H. Koster, "In Search of Relevance: Science Centers as Innovators in the Evolution of Museums," *Daedalus* 128, no. 3 (summer 1999): 285. **5.** George Brown Goode, "The Museums of the Future," lecture delivered at the Brooklyn Institute, February 28, 1889; reprinted in *Annual Report of the U.S. National Museum* (1897), pt. 2, 241–62. **6.** See Goode, "Museum-History and Museums of History," paper read before the American Historical Association in Washington, D.C., December 26–28, 1888; reprinted in *Annual Report of the U.S. National Museum* (1897), pt. 2, 65–81. **7.** Daniel Miller, *Material Culture and Mass Consumption* (Oxford, England: Blackwell, 1987), 105. **8.** Gurian, "What Is the Object?" 166, 181. **9.** Robert Harbison, *Eccentric Spaces* (Boston: David Godine, 1977), 147. **10.** Roy Rosenzweig and David Thelen, *The Presence of the Past: Popular Uses of History in Amer-

ican Life (New York: Columbia University Press, 1998), 20–22, 105–8. **11.** Spencer R. Crew and James E. Sims, "Locating Authenticity: Fragments of a Dialogue," in *Exhibiting Cultures: The Poetics and Politics of Museum Display*, ed. Ivan Karp and Steven D. Lavine (Washington, D.C.: Smithsonian Institution Press, 1991), 172–73. **12.** *Excellence and Equity: Education and the Public Dimension of Museums; A Report from the American Association of Museums* (Washington, D.C.: American Association of Museums, 1992), 11–12. **13.** On the distinction between collective memory, collected memories, and common meaning, see James E. Young, *The Texture of Memory: Holocaust Memorials and Meaning* (New Haven, Conn.: Yale University Press, 1993), xi–xiii. **14.** Fath Davis Ruffins, "Mythos, Memory, and History: African American Preservation Efforts, 1820–1990," in *Museums and Communities: The Politics of Public Culture,* ed. Ivan Karp, Christine Mullen Kreamer, and Steven D. Lavine (Washington, D.C.: Smithsonian Institution Press, 1992), 523; see also pages 573–86 for a discussion of recent changes in the Smithsonian's collecting of African American history. On the Smithsonian's collecting of Hispanic history, see Raúl Yzaguirre and Mari Carmen Aponte, *Willful Neglect: The Smithsonian Institution and U.S. Latinos, Report of the Smithsonian Institution Task Force on Latino Issues* (Washington, D.C.: The Smithsonian Institution, 1994). For an interesting presentation of the gaps in collections generally, see Lisa G. Corrin, ed., *Mining the Museum: An Installation by Fred Wilson* (Baltimore, Md.: The Contemporary; New York: New Press, 1994). **15.** Michel-Rolph Trouillot, *Silencing the Past: Power and the Production of History* (Boston: Beacon Press, 1995), 48, 56, 145ff. **16.** Michael Wallace, "Visiting the Past: History Museums in the United States," in *Mickey Mouse History and Other Essays on American Memory* (Philadelphia: Temple University Press, 1996), 4. **17.** David Hollinger, "National Culture and Communities of Descent," *Reviews in American History* 26 (1998): 321. **18.** Joyce Appleby, Lynn Hunt, and Margaret Jacob, *Telling the Truth about History* (New York: W. W. Norton, 1994), 11. **19.** Ibid., 260. **20.** Lisa G. Corrin, "Mining the Museum: Artists Look at Museums, Museums Look at Themselves," in *Mining the Museum,* ed. Corrin, 14; and Leslie King-Hammond, "A Conversation with Fred Wilson," in *Mining the Museum,* 33. **21.** Susan Vogel, "Always True to the Object, in Our Fashion," in *Exhibiting Cultures: The Poetics and Politics of Museum Display,* ed. Ivan Karp and Steven D. Lavine (Washington, D.C.: Smithsonian Institution Press, 1991), 198. **22.** John H. Falk, "Museums as Institutions for Personal Learning," *Daedalus* 128, no. 3 (summer 1999): 260. **23.** Harbison, *Eccentric Spaces,* 145. **24.** Benedict Anderson, *Imagined Communities: Reflections on the Origin and Spread of Nationalism,* rev. ed. (London: Verso, 1991), 178–85. **25.** Raphael Samuel, ed., *Patriotism: The Making and Unmaking of British National Identity,* 2 vols. (London: Routledge, 1989); quoted in Hollinger, "National Culture," 88–91. **26.** Michael Kammen, *Mystic Chords of Memory: The Transformation of Tradition in American Culture* (New York: Knopf, 1991), 521. **27.** Gary Kulik, "Designing the Past: History-Museum Exhibitions from Peale to the Present," in *History Museums in the United States: A Critical Assessment,* ed. Warren Leon and Roy Rosenzweig (Urbana: University of Illinois Press, 1989), 1–6. See also Laura Rigal, *The American Manufactory: Art, Labor, and World of Things in the Early Republic* (Princeton, N.J.: Princeton University Press, 1998), 92–113. **28.** R. T. H. Halsey, "Address," in *Addresses on the Occasion of the Opening of the American Wing* (New York: Metropolitan Museum of Art, 1925), 9–10; quoted in Kulik, "Designing the Past," 16. **29.** Quoted in Wes Hardin, William S. Pretzer, and Susan M. Steele, eds., *An American Invention: The Story of the Henry Ford Museum and Greenfield Village* (Dearborn, Mich.: Henry Ford Museum and Greenfield Village, 1999), i, 4, 10. **30.** Quoted in Warren Leon and Margaret Piatt, "Living History Museums," in *History Museums,* ed. Leon and Rosenzweig, 67. **31.** For an overview of the "history wars," see Edward T. Linenthal and Tom Engelhardt, eds., *History Wars: The Enola Gay and Other Battles for the American Past* (New York: Metropolitan, 1996). **32.** William H. McNeill, "The Care and Repair of Public Myth," in *Mythistory and Other Essays* (Chicago: University of Chicago Press, 1986), 23. **33.** Appleby, Hunt, and Jacob, *Telling the Truth,* 297. Gerda Lerner, *Why History Matters: Life and Thought* (New York: Oxford University Press, 1997), 202. **34.** Michael Lind, *The Next American Nation: The New Nationalism and the Fourth American Revolution* (New York: Free Press, 1995), 360–61. Michael Oakeshott, *On History and Other Essays* (Oxford, England: Oxford University Press, 1983), 100; quoted in Lind, *The Next American Nation,* 361. **35.** Lerner, *Why History Matters,* 201. **36.** David Hollinger, "National Culture," 319–21. **37.** Appleby, Hunt, and Jacob, *Telling the Truth,* 289. **38.** Eric Hobsbawm, *The Age of Extremes: A History of the World, 1914–1991* (New York, 1994), 3; quoted in Eric Foner, *The Story of American Freedom* (New York: W. W. Norton, 1998), xxi–xxii. **39.** From Langston Hughes, "I, Too," in *Selected Poems of Langston Hughes* (New York: Vintage Classics, 1990), 275. **40.** From Walt Whitman, "Song of Myself," stanza 30; "nation of nations" quote is from the preface to the 1855 edition of *Leaves of Grass.*

Unless otherwise cited in the notes, information given in the captions is from the accession files of the National Museum of American History. See photograph credits for accession numbers.

Celia Cruz's shoes, 1990s. Cruz, the Cuban-born vocalist known internationally as the "Queen of Salsa," began her musical career performing for Havana radio in the 1940s. She rose to fame in the 1950s singing for the Cuban band La Sonora Matancera and has been electrifying audiences ever since. During the 1990s curators began collecting and documenting contemporary Latino culture to broaden the Smithsonian's view of America. In 1997, at a ceremony honoring her fifty-year musical career, Cruz donated her flamboyant stage costume, including these custom-made platform shoes.

Further Reading

"America's Museums." *Daedalus* 128, no. 3 (summer 1999): [entire issue].

Anderson, Benedict. *Imagined Communities: Reflections on the Origin and Spread of Nationalism,* rev. ed. London: Verso, 1991.

Appadurai, Arjun, ed. *The Social Life of Things: Commodities in Cultural Perspective.* Cambridge, England: Cambridge University Press, 1986.

Appleby, Joyce, Lynn Hunt, and Margaret Jacob. *Telling the Truth about History.* New York: W. W. Norton, 1994.

Benson, Susan Porter, Stephen Brier, and Roy Rosenzweig, eds. *Presenting the Past: Essays on History and the Public.* Philadelphia: Temple University Press, 1986.

Conn, Steven. *Museums and American Intellectual Life, 1876–1926.* Chicago: University of Chicago Press, 1998.

Corrin, Lisa G., ed. *Mining the Museum: An Installation by Fred Wilson.* Baltimore: The Contemporary; New York, New Press, 1994.

Dubin, Steven C. *Displays of Power: Memory and Amnesia in the American Museum.* New York: New York University Press, 1999.

Goode, George Brown, ed. *The Smithsonian Institution 1847–1896: The History of Its First Half Century.* Washington, D.C. : Government Printing Office, 1897.

Henderson, Amy, and Adrienne L. Kaeppler, eds. *Exhibiting Dilemmas: Issues of Representation at the Smithsonian.* Washington, D.C.: Smithsonian Institution Press, 1997.

Hinsley, Curtis M., Jr. *Savages and Scientists: The Smithsonian Institution and the Development of American Anthropology, 1846–1910.* Washington, D.C.: Smithsonian Institution Press, 1981.

Kammen, Michael. *Mystic Chords of Memory: The Transformation of Tradition in American Culture.* New York: Knopf, 1991.

Karp, Ivan, and Steven D. Lavine, eds. *Exhibiting Cultures: The Poetics and Politics of Museum Display.* Washington, D.C.: Smithsonian Institution Press, 1991.

Karp, Ivan, Christine Mullen Kreamer, and Steven D. Lavine, eds. *Museums and Communities: The Politics of Public Culture.* Washington, D.C.: Smithsonian Institution Press, 1992.

Kingery, W. David, ed. *Learning from Things: Method and Theory of Material Culture Studies.* Washington, D.C.: Smithsonian Institution Press, 1996.

Kurin, Richard. *Reflections of a Culture Broker: The View from the Smithsonian.* Washington, D.C.: Smithsonian Institution Press, 1997.

Leon, Warren, and Roy Rosenzweig, eds. *History Museums in the United States: A Critical Assessment.* Urbana: University of Illinois Press, 1989.

Lerner, Gerda. *Why History Matters: Life and Thought.* New York: Oxford University Press, 1997.

Levine, Lawrence. *The Opening of the American Mind: Canons, Culture, and History.* Boston: Beacon Press, 1996.

Linenthal, Edward T., and Tom Engelhardt, eds. *History Wars: The Enola Gay and Other Battles for the American Past.* New York: Metropolitan Books, 1996.

Lowenthal, David. *The Past Is a Foreign Country.* Cambridge, England: Cambridge University Press, 1985.

Maines, Rachel P., and James J. Glynn. "Numinous Objects." *The Public Historian* 15, no. 1 (winter 1993): 9–25.

A Memorial of George Brown Goode. Washington, D.C.: Government Printing Office, 1901.

Orosz, Joel J. *Curators and Culture: The Museum Movement in America, 1740–1870.* Tuscaloosa: University of Alabama Press, 1990.

Pearce, Susan M., ed. *Interpreting Objects and Collections.* London and New York: Routledge, 1994.

Rosenzweig, Roy, and David Thelen. *The Presence of the Past: Popular Uses of History in American Life.* New York: Columbia University Press, 1998.

Schroeder-Gudehus, B., ed. *Industrial Society and Its Museums, 1890–1990: Social Aspirations and Cultural Policies.* Chur, Switzerland: Harwood, 1993.

Seelye, John. *Memory's Nation: The Place of Plymouth Rock.* Chapel Hill: University of North Carolina Press, 1998.

Stewart, Susan. *On Longing: Narratives of the Miniature, the Gigantic, the Souvenir, the Collection.* Durham, N.C.: Duke University Press, 1993.

Stocking, George, ed. *Objects and Others: Essays on Museums and Material Culture.* Madison: University of Wisconsin Press, 1985.

Trouillot, Michel-Rolph. *Silencing the Past: Power and the Production of History.* Boston: Beacon, 1995.

Wallace, Michael. *Mickey Mouse History and Other Essays on American Memory.* Philadelphia: Temple University Press, 1996.

Radio Shack Model 100 portable computer, 1983. One of the first widely successful portable computers, this model was a favorite of journalists and other mobile professionals during the early 1980s. A technology that changes as quickly as computer technology presents special collecting challenges. What appears to be an important breakthrough at the time may seem, a few years later, simply one in a very long line of minor innovations. And the rapid obsolescence of personal computers means that the Smithsonian is offered many more computers than it can possibly accept. This Model 100, acquired in 1995, is one of several computers donated by curators.

Photograph Credits

Credits indicate page number, subject, accession number, Smithsonian Institution negative number, and photographer. A long dash — indicates that data was unavailable or not applicable. For reproductions of images with negative numbers, contact the Office of Imaging, Printing, and Photographic Services, Smithsonian Institution, Washington, D.C. 20560-0644; for images marked PD&L, contact the Office of Product Development and Licensing, Smithsonian Institution, Washington, D.C. 20560-0951. Acronyms are used to indicate the Arts and Industries Building (A&I), Museum of History and Technology (MHT), and National Museum of American History (NMAH).

Cover. Table, 281476, 2000-4143, Jeff Tinsley. **Back cover.** Handbook, —, 75-3338, Lorie H. Aceto. **Endleaves.** Ellington score, 1988.3058, 95-4932, Larry Gates. **1.** The Castle, —, 93-2053, Richard W. Strauss. **2.** Clothespins, —, 91-6524, Richard W. Strauss. **5.** Signpost, 1983.0095, 83-7191, Dane A. Penland. **6–7.** East Hall, National Museum, —, 4492, —. **8.** Weather vane, 256396, 93-13175, Eric Long. **9.** Timber, 274163, 2000-6831, Richard W. Strauss. **10.** Dress, 320694, 99-2903, Richard W. Strauss. **10-11.** Storage room, National Museum, —, 3680, —. **13** (top left). The Castle, —, 93-2053, Richard W. Strauss. **13** (top right). Handbook, —, 75-3338, Lorie H. Aceto. **13** (middle). Drawing of National Museum —81-868, —. **13** (bottom). NMHT, —, 72-5114, Alfred F. Harrell. **14.** Clock, 1999.0276.01, 97-36700, Richard W. Strauss. **15.** Museum staff, —, 3663, —. **16.** Uniform, 13152, 2000-10747.08, Hugh Talman/Jeff Tinsley. **17.** Puppet, 1980.0123, 80-4313, Kim Nielson. **18** (top). Moccasins, 308316, 74-4100, Richard Hofmeister. **18** (bottom). Coin, 1985.0441, NNC cd3-16/17, Douglas Mudd. **19.** Heart pump, 223384, 93-11807, Rick Vargas. **20–21.** Fiddle, 1988.0761, 89-9219, Laurie Minor-Penland. **23.** Ruby slippers, 1979.1230, 2001-3147, Richard W. Strauss/Jeff Tinsley. **24** (top). Furniture, 45493/59140/124419, 95-5515-7, Richard W. Strauss. **24-25.** Life car, 16136, 78-18112, Kim Nielson. **26** (top). Vase, 30951, 84-805, Dane A. Penland. **26** (bottom). Mezzotint, 14054, 63810, —. **27.** Scrimshaw, —, 90-7414, Eric Long. **28–29.** *John Bull*, 15804, 86-9636, Eric Long. **30** (top). Violoncello, 1981.0289, 81-4766, Alfred F. Harrell. **30** (bottom). Ellington score, 1988.3058, 95-4932, Larry Gates. **31.** Quilt, 109459, 82-7791, Alfred F. Harrell. **32.** Certificate, 1991.0785, 79-7848, Dane A. Penland. **33.** Nickel, 1977.1199, NNC cd49-099/100, Douglas Mudd. **34.** Sovereign, 1985.0441, 95-3573, Richard W. Strauss. **35.** Emergency money, 1979.1263, NNC 05348, Douglas Mudd. **36.** Gold nugget, 135, 98-4800, Chip Clark. **37.** Flag fragment, 240139, 2000-4689, Richard W. Strauss. **38.** Cup, 274973,

2000-4685, Richard W. Strauss. **38–39.** Jefferson's desk, 68016, 2000-3209, Richard W. Strauss. **40–41.** Jefferson's desk, 68016, 2000-3210, Richard W. Strauss. **42.** Star Spangled Banner (at the Castle), 54876, 99-1583, Larry Gates. **43.** Star Spangled Banner (at MHT), 54876, 73-2623, Alfred F. Harrell. **44.** Plymouth Rock, 1985.0316, 2000-4610, Harold Dorwin. **45.** Bugle, 66761, 2000-4617, Harold Dorwin. **46.** Lunch counter, 1994.0156, 95-2071, Richard W. Strauss. **47.** Bunkers' chairs, 1978.2146, —; *All in the Family* copyright 1971, Columbia TriStar Television. **48–49.** Watch, 238282, 2000-4598/9, Hugh Talman. **50.** Jeans, 1970, 306097, 94-181, Dane A. Penland. **51.** Jacket, 1989.0539, —, Hugh Talman. **52–53.** Pennants (top, left to right), 1979.1162, 2000-4602/6/2000-4604/1/2000-4604/6/2000-4601/8, Hugh Talman; (bottom, left to right) 1979.1162, 2000-4604/8/2000-4602/1/2000-4601/6/2000-4597/10, Hugh Talman. **54.** Album, —, 2000-4603/1, Hugh Talman. **55** (top). Sword, 1981.0837, 2000-4599/2, Hugh Talman. **55** (bottom). Photograph, 1981.0837, —, —. **56.** Buttons, 314637, 2000-4600/3, Hugh Talman. **57.** Emblems, 260303, 2000-4597/5, Hugh Talman. **58.** Jewelry, 1984.0696, 2000-4626, Harold Dorwin. **59.** Trade card, 293320, 91-11800, Terry G. McCrae. **60–61.** Compass, 122864, 75-2348, Alfred F. Harrell. **63.** Presidents' hair, 13152, 2000-4600/12, Hugh Talman. **64** (top). Sword 68016, 90-10106, Rick Vargas. **64** (bottom). Walking stick, 68016, 98-3879, Hugh Talman. **65.** Medallion, 1981.0464, 2001-870/8, Hugh Talman. **66–67.** Musket, 13152, 2000-6339, Richard W. Strauss. **66.** Chair, 13152, 80-3217, Kim Nielson. **67.** Cane, 13152, 98-3880, Hugh Talman. **68.** Press, 38701, 72-7827, Alfred F. Harrell. **69.** Vase, 53695, 80-5676, Richard Brosnahan. **70–71.** Washington relics, —, 48727-A, —. **71.** Bucket, 204768, 99-2862, Terry G. McCrae. **72.** Washington statue, 1910.10.3 (Smithsonian American Art Museum), P6450, —. **73.** Pajamas, 201626, 2000-6313, Richard W. Strauss. **74.** Hat, 38912, 95-5528, Richard W. Strauss. **75.** Lincoln life mask, 20084, 93-12714, Eric Long. **76** (top). Microphone, 233610, 98-3878, Hugh Talman. **76** (bottom). Mask, 1977.0039, 76-16909, Richard Hofmeister. **77** (top). Log cabin, 299199, 94-185, Eric Long. **77** (bottom). Teddy bear, 252493, 93-7204, Eric Long. **78.** Bowling pin, 234460, 2000-4684, Richard W. Strauss. **79.** Box, 18528, 2000-7106, Terry G. McCrae. **80.** First Ladies Collection, —, 56,983, —. **81.** McKee gown, 170780, 92-1464-3, Eric Long. **82** (left). Washington gown, 106095, 92-3645, Eric Long. **82** (right). Harding gown, 268204, 91-19798, Eric Long. **83** (left). Roosevelt dress, 162687, 91-19807-13, Eric Long. **83** (right). Clinton gown, 1993.0574, 94-13462, Eric Long. **84** (top). Pin, 197631, 77-3160, John Wooten.

84 (bottom). Party favor, 299199, 87-558, Joe A. Goulait. **85.** Plate, 280399, 2000-7119, Terry G. McCrae. **86.** Microscope, 1993.0115, 93-7415, Eric Long. **87.** Medallion, 1991.0009, 95-3573-A-5, Richard W. Strauss. **88.** Flask, 13055, 2000-4614, Harold Dorwin. **89** (top). Electromagnet, 26705, 74-4488, Richard Hofmeister. **89** (bottom). Inhaler, 52400, PD&L, —. **90.** Sewing machine, 235640, 94-117, —. **91.** Cotton gin, 48865, PD&L, —. **92.** Telegraph register, 48865, PD&L, —. **93** (top). Paper bag machine, 1980.0004, PD&L, —. **93** (bottom). Lightbulb, 232729, 91-6526, —. **94.** Telescope, 248757, 60963, —. **95** (top). Drawing, 1983.0458, —, Hugh Talman. **95** (bottom). Puppet, 1999.0144, 98-41084, Hugh Talman. **96.** Jacket, 54045, 76-14088, John Wooten. **97.** Hatchet, 13152, 2000-4630, Harold Dorwin. **98.** Trophy, 1991.0781, 94-13683, Rick Vargas. **99.** Jumpsuit and motorcycle, 1995.0032/1994.0306, 95-3223, Eric Long. **100.** Uniform, 53757, 93-5844, Richard W. Strauss. **101.** Uniform, 1998.0165, 2000-3033, Richard W. Strauss. **102.** Tent, 13152, 74-4423, Richard Hofmeister. **103** (top). Pass, 182068, 2000-4603/12, Hugh Talman. **103** (bottom). Horse, 69413, 96-3074-8, Rick Vargas. **104.** Hat, 1998.0024, 2000-4609, Harold Dorwin. **104–5.** Carbine, 69413, 99-84/99-85, Richard W. Strauss. **105.** Pistols, 94639, 99-4493, Terry G. McCrae. **106.** Dog tags — 93-11702 Eric Long. **107.** Vietnam Veterans Memorial, —, 84-18136-27, Tracey Eller. **108** (top). Anthony relics, 64601, 17229-A, —. **108** (bottom). Watch, 314555, 99-36645, Richard W. Strauss. **109.** Advertising card, 309870, 74-3783, Harry Jenkins. **110.** Cap, 1980.0668, 2000-4144, Harold Dorwin. **111** (top). Buttons, 306522, 2000-4597/4, Hugh Talman. **111** (bottom). Jacket, 1993.0409, 93-11496, Richard W. Strauss. **112.** Mr. and Mrs. Tom Thumb, 1995.0231, 2000-2798, —. **113** (top). Hat, 1985.0397, 2000-4612, Harold Dorwin. **113** (bottom). Shoes, 1987.0177, 2000-4140/9, Harold Dorwin. **114** (top). Prize belt, 1983.0401, 89-10423, Dane A. Penland. **114** (bottom). Gloves and robe, 1977.1073, 93-2009, Rick Vargas. **115.** Baseballs, —, 91-19818, Eric Long. **116** (top). Hat, 1993.0457, 95-5509-1, Richard W. Strauss. **116** (middle). Kermit, 1994.0037, 80-5359, Kim Nielson. **116** (bottom). Jacket and hat, 1989.0323, 92-23, Rick Vargas. **117.** Guitar, 1993.0435, 94-1825, Richard W. Strauss. **119.** Wheelchair, 1995.0179, 2000-4605/5, Terry G. McCrae. **120–21.** Lincoln patent model, 48865, 90-7410, Eric Long. **123.** Chemistry set, 1992.0221, 93-9888, Rick Vargas. **124–25.** Spinning frame, 1790, 13137, 86-9625, Eric Long. **125.** Gene gun, 1991.0785, PD&L, —. **126.** Transportation exhibit, National Museum, —, 4493, —. **127.** Photophone, 162298, 2000-4613, Harold Dorwin. **129.** Boat Hall, National Museum, —, 2964A, —.

130. Synoptic series, —, 21389, —. **131.** Tools, 15372, 2000-4598/3, Hugh Talman. **132–33.** Pin machine, 51197, 85-7510, Eric Long. **135.** Louisiana Purchase Exposition, —, 16425, —. **136.** Telegraph exhibit, A&I, —, 9158, —. **136–37.** *John Bull*, 15804, 41354, —. **138** (top). *DeWitt Clinton* wheel, 24219, 75-11375, Richard Hofmeister. **138** (bottom). Allen wheel, 20584, 91-7262, Rick Vargas. **139.** Track sections, —, 30,911, —. **140.** Engine and boiler, 27810, 90-7409, Eric Long. **141.** Telephones, 48850, PD&L, —. **142.** Glass platter, 44943, 84-937, Dane A. Penland. **143.** Tank, —, 21861-A, —. **144–45.** Proposed design, MHT, —, 98-4769, —. **146–47.** Coal mine model, —, 28515, —. **148.** Apothecary, 1991.0664, 94-8800, Larry Gates. **149** (top). Model T, 120103, 2000-4603/11, Hugh Talman. **149** (bottom). Hall of Health, A&I, —, 44931, —. **150** (top). Machine shop, —, —, —. **150** (bottom). Agriculture Hall, MHT —, 75-13065, —. **151.** Astrolabe, 215454, 93-8024, Eric Long. **152** (top). Watch, 310796, 82-3763, Dane A. Penland. **152** (bottom). Zipper, 235975, PD&L, —. **153** (top). Velocipede, 209499, 98-944, Jeff Tinsley. **153** (bottom). ENIAC, 308932, 53192, —. **154–55.** Reaper, 89797, 91-6511, Richard W. Strauss. **157.** Rotary lens, 33057, 2000-4619, Harold Dorwin. **158.** Kelly converter, 209498, 31342-A-7, —. **159.** Musket, 32803, 2001-1279, Hugh Talman. **160.** Billboard, 314679, 2000-4315, Larry Gates. **161.** Hat, badge, and notebook, 1989.0402/1989.0473/1990.0556, 97-947, Eric Long. **162** (top). Badge, 1989.0396, 89-12803, Richard W. Strauss. **162** (bottom). Tool chest, 1999.0079, 2000-4688, Richard W. Strauss. **163** (top). Welding mask, 1986.0586, 91-1653, Eric Long. **163** (bottom). Salesman's kit, 1981.0821, 2000-4687, Richard W. Strauss. **164** (top). Polio vaccine, 221419, 99-315, Richard W. Strauss. **164** (bottom). Jarvik-7, 1987.0474, 95-5504-3, Rick Vargas. **165** (top). LED assembly, 1994.0354, 96-1977, Eric Long. **165** (bottom). Superconducting Super Collider, —, 94-9141, Richard W. Strauss/Rick Vargas. **166** (top). Poster, 1989.0674, 91-2454, Terry G. McCrae. **166** (bottom). DDT samples, —, 93-13121, Richard W. Strauss. **167** (top). Mask, 1986.0060, 2000-4596/5, Terry G. McCrae. **167** (middle). Poster, 1992.3212, 94-63, —. **167** (bottom). Macrobiotic food, 1997.0240, 2000-4686, Richard W. Strauss. **168–69.** Neon signs, 1987.0824 et al., 77-1965, Dane A. Penland. **171.** Table, 281476, 2000-4143, Jeff Tinsley. **173.** A&I, —, 4996, —. **174.** Mirror, 22479, 2000-4624, Harold Dorwin. **175.** Buck-

les, 65884, 78-4669, John Wooten. **176** (left). Copp Collection, 28810, 9106, —. **176** (right). Wine cup, 1985.0319, —, —. **177.** Gunboat, 229338, 90-7408, Eric Long. **178.** Colonial Room (1930s), 71679, 2000-4631, Larry Gates. **179** (top). Colonial Room (1970s), 71679, 77-2986, Dane A. Penland. **179** (bottom). Colonial Room (1986), 71679, 86-215, Jeff Tinsley/Eric Long. **180** (top). Bed warmer, 182022, 2000-4605/3, Terry G. McCrae. **180** (bottom). Jug, 211179, 92-5121, Rick Vargas. **181.** Drawknife, 247519, 2000-4608, Harold Dorwin. **182.** Sign, 256396, 82-2415, Alfred F. Harrell. **183.** Dollhouse, 190558, 48669CN, —. **184.** Demonstrators, —, 75-7716, Danny Thompson. **185.** Schoolhouse, 270415, 72-5491, Alfred F. Harrell. **186.** Cittern, 30719, 2000-4596/4, Terry G. McCrae. **187.** Costume, 50645, —, —. **188** (top). Shofar, 22131, 2001-870/3, Hugh Talman. **188** (bottom). Scroll, 67600, 92-13003, Rick Vargas. **189.** Icon, 25819, 87-10525, Dane A. Penland. **190.** Ambrotype, 121824, 2000-4607/11-12, Harold Dorwin. **191.** Shoe, 15995, 2000-4627, Harold Dorwin. **192.** Pistol, 13152, 97-1791, Terry G. McCrae. **193** (top). Pipe, 113605 (NMAH), 81-512, Alfred F. Harrell. **193** (bottom). Blanket, 65608, 98-3869, Hugh Talman. **194.** Plate, 34791, 77-13228, John Wooten. **195.** Medal, 178781, 2000-4602/7, Hugh Talman. **196.** Spanish colonial room, —, 3911-A, —. **197.** Jugs, 68233, 92-16902, Eric Long. **198** (left). *Ping purt*, 1987.0570, 2000-4141, Harold Dorwin. **198** (right). Dulcimer, 272574, 2000-4596-3, Terry G. McCrae. **199** (top). *Retablo*, 269937, 95-5506-7, Richard W. Strauss. **199** (bottom). Sprayers, 311497, 2000-4629, Harold Dorwin. **200** (top). Jewelry, 1996.0209, 98-4230C, Hugh Talman. **200** (bottom). Basket, 314675, 94-124, Rick Vargas. **201** (top). Coffee maker, 1984.0218, 2000-4623, Harold Dorwin. **201** (bottom). Chalice, 304142, 2000-4146, Harold Dorwin. **202** (top). Cartoon, 1988.0434, 94-13679, Rick Vargas. **202** (bottom). Mask, 1997.0097, 98-2832, Richard W. Strauss. **203** (top). Lunch boxes, 1988.3160, 89-5015, Eric Long. **203** (left). Ticket booth, 310894, 76-13875-36, John Wooten. **203** (right). Stopwatch, 1998.0265, 2000-4618, Harold Dorwin. **204** (top). Fiestaware, 1999.0136, 2000-4625, Harold Dorwin. **204** (bottom). Veg-O-Matic, 1986.0222, 2000-4615, Harold Dorwin. **205** (top). Uniform, 1986.0906, 87-2578, Dane A. Penland. **205** (bottom). Toy, 295669, 73-23, Alfred F. Harrell. **206.** Button, 250459, 98-4706, —. **206–7.** Poster, 1977.0267, 77-1159,

Richard Myers. **208.** Bracelet, 1987.0165, 2000-4599/1, Hugh Talman. **209** (top). Medallion, 1987.0005, 84-15393, —. **209** (bottom). Poster, 1978.2202, 2000-4316, Larry Gates. **210.** Signboard, 1992.0413, 93-7421, Eric Long. **211** (top). Jar, 1996.0344, 98-4545, Eric Long. **211** (middle). Sign, 1986.3067, 87-11806, Eric Long. **211** (bottom). Pin, 1987.0165, 80-16212, Richard Brosnahan. **213** (top). Sweatshop, 1997.0268, 98-3145A, Richard W. Strauss. **213** (bottom left). Sun stone, 1989.0453, 90-13700, Rick Vargas. **213** (bottom right). Quilt panel, 1998.0254, 2000-4145, Harold Dorwin. **214.** Jersey, 1984.0940, 95-5525, Eric Long. **215.** Hat, 1996.0291, 2000-4605/11, Terry G. McCrae. **216–17.** Car, 1985.0009, 85-31127, Eric Long/Jeff Tinsley. **219.** Shoes, 307480, 73-2360, Alfred F. Harrell. **220.** Picture, 148588, 88-16999, Richard W. Strauss. **221.** Pitcher, 1978.0806, 84-15421, —. **222.** Doll, 1930s, 1989.0221, 97-3605, Richard W. Strauss. **223** (top and bottom). Level, 1997.0353, 97-4678, Rick Vargas. **224** (top and bottom). Medal, 1990.0466, NNC cd42-95/96, Douglas Mudd. **225.** Phrenology model, 239772, 80-19910, Kim Nielson. **226** (left). Teapot, 1979.0917, 79-8546, Richard Brosnahan. **226** (right). Camera, 1986.0173, 2000-4620, Harold Dorwin. **227** (left). Typewriter, 54877, PD&L, —. **227** (right). Baseball, 1981.0342, 2000-4621, Harold Dorwin. **228.** Model T (1971), 311052, 71-181-1 CN, Alfred F. Harrell. **229** (top). Model T (1992), 311052, 92-4891, Jeff Tinsley. **229** (bottom). Low rider, 1990.0567, 95-3347, Eric Long. **230.** Quilt, 157340, 74-7901, Richard Hofmeister. **231** (top). Negative, 1995.0206, 2000-1036, Scott Williams. **231** (bottom). Tintype, 320862, 2000-2833, —. **232.** Lincoln gown, 70138, 57631, —. **233.** Jukebox, 292527, 91-10686, Lynnette Chewning/Bill Kendrick. **234.** Currency, —, NNC cd39-57/58, Douglas Mudd. **235.** Lamp, Centennial-73829, 81-15031, Brenda Gilmore. **236.** Plutonium sample, 272669, 85-12109, Eric Long. **237.** Phaser, 1987.0095, 95-5510, Richard W. Strauss. **238.** Dress, 1992.0620, 95-5526, Eric Long. **239.** Trumpet, 1986.0003, 86-11768, Jeffrey Ploskonka. **241.** Barbie doll, 1988.0608, 94-3264, Eric Long. **242.** Life preserver, 48296, 2000-4600/2, Hugh Talman. **244.** Pipe, 1996.0006, 2000-4628, Harold Dorwin. **245.** Hat, 92238, 94-136, Jeff Tinsley. **247.** Shoes, 1997.0291, 2000-4616, Harold Dorwin. **248.** Computer, 1995.0176, 93-3084, Richard W. Strauss.

Index